Encyclopedia of Jewish American Artists

ENCYCLOPEDIA OF JEWISH AMERICAN ARTISTS

Samantha Baskind

Artists of the American Mosaic

GREENWOOD PRESS

Westport, Connecticut• London

Library of Congress Cataloging-in-Publication Data

Baskind, Samantha.
Encyclopedia of Jewish American artists / Samantha Baskind.
 p. cm.—(Artists of the American Mosaic)
Includes bibliographical references and index.
ISBN 0–313–33637–7 (alk. paper)
1. Jewish artists—United States—Biography—Dictionaries. 2. Art, American—19th century—
Dictionaries. 3. Art, American—20th century—Dictionaries. I. Title.
N6538.J4B37 2007
704.03'924073—dc22 2006028661

British Library Cataloguing in Publication Data is available.

Library of Congress Catalog Card Number: 2006028661
ISBN: 0–313–33637–7

First published in 2007

Greenwood Press, 88 Post Road West, Westport, CT 06881
An imprint of Greenwood Publishing Group, Inc.
www.greenwood.com

Printed in the United States of America

The paper used in this book complies with the
Permanent Paper Standard issued by the National
Information Standards Organization (Z39.48-1984).

10 9 8 7 6 5 4 3 2 1

For my grandmother, Margie Aderson, with love

Contents

x Contents

A color image section follows page 166

Acknowledgments

In writing this book I requested assistance from a number of people. I am extremely grateful to the scholars who provided me with excellent initial resources from which to write about the fascinating group of artists discussed in the following pages. Especially, I thank Matthew Baigell for his groundbreaking scholarship in the field of Jewish American art and his ongoing support of my work.

I am equally indebted to my colleagues and the staff at Cleveland State University. Jan Milic, administrative coordinator and more, cheerfully endures my seemingly interminable requests for help and Qian Li has been generous with her scanning expertise. To the staff at my university library, I offer sincere appreciation for their assistance and persistence in filling what at times seemed impossible requests. Many thanks to my research assistant, Laura Rother, for her resourcefulness, efficiency, and willingness to work under time constraints. To my students Amanda Davis and Rachael Romine, I owe a thank you for their enthusiasm and love of art history. They have made teaching a true joy.

For her graciousness, I extend my best to Ziva Amishai-Maisels, who drove us far out of our way in the traffic of Jerusalem to give me a copy of her magisterial, out-of-print book, which has undoubtedly augmented the present volume. Many thanks are due to my thoughtful editor, Debby Adams, and to Michael O'Connor, my expert project manager. I am pleased to recognize Jerry Jackson of the Smith-Girard Gallery and Patricia Burnham, who came through in a pinch with help choosing and accessing the Theresa Bernstein painting on the cover of the book. Appreciation is also due to Nancy Niels and Andrea Pappas, with whom I have shared lively conversations and benefited from insightful comments about the nature of Jewish art and artists. With pleasure I express my continuing gratitude to Mary Sheriff, my advisor throughout graduate school. Even now, several years after finishing my degree, she serves as a shining example, important mentor, and friend. Although there are too many to name specifically, I am most grateful to those galleries and museums that lowered or waived fees so that image reproductions could appear in the

book. Every effort has been made to locate and contact the owners of the art reproduced. To those owners I could not find, I offer my apologies, and I am glad to add appropriate collection names in any subsequent printing or edition of this book.

I owe a heartfelt thank you to those artists who responded to my questions in writing or granted me oral interviews: Eleanor Antin, Ida Applebroog, Shimon Attie, Jonathan Borofsky, Alice Lok Cahana, Judy Chicago, Audrey Flack, Lee Friedlander, Tobi Kahn, Jack Levine, Sol LeWitt, Arnold Newman, Philip Pearlstein, Archie Rand, and Miriam Schapiro. Their generosity of time and spirit means so much to me, and their comments have significantly enhanced this project. With warm appreciation I acknowledge two special friends: Rabbi Leonid Feldman, for his assistance with Hebrew and Yiddish translations, and Scott Simon, for his generous and thorough editing of my work.

Finally, I thank my husband, Larry Baum, for his love and patience while living with me and this project from A to Z.

Preface

The term Jewish American art, as the more generalized Jewish art, is fraught
with complications and variously understood. Critics debate whether Jewish
American art need only be art made by a Jewish American, independent of
content, or if both the artist's and the artwork's identity must be Jewish. As
will be described below, one critic even asserted that Jewish art must be
defined by a coherent style across geographic boundaries and the nearly
four-millennia existence of the Jews. Taking a broad approach, this book exam-
ines eighty-five Jewish American artists working in myriad styles, and who
adopted both figuration and abstraction. While some artists make art indistin-
guishable in subject from their Gentile counterparts, others in this book
address Jewishness or the more specific Jewish American encounter. Religious
imagery would be the most obvious manifestation of Judaism in the work of
the artists described. Jewishness though, in America or elsewhere, is much
more than a religious evocation. Parochial imagery, as of a menorah, a rabbi,
or a biblical subject, is only one expression of the Jewish experience. The spe-
cial position of Judaism as both a religion and a secular culture instigates a
wide variety of artwork that evokes the Jewish experience, and so religious
matter is only one element discerned in the work by artists described in the fol-
lowing pages.

Sometimes Jewish American artists make art that does not overtly appear to
be Jewish (religious or secular), but close observation of an artist's work
reveals that Jewish identity is encoded in the art. For example, in her discus-
sion of **Ben Shahn**, art historian Ziva Amishai-Maisels argues that for a period
of time Shahn avoided direct reference to the Holocaust while still exploring
his Jewish identity by employing more generalized subjects. She arrived at this
conclusion by uncovering Shahn's use of Holocaust photographs as source
material for paintings on other socially conscious topics that say something
about the plight of Jews as well. Similarly, in my own research I found Jewish
substance in the work of **Raphael Soyer** even when his paintings included no
explicit Jewish matter. Soyer painted several canvases of the homeless during
the Great Depression. On the surface these paintings do not appear to embody

Jewish content. However, after researching Soyer for nearly four years, I dis-
covered that he took a special interest in the homeless. In my book, I argue that
Soyer was acutely aware of, and acknowledging developments in the Ameri-
can art world, but fashioning his imagery in a way that reflected his sense of
Jewish responsibility. Although in the 1930s overt Jewish subjects cannot be
discerned in Soyer's work, his primary subject matter, the homeless, demon-
strates that he was still influenced by his religiocultural heritage in the form
of the Jewish belief in social justice known as *tikkun olam*, or repair of the
world. Moreover, after examining Soyer's paintings of the homeless from the
New Deal period, paying special attention to works that include a homeless
man named Walter Broe, I maintain that Soyer used Broe as a metaphor for
himself, in part because to be Jewish is to live in a state of homelessness. This
argument was pursued through a discussion of Soyer's affiliation with the
Communist Party, whose view of the plight of the masses heightened his social
awareness, particularly in relation to his Jewish identity. At this time, current
social, artistic, and political ideologies combined to influence Soyer's concep-
tion of the world as revealed in his artistic production.

For me to ultimately make the Soyer–Broe connection, I read Soyer's four
autobiographies, combed eight microfilm reels of his personal papers at the
Archives of American Art, and interviewed his living family members and
his friends. Obviously, I cannot do this for all of the artists in this book. I won-
der—for how many artists did aspects of the Jewish experience influence their
artwork in a similarly covert way? Thus, in the following pages I include
artists known for their contributions to American visual culture, and then let
readers discover if these artists *did* portray elements of their Jewish identity
in their art. I believe this approach is essential, for when not keeping the door
open for the recognition of Jewish expression, some past scholars viewed
Soyer's work (and his brother Moses' art) as devoid of Jewish sensibility. For
instance, in 1981 Mahonri Sharp Young erroneously observed, "No Jewish con-
tent appears in the work of the Soyers, but they are accepted as Jewish artists"
(173).

After setting up this initial standard, I was left with an additional question: if
an artist denied that Jewish identity influenced his or her work should I omit
an entry for that artist? This option is uncomfortable to me, as for much of
his life, Soyer disputed that his art was influenced by his Jewish heritage, pre-
ferring instead to adopt the moniker "New York Painter." Take the case of
Helen Frankenthaler, a postpainterly color-field artist. Frankenthaler
described her views on Judaism and her work in 1998: "My concern was and
is for good art: not female art, or French art, or black art, or Jewish art, but good
art" (Brown, 28). Omitting Frankenthaler while including **Mark Rothko**,
whose early mythological works have been read by Andrea Pappas along with
lesser-known crucifixion images as an attempt by Rothko to circumvent critical
pigeonholing as a Jewish artist, seems dismissive. Before Pappas' in-depth
study, Rothko was understood by most scholars as having eschewed Jewish-
ness in his art. What might come of similar studies on Frankenthaler? Further-
more, if a Jewish American artist should be defined sociologically or by theme
remains an open question. Thus, here I adopt a wide perspective, accepting

Jewish American artists by either criteria, again leaving the matter for the reader to decide.

In sum, this book is not meant to be a best of list, nor is it intended to be all-inclusive (which would be impossible due to length constraints) or indicative of those artists who most emphatically express Jewishness in their work; a few, such as **Leon Kroll** and **Will Barnet**, have no explicitly Jewish content. No doubt, some of my choices will be criticized, but such a discourse will only serve my larger purpose: to provide a useful tool for those already interested in the material and to incite those readers to use these brief discussions as a catalyst to stimulate further exploration as to what may or may not be Jewish about the artists' work, as I did in my own research on Raphael Soyer. Equally important, the book will also introduce Jewish American art to an audience unfamiliar with the subject.

Having described why certain artists are included, I think it is also important to mention why others are not. To name a few artists that readers may be surprised to discover are not discussed: Arthur Szyk created his most famous works in Europe and was not profoundly influenced by his American environment. Born in 1894, Szyk only immigrated to the United States in 1940, eleven years before his death. Similarly, Jacques Lipchitz developed his mature style long before he arrived in the United States as an artist refugee and therefore he also does not receive an entry. In other words, while the majority of artists described herein were born abroad—mostly in Eastern Europe—they arrived in the United States at a young age and identified as Americans.

There are also several artists that have been accepted as Jewish on occasion, but who I discovered are not Jewish during my research. Among the most conspicuous are **William Zorach**'s wife Marguerite Thompson Zorach, who was raised in California by a Quaker father and a Christian mother; Louis Eilshemius; Ad Reinhardt; and Margaret Bourke-White. Reinhardt is included in Ori Soltes' book on Jewish American artists, *Fixing the World* (70). In an undated document titled "Religious Strength Through Market-Place Joy," however, Reinhardt wrote a brief commentary elucidating the problem of religious stratification in the arts, which indicates that he, in fact, is not Jewish:

> What's wrong with the art world is not Andy Warhol or Andy Wyeth but Mark Rothko.
> The corruption of the best is the worst.
> Motherwell said someone said, "Rothko is the best Jewish artist in the world."
> Motherwell and I are Protestant Christians.
> You don't have to be Jewish to show at the Jewish Museum.
> Are all art-museum curators Wasps? Are all art critics Jews?
> How about Christians making synagogue murals? (Motherwell)
> How about Jews decorating Catholic churches? (Rothko)
> How about a ~~Lutheran~~ adopting the Hebraic-Islamic disdain for images (Reinhardt).
>
> (Reinhardt, 190)

Even if Reinhardt misunderstands Rothko's commission, which was for a nondenominational chapel (and Reinhardt thus erroneously judges Rothko for accepting a commission to paint a church), he brings up an important point: that there are no pat categories for artists' work and that an artist's religion does not lead to easy categorization, or assumption of ideology or artistic interests. Indeed, as the varied interests of the artists in this book vividly demonstrate, a Jewish heritage does not lead to a homogenous art.

While Eilshemius has been included in a few art exhibitions focused on Jewish artists, my research has provided inadequate documentation that this prodigious and idiosyncratic painter is Jewish. In William Schack's nearly 300-page biography of the artist, who the writer personally knew, he references Eilshemius' French-Swiss mother and Dutch father, "who came from a long line of pastors, his grandfather having been Bishop of Leer" (22). Paul Karlstrom, the leading Eilshemius scholar, mentions nothing about Eilshemius' alleged Jewish heritage in his writings on the artist. Further, in a recent conversation with me, Karlstrom confirmed that his copious research did not provide evidence of a Jewish background.

Finally, *Life* magazine photographer Margaret Bourke-White was born to a Christian mother and a Jewish father, both adherents of Felix Adler's philosophy of Ethical Culture. They raised their daughter along the ideology of this humanistic religion, although she sometimes went to church, and Bourke-White did not even learn of her Jewish heritage until her late teens after her father passed away. With this background in mind, I chose not to include Bourke-White in this book because the goal here is not to appropriate any artist born as a Jew as a Jewish artist but to present artists that were raised as Jewish to a critical audience interested in exploring whether or not the artists' religio-cultural inheritance influenced their art. As previously described, in some instances it is obvious that the artist explored Judaism, but in other cases research and careful looking needs to be done. In Bourke-White's case, it would be impossible to discern the influence of Jewishness on her art, as she was not imbued with Jewish values as a child. Perhaps Bourke-White's shame of her Jewish background—which she concealed to such an extent that she made no mention of it in her autobiography—influenced her approach to photography, but that analysis is inconsequential to the material and aims of this book.

Each entry includes a brief biography of an artist, highlighting his or her accomplishments. Some entries provide critical responses to the artist's work and a discussion of societal and stylistic influences. A description of a significant image or two, at times with an interpretation of the image, is accompanied by an illustration whenever possible. When at least one work clearly indicates the influence of the artists' Jewish background, it is noted in the entry. Similarly, if an artist commented on Jewish art or held a position on the topic of Jewish artists a quote is provided (as are direct quotes about other subjects relating to the artist's work). For instance, in 1984 the sculptor **Chaim Gross** explained: "First of all, I would say that I am an American artist. Because I

am an American; but I am Jewish, so I do a lot of Jewish subjects....I had a brother, a great Yiddish poet, Naftali Gross. He used to say, 'Chaim, your work is Yiddish. You can tell. The way you are doing your figures. They are Jewish girls.' You can't get away, because I am a Jew. And you cannot get away from it. You can't get away mentally or physically. And maybe, if you try to get away from it, there is always something Jewish in your art" (Soltes, *Tradition and Transformation*, segment 7B). When possible, I have corresponded with living artists, including that material as well. Within each entry, if an artist elsewhere in the book is cited, the artist's name appears in bold. At the end of each entry a brief bibliography is provided, which varies considerably in length and contemporaneity of sources depending on how much research has been done on the artist. **Jennings Tofel**, for example, has to this point been critically neglected, and so I had to turn to the few sources that exist as well as to conduct some primary research of my own, in this case examining an exhibition review from 1917, an exhibition catalog from 1948, and the artist's personal papers at the Smithsonian Institution's Archives of American Art. Even in the case of better-known artists, such as photographer **Richard Avedon**, the bibliography does not purport to be comprehensive, but rather includes those works that I consulted for the entry and perhaps a few more of interest. Following the bibliography, readers will find a selected list of public collections where the artists' works can be found.

Bibliography

Amishai-Maisels, Ziva. "Ben Shahn and the Problem of Jewish Identity." *Jewish Art* 12–13 (1986–87): 304–319.

Baskind, Samantha. *Raphael Soyer and the Search for Modern Jewish Art*. Chapel Hill: University of North Carolina Press, 2004.

Bourke-White, Margaret. *Portrait of Myself*. New York: Simon and Schuster, 1963.

Brown, Julia. *After Mountains and Sea: Frankenthaler 1956-1959*. New York: Guggenheim Museum, 1998.

Goldberg, Vicki. *Margaret Bourke-White: A Biography*. New York: Harper and Row, Publishers, 1986.

Karlstrom, Paul J. *The Romanticism of Eilshemius*. New York: Bernard Danenberg Galleries, 1973.

———. *Louis Michel Eilshemius*. New York: Harry N. Abrams, Inc., Publishers, 1978.

———. *Louis M. Eilshemius: Selections from the Hirshhorn Museum and Sculpture Garden*. Washington, D.C.: Smithsonian Institution Press, 1978.

Pappas, Andrea. "Mark Rothko and the Politics of Jewish Identity, 1939-1945." Ph. D. dissertation, University of Southern California, 1997.

Rose, Barbara, ed. *Art-as-Art: The Selected Writings of Ad Reinhardt*. New York: Viking Press, 1975.

Schack, William. *And He Sat Among the Ashes*. New York: American Artists Group, 1939.

Soltes, Ori Z., dir. *Tradition and Transformation: A History of Jewish Art and Architecture*. Cleveland: Electric Shadows Corporation, 1984–1990.

————. *Fixing The World: Jewish American Painters in the Twentieth Century.* Hanover,
 NH: Brandeis University Press, 2003.
Tarbell, Roberta K. *Marguerite Zorach: The Early Years, 1908-1920.* Washington, D.C.:
 Smithsonian Institution Press, 1973.
Young, Mahonri Sharp. "Leaning Left." *Apollo* 113 (March 1981): 172–179.

A Brief History of Jewish American Art

Before 1900

While Jews arrived in America as early as 1654, they did not enter the visual arts in a meaningful way until the nineteenth century.[1] The freedoms accorded Jews enabled them to participate in the plastic arts, but the loosening of religious constraints as well as uneasiness about the respectability of an art career disappeared slowly. Hesitancy was sometimes the result of the Second Commandment, the prohibition against graven images. Interpreted stringently, as it was for centuries, the Second Commandment has been understood as prohibiting the creation of art: "Thou shalt not make any graven image, or any likeness of any thing that is in the heaven above, or that is in the earth beneath, or that is in the water under the earth" (Exod. 20:4). Deuteronomy repeats and broadens this ban: "lest ye deal corruptly, and make you a graven image, even the form of any figure, the likeness of male or female, the likeness of any fowl that flieth in the heaven, the likeness of any beast that is on the face of the earth, the likeness of anything that creepeth on the ground, the likeness of any fish that is in the water under the earth" (Deut. 4:16–18). Close reading of the text shows that the commandment was directed against figuration used for idol worship, not other types of artistic expression.

Jewish art was fabricated in ancient times, albeit rarely—likely a result of the Jews' diasporic lifestyle and subsequent inability to transport art more than a literal understanding of the biblical text. Too, the Jew may have been so focused on studying the Torah, considered the most vital pursuit in Judaism, that time for creating pictorial art was scarce. Regardless, the Second Commandment did not preclude art entirely. Human renderings appear in the third-century synagogue murals of Dura Europos in Syria, and in Exodus, Bezalel—the first Jewish artist—designed the Tabernacle and its holy vessels (Exod. 35:31).[2] Apologetic for the lack of Jewish art, for whatever reason, Rabbinic interpreters viewed God as the great artist of humankind, and the Jew as destined instead to live a life of goodness: "The opinion is often expressed

that there is no art in Judaism; that the Jew lacks aesthetic sense; and that this is largely due to the influence of the Second Commandment, which prohibited plastic art in Israel. Defenders of the Jew and Judaism usually reply that Judaism was determined to lift the God-idea above the sensual, and to represent the Divine as spirit only; that Art was not Israel's predestined province; that whereas the legacy of Greece was Beauty, the mission of Israel was Righteousness" (Hertz, 376).

In the nineteenth century, some Jewish American artists designed ritual objects, acceptable under the stricture of the Second Commandment. For example, Myer Myers was an eighteenth-century silversmith who made both lay and religious objects for colonial merchants. He created *rimmonim* for several synagogues, including New York's Congregation Shearith Israel and the Yeshuat Israel Congregation in Newport, Rhode Island. In the nineteenth century, a handful of Jews did paint, most frequently portraits. Wealthy patrons commissioned the brothers Joshua and John Canter (or Canterson) to record their visages. Theodore Sidney Moïse, Frederick E. Cohen, and Jacob Hart Lazarus are other nineteenth-century Jewish portraitists of note.

Solomon Nunes Carvalho is the best-known artist from this period. In addition to making portraits of members of the Jewish community, he also painted allegorical portraits, including one of Abraham Lincoln (1865). Carvalho created a few biblical paintings and landscapes as well, but his fame rests on his work as a daguerreotypist for John C. Frémont's 1853 exploratory expedition through Kansas, Utah, and Colorado. Primarily known in his time as a printmaker, Max Rosenthal was the official illustrator for the United States Military Commission during the Civil War. Later, Rosenthal painted *Jesus at Prayer* for a Protestant church in Baltimore, presenting Jesus with phylacteries (boxes containing scripture that Jews wear during morning prayer) on his forehead and right arm. The altarpiece was promptly rejected. **Henry Mosler** began his career as an artist correspondent for *Harper's Weekly* during the Civil War. Like many non-Jewish artists, Mosler went to Europe for artistic training. He soon became a painter of genre scenes, frequently picturing peasant life in Brittany, France. His canvas *The Wedding Feast* (c. 1892), which was exhibited at the Paris Salon, records Breton marriage customs.

The eminent sculptor **Moses Jacob Ezekiel** made numerous portrait heads, including a bronze bust of Rabbi Isaac Mayer Wise (1899), a leader of Reform Judaism. The B'nai B'rith commissioned Ezekiel's large marble Neoclassical group *Religious Liberty* for the Centennial Exhibition of 1876, and in 1888 he designed the seal for the recently established Jewish Publication Society of America. Ephraim Keyser created commemorative sculptures, including President Chester Arthur's tomb at the Rural Cemetery in Albany, New York. Katherine M. Cohen studied with the famous sculptor Augustus Saint-Gaudens and made portrait busts, as well as sculptures with Jewish themes such as *The Vision of Rabbi Ezra* and *The Israelite*. These early painters and sculptors worked independently and were not readily known to each other. They created in relatively divergent styles along the same trends as the larger American community. It was not until the twentieth century that Jewish American artists began interacting and taking art classes together.

1900–45

Among the large 1880 to 1920 influx of immigrants to the United States were two million Jews. Mostly from poor communities in Eastern Europe, these immigrants were eager to assimilate. The Educational Alliance, a settlement house on the Lower East Side of New York City where many immigrants went to learn American manners and customs, offered art classes starting in 1895. Art classes were discontinued in 1905, resuming in 1917. From the school's reopening until 1955, Russian immigrant Abbo Ostrowsky served as director of the institution. Many artists who later achieved great success studied at the Alliance, including the sculptors **Saul Baizerman** and **Jo Davidson**, and the painters **Peter Blume** and **Philip Evergood**. The Alliance sponsored art exhibitions as did other Jewishly identified venues in New York. In 1912, the Ethical Culture Society's Madison House Settlement arranged a show of Jewish Russian immigrant artists, such as Samuel Halpert, in which Gentile artists also participated. The People's Art Guild held sixty exhibitions from 1915 to 1918. In May 1917, nearly 300 works by eighty-nine artists were exhibited at the Forverts Building (home of the Yiddish daily newspaper *The Forward*), of which over half were Jewish. Well-known Jewish philanthropists Stephen Wise, Judah Magnes, and Jacob Schiff helped sponsor the exhibition. From 1925 to 1927 the Jewish Art Center, directed by **Jennings Tofel** and Benjamin Kopman, held exhibitions focusing on Yiddish culture.

In the early decades of the twentieth century some artists, such as **Abraham Walkowitz**, **William Meyerowitz**, and **Jacob Epstein**, began their nascent careers by picturing imagery of the Lower East Side. The Gentile observer Hutchins Hapgood described east side imagery in his book *The Spirit of the Ghetto* (1902) as typically Jewish. Characterizing this work as "Ghetto art," Hapgood named Epstein, Bernard Gussow, and Nathaniel Loewenberg as exemplars of the mode (255). To illustrate Hapgood's evocation of the cultural and religious nature of the Jewish people, Epstein made fifty-two drawings and a cover design for the book. Epstein later became an expatriate, settling in London and gaining fame as a modernist sculptor.

The photographer **Alfred Stieglitz** championed the avant-garde in the 1910s. While most of the artists that Stieglitz supported were not Jewish, his coreligionist **Max Weber**, a painter and sculptor influenced by Cubist developments, and the modernist Walkowitz enjoyed his patronage. An underlying tone of anti-Semitism, or at least an intense nativism, pervaded some discussions of modernism at this time; the conservative critic Royal Cortissoz described modernism as "Ellis Island art" (18). Certainly, modernism was frequently associated with Jews—especially in Europe—a position later adopted by Adolf Hitler.

Many artists addressed political, social, and economic issues, especially during the Great Depression. It has been argued that traditions of social justice—*tikkun olam*, as described in the preface in relation to **Raphael Soyer**—impel Jewish artists to create imagery of the underdog (e.g., Baskind; Soltes, *Fixing the World*). Although secular in theme, these works—influenced by the Jewish

experience—would be recognized as Jewish American art even by critics who define the term in its strictest sense. Working as Social Realists in the 1930s, Soyer, as well as his brothers **Moses Soyer** and Isaac Soyer, observed the mundane details of life—like waiting in an unemployment line—with gentleness and compassion. Blume, **Ben Shahn**, **Mitchell Siporin**, and **Harry Sternberg** were more emphatic about their political commitments; Shahn made over twenty images decrying the ethnically biased trial and execution of Italian American anarchists Nicola Sacco and Bartolomeo Vanzetti. **William Gropper** expressed his political sympathies as a cartoonist for the left-wing publications *New Masses* and the Yiddish daily *Morning Freiheit*. Several of the artists' desire for social change encouraged them to find a like-minded community, and thus some joined Socialist or Communist organizations, such as the John Reed Club.

Louis Lozowick, who worked as a Precisionist painter of city scenes and sometimes as a Social Realist, wrote the introduction for the first full-length book on Jewish American artists and contributed art criticism to the *Menorah Journal*, a periodical devoted to Jewish culture that also attempted at various times to define Jewish art. In a 1924 article on Jewish artists who recently exhibited in New York, Lozowick mentions **Theresa Bernstein**, Gropper, and **William Zorach**, among others. Although few of these artists depicted Jewish themes (at least at that time), Lozowick's identification of the artists as Jewish indicates that he, like many critics, understood the term Jewish artist as connoting the ethnic identification of the artist rather than the artist's subject matter. A year later Peter Krasnow explicitly defined Jewish art in the *Menorah Journal*, broadly understanding any art produced by a Jew as "essentially Jewish art, independent of subject" (540).[3] In this early period of Jewish integration into America, most artists tried to avoid this kind of discourse, fearing that such categorization would pigeonhole their work as Other or parochial. Too, the fear of anti-Semitic backlash remained a real concern, even after World War II. There was, however, ambivalence on the part of many artists; even if artists shied away from the classification "Jewish artist," several still displayed their work at the aforementioned Jewish Art Center and the Educational Alliance, among other Jewish locales. The art exhibitions of the Yiddisher Kultur Farband (YKUF), a Communist organization dedicated to fighting fascism, were also quite popular. Established in September 1937 by the World Alliance for Yiddish Culture, YKUF's first art exhibition was held in 1938. Minna Harkavy, Lionel Reiss, and Louis Ribak were among 102 artists who showed work delineating both Jewish and non-Jewish material.

In 1935, nine Jewish artists formed a group they dubbed "The Ten" (the tenth spot was reserved for a guest artist). **Ilya Bolotowsky**, **Ben-Zion**, **Adolph Gottlieb**, Louis Harris, Jack (Yankel) Kufeld, Marcus Rothkowitz (**Mark Rothko**), Louis Schanker, Joseph Solman, and Nahum Tschacbasov—members of the original group—exhibited together for four years. That the artists shared a Jewish background is typically understood as a coincidence. No common style or theme pervades the group's work, but most members were committed to modernist developments. Critic Henry McBride of the *New York Sun* commented on the artists' origins in 1938: "Practically all of the men paint in somber tones and this may be merely a coincidence or it may be racial, for the

names of the artists suggest recent acclimatization and it is not always at once that newcomers pass into the glories and joys of living in America" (quoted in Dervaux, 7).

During the 1940s **Jack Levine** worked as a Social Realist, although he painted more satirically and expressionistically than did the practitioners of the mode in the 1930s. Beginning in 1940, Levine painted and made prints of biblical figures and stories in addition to his politically motivated art. Since his first biblical painting, *Planning Solomon's Temple*, Levine has rendered hundreds more images inspired by the Bible's narrative. Often employing Hebrew labels to identify figures, Levine's biblical works, he explained, attempt to augment Jewish pictorial expression, which he felt was hampered by the Second Commandment: "Because of the Second Commandment, against graven images, there is a relatively sparse pictorial record of Jewish history or the Jewish imagination. I felt the desire to fill this gap" (Frankel, 134). The Boston-born Levine began a lifelong friendship with **Hyman Bloom** when the pair studied art together at a Jewish Community Center in their early teens. Bloom also retained the human figure in an increasingly abstract art world, painting secular and religious matter in brilliant colors. Two other Jewish artists are associated with the Boston Expressionist school: **David Aronson**, who like Levine, frequently painted biblical subjects, and **Philip Guston**, an abstract artist who moved to New England late in life to teach at Boston University. After his arrival in Boston, Guston adopted Jewish themes, painted representationally, on a more consistent basis.

1945–90

A number of the leading Abstract Expressionists were Jewish. Gottlieb, Guston, **Lee Krasner**, **Barnett Newman**, and Rothko are among several Jewish artists who eschewed representation in the late 1940s and 1950s. The style(s) in which the artists worked are difficult to generalize, but they typically painted on large canvases and were interested in spontaneous expression. While abstract, Newman's canvases have been understood as shaped by his Jewish sensibilities, in part because of titles like *Covenant* and *The Name*. It has also been argued that Newman's knowledge of Kabbalah influenced his "zip" paintings, which can be read as symbolic of God and Creation (Baigell, "Barnett Newman's Stripe Paintings," Hess). Some second-generation Abstract Expressionists were Jewish. **Helen Frankenthaler** and **Morris Louis** stained unprimed canvases with thinned color that seems to float on and through the canvas, and over many years **Jules Olitski** experimented with abstraction in several media. Currently, and since the 1980s, **Tobi Kahn** paints abstract canvases that convey landscape through color. Clement Greenberg and Harold Rosenberg, two of the main art critics who promulgated Abstract Expressionism in its beginnings, were Jewish.

Although better known for his criticism of contemporary art, Rosenberg also wrote one of the canonical articles on Jewish art. Published in *Commentary* in July 1966, Rosenberg's sarcastic and provocative essay "Is There a Jewish

Art?" continues to serve as a springboard for scholarly discussions of Jewish art in America and abroad. Influenced in part by the formalist concerns of Abstract Expressionism, Rosenberg argued that an authentic Jewish art must be defined stylistically. Rosenberg's premise is that the term Jewish art is ambiguous because artists as diverse as Marc Chagall, Chaim Soutine, and Amedeo Modigliani have so little in common. Rosenberg proposes possible ways to understand Jewish art—similar to those commentators examined thus far—ranging from simply art that is produced by Jews to art containing Jewish subject matter, which he termed "East Side realism." Rosenberg notes that aside from a period at the beginning of the twentieth century when Jewish artists were involved in painting their ghetto environment, Jews have not readily depicted Jewish subjects. Repudiating the definition of Jewish art by subject matter, Rosenberg makes the analogy that Christian subject matter, like the Crucifixion, has been produced by artists from diverse countries embracing different styles, and that ultimately it is style, not theme, that gives art its distinct flavor: "To grasp the feeling of a work, one must look beyond its subject to the style in which it is painted. Style, not subject matter or theme, will determine whether or not paintings should be considered 'Jewish' or placed in some other category" (58). While Rosenberg suggests that Jewish art should be defined by style, he concludes that whether or not a Jewish style will ever exist remains a matter of speculation (59). To that end, art historian Robert Pincus-Witten defined Jewish art stylistically in 1975, asserting that abstraction is inherently Jewish because of the Second Commandment's prohibition against imagery. Jewish aniconism, Pincus-Witten argued, is so ingrained in the Jewish psyche that legitimate expressions of Jewishness, as espoused over several millennia, must therefore be abstract. Obviously, commentaries on what Jewish art may or may not be vary, with the arguments described here only a few of many.

Some artists who worked as Social Realists during the 1930s turned their sensibilities toward the civil rights movement of the 1960s. Raphael Soyer made a lithograph titled *Amos on Racial Equality* (1960s), which quotes Amos in Hebrew and English and depicts a white woman carrying a black infant. Shahn's lithograph *Thou Shalt Not Stand Idly By* (1965) portrays an oversized interracial handshake; the title comes from Leviticus 19:16 and is printed in Hebrew and in English at the top of the image. Artists of the next generation also engaged social issues. After the fact, **R.B. Kitaj** comments on the integration of blacks into professional baseball with his painting *Amerika (Baseball)* (1983–84). Jewish–Black relations have become strained since the civil rights movement, a situation cartoonist Art Spiegelman tackled with his cover design of a black woman kissing a Hasidic man for the February 1993 issue of the *New Yorker*.

Two Jewish artists initiated the Feminist Art Movement. At the height of the Women's Liberation Movement, **Judy Chicago** and **Miriam Schapiro** jointly founded the Feminist Art Program at the California Institute of the Arts in 1971. Chicago is especially known for her enormous multimedia installation *The Dinner Party: A Symbol of our Heritage* (1974–79). Made with over 400

collaborators, *The Dinner Party* was created to raise awareness of a forgotten women's history in a world that privileges men. **Eleanor Antin**, **Ida Applebroog**, **Audrey Flack**, **Barbara Kruger**, and **Nancy Spero** are other important feminist artists; Flack's photorealist paintings comment on stereotypes of femininity, and Kruger deconstructs power relations, often related to gender, in her photomontage images (in paint, Applebroog addresses power relationships as well). Recent scholarship has argued that many of the early feminist artists were Jewish because as perennial outsiders and as the children or grandchildren of radical immigrants, fighting for justice and equality was a natural heritage (Levin; Zalkind). With such a link, critics who feel that elements of the Jewish experience, spiritual or secular, must be a prerequisite for art to receive this label would also consider feminist art by Jews as "Jewish art."

In the 1960s, 1970s, and 1980s, Jewish artists worked in diverse manners. **Jim Dine** and **Roy Lichtenstein** first adopted a Pop idiom during the 1960s. Emerging into the public eye in the 1970s, **Philip Pearlstein** paints figures in a flat, unemotional style that treats the human form with the same objectivity as the inanimate objects surrounding the model. Also painting figuratively, **Alex Katz** typically fills his large canvases with the flattened, simplified heads and shoulders of his sitters rendered in crisp color. **Sol LeWitt** explored and wrote about Conceptual Art in addition to making Minimalist sculpture, and **Jonathan Borofsky** continues to make multimedia site-specific installations using his own life as source material. In contrast, sculptor and Process artist **Richard Serra** asserts that his focus on the physical qualities of materials and the act of creation leave little room for expressions of the artist's personality. At the same time that LeWitt, Borofsky, and Serra experimented with avant-garde modes of artistic expression, they made works investigating or memorializing the Holocaust.

Some artists who mostly worked akin to the mainstream for the majority of their careers became interested in Jewish matter late in life. Raphael Soyer illustrated two volumes of Isaac Bashevis Singer's memoirs (1978 and 1981) and two short stories by Singer for the Limited Editions Club (1979). **Larry Rivers** also illustrated a Singer story for the Limited Editions Club (1984) and painted an enormous three-paneled painting, *History of Matzah (The Story of the Jews)* (1982–84), tackling the nearly four-millennia history of the Jews. In his eighties, Sternberg worked on a series of prints, drawings, and paintings delineating Jewish prayer and study as part of the Tallit Series, named after the shawl worn by observant Jews when they pray. Husband and wife Meyerowitz and Bernstein traveled to Israel thirteen times after 1948 and painted many images of the land after pursuing a more traditional American art trajectory before this time. **Chaim Gross** began sculpting Jewish subjects in the 1960s. While Shahn and **Leonard Baskin** explored some Jewish topics early on, they more consistently embraced Jewish identity in the visual arts as they aged, notably with Haggadah illustrations done in 1965 and 1974, respectively. Earlier in the century Saul Raskin (1941) illustrated a Haggadah with woodcuts.

Photography

As William Meyers points out, a large number of Jews made their names as photographers: "Jews have played an indispensable role in the history of American photography, at least as important a role as blacks in the development of jazz" (45).[4] Meyers does not exaggerate here, for from the early part of the twentieth century Jews did dominate the field. In addition to taking many innovative pictures, Stieglitz nearly single-handedly legitimized photography as a rightful counterpart to painting and sculpture. Moreover, Stieglitz mentored several important photographers in their own right, including **Arnold Newman** and **Paul Strand**. In the 1930s Shahn took documentary pictures for the Farm Security Administration, a government program enacted to chronicle for urban Americans the desperation of rural refugees. The photographs were essentially produced to educate and inform the country of the poverty and desperation in Dust Bowl America. Several Jews worked as photojournalists, including **Richard Avedon**, **Alfred Eisenstaedt**, **Irving Penn**, and **Weegee**. The only photographer aligned with the Abstract Expressionists was **Aaron Siskind**. Later in the century, women photographers used the medium to varying ends: Kruger as a means to explore power relations and **Diane Arbus** as a record of Others within larger society, such as transvestites and dwarfs. Notably, two of the original street photographers were **Lee Friedlander** and **Garry Winogrand**.

The Holocaust

Many Jewish American artists have treated the events of the Holocaust.[5] Tschacbasov's 1936 canvas *Deportation* shows a crowd of emaciated deportees restrained by a fence. One of **Seymour Lipton**'s last representational sculptures responded to news of Nazi persecution of the Jews. Titled *Let My People Go* (1942) based on an utterance by God from the biblical chapter Exodus, Lipton's sculpture portrays a bust of a pious Jewish male wearing a prayer shawl. Ben-Zion was a poet who turned to painting because he felt that words could not adequately express the horrors of fascism and later the Shoah. Exhibited as a whole in 1946, the series *De Profundis (Out of the Depths): In Memory of the Massacred Jews of Nazi Europe* comprises seventeen expressionistic works conveying the artist's distress at the events of the Holocaust, and pays homage to those who perished by Nazi hands. **Leon Golub**'s lithograph *Charnel House* (1946) and the *Burnt Man* series of the early 1950s describe exterminated victims, also in an expressionist fashion.

Interest in the Holocaust as a subject for art has only increased in the years since artists felt the immediacy of the tragedy. Flack's photorealist canvas *World War II (Vanitas)* (1976–77) presents a still life in collage format, including a Jewish star from her key chain and a photograph of the 1945 liberation of Buchenwald taken by *Life* magazine photographer Margaret Bourke-White. **Alice Lok Cahana**, a survivor of concentration and labor camps, uses the

visual to work through her memories of the Holocaust in semiabstract mixed media collages. Cahana's art, she explains, is her *Kaddish* for those who perished. The sculptor **George Segal** symbolically employs the biblical figures Eve, Abraham, Isaac, and Jesus in his *Holocaust Memorial* (1983), which overlooks the Pacific Ocean in San Francisco's Legion of Honor park. Another Holocaust sculpture group by Segal is in the permanent collection of the Jewish Museum in New York (1982). Chicago's enormous installation *Holocaust Project: From Darkness into Light* (1985–93) is anchored by a 4½ × 18-foot tapestry titled *The Fall*, which portrays the disintegration of rationality. While united by an interest in imaging the unthinkable, Holocaust works by Jewish American artists differ greatly in approach, conception, and style.

Last Decades of the Twentieth Century

In the last decades of the twentieth century, Jewish identity became an increasing concern in the visual arts. New York City's Jewish Museum initially investigated this phenomenon in two exhibitions, the first in 1982 and the second four years later in 1986. The eighteen living artists in the premier show, *Jewish Themes/Contemporary American Artists*, and twenty-four in the subsequent exhibition, *Jewish Themes/Contemporary American Artists II*, explored aspects of Jewishness in media ranging from video installation to painting. The coolness and impersonality of the movements preceding the 1980s, Pop Art and Minimalism, for example, were also eschewed in the art world in general, when pluralism and subjectivity became a focus of artists from all backgrounds. Indeed, the work in these two exhibitions investigated religious and cultural elements of Judaism, sometimes in an autobiographical manner. Hebrew text, Jewish literature, religious ritual, and explorations of the Holocaust can be found in the imagery of these artists, including Flack, Kitaj, and **Archie Rand**.

A decade later, the Jewish Museum mounted the exhibition *Too Jewish?: Challenging Traditional Identities*. Again paralleling a larger interest in multicultural difference by other marginalized groups, the eighteen artists in the show explored Jewish consciousness, while testing the viewer's and the art world's (dis)comfort with what was perceived by some as excessively conspicuous Jewishness. These highly assimilated younger artists portray vastly different concerns than their immigrant and first-generation predecessors. Long after Andy Warhol, Deborah Kass appropriates Pop techniques and a fascination with celebrity in her portraits of Barbra Streisand (1992) and Sandy Koufax (1994). Titling her Streisand silkscreens *Jewish Jackies* (playing on Warhol's iconic silkscreens of Jackie Kennedy), Kass proffers the ethnic star while subverting American norms of beauty. Also influenced by Warhol, Adam Rolston's *Untitled (Manischewitz American Matzos)* (1993) asserts ethnicity into a once "pure" American consumer culture. Dennis Kardon's installation *Jewish Noses* (1993–95) presents an array of noses sculpted from forty-nine Jewish models, destabilizing the notion that the Jew can be categorized as a monolithic type.

Just as Kardon demonstrates that the Jew's body cannot be homogenized, neither can Jewish American art. As this essay has described, Jewish American artists have worked in manifold fashions, partly and sometimes entirely influenced by larger trends, and at the same time making significant contributions in style and content. Covering painters, sculptors, printmakers, and photographers, as well as artists who engage in newer forms of visual expression such as video, conceptual, and performance art, this book introduces the nascent field of Jewish American art, a subject rich in material and long due for further exploration.

Bibliography

Amishai-Maisels, Ziva. *Depiction and Interpretation: The Influence of the Holocaust on the Visual Arts*. New York: Pergamon Press, 1993.

"An Album of Paintings, Drawings and Sculpture by 60 Jewish Artists of America, Europe and Israel." *Menorah Journal* 37, no. 3 (Summer 1949).

Baigell, Matthew. "Barnett Newman's Stripe Paintings and Kabbalah: A Jewish Take." *American Art* 8, no. 2 (Spring 1994): 32–43.

———. *Jewish-American Artists and the Holocaust*. New Brunswick, NJ: Rutgers University Press, 1997.

———. *Jewish Artists in New York: The Holocaust Years*. New Brunswick, NJ: Rutgers University Press, 2002.

Baskind, Samantha. *Raphael Soyer and the Search for Modern Jewish Art*. Chapel Hill: University of North Carolina Press, 2004.

Bland, Kalman P. *The Artless Jew: Medieval and Modern Affirmations and Denials of the Visual*. Princeton: Princeton University Press, 2000.

Cortissoz, Royal. *American Art*. New York: Charles Scribner's Sons, 1923.

Dervaux, Isabelle. *The Ten: Birth of the American Avant-Garde*. Boston: Mercury Gallery, 1998.

Frankel, Stephen Robert, ed. *Jack Levine*. Commentary by Jack Levine; Introduction by Milton W. Brown. New York: Rizzoli International Publications, Inc., 1989.

Goodman, Susan. *Jewish Themes/Contemporary American Artists*. New York: Jewish Museum, 1982.

———. *Jewish Themes/Contemporary American Artists II*. New York: Jewish Museum, 1986.

Gutmann, Joseph. "The 'Second Commandment' and the Image in Judaism." *Hebrew Union College Annual* 32 (1961): 161–179.

———. "Jewish Participation in the Visual Arts of Eighteenth- and Nineteenth-Century America." *American Jewish Archives* 15, no. 1 (April 1963): 21–57.

Hapgood, Hutchins. *The Spirit of the Ghetto*. 1902. Reprint, Cambridge: Harvard University Press, 1967.

Hertz, J.H. ed. *The Pentateuch and Haftorahs*. 2nd ed. London: Soncino Press, 1987.

Hess, Thomas. *Barnett Newman*. New York: Museum of Modern Art, 1971.

Kleeblatt, Norman L., ed. *Too Jewish?: Challenging Traditional Identities*. New York: Jewish Museum; New Brunswick, NJ: Rutgers University Press, 1996.

Kleeblatt, Norman L. and Susan Chevlowe, eds. *Painting a Place in America: Jewish Artists in New York, 1900-1945*. New York: Jewish Museum, 1991.

Kozloff, Max. *New York: Capital of Photography*. With contributions by Karen Levitov and Johanna Goldfeld. New York: Jewish Museum; New Haven: Yale University Press, 2002.

Krasnow, Peter. "What of Jewish Art?: An Artist's Challenge." *Menorah Journal* 11, no. 6 (December 1925): 535–543.

Levin, Gail. "Beyond the Pale: Jewish Identity, Radical Politics and Feminist Art in the United States." *Journal of Modern Jewish Studies* 4, no. 2 (July 2005): 205–232.

Lozowick, Louis. "Jewish Artists of the Season." *Menorah Journal* 10, no. 3 (June–July 1924): 282–285.

———. *One Hundred Contemporary American Jewish Painters and Sculptors.* New York: YKUF Art Section, 1947.

Meyers, William. "Jews and Photography." *Commentary* 115, no. 1 (January 2003): 45–48.

Olin, Margaret. *The Nation Without Art: Examining Modern Discourses on Jewish Art.* Lincoln: University of Nebraska Press, 2001.

Pincus-Witten, Robert. "Six Propositions on Jewish Art." *Arts Magazine* 5, no. 4 (December 1975): 66–69.

Soltes, Ori Z. *Fixing The World: Jewish American Painters in the Twentieth Century.* Hanover, NH: Brandeis University Press, 2003.

Zalkind, Simon. *Upstarts and Matriarchs: Jewish Women Artists and the Transformation of American Art.* Essays by Gail Levin and Elissa Authur. Denver, CO: Mizel Center for Arts and Culture, 2005.

A

Eleanor Antin (1935–), conceptual and performance artist, filmmaker, and sculptor.

An artist whose pioneering work utilizes many different media, including photographs, installations, performances, videos, and feature-length films, Eleanor Antin's diverse enterprises frequently make use of the narrative, humor, and autobiographical elements. Appearing in many of her projects are Antin's adopted fictional personas: the King of Solana Beach, inspired by a seventeenth-century portrait of Charles I painted by Anthony van Dyck; the black ballerina Eleanora Antinova; and the nurse Eleanor Nightingale.

Born as Eleanor Fineman in New York to Eastern European immigrant parents, Antin grew up as "a red diaper baby" in an environment that provided "a distinctively Jewish background without a hint of religion" (E-mail correspondence). Her mother, a Yiddish theater actress in Poland, influenced Antin's penchant for film and drama. Antin recalls that as a child, "whenever I had a tantrum, my mother would roll her eyes and call me 'Jenny Goldstein!' after the melodramatic heroine of countless 2nd Avenue Yiddish theatre tear jerkers" (Ibid.).

Antin received a B.A. from the City College of New York in creative writing with a minor in art, and also studied at the Tamara Daykarhanova School for the Stage (1955–57) and the New School for Social Research (1956–59), both in New York. Early on she worked as an actress, while also painting in an Abstract Expressionist style that sometimes included found objects, akin to **Jim Dine**. To support herself she also modeled for artists, including **Moses Soyer**, **Raphael Soyer**, **Jack Levine**, and **Ruth Gikow** (Ibid.).

Influenced by Fluxus, an experimental movement that incorporated diverse media in art, such as performance, music, and poetry, Antin began to explore more radical expressions. After collecting blood samples from one hundred poets, including Allen Ginsberg and John Ashbery, Antin dabbed the samples on glass slides. She placed the one hundred slides in a commercial box along with a labeled and numbered list, thus completing *Blood of a Poet Box* (1965–68). Howard Fox describes this piece as "prescient....The artist had already established the tenets that would abide in her art until the present: an interest in evoking personal history through narrative; a fascination with artists, and an even more pronounced preoccupation with the relationship between life

and art; and an inherently romantic faith in art as a practice through which to realize one's life" (22).

Following a move to California in 1968 when her husband, poet David Antin, got a job at the University of California at San Diego, Antin initiated a conceptual, mail art piece and one of her best known works: *100 Boots* (1971–73). *100 Boots* originated as a series of fifty-one postcards of boots in different locations. From March 1971 until July 1973, Antin intermittently mailed a single postcard to nearly 1,000 people around the world. Each postcard was arranged on a site and photographed (Philip Steinmetz, not Antin, did the photography), documenting the escapades of a band of one hundred Army-Navy black rubber boots through Southern California and then far a field. Initially the postcards depict the boots as they go to church, shop at a grocery store, and engage in other everyday activities. Soon the boots become more adventurous (and angry)—reflecting the tenor of the era—and trespass on private property at the same time that antiwar activists were being arrested for radical acts. Eventually the boots get drafted and go to war. The adventure ends in New York, where the boots ride the Staten Island Ferry and enjoy the city, ultimately visiting the Museum of Modern Art (MoMA). At MoMA, all fifty-one postcards hung on a wall displaying the full narrative of their experiences in a room complete with the actual boots in a spare "apartment" that comprised a sink, light bulb, mattresses, sleeping bags, and radio. Following the MoMA exhibition, a final postcard was mailed on July 9, 1973: "100 Boots On Vacation." This last image presents the boots piled haphazardly into the back of a van with sunglasses on the dashboard.

In 1973 Antin also conceived the performance piece *Carving: A Traditional Sculpture,* which initiates Antin's interest in autobiography. Playing on the traditional mode of creating sculpture, where the artist chisels at marble until a beautiful work of art appears, Antin created a life "sculpture." While on a thirty-six-day diet, Antin took Polaroid pictures of herself posing nude at different angles to chart her progress. Noting the time of day each photograph was taken, Antin arranged 144 of the photographs chronologically in four poses as she refined her body into an aesthetic ideal. Cindy Nemser interprets the piece as "a commentary on how women are always concerned with the need to improve their bodies" (281). While the Feminist Art Movement influenced the work, and indeed Antin is an important feminist artist, Lisa Bloom also understands *Carving* as affected by Antin's Jewish background. Bloom reads the work as marked by Antin's feminine body, and also her Jewish, or ethnic body. Observing that the pictures that make up the piece reference "police or medical photographic and cinematic practices of the early twentieth century in which discourses of physiognomy, photographic science, and aesthetics coincided and overlapped....we can view Antin as playing off these early traditions to mark herself as jewish [sic]" (156–157). Perhaps, too, as Peggy Phelan observes, the work may be "a response to the history of the catastrophic disappearance of Jewish bodies during World War II" (Reckitt, 30).

She started making videos in 1972, featuring herself as the King of Solana Beach in *The King.* Her ballerina persona, Eleanora Antinova, appeared in many films between 1979 and 1989, including the full-length *It Ain't the Ballet*

Russes (1986) and *The Last Night of Rasputin* (1989). These roles function as other selves and are a means for Antin to explore aspects of who she could have been had her life and life choices been different and to discover what life is like as another person (including differences of gender and race). Juliet Bellow understands Antin's interest in exploring Antinova's blackness as an allusion "to Antin's Jewish heritage, and perhaps to the exotic aura imputed to the numerous Jews participating in Diaghilev's Ballets Russes by their Western European audiences" (48–49).

In two film projects, Anton explicitly explores Judaism. Directed under the pseudonym Yevgeny Antinov, the ninety-eight minute silent, black-and-white film *The Man Without a World* (1991) is Antinov's rediscovered masterpiece, which was said to be lost during the Holocaust. *The Man Without a World* tells a nostalgic, melodramatic, and even satiric story about shtetl life in Poland before World War II (see figure). The related filmic installation *Vilna Nights* (1993) also explores a lost Eastern European Jewish world. Within a gallery, part of a wall is smashed, evoking the scene of a bombing; through the broken wall viewers see a set of the destroyed Vilna Jewish quarter. Accompanied by audio reproducing sounds of the Jewish world during the Holocaust, Antin projects several scenes simultaneously to convey aspects of the last years in the shtetl. Antin's interest in exploring the tragedy of a decimated Yiddish world emerges from her childhood when her mother owned "lefty hotels for basically first generation, aging Jews passionately devoted to Russia and the working class (though by then many of them had moved up) along with high

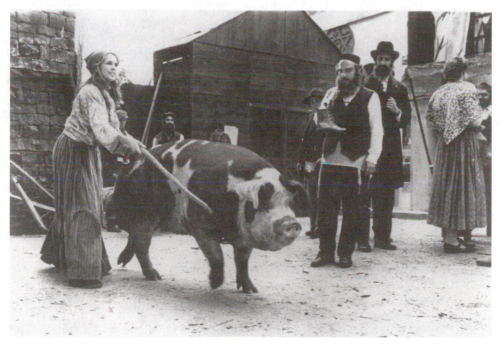

Eleanor Antin, *The Man Without a World*, 1991. Film still. Courtesy of Milestone Film & Video, www.milestonefilms.com.

Yiddish culture and language. They adored Sholem Aleichem and the poet I. L. Peretz" (Written correspondence).

Recently, Antin described her perspective on the Jewishness of her art: "I did two specifically Jewish works. My Yiddish silent feature film supposedly made in 1928 by my invented Soviet Jewish filmmaker, Yevgeny Antinov, 'The Man without a World' (distributor: Milestone Film and Video) and the video installation 'Vilna Nights' (Jewish Museum, New York). Otherwise, I don't think being Jewish has been particularly relevant in my work, though maybe my independence has had something to do with it. I've been more or less fortunate in my career—though artists are never satisfied—but I've always been something of an outsider. I never fit in that neatly with anybody else. My state of permanent exile. My personal Diaspora. Given this lousy world, it's not such a bad place to be. And perhaps my comedy. My work has a dark streak but it's also funny. Maybe that's a Jewish trait. Laughing all the way to the cemetery" (Ibid.).

Since 1975 Antin has been teaching in the art department at the University of California at San Diego. The recipient of a John Simon Guggenheim Memorial Foundation Fellowship (1997) and a Cultural Achievement Award from the National Foundation for Jewish Culture (1998), Antin also enjoyed a large retrospective at the Los Angeles County Museum of Art in 1999.

Bibliography

Antin, Eleanor. *100 Boots.* Introduction by Henry Sayre. Philadelphia: Running Press, 1999.
———. E-mail correspondence with the author. January 9, 2006.
Bellow, Juliet. "A Feminine Geography: Place and Displacement in Jewish Women's Art of the Twentieth Century." In *Transformation: Jews and Modernity.* Edited by Larry Silver, 35–55. Philadelphia: Arthur Ross Gallery; Distributed by the University of Pennsylvania Press, 2001.
Bloom, Lisa. "Ethnic Notions and Feminist Strategies of the 1970s: Some Work by Judy Chicago and Eleanor Antin." In *Jewish Identity in Modern Art History.* Edited by Catherine M. Soussloff, 135–163. Berkeley: University of California Press, 1999.
———. *Performing the Body/Performing the Text.* Edited by Amelia Jones and Andrew Stephenson, 153–169. London: Routledge, 1999.
Fox, Howard N. *Eleanor Antin.* Los Angeles: Los Angeles County Museum of Art, 1999.
Goodman, Susan Tumarkin. *From the Inside Out: Eight Contemporary Artists.* New York: Jewish Museum, 1993.
Nemser, Cindy. *Art Talk: Conversations with 12 Women Artists.* New York: Charles Scribner's Sons, 1975.
Raven, Arlene. "Outsider-Artist: Eleanor Antin." *Profile* 1, no. 4 (July 1981): 1–23.
Reckitt, Helena, ed. *Art and Feminism.* Survey by Peggy Phelan. London: Phaidon Press Limited, 2001.

Sayre, Henry. *The Object of Performance: The American Avant-Garde Since 1970.* Chicago: University of Chicago Press, 1989.

Zweig, Ellen. "Constructing Loss: Film and Presence in the Work of Eleanor Antin." *Millennium Film Journal* 29 (Fall 1996): 34–41.

Selected Public Collections

Art Institute of Chicago
Jewish Museum, New York
Los Angeles County Museum of Art
Museum of Modern Art, New York
San Diego Museum of Art
San Francisco Museum of Modern Art
Walker Art Center, Minneapolis
Whitney Museum of American Art, New York

Ida Applebroog (1929–), painter and sculptor.

Commenting on disparities in social, power, and political relationships, sometimes from a feminist perspective and often by presenting what at first appears to be mundane, Ida Applebroog's disquieting art combines text and image on various scales. Born as Ida Applebaum in the Bronx to Orthodox, Yiddish-speaking immigrants from Poland, Applebroog attended the New York State Institute of Applied Arts and Sciences (1948–50), where she studied graphic art. Following graduation, Applebroog briefly worked at an advertising agency and then at other odd jobs, after which she married and started a family. Following a move to Chicago with her husband and daughter, Applebroog had two additional children, greatly curtailing the time she had to make art. Applebroog returned to school in 1965, enrolling at the School of the Art Institute of Chicago, where she remained until her husband accepted a job in California (1968). Her work showed at her first solo exhibition at the Boehm Gallery in San Marcos, California (1971), the same year that Applebroog attended the initial Feminist Artists Conference in Valencia, California, organized by **Judy Chicago** and **Miriam Schapiro**. In 1973 Applebroog taught in the art department at the University of California at San Diego, a program run by Schapiro's husband, artist Paul Brach, and where her colleagues included **Eleanor Antin**.

After returning to New York in 1974, Applebroog changed her name (1975), fusing her maiden name and her married name (Horowitz) as if she had slurred the two together. She announced her entrance into the New York art-world with the design and dissemination of three small (approximately 6 × 6 inches) books—which she termed performances—in editions of 500: *Galileo Works* (1977, ten in set), *Dyspepsia Works* (1979, eleven in set), and *Blue Books* (1981, seven in set). Mailed over time in sets to friends and artists she admired, each book repeats a scene in every frame, with an ambiguous sentence under the final picture that throws the viewer's perceptions into doubt or confirms

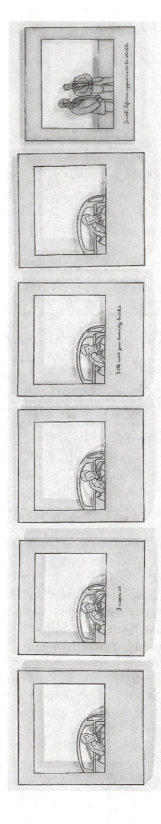

Ida Applebroog, *I Mean It*, 1981. Ink and rhoplex on vellum, six panels, 10½ × 9½ × 1 inches each, 14¼ × 67¾ × 2¼ inches overall. Private collection. Photo: Jennifer Kotter. Courtesy of Ronald Feldman Fine Arts, New York.

/>the reader's personal understanding of the picture's message. Introducing the cartoon-like figures that characterize her future work, Applebroog's books contrast with the more aggressive commentary and style found in art by such contemporaries as **Leon Golub**. Throughout her oeuvre Applebroog purposefully remains vague, aiming to slowly reveal the work's message to a viewer who reads his or her own meaning into it. As Arthur Danto observes, by terming her books performances, Applebroog "implies that they were not to be looked at but worked through by interactive rather than passive readers" (Sultan, Danto, and Allison, 46). Similarly, Applebroog explains the importance of the viewer's position vis-á-vis her imagery's open-endedness: "The books, like my current work, were ambiguous, open-ended. My pieces are like projective tests. When you are looking at them, they deal with how the viewer interprets the meaning. With each person the meaning shifts, so that no matter what you think you see in that piece, the next person will see something entirely different. It doesn't matter if it is what I wanted to say, or what I thought I was saying, or what it is that was built into that piece" (Lignel, 160).

Adopting a new medium, rhoplex on vellum (1976–81), Applebroog continued to question societal inequities and the abuse of power through sequential imagery. *I Mean It* (1981, private collection) (see figure), for example, comprises six nearly monochrome panels, the first five showing the same image of a couple in a car with the woman's head on the man's shoulder. Two panels contain text, while the others remain empty; the second panel's text reads "I mean it," leading the viewer/voyeur to think, perhaps, that the couple is having a fight, and the fourth panel's text states, "It'll cost you twenty bucks," suggesting instead that the woman is a prostitute negotiating a price with the man. Then, the sixth panel presents a completely different image, slightly smaller in size than the previous standardized six, and tinged with a reddish hue. Here two men stand against an empty background, accompanied by the text "South Africa appears to be stable," possibly indicating that even in our most intimate moments the media, such as an announcement on the radio, intrudes.

Employing the same text–image approach, in the late 1980s Applebroog's images grew significantly in scale and repetition became subordinate to multiple images. In works such as *Emetic Fields* (1989, Whitney Museum of American Art, New York) multiple panels are used, removed from the neat box-like structure typical of her earlier imagery. Compared in form by some scholars to medieval altarpieces (Sultan, 7; Sims, 12), these multi-paneled paintings create connections between the larger image and the smaller ones. Additionally, within the works Applebroog sometimes includes sequential images akin to her earlier works. Composed of four panels, *Crimson Gardens* (1986, private collection), originally titled *Auschwitz Gardens,* portrays figures in striped concentration camp uniforms, and also an ordinarily dressed man picking flowers. Before the flowers are picked they are red, but after they have been removed from the soil they lose their color, thus possibly acting as a metaphor for the destruction of life. On the other hand, the flowers could symbolize hope amid the destruction wrought by the Nazis. Around 1991 Applebroog added a new innovation to the structure of her imagery. Rather than attach

her visual commentaries to the main image, she made freestanding work—called "marginalia" by the artist—to accompany the central painting that hung on the wall. Thus conceived as installations within the room where the work(s) is exhibited, such groupings can be arranged in differing configurations depending on the room size or other aspects of the venue. Moreover, the viewer is more aggressively accosted by the vertically standing images than her earlier accusatory works, as the former are even more in-your-face because they literally exist within your space.

Collaborating with her daughter, the filmmaker Beth B., in 1989 Applebroog made a twelve-minute film, *Belladonna*, which takes a similar disjunctive approach as her painted work (Applebroog made two earlier videos, in 1977 and 1978). Several speakers are presented against a plain dark backdrop alternately uttering sentences that are oblique in meaning. At the end of the tape the viewer is privy to the disjointed dialogues as a whole, narrated from start to finish. The credits then roll, attributing the "stories" to Josef Mengele's victims; excerpts from the trial of Joel Steinberg, a man who murdered his adopted child; and passages from "A Child is Being Beaten," an essay (1919) by Sigmund Freud. While commenting on the victimization of children, Applebroog also indicates that one never knows who can perpetrate such malevolence. Indeed, until we are supplied with the identity of the original perpetrators, the tales are shared by the average person, who could even be us.

The recipient of many honors, Applebroog has held a Guggenheim Fellowship (1990) and a MacArthur Foundation Fellowship (1998), and received a Lifetime Achievement Award from the College Art Association (1995). On the inspiration for her imagery, Applebroog replies: "I look at the world I live in from the point of view of a woman, a feminist, a Jew, an American, including everything that I have experienced in my lifetime" (Written correspondence).

Bibliography

Applebroog, Ida. Written correspondence with the author. April 17, 2006.

Feldman, Ronald, et al. *Ida Applebroog*. New York: Ronald Feldman Fine Arts, 1987.

Lignel, Benjamin, ed. *Ida Applebroog 1976–2002: Are You Bleeding Yet?* New York: La maison Red; D.A.P./Distributed Art Publishers Inc., 2002.

Sims, Lowery S., Thomas W. Sokolowski, and Marilyn A. Zeitlin. *Ida Applebroog: Happy Families, A Fifteen-Year Survey.* Houston: Contemporary Arts Museum, 1990.

Sultan, Terrie, Arthur C. Danto, and Dorothy Allison. *Ida Applebroog: Nothing Personal, Paintings 1987–1997*. Washington, D.C.: Corcoran Gallery of Art; New York: D.A.P./Distributed Art Publishers, Inc., 1998.

Selected Public Collections

Cincinnati Museum of Art
Denver Art Museum

Metropolitan Museum of Art, New York
Milwaukee Museum of Art
Museum of Modern Art, New York
Pushkin State Museum, Moscow
San Francisco Museum of Modern Art
Wadsworth Atheneum Museum of Art, Hartford, Connecticut

Diane Arbus (1923–71), photographer.

Recognized for a body of photographs that explore and question the fine line between normality and difference, Diane Arbus, nee Nemerov, is popularly described as a photographer of misfits and freaks. As Arbus explained, "Freaks was a thing I photographed a lot. It was one of the first things I photographed and it had a terrific kind of excitement for me. I just used to adore them. I still do adore some of them. I don't quite mean they're my best friends but they made me feel a mixture of shame and awe. There's a quality of legend about freaks. Like a person in a fairy tale who stops you and demands that you answer a riddle. Most people go through life dreading they'll have a traumatic experience. Freaks were born with their trauma. They've already passed their test in life. They're aristocrats" (Arbus and Israel, 3). Indeed, during her brief career Arbus photographed those on the margins—nudists, dwarfs, and transvestites, for example—and also exposed the abnormal in what appears at first glance to be ordinary. One of her canonical pictures, *A young Brooklyn family going for a Sunday outing, N.Y.C., 1966* (Smithsonian American Art Museum, Washington, D.C.), shows a husband and wife walking down the street with their infant and son. Pictured fully frontal, the family is captured at an awkward moment, when the cross-eyed son squirms and contorts his face oddly, almost as if he is deranged. Moreover, the wife, with her bouffant hairstyle, large physique, and leopard coat, resembles a drag queen. Her stiff husband looks tiny in comparison and the infant appears as a bundled package. This photograph and others confirm Arbus' assertion that "a photograph is a secret about a secret. The more it tells you the less you know" (Arbus, "Five Photographs," 64). In opposition to the suggested objectivity of documentary photography, Arbus' work is clearly subjective. Moreover, Arbus' America is disturbing and unsentimental, much like the vision presented by **Weegee** and **Robert Frank**.

Arbus' early life belies the subject matter of her unsparing, raw photographs. Born to a wealthy family in New York City, Arbus' interest in photography began after her husband, Allan Arbus, who she married in 1941, bought her a camera around 1943. Following the war she and Allan opened a fashion photography studio, taking pictures for magazines such as *Glamour,* among other periodicals. By 1956 Arbus decided to leave fashion photography to explore commercial and personal photography on her own. She took classes with Berenice Abbott and Alexey Brodovitch in the early 1950s. Lisette Model made the most lasting impact on Arbus, encouraging her pupil to take pictures

that explored her individual vision (c. 1956–57). Allan and Diane separated in 1959, a year before her first solo commercial photographs appeared in *Esquire,* and subsequently in other magazines such as *Harper's Bazaar.* Taken with a 35-mm camera, these early photographs possess a hazy quality around 1962 when Arbus began using a Rolleiflex and then a Mamiyaflex camera that enabled her to produce the higher contrast images synonymous with her name. Arbus' move from a grainy quality to sharply focused images enabled her to clarify —literally and figuratively—the psychological elements of her subjects.

In 1963 Arbus received a Guggenheim Fellowship for her project "American Rites, Manners and Customs," a project that aimed, to use Arbus' words from her grant application, "to photograph the ceremonies of our present. . . . I want simply to save them, for what is ceremonial and curious and commonplace will be legendary" (Phillips, 57). She received a second Guggenheim Fellowship for "The Interior Landscape" in 1966. A few of Arbus' photographs appeared in the Museum of Modern Art's (MoMA) *New Documents* show (1967)—the only museum appearance during her lifetime—along with the work of **Lee Friedlander** and **Garry Winogrand**.

Her narrative titles typically provide a brief description of the picture's subject, a notation of the space the photograph was taken (e.g., an apartment, a room, etc.), and a broad address (e.g., NYC), as exemplified by *A Jewish giant at home with his parents in the Bronx, N.Y., 1970* (Museum of Modern Art, New York). For nearly a decade, Arbus tried to capture the 495-pound, 8-foot tall Eddie Carmel on film in just the right way. It was not until she shot Carmel hunched over in his natural environment against the startling juxtaposition of his normal-sized, bewildered parents in their cramped middle-class apartment that she discovered the moment she was waiting for. Under Arbus' eye, what could be a sentimental picture of family life instead becomes a portrait of absurd oddity within what might have been a typical family if not for a genetic aberration. For Arbus, the extended process of picture making depended on her subjects' cooperation. Although she had photographed Carmel many times, at work, at play, and then at home, it took the collaboration of both subject and artist for Arbus to find her final vision.

A Jewish giant at home with his parents in the Bronx, N.Y., 1970 is one of several shots of Jews, both named and unnamed. For instance, *Andrew Ratoucheff, actor in his rooming house, N.Y.C., 1960* (Spencer Museum of Art, Lawrence, Kansas) pictures a Jew, although not specified by the title, while the title *A Jewish couple dancing, N.Y.C., 1963* specifically notes the religious character of the dancers. Such identifications or nonidentifications in captions influence the viewer's perception of the imagery. As literary critic Leslie Fiedler observed, Arbus' "title and treatment strip the Barnum and Bailey show Giant [sic], who lived from 1938 to 1972, of all identity except his Jewishness. And precisely this gives an added *frisson* to the picture, since in legend Giants are the most *goyish* of all Freaks–typified by the monstrous Goliath sent against the frail champion of the Jews, the boy-man David. Yet to compound the irony, American-born children of East European immigrants *do* customarily tower over their parents, though not to so exaggerated a degree" (118; emphasis in original).

Arbus' many shots of families were intended for a planned book project, never published, with the working title "Family Album." Art historian Anthony W. Lee offers conjectures about the book, tentatively connecting Arbus' interest in families to her Jewish background, notably the dilemma of the postwar Jewish American family. Lee suggests that the successful integration of the Jewish American family into the mainstream threatened the survival of Judaism in the country, for what distinctive religiocultural elements remained amid such rapid assimilation? He links Arbus' pictures of Jewish families, including *A Jewish giant at home with his parents in the Bronx, N.Y., 1970* and *A Jewish couple dancing, N.Y.C., 1963,* with some of Arbus' comments about her own Judaism, including a statement Arbus gave Studs Terkel for his seminal book *Hard Times: An Oral History of the Great Depression* and her other commentary on the subject. For example, quoted in Terkel under the pseudonym Daisy Singer, Arbus asserted that raised "upper middle-class Jewish, you know, second-generation American....I grew up feeling immune and exempt from circumstance. One of the things I suffered from was that I never felt adversity. I was confirmed in a sense of unreality" (110–111). Arbus' ambivalent position as a Jew and an American was worthy, in her mind, of investigation—of exploring the "unreality" of her Jewishness (31). Thus, Arbus' photographs of Jewish subjects, who at times would be unmarked without the identification of them as Jewish—*A Jewish couple dancing, N.Y.C., 1963* is a close-up shot of a smiling elderly couple on the dance floor—was an obvious accentuation of Jewishness. Lee concludes that "Arbus' interests in the family can be situated in a larger framework of social visibility and competing meanings for the Jewish family....For Arbus, those pressures made it a deeply fraught and therefore deeply interesting subject, full of the strangenesses and oddities—the fascination and creepiness of families trying to name themselves—that easily attracted a photographer on the prowl for her album" (32).

A year after she committed suicide at age forty-eight, Arbus' work was shown at MoMA. Her first major retrospective since then, *Diane Arbus Revelations,* appeared at the San Francisco Museum of Modern Art in 2003, traveling until late 2006 to other venues in the United States and Europe. Arbus taught photography at several venues, notably the Parsons School of Design where her students included **Barbara Kruger**.

Bibliography

Arbus, Diane. "Five Photographs by Diane Arbus." *Artforum* 9, no. 9 (May 1971): 64–69.

Arbus, Doon and Marvin Israel, eds. *Diane Arbus: An Aperture Monograph.* Millerton, NY: Aperture, 1972.

———. *Diane Arbus: Magazine Work.* Millerton, NY: Aperture, 1984.

Arbus, Doon and Yolanda Cuomo, eds. *Diane Arbus: Untitled.* Millerton, NY: Aperture, 1995.

Bosworth, Patricia. *Diane Arbus: A Biography.* New York: Alfred A. Knopf, 1984.

Budick, Ariella. "Factory Seconds: Diane Arbus and the Imperfections in Mass Culture." *Art Criticism* 12, no. 2 (1997): 50–70.

Fiedler, Leslie. *Freaks: Myths and Images of the Secret Self.* New York: Simon and Schuster, 1978.

Hulick, Diana Emery, ed. "Diane Arbus." *History of Photography* 19, no. 2 (Summer 1995). The entire issue is dedicated to Arbus' work.

Lee, Anthony W. and John Pultz. *Diane Arbus: Family Albums.* New Haven, CT: Yale University Press, 2003.

Phillips, Sandra S. *Diane Arbus: Revelations.* New York: Random House, 2003.

Terkel, Studs. *Hard Times: An Oral History of the Great Depression.* New York: Pantheon Books, 1970.

Selected Public Collections

Cleveland Museum of Art
Los Angeles County Museum of Art
Metropolitan Museum of Art, New York
Museum of Contemporary Art, Los Angeles
National Gallery of Canada, Ottawa
New Orleans Museum of Art
Norton Simon Museum, Pasadena, California
Whitney Museum of American Art, New York

David Aronson (1923–), painter, sculptor, and draftsman.

Grappling with his Jewish identity throughout his career, David Aronson is one of several Jewish (and long-lived) artists from Boston—including himself, **Jack Levine**, and **Hyman Bloom**—who retain the figure and use expressionism while exploring aspects of Judaism in their visual production. Born in Shilova, Lithuania, Aronson, his four siblings, and his mother immigrated to Dorchester, Massachusetts in 1929 to join his father—a rabbi in the old country and a *mashgiach* (a supervisor of ritual slaughter) in America—who had arrived five years earlier. Aronson's art was very much influenced by his Orthodox background and immigrant experience. Among the issues that Aronson struggled to reconcile was the Jewish prohibition against graven images with his calling as an artist. As Aronson recalled in an oft-quoted 1967 Boston University lecture, "Real and Unreal: The Double Nature of Art": "The New World made only slight inroads into a closely ordered family hierarchy and a pattern of living centered around breadwinning, the synagogue, and religion-related scholarship. These were people for whom religion was the main purpose for survival and for whom figurative art was denied by Scriptural precept....I committed the combined profanations [*sic*] of refusing confirmation and choosing as my life's work that which is prohibited in the second commandment–the making of graven images" (Biemann, 144).

Although he took art classes as a teen, at eighteen years old, Aronson began studying art full-time at the School of the Museum of Fine Arts with Karl

Zerbe. Aronson's experiments with New Testament imagery began shortly thereafter, at which time he adopted an encaustic technique—a traditional method by which paint and wax are combined and then fixed with heat after the mixture is applied. The end result, Aronson explained, was "a very meaningful fusion of technique and message. The luminous, waxy colors offered a deeply religious aspect to the proceedings, like a stained-glass window in a church that thrusts you into a mood or state of mind" (Kur, 28). Indeed, painted in rich hues, the lustrous, gesticulating figures and hovering angel in *Coronation of the Virgin* (1945, Virginia Museum of Fine Arts, Richmond) glow. Aronson's Jesus in *Young Christ with Phylacteries* (1949, private collection) (see figure) bears a unique Jewish stamp. Painted in three-quarter's view, Jesus wears a single leather box on his forehead containing parchment with verses from the Bible, and around his left arm and hand the viewer observes the straps that bind a second box to Jesus' bicep (known as phylacteries or tefillin, they are worn by Jews during morning prayers). Of his New Testament subjects, seemingly contradictory for a young Jew raised in Orthodoxy, Aronson said: "I, as a painter with an intense Jewish background, was doing something daring and dangerous.... what better way to punish my father for the years of restrictions?" (Grossman, 23).[6] Too, Aronson turned to New Testament subjects because of their long heritage in the history of art. Nonetheless, Aronson also described his New Testament images as "Jewish paintings. My own religious background was deeply woven into the fabric of the work" (Kur, 26). Several of these paintings were exhibited at his first one-person show in New York at the age of twenty-two (1945) and also in the "14 Americans" show at New York's Museum of Modern Art the following year.

On a scholarship, in 1949 and 1951 Aronson traveled through Europe and the Near East, studying art by the great masters of biblical imagery such as Caravaggio and Rembrandt. A few years after returning from Europe, Aronson started to explore Old Testament themes, and from 1958 to 1960 he turned his interests to Cabbalistic mysticism. Several versions of *Joseph and the Ishmaelites* (e.g., 1954, Krannert Art Museum, University of Illinois, Champaign) come from this period as does *Sacrifice of Isaac* (1957, private collection).

The 1960s added a new element to Aronson's oeuvre when he began sculpting. First executing large relief sculptures—Aronson's *The Door* measures eight feet tall by four feet wide—soon he made freestanding bronze sculptures of a biblical nature, including *Blind Samson* (1961) and *David* (1987), while also considering the recurring theme of angels. As is typical of Aronson's sculptures, the 41-inch tall, crowned, striding *David* is composed of fragmented, craggy scraps of metal amalgamated to create recognizable forms. Secular subjects, most notably musicians and entertainers, accompany Aronson's religiously inspired works (many of these smaller sculptures were cast in editions). Asher Biemann describes Aronson's fracturing of the figure—what he terms the imperfections of the artist's three-dimensional work—as "an antidote to idolatry.... a shattered idol is no longer an idol of power. It is, in fact, more powerless than no idol at all.... The fracture negates idolatry" (28).

Aronson, who also worked at various times in pastel, charcoal, and other media, often on a large scale, taught painting at the Boston Museum

David Aronson, *Young Christ with Phylacteries,* 1949. Oil on canvas, 27 × 17 inches. Private collection. Image courtesy of Pucker Gallery, Boston.

School (1946–54) and was chairman of Boston University's Art Department (1954–63), which he helped inaugurate, and where he taught until his retirement in 1989. While at Boston University he helped arrange several important one-man shows in the area, including exhibitions of the work of **Raphael Soyer** and **Max Weber**. Aronson was also instrumental in the appointment of **Philip Guston** as a professor in 1973; their subsequent interactions further stimulated Guston's interests in his own Jewish identity, which he had recently been investigating in his art. While affirming his belief in religion, Judaism and otherwise, Aronson also notes: "As an artist I believe in any thing [*sic*] that will set my imagination in motion toward the purpose of creating meaningful fantasies" (Ibid., 154). These "meaningful fantasies" were created in an America and in an art world that cast the artist,

to use his words, as "a Jew among Christians and a Christian among Jews" (Ibid., 147).

Bibliography

Aronson, David. *David Aronson: New Encaustics, Temperas and Drawings.* New York: Nordness Gallery, 1960.

———. *David Aronson: A Retrospective.* With an introduction by Philip Guston. Boston: Pucker/Safrai Gallery, 1979.

Biemann, Asher D. *David Aronson: Paintings, Drawings, Sculpture.* Reproduction of 1967 Boston University lecture by David Aronson. Boston: Pucker Art Publications, 2004.

Bookbinder, Judith. *Boston Modern: Figurative Expressionism as Alternative Modernism.* Durham, NH: University of New Hampshire Press; Hanover: University Press of New England, 2005.

Grossman, Emery. *Art and Tradition.* New York: Thomas Yoseloff, 1967.

Kur, Carol. "David Aronson's Art." *Moment* 4, no. 1 (November 1978): 25–37.

Selected Public Collections

Art Institute of Chicago
Corcoran Gallery of Art, Washington, D.C.
Jewish Museum, New York
Museum of Fine Arts, Boston
Museum of Modern Art, New York
Pennsylvania Academy of the Fine Arts, Philadelphia
Virginia Museum of Fine Arts, Richmond
Whitney Museum of American Art, New York

Shimon Attie (1957–), installation artist and photographer.

Los Angeles-born Shimon Attie's projected installations are, as James Young aptly observes, "part photography, part installation, and part performance, the totality of these projects might best be described as 'acts of remembrance'" (Attie, *Sites Unseen,* 10). Indeed, by projecting images from the past, Attie does not aim to recover history, but to clarify it and make it tangible for the present time. His installations engage with the specific sites and histories of the locales he works in, aiming to question that which we remember and that which actually occurred. After projecting the installations for a period of time, Attie takes photographs to document the ephemeral event.

Raised with an awareness of the Holocaust, Attie, as he explains, was "profoundly influenced by the stories about the war told to me as a small child by my parents and their friends, some of whom were Holocaust survivors. I learned through these stories, particularly those told by my father, that part of being Jewish meant I was connected to a life and culture that no longer existed" (Ibid., 9). He describes his upbringing as one saturated with a "secular Jewish, humanist, intellectual tradition imbued with progressive politics. I was

raised to feel extremely Jewish in my identity, to be part of a long intellectual and cultural tradition in which being 'Jewish' meant having a deep and profound regard for universal human rights and the welfare of minority groups throughout the world. In my family, being 'Jewish' was not about religion, but rather about a sensibility, a tradition, a culture, a way of thinking. It was about understanding the experience of being part of a group that has experienced oppression through the ages, and to take that experience as a basis towards appreciating the importance of universal human rights" (Written correspondence).

As a teenager Attie spent two years in Israel. Initially studying psychology, Attie received a B.A. from the University of California at Berkeley (1980) and an M.A. from Antioch University (1982). He soon decided to pursue a career in the arts, and after earning an M.F.A. from San Francisco University (1991), Attie moved to Berlin, Germany in the summer of 1991 to pursue this goal. Until 1996, Attie worked on a series of projects in Europe collectively called *Sites Unseen.* In several countries, Attie projected photographs onto or from public buildings, and in one case on a body of water, all utilizing images from World War II.

The earliest installation of *Sites Unseen* was made in Attie's adopted city of Berlin. Struck by the absence of a once vibrant German Jewish community, Attie conceived *The Writing on the Wall* (1991–93) in "response to the discrepancy between what I felt and what I did not see. I wanted to give this invisible past a voice, to bring it to light, if only for some brief moments.... The Writing on the Wall project is my personal response to being in Germany and to my search for a people and culture that I would never know" (Attie, *The Writing on the Wall,* 9). He sought, to use Michelle Freidman's words, "not to repopulate Berlin with long-dead Jews, but to illuminate the haunting presence of their absence" (36). First researching images in the city's archives, Attie discovered prewar photographs of Jewish residents of the Scheunenviertel district. After consulting prewar maps of the area, for a year he then projected fragments of those images of everyday life at the original locales the pictures were taken in the 1920s and 1930s, or on sites nearby. *Almstadtstrasse 43* (1992) (Color Plate 1) shows a superimposed male figure entering the Hebrew bookshop, which is also projected onto the building and bears a Yiddish sign identifying the building. The black-and-white projections appear ghostly amidst the color building, and contrast with the contemporary record of the environment, which includes a blue car and a graffiti-defaced door. Later projects devised as part of *Sites Unseen,* include *Trains* (1993), photographs projected for two weeks of Dresden's Jews on the trains, tracks, and walls of the Dresden train station, a site from which many German Jews were deported by the Nazis, and *The Neighbor Next Door* (1995). Projected in Amsterdam, this latter installation appeared for a week. In this work, Attie reversed his usual mode and projected images from within buildings. From three apartments on Prinsengracht—the street where Anne Frank's family hid—Attie showed short bits of film footage taken during the Nazi occupation, including clips showing the Dutch assisting Nazis. His goal was to reveal the point of view of those hidden and to remind the Dutch that many of Holland's Jews perished. In

other words, Attie aimed to deconstruct the national mythology of Holland as a safe haven during the Holocaust, as a considerable number of Dutch Jews were exterminated. Attie also commented on a current problem in Holland: over 100,000 illegal immigrants live in the country today.

Upon returning to the United States, Attie conceptualized *Untitled Memory* (1998), for which he projected images of his friends and lovers into his old apartment in San Francisco. To document his absence, Attie signifies himself by an empty chair or another space that should be occupied by a human being but remains vacant. Later in 1998, Attie created *Between Dreams and History* on New York's Lower East Side. This installation did not employ photographs, but written recollections about the Lower East Side projected by blue lasers. An area heavily populated by immigrants, most notably Jews from as far back as the turn of the twentieth century (including Attie's grandparents), the Lower East Side holds important sway over the imagination of Jews to the current day. The texts Attie inscribed on buildings were not culled from archives, but rather his own interviews with various people, Jewish and otherwise.

In 2002 Attie projected archival photographs of Italian Jews from between 1890 and 1920 onto Rome's ruins (e.g., the *Colosseum*). Projected close to the original Jewish ghetto, and in one instance on the exact spot the picture was originally taken, Attie juxtaposes Jewish figures, often children and street vendors, on ancient remains and excavations. By virtue of the installation taking place in the twenty-first century, the documentation of the event also incorporates contemporary Rome. As Natasha Egan observes, "His placing the marginalized against Roman ruins raises questions of who belongs to a particular history, who might not, and how history is constructed–some subjects valorized and some overlooked and suppressed.... Dividing our attention carefully between three moments in the human history of this place [Rome], he implies that history might not have anything to do with time, but might be better thought of as a continuous, repetitious loop that contains both stone ruins and less tangible human ruins" (Attie, *The History of Another,* unpaged). Photographed near dusk so that the tangible architecture and the superimposed photographs could both be seen, the images possess an otherworldly feeling, suffused with a glowing dark blue sky and warm shadows that contrast with the black-and-white apparitions.

When asked if he sees anything Jewish in his art, Attie explains that "I resist having my work typecast in ethnographic terms, so this question is a bit difficult for me. Clearly, my work deals with issues of memory, history, and the layering of place, identity and time. I would feel a bit uncomfortable speculating whether or not those are particularly 'Jewish' concerns....I do not see my work in ethnographic or group-specific terms" (Written communication). Attie also resists the definition of Jewish art: "I have no definition of 'Jewish art.' I basically don't believe in these kinds of designations. I believe in strong, powerful and compelling Art [*sic*]" (Ibid.).

Attie's projects have been underwritten by several prestigious grants, including fellowships from the Pollock-Krasner Foundation, the National Endowment of the Arts, and the New York Foundation for the Arts. In 2006, Attie won a Jewish Cultural Achievement Award in the visual arts from the National Foundation for Jewish Culture.

Bibliography

Attie, Shimon. *The Writing on the Wall: Projections in Berlin's Jewish Quarter, Shimon Attie – Photographs and Installations.* With essays by Michael André Bernstein and Erwin Leiser. Heidelberg: Edition Braus, 1994.

———. *Sites Unseen: Shimon Attie – European Projects, Installations and Photographs.* With an introduction by James Young. Burlington, VT: Verve Editions, 1998.

———. *The History of Another.* Santa Fe, NM: Twin Palms Publishers, 2004.

———. Written correspondence with the author. April 22, 2006.

Bohm-Duchen, Monica. *After Auschwitz: Artist Responses to the Holocaust in Contemporary Art.* London: Northern Centre for Contemporary Art in association with Lund Humphries, 1995.

Friedman, Michelle A. "Haunted by Memory: American Jewish Transformations." In *Impossible Images: Contemporary Art after the Holocaust.* Edited by Shelley Hornstein, Laura Levitt, and Laurence J. Silberstein, 31–50. New York: New York University Press, 2003.

Lang, Berel. "Second Sight: Shimon Attie's Recollection." In *Image and Remembrance: Representation and the Holocaust.* Edited by Shelley Hornstein and Florence Jacobowitz, 22–30. Bloomington: Indiana University Press, 2003.

Soltes, Ori Z. *Finstere Medine: Photograph by Shimon Attie.* Washington, D.C.: B'nai B'rith Klutznick National Jewish Museum, 1995.

Young, James E. "Sites Unseen: Shimon Attie's Acts of Remembrance, 1991-1996." In *At Memory's Edge: After-Images of the Holocaust in Contemporary Art and Architecture,* 62–89. New Haven: Yale University Press, 2000.

Selected Public Collections

Berlinische Galerie, Berlin
Bibliothèque Nationale, Paris
Center for Creative Photography, Tucson
Cleveland Museum of Art
High Museum of Art, Atlanta
Jewish Museum, New York
Museum of Fine Arts, Houston
Museum of Modern Art, New York

Richard Avedon (1923–2004), photographer.

Richard Avedon's career spanned sixty years, beginning as a fashion photographer for *Harper's Bazaar* in the 1940s when he was barely twenty years old. His pioneering pictures set standards for the fashion industry, and his subsequent portraits—most not taken on commission but as part of the artist's own project—chronicle the faces of major twentieth-century celebrities and public

figures. Marilyn Monroe (1957), Dwight D. Eisenhower (1964), and Henry Miller (1968) are among the thousands of personalities subjected to Avedon's scrutiny.

Born in New York City, as a child Avedon evidenced more than a passing interest in photography when he joined the Young Men's Hebrew Association Camera Club at age twelve. After briefly attending Columbia University with the goal of pursuing poetry (1941–42), Avedon served as a photographer for the U.S. Merchant Marine (1942–44) during World War II, shooting spare head shots for identification cards (a manner that surely influenced his later austere portraiture). Following his release from the service, Avedon studied photography at the New School for Social Research with Alexey Brodovitch (**Irving Penn** and **Garry Winogrand** also studied with Brodovitch), the art director at *Harper's Bazaar,* who hired Avedon as a staff photographer in 1945. Covering the French couture collections in Paris and other fashion events, Avedon introduced a flair to his pictures; rather than photographing staid models in fancy dress, he captured them expressing a range of emotions and sometimes literally in motion. Avedon was so well known that in 1957 a fictional account of his career was filmed as the movie *Funny Face,* starring Fred Astaire as a fashion photographer named Dick Avery. The following year Avedon was named one of the world's ten greatest photographers by *Popular Photography* magazine.

Unlike the photographic portraiture of **Arnold Newman**, which strives to convey his sitters' personalities by their environment as well as their faces, Avedon shoots his portraits against a plain white background and without accoutrements. Dispensing with any photographic distractions, such as inventive angles, props, and elaborate lighting, Avedon scrupulously records his sitter's face and character. Avedon's portraits have provoked some criticism for a perceived lack of compassion for his sitters, while others see the beauty in laying all pretense bare. Susan Sontag described the realistic style of Avedon's portraiture and relates it to his fashion photographs: "There is a perfect complementarity between Avedon's fashion photography, which flatters, and the work in which he comes on as The One Who Refuses to Flatter" (104). Sontag refers here to seven photographs of Avedon's father Jacob Israel Avedon (1969–72), which chronicle his disintegration from a composed, elegant man in a suit and tie to a weak, suffering victim of terminal liver cancer pictured in a hospital gown. While in the early portraits Jacob Avedon's countenance is that of a wealthy businessman, as the series continues the subject's resolve and confidence deteriorates. To use Harold Rosenberg's evocative description: "On the features of the dying man an expression of apprehension deepens into outright terror that culminates in a hopeless appeal (in the sixth portrait), then subsides into resignation. At the height of his desperation, the older Avedon's head seems on the verge of metamorphosis into a petrified skull, like the light-absorbing masks in semi-precious stone of ancient Mexico – in features and strained expression the photo resembles a representation in gold of the Mixtec death god" (Avedon, *Portraits,* unpaged).

Taken the same year that his father died, Avedon's photograph of Groucho Marx (1972) (see figure) is similarly unflinching and characteristic. Devoid of

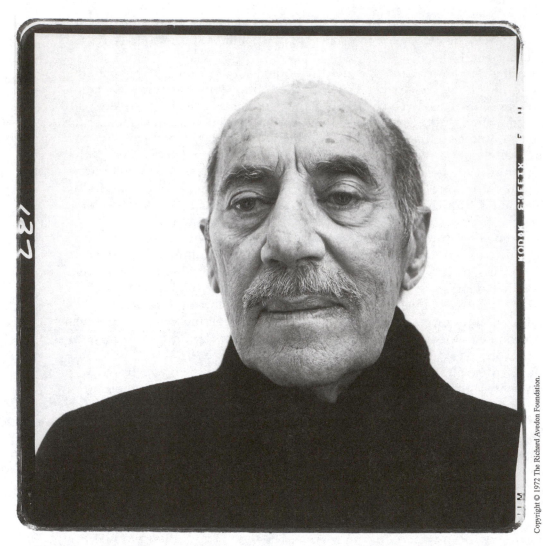

Photograph by Richard Avedon, *Groucho Marx, actor, Beverly Hills, California, April 9, 1972.*
Courtesy The Richard Avedon Foundation.

his greasepaint mustache, glasses, and signature smirk, the tightly framed Marx appears as a tired old man with age spots on his balding pate. The sharp light and unidealized, sparse environment serve the photographer's purpose; Avedon's goal is not to present the viewer with an image of the iconic Groucho but rather the person behind the performed character. Discussing this portrait in a catalog accompanying a 2002 retrospective at the Metropolitan Museum of Art, Maria Morris Hambourg and Mia Fineman understand the characterization as one in which Avedon "approached Groucho Marx with love in his eye, portraying him not as a popular prankster but as a wise elder states-man of Jewish culture" (Avedon, *Richard Avedon Portraits*, unpaged). Indeed, in the introduction to his visual memoir, *An Autobiography* (1993), Avedon explains that the book is not arranged chronologically, and instead "each moment reaches backward and forward to all other moments.... The story in the book is the story of my life, but sometimes I've found the image of a later event in an early photograph, and once or twice a late picture was made in the grip of a lost emotion" (unpaged). Avedon also points out that the photo-graphs on adjacent pages may seem unrelated, but they are "driven by their own eccentric logic." To that end, he describes his portrait of Groucho "as a kind of presiding Jewish intellectual [who] is placed among pictures of my fam-ily." I would argue that Avedon saw himself as part of a continuum of Jews, that is to say, a lineage descending from Abraham, Isaac, and Jacob, and Sarah, Rebecca, Rachel, and Leah. Viewed this in this light, Groucho *is* a member of Avedon's family. Although to date the influence of Avedon's Jewish identity on his art has yet to be sorted out, this evidence as well as additional indications suggest that there was an effect. Avedon took pride in his Jewish background; as a child he reserved a space in his autograph album for "Great Jews and Judges," and in a 1995 documentary Avedon asserted: "I'm such a Jew. But at the same time completely... is it agnostic, someone who doesn't believe in any-thing?" (Whitney).

For decades Avedon's pictures regularly appeared in magazines, and also in several books, often with accompanying text by well-known writers. His first, *Observations* (1959), with text by Truman Capote, appeared in 1959, and primarily comprised portraits of distinguished persons. Collaborating with the writer James Baldwin on *Nothing Personal* (1964), Avedon produced pictures on the state of America at the time. The book includes photographs of a nude Allen Ginsberg; a portrait of George Lincoln Rockwell, Commander of the American Nazi Party; and black civil rights workers, among other relevant subjects characterizing the period. For five years (1979–84) Avedon worked on a commission from the Amon Carter Museum in Forth Worth, Texas to chronicle the life of the American working class, resulting in photo-graphs of 752 people—ranging from coal miners to waitresses—in seventeen western states, published as *In the American West.* Avedon left *Harper's Bazaar* in 1965 to accept a position at *Vogue* (1966–90) and then later served as the first staff photographer at *The New Yorker* (1992–2004), where he worked until his death while on location. In his lifetime, Avedon was honored with many one-person exhibitions, including a retrospective at the Whitney Museum of Art (1994), and a more recent show of his portraits at the Metropolitan

Museum of Art (2002), preceded by an exhibition of his fashion photography at the same venue in 1978. He was inducted into the American Academy of Arts and Sciences in 2001.

Bibliography

Avedon, Richard. *Portraits.* With an essay by Harold Rosenberg. New York: Farrar, Straus and Giroux, 1976.

Avedon, Richard and James Baldwin. *Nothing Personal.* New York: Atheneum Publishers, 1964.

Avedon, Richard and Truman Capote. *Observations.* New York: Simon and Schuster, 1959.

———. *Photographs, 1947-1977.* New York: Farrar, Straus and Giroux, 1978.

———. *In the American West.* New York: Harry N. Abrams, Inc., Publishers, 1995.

———. *An Autobiography.* New York: Random House, 1993.

———. *Richard Avedon Portraits.* New York: Harry N. Abrams, Inc., Publishers, 2002.

Shanahan, Mary, ed. *Evidence, 1944-1994, Richard Avedon.* New York: Random House, Eastman Kodak Professional Imaging in association with the Whitney Museum of American Art, 1994.

Sontag, Susan. *On Photography.* New York: Farrar, Straus and Giroux, 1977.

Whitney, Helen, dir. *Richard Avedon: Darkness and Light.* Chicago: Home Vision Arts, 1995 (87-minute videocassette).

Selected Public Collections

Amon Carter Museum, Fort Worth, Texas
Art Institute of Chicago
High Museum of Art, Atlanta
Metropolitan Museum of Art, New York
Museum of Modern Art, New York
National Portrait Gallery, Washington, D.C.
San Francisco Museum of Modern Art
Victoria and Albert Museum, London

B

Saul Baizerman (1889–1957), sculptor and draftsman.

Known for the sculptural technique he adopted in 1926 in which he hammered copper sheets into representational figures often on a monumental scale, a physically exhausting procedure that displays the artist's labor as much as the subject represented, Saul Baizerman was born in Vitebsk, the same Russian town where Marc Chagall was raised. At thirteen he received some artistic training; a painter-craftsman with whom Baizerman apprenticed told him that he did not have enough talent to succeed as a sculptor. After escaping from an Odessa prison where he had been incarcerated for a year and a half for revolutionary involvement, Baizerman arrived in America in 1910 at the age of twenty-two. While he briefly studied at an art school in Odessa (c. 1905), Baizerman's professional instruction did not begin in earnest until 1911 when he enrolled in classes at New York's National Academy of Design for a year. Subsequently, he took classes at the Beaux-Arts Institute of Design for nine years (1911–20) and also at the Educational Alliance (c. 1919), where he found his mature style after sculpting figures in a traditional, academic vein.

In the early 1920s Baizerman began a series of carved plaster figures, later cast in bronze and hammered, to inhabit a model of New York City. Until his death he worked on this project, titled *The City and the People*; up to 1936 he called it *The Labor Group* to specify labor as a collective undertaking. Based on realistic drawings of New York's populace that he refined to more generic types, approximately fifty-six pieces show urban workers on a small scale; some of the figures—which primarily comprise unskilled laborers—are only three inches tall. The actual city is a nearly abstract, Cubo-Futurist form composed of asymmetrical verticals and horizontals to convey a sense of an energetic metropolis where the laborers might toil (1921, Philadelphia Museum of Art). Even so, Baizerman often exhibited the sculptures as independent entities rather than creating a narrative for figures such as *Rabbi* (1922), *Asphalt Paver* (1922), and *Man with Shovel* (1921–23).[7] A hammered bronze measuring five inches tall, the compact, stylized *Man with Shovel* (the first of several denizens of the city he ultimately enlarged beginning in the 1920s) is a faceless figure appearing geometric and simplified, even partially abstracted in the manner of Cubism. This angular style contrasts with a second, more rounded technique Baizerman employed for other

workers. Baizerman's generalized style is indebted to his hammering technique, and also to a visit to London in 1923 where he saw the simplified vocabulary of Greek, Assyrian, and Egyptian sculpture (Baizerman returned to London in 1924 where he remained for two years, finding the public and critics more receptive to his sculptures there). The approach used to make the hammered bronzes of *The City and the People*, and even more the hammered copper sculptures, has its roots in Baizerman's Russian childhood; his father, a third-generation harness-maker, hammered leather into harnesses. His upbringing in Russia not only influenced his chosen medium but also his subject, indicative of Baizerman's own Socialist philosophy where work is viewed as a utopian, communal activity. The politically concerned, humanistic labor series anticipates the Social Realism of the 1930s as practiced by the painters **Raphael Soyer** and **Philip Evergood**, among others.

Copper proved to be an effective, flexible, and inexpensive metal for Baizerman's hammered work, which took years to complete. To stabilize a flat sheet of copper, Baizerman would clamp it in a frame, thus allowing him to beat the alloy on both sides. With all aspects of the metal retained in the sculpture's final form (as opposed to carvers such as **William Zorach** who chip away material), the sculptures appear solid and heavy although the hammered metal is thin and hollow. A typical copper relief, the ninety-six-inch tall *Crucifixion* (c. 1947–50, Jewish Museum, New York) (see figure), shows an elongated Jesus with arms upraised beaten into the metal. He hangs full length amid the animated, rippled surfaces of the copper; being concave as well as convex, *Crucifixion*, like all of Baizerman's other copper reliefs, is meant to be seen in the round. Baizerman described his technique as imbuing sculptures with *"the suggestiveness of living*—for the dead material, the dead forms, must breathe and move and change— yet never seem to leave the place they are in" (Baizerman, "Saul Baizerman," 10; emphasis in original). Although Baizerman "discovered" the method in 1920 when he attempted to refurbish a bronze figure that had been smoothed at a foundry during the casting process, artists in ancient Egypt and Greece also used the process.

A January 1931 fire in his New York studio destroyed much of his hammered sculpture, but with renewed energy he created a body of work that was shown in exhibitions in the 1930s and 1940s, including one-man shows in 1933, 1938, and 1948. Sculptures from this period were frequently named after musical terms, such as *Pastoral Symphony No. 2* (1930–50, Weatherspoon Art Museum, University of North Carolina at Greensboro) and *Crescendo (Fifth Sculptural Symphony)* (c. 1942–52, Hirshhorn Museum and Sculpture Garden, Washington, D.C.), likely inspired by the vibrating tones he, the conductor, made as he beat the copper sheet with his hammer (Tarbell, 41). His work occasionally took on biblical themes, such as *Eve* (1949, collection unknown), shown as a torso; the aforementioned *Crucifixion*; and *Creation* (1950–57, Hirshhorn Museum and Sculpture Garden, Washington, D.C.), which stands eight feet tall. Baizerman also executed a few portrait heads, including a likeness of Albert Einstein (1940–49,

Saul Baizerman, *Crucifixion,* c. 1947–50. Hammered copper, 96 × 30 × 25 inches. The Jewish Museum, New York. Gift of Miss Irene Worth, 1991–91. Photo: The Jewish Museum/Art Resource, New York.

collection unknown), who was also depicted by **Jo Davidson** and **Jacob Epstein**.

Even if he is not well known today, Baizerman achieved success in his lifetime. In addition to several one-person shows and the representation of his work at the World's Fair in 1939, in 1952 he was a fellow under the auspices of the Guggenheim Foundation. A year later his first retrospective was held at the Walker Art Center in Minneapolis (the traveling exhibition went to the Des Moines Art Center, the San Francisco Museum of Art, and the National Gallery of Canada, Ottawa), followed by a second traveling retrospective originating at Boston's Institute of Contemporary Art soon after his death (1958). Baizerman described the challenge of his working process as well as his philosophy of artmaking in an interview from 1952: "How do I know when a piece is finished? When it has taken away from me everything I have to give. When it

has become stronger than myself. I become the empty one and it becomes the full one. When I am weak and it is strong the work is finished" (Goodnough, 67).

Bibliography

Baizerman, Saul. "Saul Baizerman: The Journal, May 10, 1952." Edited by Carl Goldstein. *Tracks: A Journal of Artists' Writings* 1, no. 2 (Summer 1975): 8–23.

———. *Saul Baizerman's Lifetime Project: The City and the People.* Greensboro, NC: Weatherspoon Art Gallery, 1998.

Debakis, Melissa. "The Sculpture of Saul Baizerman." Ph.D. dissertation, Boston University, 1987.

Debakis, Melissa and David Finn. *Vision of Harmony: The Sculpture of Saul Baizerman.* Redding Ridge, CT: Black Swan Books, Ltd., 1989.

Goldstein, Carl. "The Sculpture of Saul Baizerman." *Arts* 51, no. 1 (September 1976): 121–125.

Goodnough, Robert. "Baizerman Makes a Sculpture." *ARTnews* 51 (March 1952): 40–43, 66, 67.

Held, Julius S. *Saul Baizerman: An Exhibition Initiated by the Walker Art Center, Minneapolis.* Minneapolis: Walker Art Center, 1953.

McCabe, Cynthia Jaffee. *The Golden Door: Artist-Immigrants of America, 1876-1976.* Washington, D.C.: Smithsonian Institution Press, 1976.

Tarbell, Roberta K. *Vanguard American Sculpture.* New Brunswick, NJ: Rutgers University Art Gallery, 1979.

Selected Public Collections

Georgia Museum of Art, University of Georgia, Atlanta
Hirshhorn Museum and Sculpture Garden, Washington, D.C.
Johnson Museum of Art, Cornell University, Ithaca, New York
San Diego Museum of Art
Sheldon Memorial Art Gallery, Lincoln, Nebraska
Smithsonian American Art Museum, Washington, D.C.
Walker Art Center, Minneapolis
Whitney Museum of American Art, New York

Will Barnet (1911–), painter, printmaker, and draftsman.

Oscillating throughout his career between abstraction and figuration, Will Barnet has experimented with the styles of his day, beginning with Social Realism in the 1930s, then abstraction in the 1940s and 1950s, and returning to representational art in the mid-1960s. Born to Eastern European immigrant parents in Beverly, Massachusetts, a prototypical New England community that influenced his later artistic interest in the sea, Barnet started drawing as a young boy. As a teenager he studied at the art school of the Boston Museum of Fine Arts (1928–31) after he dropped out of high school in his junior year. In

1930, the year he issued his first lithograph, Barnet received a scholarship to study printmaking at the Art Students League in New York City, where he took classes with Stuart Davis and Charles Locke (1931–33). By 1934 he started serving as the League's official printer, supervising editions by **William Gropper**, among others, and soon thereafter he became an instructor of graphic art at the League. Through this early period Barnet depicted socially conscious themes influenced by the work of the Mexican muralists, particularly José Clemente Orozco, and the nineteenth-century French lithographer Honoré Daumier. He recorded city life in lithographic and etched prints such as *Conflict* (1934), a scene presenting a group of bulky men storming a city building, and *Idle Hands* (1935), which shows the mind dulling effect of the Great Depression on a homeless man. Barnet held his first one-man exhibition at the Eighth Street Playhouse in New York in 1935 and acted as a technical adviser and printer for graphic art for the Works Progress Administration in 1936.

During the 1940s, Barnet focused on painting, making colorful, simplified canvases of his children and wife, subjects that appear often in his art. Aiming to create a "real American art," soon Barnet's printwork and painting became even more abstract, influenced by the design, nonillusionism, and balance of Native American art. (Stavitsky, 61). A typical Indian Space painting, *Fourth of July* (1954, private collection) was inspired by Barnet's sketches of his three sons playing with sparklers. In its final abstracted form, *Fourth of July* reduces the children to vertical figures arranged as balanced, geometric forms that merge with the canvas' background.

As a participant in a seminar titled "The Influence of Spiritual Inspiration on American Art," (**Jack Levine** was also a speaker) sponsored by the Vatican Museums and the Smithsonian Institution (1976), Barnet delivered a paper titled "A Personal Reflection on the Spiritual Aspects of American Art." Citing the severity of Puritan ethics and the mysticism of Transcendentalism, Barnet endowed the spiritual in art to style. For example, Barnet understands the austere lines of Grant Wood's *American Gothic* (1930, Art Institute of Chicago) as endowing the painting with a "puritan element" (125), and the "supernatural quality" of Albert Pinkham Ryder's work as "transcendental painting at its zenith" (126). Barnet connects these formal qualities to his own imagery: "As an artist I was first attracted and influenced by the formal aspects of religious painters and how the strength of their formal painting ideas sprang from their religious beliefs, which in turn, were based on their church. Like those devoted believers, I have felt that I must express in my work a similar commitment to a strong belief. Upon taking up a subject for painting I reach in the depths of my own experience" (127). This somewhat ambiguous lecture leaves Barnet's spiritual leanings (and their connection to his art) unclear; however, one might infer that the diverse styles he has employed over the years were necessary alternatives for him to communicate his personal expression in his art. Indeed, Gail Stavitsky observes that "for Barnet, the spiritual, transcendentalist aspects of art reside in the beauty, strength, and construction of form" (41).

Barnet's personal expression—not iconographically religious in the traditional sense—conveys the sacred in less overt ways (and ways that additional

scholarship will need to flesh out) than that of artists such as **Ben-Zion** and **Hyman Bloom**. For instance, of his Maine landscapes and seascapes, started after Barnet and his family began spending summers in Maine in 1971, Barnet noted that he returned "to the visual heritage of my youth–the sea and the transcendental history of New England" (*Will Barnet: Recent Paintings and Drawings,* unpaged). Part of a series delineating women by the sea, *Infinite* (1975–76, Farnsworth Art Museum, Rockland, Maine) (see figure) portrays four stylized women in shawls overlooking the ocean. Recognizable figures from another century but constructed by planes and forms typical of abstraction, the women function as universal humans at one with nature, a central tenet of Transcendentalist thought. Infused with radiant, luminous light conceived in graduated tones of grey, blue, and lavender, the moody painting imparts a sense of isolation, austerity, and quiet while retaining Barnet's interest in asserting the flatness of his compositions. Identifying Barnet as a painter of New England and evoking the traditions of New England, critic Cliff McMahon notes, "in his strong, silent, intellectually brooding women we

Will Barnet, *Infinite,* 1975–76. Oil on canvas, 63½ × 47½ inches. Collection of the Farnsworth Art Museum, Rockland, Maine. Gift of Robert and Maurine Rothschild, 1999. Accession No.: 99.10. Art © Will Barnet/Licensed by VAGA, New York, New York.

should see not just the fierce, isolated and confident individualism of Emerson and Thoreau, but also the powerful and intellectual Hester Prynne of *The Scarlet Letter,* as well as the powerful, secretive and enduring mind of Emily Dickinson" (30). New England's intellectual life and style appear in a later project as well; Barnet provided twenty-four interpretative drawings for a selection of Dickinson's poems, compositions that also inspired a related series of paintings and prints.

Barnet has worked as an instructor of graphic art and painting at several venues, most notably the Art Students League (until 1980) and the Cooper Union in New York (1945–67). Other institutions at which Barnet has taught include the Pennsylvania Academy of the Fine Arts (1967–92) and the University of Minnesota at Duluth (summers 1958, 1959). His students who later went on to illustrious art careers include **Mark Rothko**, **Audrey Flack**, and **Eva Hesse**.

Bibliography

Barnet, Will. "A Personal Reflection on the Spiritual Aspects in American Art." In *The Influence of Spiritual Inspiration on American Art,* 123–129. Rome: Liberia Editrice Vaticana, 1977.

————. "Maine and Its Influence on My Art." In *Will Barnet: Recent Paintings and Drawings.* Rockland, ME: William A. Farnsworth Library and Art Museum, 1985.

Cole, Sylvan Jr., ed. *Will Barnet: Etchings, Lithographs, Woodcuts, Serigraphs, 1932-1972, Catalogue Raisonné.* With a foreword by Robert Doty. New York: Associated American Artists Gallery, 1972.

Dickinson, Emily. *The World in a Frame.* Drawings by Will Barnet. New York: George Braziller, 1989.

Doty, Robert M. *Will Barnet.* New York: Harry N. Abrams, Inc., Publishers, 1984.

Garfield, Johanna. "Will Barnet and the Family: From the Collection of the National Museum of American Art." *American Art* 9, no. 1 (Spring 1995): 110–115.

McMahon, Cliff. "The Sublime is How: Philip Taafe and Will Barnet." *Art & Design* 10, no. 1–2 (January–February 1995): 19–33.

Meyer, Susan E. *Will Barnet: 27 Master Prints.* New York: Harry N. Abrams, Inc., 1979.

Stavitsky, Gail. *Will Barnet: A Timeless World.* Montclair, NJ: Montclair Art Museum; Distributed by Rutgers University Press, 2000.

Selected Public Collections

Albright-Knox Art Gallery, Buffalo, New York
Butler Institute of American Art, Youngstown, Ohio
Museum of Fine Arts, Boston
Nelson-Atkins Museum of Art, Kansas City, Missouri
Pennsylvania Academy of the Fine Arts, Philadelphia
San Diego Museum of Art
Smithsonian American Art Museum, Washington, D.C.
Whitney Museum of American Art, New York

Leonard Baskin (1922–2000), sculptor, printmaker, watercolorist, and illustrator.

Conversant in an array of media, Leonard Baskin's frequent subject is man, often tragic and suffering, rendered in a manner that shows the artist's stylistic debt to German expressionist artists and ideologic influence to socialist principles. Baskin's work in both sculpture and print hovers between realism and abstraction, a challenging position in the American world in the late 1950s and early 1960s. He created an exhaustive number of works concerning Jewish themes, including one of the most widely used Passover Haggadahs in America; illustrated in 1974, Baskin provided watercolors as well as hand lettering of much of the Hebrew text for the Haggadah. Jewishness was pervasive for Baskin: "My brain is serried with an infinity of memory-traces that recall the sound and smell of *shul*, of home, of Yeshiva, of the nearly all-Jewish street" (Baskin, "To Wear Bloodstain with Honor," 295).

Born in New Brunswick, New Jersey, Baskin was the son of a leading Orthodox rabbi. His earliest education was at a yeshiva in Brooklyn, where his family had moved when he was seven. Until he was fifteen years old, Baskin studied Talmud for ten hours a day, seven days a week. This training, Baskin noted, "gave my mind its fine Aristotelian edge. Understanding the labyrinthine logic of the Talmud would make me a wonderful abstract expressionist if I didn't have other ambitions!" (Rodman, 176). After developing an interest in sculpture at age fourteen, he attended day classes at the yeshiva and took evening art classes at the Educational Alliance (1937–39). Baskin had his first exhibition at his mentor Maurice Glickman's studio in 1939, and a year later he won an Honorable Mention for Sculpture in the Prix de Rome competition at the age of eighteen, after which he studied art at New York University (1939–41) and at Yale University (1941–43) on a scholarship. Three years in the Navy during World War II temporarily curtailed Baskin's artistic activity. Following the war he completed his B.A. at the New School for Social Research (1949) under the G.I. Bill, and in the early 1950s he also studied in Paris and in Florence, at the Académie de la Grande Chaumière and the Accademia di Belle Arti, respectively.

While at Yale, Baskin discovered the British artist William Blake. Impressed by Blake's role as a poet-artist-bookmaker, Baskin founded the Gehenna Press in 1942 and learned printmaking. The private press published over 100 limited edition illustrated books, such as Homer's *Iliad* (1962), Dante's *Divine Comedy* (1969), and *Jewish Artists of the Early and Late Renaissance: A Book of Etchings and Words* (1993). In 1956 Baskin collaborated with **Ben Shahn** on the Gehenna Press publication *Thirteen Poems by Wilfred Owen*, which Shahn illustrated. Baskin's illustrations for *Hosie's Alphabet* won him the Caldecott Medal in 1974, an annual award for best children's picture book.

Although sculpture was Baskin's favored medium—carved in wood, stone, and marble, and cast in bronze—he first gained acclaim for his printmaking. Baskin preferred the medium of wood because of the democratic nature of

prints, which can be reproduced widely at low cost and because didactic messages can more easily be conveyed by prints than by sculpture. In addition to wood engravings and woodcuts, Baskin made many etchings, working in this media in earnest in the 1960s, and then later designing lithographs.

Leonard Baskin, *Man of Peace,* 1952. Woodcut, 66½ × 36 inches. Photo © Cleveland Museum of Art, Gift of The Print Club of Cleveland 1959.226. By permission of the Estate of Leonard Baskin. © The Estate of Leonard Baskin.

His amalgamation of wiry, delicate lines arranged to depict subjects ranging from biblical stories to mythology to natural history is described by Judith O'Sullivan as related to Baskin's heritage: "his style springs from Hebrew script itself–all of those Alephs, Bets, Lameds, Yods, crammed in a basketry of nerves, growing heads, tails, feelers, hair, mouths. And the typical lonely isolation of his figures both sharpens our sense of them as hieroglyphs, cryptograms, and intensifies that atmosphere of Cabala, where each image is striving to become a syllable of the world as a talismanic Word–or at least to become a Golem, bursting with extrasensory news, bulging the cage-mesh of lines" (11–12).

Often working on a monumental scale in both his prints and his sculpture, Baskin's 1952 woodcut *Man of Peace* (Cleveland Museum of Art) (see figure) measures five feet tall and *The Altar* (1977, Jewish Museum, New York), a wood sculpture showing the binding of Isaac, is nearly six feet long. *Man of Peace* presents a distorted, anxious man—whose anatomy appears partially flayed—standing behind barbed wire, holding a dead bird as a sacrificial offering. Rendered with a nervous line, the patterning of the wire suggests both containment and hope as the twisted wire evokes flowers on a trellis. The work may be illustrating the ceremony of *Kapparah,* a ritual during which a man offers a cock for the expiation of sins the day before Yom Kippur (a woman offers a hen). *The Altar* provides a unique interpretation of the binding of Isaac; rather than showing the moment when God sends the angel to interrupt Abraham's act of faith, Baskin depicts a nude Isaac laid out on the altar with the ram at his feet and his back joined with Abraham who faces in the opposite direction. Between the pair the angel's wings envelop and protect Isaac's body. Starkly executed with the chisel marks apparent, this dramatic sculpture is rightly considered among Baskin's most important works.

From 1953 to 1974, Baskin taught printmaking and sculpture at Smith College in Northampton, Massachusetts. He spent ten years in England (1975–84), in part to be close to Ted Hughes with whom he collaborated on several books. Upon returning to the United States he taught at Hampshire College (1984–94). Baskin received many important commissions, including a seven-foot tall seated, anguished bronze figure for a Holocaust memorial at the First Jewish Cemetery in Ann Arbor, Michigan (1994) and a thirty-foot long bas relief, *The Funeral Cortege* (1997), for the Franklin D. Roosevelt Memorial in Washington, D.C. Among his many awards, Baskin received the Gold Medal of the National Academy of Arts and Letters (1969).

Bibliography

Baskin, Leonard. "To Wear Bloodstain with Honor." *Judaism: A Quarterly Journal* 10, no. 4 (Fall 1961): 294–295.

———. *Baskin: Sculpture, Drawings, and Prints.* New York: George Braziller, 1970.

———. *Jewish Artists of the Early and Late Renaissance: A Book of Etchings and Words.* Northampton, MA: Gehenna Press, 1993.

———. "Impulsions to Print." *Yale University Library Gazette* 69, no. 3–4 (April 1995): 163–169.

Bronstein, Herbert, ed. *A Passover Haggadah: The New Union Haggadah.* Drawings by Leonard Baskin. New York: Grossman Publishers, 1974.

Brook, Stephen. *A Bibliography of the Gehenna Press: 1942-1975.* Northampton, MA: J.P. Dwyer, 1976.

Fern, Alan. *Leonard Baskin.* With annotations by Leonard Baskin. Washington, D.C.: Smithsonian Institution Press, 1970.

Fern, Alan and Judith O'Sullivan. *The Complete Prints of Leonard Baskin: A Catalogue Raisonné, 1948–1983.* Introduction by Ted Hughes. Boston: Little, Brown and Company, 1984.

Jaffe, Irma B. *The Sculpture of Leonard Baskin.* New York: Viking Press, 1980.

Rodman, Seldon. *Conversations with Artists.* New York: Capricorn Books, 1961.

Selected Public Collections

Carnegie Museum of Art, Pittsburgh
Columbus Museum of Art, Ohio
Hirshhorn Museum and Sculpture Garden, Washington, D.C.
John and Mable Ringling Museum of Art, Sarasota, Florida
Metropolitan Museum of Art, New York
National Portrait Gallery, Washington, D.C.
San Diego Museum of Art
Whitney Museum of American Art, New York

Ben-Zion (1897–1987), painter, sculptor, and printmaker.

An expressionist who believed that art must convey one's "inner life" (Ben-Zion, 7–30), Ben-Zion is best known for his images of prophets, Eastern European figures, and biblical stories, although he did at times explore other genres such as landscape. The artist himself understood the Bible's ancient stories as having resonance for the present: "I know of no other book in which the apocalyptic and elementary conflicts, as well as the psychological complications of our time come to a stronger symbolic expression than in the Bible" (Kayser, *Ben-Zion, 1933-1959,* 11–12). Indeed, over 150 of Ben-Zion's paintings are interpretations of biblical themes, reflecting the Jewish education of his early years in Eastern Europe.

Born Ben-Zion Weinman in Ukraine, he was the son of a third-generation cantor and received a strong religious education, as his father had ambitions for his son to enter the rabbinate. Although his father discouraged his early artistic proclivity, Ben-Zion prevailed and by the age of seventeen enrolled at the Academy of Fine Arts in Vienna. After enduring anti-Semitism at the Academy as well as feeling stifled by the traditional instruction, he wrote poetry, plays, and fairy tales in Hebrew. In 1920 Ben-Zion immigrated to New York where, after a number of publications, he found less interest in his writing and started to teach Hebrew to support himself. By the early 1930s (when he dropped his surname), Ben-Zion returned to art to comment on the rise of fascism in Europe, events that he felt could not be adequately explored in print. Words, he said, were "ridiculous and futile. And just like that, nothing. I couldn't write. I felt so helpless, I couldn't go out" (Dervaux, 8).

Largely self-taught, Ben-Zion visited the museums of New York City to learn his trade. His first painting on a large scale, *Friday Evening* (1933, Jewish Museum, New York), depicts a Sabbath dinner table as recalled from his family home. Aided by funding from the Works Progress Administration's Federal Art Project, Ben-Zion thrived and galleries began to show his work. In early 1936, after his first one-man show at the Artists' Gallery in New York (1935), Ben-Zion joined "The Ten," an artist group that included such progressive artists as **Mark Rothko, Adolph Gottlieb**, and **Ilya Bolotowsky**. Of the members of The Ten, who exhibited together until 1939, Ben-Zion created art with the most obvious Jewish subjects.

His work steers away from pure representation, but even when eschewing academic modes Ben-Zion maintains elements of realism. He imaginatively interpreted biblical scenes, a staple of the art world for centuries, in canvases such as *The Prophet in the Desert* (1935, collection unknown)—his first biblical painting—followed by others such as *Joseph's Dreams* (c. 1939, Sosland family collection) (see figure) and *Moses and the Tablets* (1952, Jewish Museum, New York). Using a reduced palette of black, green, and white, the boldly rendered *Joseph's Dreams* presents a flatly conceived reclining Jacob staring into a sky filled with black outlined oversized stars and a moon. On either side of the horizontal canvas the viewer is privy to a partial ladder that a figure, whose large feet we can only see, climbs. The ladder refers to a ladder leading from the ground to heaven that Jacob saw in a vision (Gen. 28:12). Ben-Zion's colleague Joseph Solman, also of The Ten, recently described Ben-Zion's canvases as "unusually stark and powerful. He carved out in paint lumbering black and white shapes as though the letters of the Hebrew alphabet had returned to imagery. . . . Ben-Zion's Biblical pieces are the only profound works in that genre in modern art besides some early works of Chagall and the dramatic scenes of Rouault" (Shalem and Soltes, 4). Thirty-nine of these paintings were first shown at the opening exhibition of the Jewish Museum in New York in 1948. Ben-Zion's etchings of biblical subjects were collected in several portfolios, including *Biblical Themes* (1951), *Prophets* (1952), and *The Book of Ruth, Job, and Song of Songs* (1954), and *Judges and Kings* (1964).

A series of seventeen works (fourteen gouache and three oils), given the title *De Profundis* (Out of the Depths), convey Ben-Zion's distress at the events of the Holocaust, while also functioning as a memorial to the Jews murdered under the Nazi regime. Exhibited as a whole in 1946, these paintings show only the figures' heads, often distorted and painted in muted color. The suffering of the economically conveyed figures is rendered by a strong linear structure, employed in part, Ben-Zion explained in 1959, to express "the strength of character and rare courage to keep their belief and mode of life inwardly as well as outwardly" (Kayser, *Ben-Zion, 1933-1959*, 13). Many other canvases, gouaches, and watercolors present single or multiple, frequently stylized heads of emotive Eastern European figures, as do hundreds of pebbles that Ben-Zion collected and subsequently painted. The pebble memorials resonate on an additional level, as when Jews visit the burial sites of loved ones they place a stone on the grave markers as a sign of remembrance.

Ben-Zion, *Joseph's Dreams,* c. 1939. Oil on canvas, 35 × 45 inches. Sosland family collection. Photo courtesy of the Sosland family.

In 1959 Ben-Zion began sculpting in iron, in some ways a natural artistic progression as the sculptural quality of the figures in his paintings suggest this new medium. Additionally, Ben-Zion's predilection for collecting (e.g., pebbles and also his substantial collection of non-Western artifacts as well as a childhood proclivity for accumulating remnants such as wood and metals) contributed to his unique sculptural vision. To be sure, his sometimes charming, fanciful sculptures frequently incorporate found materials such as nails, screws, and fireplace grates that transform into recognizable figures and objects. As with his painting, Jewish themes preoccupy a number of Ben-Zion's sculptures, such as *Sacrifice of Isaac* (1961, Haifa Museum, Israel) and *Moses Dropping the Tablets* (1979, collection unknown). His artist statement for a monograph on his sculpture includes the following comment: "The Bible revealed itself to me in many of its aspects and also the heritage of my nation with which I feel deep affinity endowed me with insight to its inner life and revealed itself in my work prominently" (Dubin and Shalem, 9). At an earlier time, Ben-Zion offered his opinion on Jewish art: "Jewish art is like any other art: it depends on the character and strength of the artist. According to his character and convictions, his art will crystallize and find its place in the chain of the Jewish creative stream. The more an artist tries to be 'Jewish,' the less his work will have creative value. It is only when the Jewish throb subconsciously emerges from his work that real creativity will result" (Grossman, 35).

Bibliography

Baigell, Matthew. *Jewish Artists in New York: The Holocaust Years.* New Brunswick, NJ: Rutgers University Press, 2002.

Ben-Zion. Oral History Interview with Barbara Shikler. Archives of American Art, Smithsonian Institution, Washington, D.C., August 3, 1982. http://www.aaa.si. edu/collections/oralhistories/transcripts/benzio82.htm

———. *On the Inner Life.* Tel Aviv: Eked, 1983.

Dervaux, Isabelle. *The Ten: Birth of the American Avant-Garde.* Boston, MA: Mercury Gallery, 1999.

Dubin, Lillian and Tabita Shalem, eds. *Ben-Zion: Iron Sculpture.* With a statement by the artist. New York: Alpine Fine Arts Collection, Ltd., 1985.

Grossman, Emery. *Art and Tradition.* New York: Thomas Yoseloff, 1967.

Kayser, Stephen S. *Ben-Zion: Biblical Paintings, 1948-1952.* New York: The Jewish Museum, 1952.

———. *Ben-Zion, 1933-1959: A Retrospect.* New York: Jewish Museum, 1959.

Shalem, Tabita and Ori Z. Soltes. *Ben-Zion: In Search of Oneself.* With a foreword by Joseph Solman. Washington, D.C.: B'nai B'rith Klutznick National Jewish Museum, 1997.

Selected Public Collections

Jewish Museum, New York
John and Mable Ringling Museum of Art, Sarasota, Florida
Metropolitan Museum of Art, New York
Museum of Modern Art, New York
Nelson-Atkins Museum of Art, Kansas City, Missouri
Newark Museum, New Jersey
The Philips Collection, Washington, D.C.
Whitney Museum of American Art, New York

Theresa Bernstein (1890–2002), painter and printmaker.

Committed to realism in many different forms, Theresa Bernstein wrote an art credo in 1947 that emphasized her belief in the universal power of art: "I believe that Art must have atomic power to weld the world of beauty into a unified whole. I believe that my work has this power. I believe that vitality, motion and dynamic force are qualities to be retained, rather than restrained, in painting. I believe that Art should be so direct that it can bridge all languages, all peoples, and even reach the understanding of children....I believe that every artist has a message, how important that message may be depends on the importance of its content....I believe that the artist must animate all peoples of all nationalities and all creeds to a greater love and understanding of Art" (Lozowick, 22).

Born in Philadelphia to cultured, immigrant parents, Bernstein showed an interest in art as a child. She attended lectures on anatomy and architectural design at the Pennsylvania Academy of the Fine Arts and earned a degree at the Philadelphia School of Design for Women (now the Moore College of Art)

after attending on a scholarship. In Bernstein's autobiography she recalls that an early painting, *Adam and Eve* (collection unknown), won an award from the School of Design in 1912 (*The Journal*, 22). That year she moved to New York City, where she briefly studied at the Art Students League with William Merritt Chase. During this period she painted in an Ashcan style, influenced by John Sloan and other artists of the moment who depicted the everyday life of the city in dark tones. *New York Street* (1912, Jack S. Blanton Museum of Art, Austin, Texas) and *Waiting Room: Employment Office* (1917, Jewish Museum, New York), a picture of several immigrant women aimlessly passing time, exemplify Bernstein's realist tendency of this period. Based on Bernstein's recollection after a visit to an employment office, *Waiting Room: Employment Office* is one of many canvases that explore the female experience in early twentieth-century America; Bernstein also made several canvases on the subject of suffrage between 1914 and 1916. Painted with a strong brushstroke, Bernstein's gritty, urban landscapes were praised by critics, some of whom noted approvingly (and misogynistically) that she was "a woman painter who paints like a man" (Nelson, c) and "There is nothing feminine about the paintings of Theresa Bernstein....It is with a man's vision that this artist looks at her subjects...Then, having found what she wants, it is with a man's vigor that she gets it down to stay" (Swinth, 191).[8] Bernstein had her first one-person show at the Milch Gallery in New York City in 1919, the same year that she married the artist **William Meyerowitz**.

An expressionist technique pervades Bernstein's work in the 1920s and 1930s, during which time she added jazz musicians to her repertoire, a subject naturally in accord with her increasingly rhythmic, painterly style and her life-long love of music. Soon after her marriage, Bernstein spent summers in Gloucester, Massachusetts, with her husband. These vacations produced plein air paintings of beaches, harbors, and fish rendered with an expanded palette. The couple also enjoyed the company of many artist-visitors such as **Peter Blume**, **Raphael Soyer**, Edward Hopper, and **Leon Kroll**. She and Meyerowitz taught a six-week art class during their summers in Gloucester, which they called the Summer Art Course. Among their students was **Louise Nevelson**, who went on to become an eminent sculptor.

Through the 1930s Bernstein continued painting a wide range of subjects, including portraits, still lifes, and beach scenes. During the Great Depression she had at least 150 portrait commissions. Under the auspices of the Works Progress Administration's Federal Art Project, Bernstein created a mural titled *The First Orchestra in Americas* (1938) for the Manheim, Pennsylvania post office, which shows several colonialists playing a concert outdoors. She did two other paintings for the federal government: *Women of America* and *The Elevated Station.*

While many artists in the 1930s joined the Communist Party, Bernstein's political consciousness centered on Zionism, a cause to which she had been dedicated since the 1920s. Bernstein recalls in her two autobiographies, *The Journal* and *Israeli Journal,* that her husband's father, a cantor, belonged to two groups dedicated to Zionism (the Lovers of Zion in Russia and the Friends of Zion #2 in America) (*The Journal*, 83) and that her interest in Israel was

instigated by her father-in-law (*Israeli Journal*, 17). Painted in dark hues and broad brushstrokes, characteristic of Bernstein's work from the period, *Zionist Meeting, New York* (1923, Jewish National Fund) chronicles the meeting's distinguished attendees; Albert Einstein appears in the lower right corner of the canvas sitting next to Chaim Weizmann.

Seder (c. 1940, The Martin B. and Edith A. Stein Collection, Boca Raton, Florida), a painting of a Seder table with Hebrew lettering at the top of the canvas, and *Allen Street, Manhattan* (c. 1941, The Martin B. and Edith A. Stein Collection, Boca Raton, Florida), a depiction of a bustling Jewish neighborhood, are among Bernstein's many Jewishly influenced works. The latter painting is one of many made by Jewish artists that describe the immigrant experience on the Lower East Side (e.g., **Abraham Walkowitz**) complete with figures in traditional dress and other accoutrements that signify the presence of Jews. At the center of canvas, Bernstein portrays a synagogue with a Jewish star on its facade and to the left of the temple one sees a menorah in a store window. Also concerned with the Jewish world are *Prayer* (1938, The Martin B. and Edith A. Stein Collection, Boca Raton, Florida), which shows the energy of the worshippers through a gestural brushstroke, and the vibrantly colored and vigorously rendered canvas *The Student* (1945, The Martin B. and Edith A. Stein Collection, Boca Raton, Florida) (see cover of book). In this combination still life and genre scene, Bernstein incorporates a Hebrew book on a table alongside more prosaic objects. Sitting at the festive table, filled with flowers and fruit, is a woman engrossed in a book. That the student, as per the title of the painting, is female indicates two of Bernstein's interests: women's rights and Judaism. This devout woman appears to be both a caretaker of her home and educated—a less common position in 1945 than at the current time. The woman's profound interest in her book combined with the words on the cover of the book mounted on the table indicate her piety; although slightly misspelled the cover of the book reads "A wise woman knows God."

After the establishment of Israel, Bernstein and Meyerowitz visited the country thirteen times during a thirty-year period, beginning in 1952. In *The Journal*, Bernstein dedicates a full chapter to her experiences in Israel and her attraction to the land; she painted several canvases of Israel, such as scenes of immigrants and kibbutzim. *Israeli Journal* chronicles her many trips to the country in more detail. The journal betrays her strong feelings for the country, of which she writes: "Israel is a light unto the nations, the emanating spirit of faith, man to man, and man to God. Let us hope and pray for calm" (92).

As evidenced by her multiple journals, Bernstein's creativity transcended the fine arts. She enjoyed writing since childhood; at eleven years old she entered a writing competition held by the *Philadelphia Bulletin* and was awarded a prize. Despite her varied interests, Bernstein noted in her journal that, "I always found oil to be the classic mode for insistent vibrations and the most rewarding of all media" (*The Journal*, 127). She also published a biography of her husband, titled *William Meyerowitz: The Artist Speaks*, and a compilation of her poetry, *The Poetic Canvas*. The latter book comprises poems on art, her husband, Gloucester, Israel and additional Jewish

subjects—including "Israel before 1948 UN Vote" (1947), "This Tiny Land" (1973), "Oh! Jerusalem" (1975), and "Moses" (1978), among many others.

The long-lived Bernstein had more than forty one-woman shows, notably a 1973 exhibition at the Butler Institute of American Art in Youngstown, Ohio. She also exhibited work at the National Academy of Design and was a charter member of the New York Society of Women Artists.

Bibliography

Bernstein, Theresa. *Theresa Bernstein.* Stamford, CT: Smith-Gerard, 1985.

Burnham, Patricia M. "Theresa Bernstein." *Woman's Art Journal* 9, no. 2 (Fall–Winter 1989): 22–27.

———. *Theresa Bernstein (1890-): An Early Modernist.* New York: Joan Whalen Fine Art, 2000.

Lozowick, Louis. *One Hundred Contemporary American Jewish Painters and Sculptors.* New York: YKUF Art Section, 1947.

Meyerowitz, Theresa Bernstein. *William Meyerowitz: The Artist Speaks.* New York: Cornwall Books, 1986.

———. *The Poetic Canvas.* New York: Cornwall Books, 1989.

———. *Echoes of New York: The Paintings of Theresa Bernstein.* New York: Museum of the City of New York, 1990.

———. *The Journal.* New York: Cornwall Books, 1991.

———. *Israeli Journal.* New York: Cornwall Books, 1994.

Movalli, Charles. "A Conversation with William Meyerowitz and Theresa Bernstein." *American Artist* 44, no. 450 (January 1980): 62–67, 90–92.

Nelson, W.H. de B. "Theresa F. Bernstein." *International Studio* 66, no. 265 (February 1919): xcvii–cii.

Swinth, Kirsten. *Painting Professionals: Women Artists and the Development of Modern American Art, 1870-1930.* Chapel Hill: University of North Carolina Press, 2001.

Wardle, Marian, ed. *American Women Modernists: The Legacy of Robert Henri, 1910-1945.* Brigham Young University Museum of Art in association with New Brunswick, NJ: Rutgers University Press, 2005.

Selected Public Collections

Art Institute of Chicago
Jack S. Blanton Museum of Art, Austin, Texas
Metropolitan Museum of Art, New York
Museum of Fine Arts, Boston
National Museum of Women in the Arts, Washington, D.C.
Seattle Art Museum, Washington
Victoria and Albert Museum, London
Whitney Museum of American Art, New York

Albert Bloch (1882–1961), painter.

Frequently described as the American Blue Rider in reference to the exhibition of his drawings and paintings at the avant-garde group's first two Munich

shows (1911 and 1912) and a few other venues, Albert Bloch retained the figure in paintings and drawings to two diverse ends: as a means to satire contemporary life and also to explore the spiritual. Born in St. Louis, Missouri to immigrant parents from Bohemia, Bloch dropped out of high school at age sixteen to study at the St. Louis School of Fine Arts (1898–1900). Beginning his professional career in 1901 making cartoons for the St. Louis *Star,* by 1905 Bloch gained employment as a cartoonist for the *Mirror,* a weekly magazine based in St. Louis with an international readership. His biting caricatures satirized figures ranging from Rudyard Kipling to Theodore Roosevelt. Bloch also made many other cartoons and thirty-one covers for the *Mirror.*

Under the patronage of the *Mirror*'s editor and publisher, Bloch, his wife, and his son moved to Munich in early 1909. He met Wassily Kandinsky in 1911, who invited Bloch to exhibit with him, Franz Marc, and their group, Der Blaue Reiter (The Blue Rider). The group's independent spirit and propensity toward the spiritual appealed to Bloch, who propagated these qualities long after he left Munich and returned to the United States. Translating his drawing style to paint, Bloch showed six paintings at the first show including *The Three Pierrots No. 2* (1911, Collection Mrs. Albert Bloch, Lawrence, Kansas), a canvas depicting three dancing figures. Painted in his typical style of that period, Bloch employed flowing lines, indefinite space, flat shapes, and arbitrary, swirling colors. At this time Bloch started to paint subjects that would recur in his art for the rest of his career: figures from the commedia dell'arte (especially clowns, Harlequin, and Pierrot) as in *The Three Pierrots No. 2,* biblical stories (predominantly scenes from the life of Jesus), and landscapes, frequently portraying a visionary, otherworldly atmosphere conveyed partly by mist and moonlight. Sometimes Bloch even fused these interests; *The Entombment* (1914, Städtische Galerie im Lenbachhaus, Munich) is ambiguous in nature, representing either the burial of Jesus or the burial of Pierrot. While in Europe, Bloch continued to send drawings and articles to the *Mirror,* and enjoyed a solo exhibition of twenty-five paintings that originated at the Art Institute of Chicago and later traveled to the City Art Museum in St. Louis (1915).

Returning permanently to America in 1921, Bloch began his teaching career at the Chicago Academy of Fine Arts. In 1923, Bloch moved to Lawrence, Kansas where he accepted a position as professor at the University of Kansas (1923–47). As his painting style developed further, Bloch used deeper, more thickly painted colors and embraced bulky, materialized human forms that exist within realistic space for work that commented on the trials of the Great Depression and later the war years. Using these new techniques, Bloch painted *March of the Clowns* (1941, Jewish Museum, New York) (Color Plate 2), a canvas that shows Bloch's satiric tendencies at their finest. Both bleak and hopeful, yet also angry, *March of the Clowns* anticipates Hitler's defeat. Bloch depicts a large parade of clowns celebrating amid numerous spectators against a sky filled with a crescent moon, stars, and the Star of David. The focal point of the canvas is a foregrounded marching clown holding up a swastika-topped pole from which a tiny doll of Hitler hangs. To emphasize the foolishness of Hitler's quest, Bloch equates him

with the onlookers, which not only include clowns but also cartoon characters in the left foreground of the canvas—Popeye, Olive Oyl, Wimpy the hamburger man, and Krazy Kat, among others—who in their inanity endorse Hitler.

Although born a Jew, Bloch was not observant. In fact, while he never formally converted to Christianity, it appears that the Catholic atmosphere of St. Louis made a lasting impact on him. His multiple paintings and drawings delineating Jesus' life (more than fifty-six) were accompanied by a significantly lesser number of Old Testament subjects. Bloch also wrote poems that reflected the influence of Christianity. Despite Bloch's overt repudiation of Jewish themes and alliances, art historian Henry Adams argues that aspects of Bloch's life philosophy "suggest a strong connection, if only an unconscious one, to his Jewish background – his willingness to work as an outsider, his pursuit of the spiritual above all other goals, and his devotional attachment to a writer of Jewish background, Karl Kraus, whose writings and whose reverence for the word as a sacred thing seem connected to his Jewish heritage. . . . While outwardly Bloch rebelled against his Jewish background, in essential ways he remained true to its central spirit" (Adams, Conrads, and Hoberg, 48).

Bloch wrote about the arts and literature, and was dedicated to the translation and dissemination of the work of the German poet Karl Kraus. Bloch translated many of Kraus' poems in the late 1920s, culminating in the publication of some of his material in 1930. A poet himself, Bloch saw his own verse reach publication in the volume *Ventures in Verse: Selected Pieces* (1947). Sequestered in Kansas and away from the art scene in New York, Bloch fell into relative obscurity, in part because he closely guarded his privacy and also because he declined to submit his work to juries, a stance akin to his Blue Rider contemporaries. Bloch had been largely forgotten until 1997 when the Nelson-Atkins Museum in Kansas City, Missouri mounted a major exhibition of his work.

Bibliography

Adams, Henry, Margaret C. Conrads, and Annegret Hoberg, eds. *Albert Bloch: The American Blue Rider.* Munich: Prestel, 1997.

Baron, Frank, ed. *German Poetry in War and Peace: A Dual-Language Anthology.* With translations, paintings, and drawings by Albert Bloch. Lawrence, KS: Max Kade Center for German-American Studies, University of Kansas, 1995.

Baron, Frank, Helmut Arntzen, and David Cateforis, eds. *Albert Bloch: Artistic and Literary Perspectives - Künstlerische und Literarische Perspektiven.* Lawrence, KS: Max Kade Center for German-American Studies, University of Kansas; Munich: Prestel, 1997.

Bloch, Albert. *Ventures in Verse: Selected Pieces.* New York: Frederick Ungar, 1947.

Green, Richard C. "Albert Bloch, His Early Career: Munich and Der Blaue Reiter." *Pantheon: Internationale Zeitschrift für Kunst* 39 (1981): 70–76.

Kraus, Karl. *Poems: Authorized Translations from the German.* Translated by Albert Bloch. Boston: Four Seas Press, 1930.

Mohr, Werner. *Albert Bloch: Caricaturist, Social Critic, and Translator of Karl Kraus.* Riverside, CA: Ariadne Press, 2003.

Selected Public Collections

Art Institute of Chicago
Columbus Museum of Art, Ohio
Jewish Museum, New York
Krannert Art Museum, University of Illinois, Champaign
Nelson-Atkins Museum of Art, Kansas City, Missouri
Neuberger Museum of Art, Purchase, New York
San Diego Museum of Art
Whitney Museum of American Art, New York

Hyman Bloom (1913–), painter and draftsman.

Often painting works with Jewish themes in a colorful, expressionistic fashion, Hyman Bloom explores spirituality, life, and death in an art that often distorts reality for emotional and aesthetic effects. Born in Brunoviski, Latvia, Bloom and his Orthodox family moved to Boston in 1920, whereupon they changed their name from *Melamed* ("teacher" or "educator" in Hebrew) to the more American sounding Bloom. Bloom grew up in a small apartment where eight people lived in three rooms, kept the Sabbath, and spoke Yiddish. As a child Bloom read the Yiddish writer Isaac Bashevis Singer's stories aloud to his mother, stories that he remembered as being "too Jewish, too familiar, too descriptive of everyday life in a Jewish household" (Thompson, 22). Although raised as an Orthodox Jew, in the 1930s Bloom explored other avenues of spirituality. He attended meetings of the Psychical Research Society in Boston, the Order of the Portal, a group affiliated with Rosicrucianism (a nonsectarian brotherhood that claims various occult powers and focuses on the study of humanity and nature), and became interested in astrology and séances.

At the age of fourteen Bloom took drawing classes at Boston's Museum of Fine Arts and began studying art at a Jewish Community Center with Harold Zimmerman, who had already been mentoring **Jack Levine** for a year. Zimmerman taught both artists to work from their imaginations, a lesson that significantly impacted Bloom's future work. Bloom and Levine later studied art with Denman Waldo Ross of Harvard University who familiarized the pair with art history. This background in addition to travels to the recently opened Museum of Modern Art in New York provided Bloom with influential artistic precedents. In particular, Bloom was impressed by Chaim Soutine's painterly emotionalism and Georges Rouault's expressionistic religious mysticism.

Around 1933, Bloom started working as a Works Progress Administration (WPA) painter, and began sharing studio space with Levine (for three years). As a WPA artist Bloom painted impressions of Judaic rituals and synagogue interiors with thick pigment rendered in luminescent tones. This style first won him acclaim in 1942 when New York's Museum of Modern Art purchased *The Bride* (1941), a personification of the Sabbath bride, and *The Synagogue*

(c. 1940, Museum of Modern Art, New York) (Color Plate 3), of which Bloom created two versions.[9] The latter painting, which features an ecstatic worshipper holding the Torah while singing amid other congregants, inspired several additional works on this theme. Indeed, in the 1940s Bloom painted four paintings of Jews holding Torahs, including *Jew with Torah* (1940), *Rabbi* (c. 1942–44, private collection), *Older Jew with Torah* (1945, collection unknown), and *Younger Jew with Torah* (1942–44, Smith College Museum of Art, Northampton, Massachusetts). These canvases employ rich colors that blend the figure with the ritual object. In a 1995 preface to a catalog of Bloom's work, the artist **Leonard Baskin** suggested that these large rabbis clutch "their scrolls of the Torah against the universal disintegration of the diaspora" (7).[10] The artist himself recalls that as a child his mother explained to him that Jews must remain separate to survive (Thompson, 30).

Engaging his interests in color and light, and building on the luminescent chandeliers in *The Synagogue*, Bloom made several paintings from 1943 to 1945 based on the light fixtures in his Boston synagogue. These canvases show enlarged, glittering chandeliers dominating the canvas. In this period he also painted Christmas trees (1938–39 and 1945) indicating, as Holland Cutter notes, that it was a fragmented, glowing object as the subject of the works that interested Bloom rather than the source of the light itself (Ibid., 9).

By the mid-1940s Bloom began painting cadavers and body parts, influenced in part by his interest in Soutine's carcasses and seen on visits to a local hospital to view autopsies with **David Aronson**. Some scholars have interpreted these paintings, showing colorful, putrefying, at times life-size flesh in a painterly manner, as related to Holocaust preoccupations (Amishai-Maisels, 82; Baigell, *Jewish American Artists*, 32; Bloom, *Hyman Bloom*, 6; Bookbinder, 141; Freedberg, "Bloom," 52). While linking the corpses to the Shoah, on another occasion Matthew Baigell has also argued that however unconsciously, "the body parts can be considered symbols of the Jewish people in the Diaspora, passive, weak, fragmented, violated, literally incomplete" (*Jewish Artists in New York*, 154). As both Baskin and Baigell infer, the once traditional Bloom may be using his art to comment on the dissolution of religious Judaism in America.

For nearly ten years, beginning in the late 1950s, Bloom focused on honing his draftsmanship. While many of these drawings incorporated these explored in oil, including corpses and Jews holding the Torah, Bloom also explored his interest in landscape. In the 1980s Bloom painted in the traditional genre of still life, infusing these studio subjects with his characteristic interest in light and color. The 1990s found Bloom returning to the subject of Jews with Torahs, although these religious adherents have aged, much like the artist himself.

In a 1954 catalog accompanying an exhibition of Bloom's work, which showed at several venues, including the Institute of Contemporary Art in Boston and the Whitney Museum in New York, Frederick Wight observed that Bloom "is essentially a religious painter, his work stays with a few deep and persistent themes; the separate paintings are related as the psalms are related. The spectator is given a scene, but what Bloom has chosen for subject is not visible. It is progressively his self-awareness, his Jewish identity; it is

childhood, birth, the mystery of origins; and in a more recent series of canvases, it is mortality. In short, he has painted a testament, at times recognizably an Old Testament" (Wight, 2).

The Jewish elements of Bloom's work have not always been appreciated. In a 1955 review the critic Hilton Kramer criticized Bloom's "Jewish pictures": "To the 'foreign' eye, which brings no associations to it, it must be as absorbing as a kosher dinner–a matter of taste. But for the observer who has associations with this imagery from childhood onwards, Bloom's Jewish paintings stimulate the same surprise and dismay one feels at finding *gefilte* fish at a cocktail party. It's a bit too stylish to be palatable" (586). Sydney Freedberg more empathetically described the influences on Bloom's work: "Bloom's art is more than American...more than with most Americans his heritage of Europe is close and perceptible....Bloom's personality and his art make a bridge between two worlds" (*Perspectives*, 54).

Bibliography

Amishai-Maisels, Ziva. *Depiction and Interpretation: The Influence of the Holocaust on the Visual Arts.* New York: Pergamon Press, 1993.

Baigell, Matthew. *Jewish American Artists and the Holocaust.* New Brunswick, NJ: Rutgers University Press, 1997.

———. *Jewish Artists in New York: The Holocaust Years.* New Brunswick, NJ: Rutgers University Press, 2002.

Bloom, Hyman. *The Drawings of Hyman Bloom.* Storrs: University of Connecticut, 1968.

———. *Hyman Bloom: Paintings and Drawings.* With essays by Holland Cotter and Dorothy Abbott Thompson. Durham, NH: University of New Hampshire, 1992.

Bookbinder, Judith. *Boston Modern: Figurative Expressionism as Alternative Modernism.* Durham, NH: University of New Hampshire Press; Hanover: University Press of New England, 2005.

Dervaux, Isabelle. *Color and Ecstasy: The Art of Hyman Bloom.* New York: National Academy of Design, 2002.

Freedberg, Sydney J. "Bloom: Macabre Anatomy." *ARTnews* 47, no. 10 (February 1949): 52.

Freedberg, Sydney. "Hyman Bloom: The Career to Date of a Major Modern Painter." *Perspectives USA* 6 (Winter 1954): 45–54.

Kramer, Hilton. "Bloom and Levine: The Hazards of Modern Painting." *Commentary* 19, no. 6 (June 1955): 583–587.

Thompson, Dorothy Abbott. *Hyman Bloom.* Preface by Leonard Baskin; Introduction by Holland Cotter. New York: Chameleon Books, Inc., 1996.

Wight, Frederick. *Hyman Bloom.* Boston, MA: Institute of Contemporary Art, 1954.

Selected Public Collections

Art Institute of Chicago
Hirshhorn Museum and Sculpture Garden, Washington, D.C.
Los Angeles County Museum of Art
Museum of Fine Arts, Boston
Museum of Modern Art, New York
Rose Art Museum, Brandeis University, Waltham, Massachusetts

Skirball Museum, Hebrew Union College, Los Angeles
Whitney Museum of American Art, New York

Peter Blume (1906–92), painter and sculptor.

A critically neglected artist who has been alternately described as a Precision-
ist, a Purist, and a Surrealist, the Russian-born Peter Blume delineated his
artistic philosophy in 1934: "[The artist] should devote himself to the cause of
purity and precision and to the construction of a vast, impersonal technical
machinery that would become, some day, the perfect vehicle for expression"
("After Superrealism," 339).

Blume immigrated to Brooklyn, New York in 1911 with his family. Beginning
at age thirteen he studied art at several venues, most notably at the Educa-
tional Alliance (1921–24) after the National Academy of Design rejected him
for refusing to take a cast-drawing class. Blume's early work was shown at
the Daniel Gallery, one of the most progressive venues in New York, which
also at times represented the art of **Abraham Walkowitz** and **William Zorach**.
His imagery from this period, mostly landscapes such as *New England Barn*
(1926, Whitney Museum of American Art, New York) and still lifes such
as *Cyclamen* (1925, Columbus Museum of Art, Ohio), is defined by sharply
delineated Purist lines and forms.

Typically, Blume's highly stylized work combines fantasy elements with
depictions of modern life. In *South of Scranton* (1931, Metropolitan Museum of
Art, New York), he employed a precise, miniature, fifteenth-century technique
to create a twentieth-century image of German soldiers exercising on the
deck of a ship amid the quaint town of Charleston, South Carolina. Merging
Surrealist imaginings with recollections of a scene he saw during a road trip,
the idiosyncratic painting—his largest to date (56¼ × 66¾ inches)—won
first prize at the 1934 Carnegie International Exhibition, making the twenty-
eight-year-old Blume the youngest painter to have earned this distinction.

Visits to Italy in the 1930s funded by Guggenheim grants in 1932 and 1936
inspired his best-known painting: a large antifascist canvas titled *The Eternal
City* (1934–37, Museum of Modern Art, New York) (see figure). First conceived
in sketches and then a cartoon, Blume portrayed a ruby-lipped Mussolini as an
enormous green jack-in-the-box amid the ruins of the Roman Forum. Blume's
conception of Mussolini was instigated by a papier-maché rendering of
the leader that protruded from a wall at the Decennial Exposition in Rome
celebrating ten years of fascism (Parker, 75). The painting was one of the
artist's first to explore one of two recurring themes, described by biographer
Frank Anderson Trapp as "the vision of decay or utter destruction or else of
inanimate nature as contrasted with new life" (9). The crisply rendered *The
Eternal City* garnered mixed reviews because of its controversial, propagandis-
tic subject and the painting's cacophonous colors; the Corcoran Gallery
even excluded the painting from its 1939 biennial exhibition (five years later

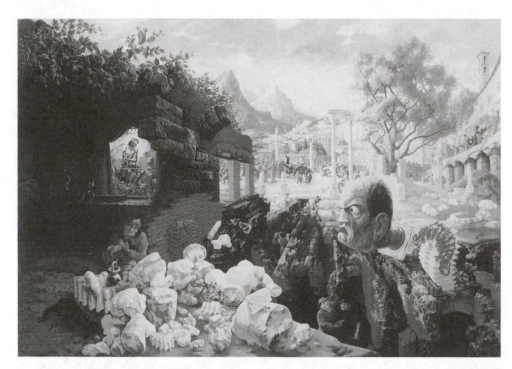

Peter Blume, *The Eternal City,* 1934–37. Dated on painting 1937. Oil on composition board, 34 × 47⅞ inches. The Museum of Modern Art, New York. Mrs. Simon Guggenheim Fund (574.1942). Digital Image © The Museum of Modern Art/Licensed by SCALA/Art Resource, NY. Art © The Educational Alliance, Inc./Estate of Peter Blume/Licensed by VAGA, New York, New York.

the Museum of Modern Art purchased the painting for its permanent collection). Blume explained that the jarring hues of the composition were necessary to express the painting's ideology: "A lot of people felt the head was a violation of the harmonies of the rest of the picture, but heavens that's what the picture is about. How else can you say this? You can't say it sweetly and harmoniously, you have to say it with some punch" (Brown, 11).

During the late 1930s Blume produced several works under the auspices of the Public Works of Art Project and the Works Progress Administration, including the boldly colored murals *Barns* (1937), *Vineyard* (1942), and *Two Rivers* (1942) for post offices in Cannonsburg, Pennsylvania; Geneva, New York; and Rome, Georgia, respectively. His paintings showed widely during the Great Depression in venues such as the Museum of Modern Art in New York and at an exhibition sponsored by the World Alliance for Yiddish Culture (YKUF).

Although uninterested in subjects of a religious Jewish nature, Blume did explore Christian imagery on several occasions. For example, following a 1949 trip to Mexico Blume painted *The Shrine* (1950, private collection), *Crucifixion* (1951, Maier Museum of Art, Randolph-Macon Woman's College, Lynchburg, Virginia), and *Man of Sorrow* (1951, Whitney Museum of American Art, New York) in an effort to convey, using the artist's words, "the Mexican

conception of Christ," which is influenced by the fact that the Mexicans have "been brutalized in a way that the Italians never have" (Trapp, 84). Accordingly, Blume shows a battered, emaciated Jesus overwrought by a weighty cross and wearing an enlarged crown of thorns in the two canvases from 1951.

Blume briefly changed mediums in the early 1970s when he produced a sculpture series titled *Bronzes About Venus*. Comprised of twenty-seven sculptures on the theme of the goddess of beauty and pleasure, ten large and seventeen smaller pieces were initially modeled in wax and then cast in bronze. In a 1983 oral interview Blume described his artistic philosophy, especially in relation to the prominent abstraction of his time: "My purpose as far as my life is concerned and what there is left of it, is to perpetuate a meaning which belongs to humanity, and even narrative" (Brown, 13).

Bibliography

Blume, Peter. "After Superrealism." *The New Republic* 80 (October 31, 1934): 338–340.

———. *Peter Blume in Retrospect, 1925 to 1964: Paintings and Drawings*. Manchester, NH: Currier Gallery of Art, 1964.

———. *Peter Blume: A Retrospective Exhibition*. Chicago: Museum of Contemporary Art, 1976.

Brown, Robert F. "Interview with Peter Blume." *Archives of American Art Journal* 32, no. 3 (1992): 2–13.

Davidson, Abraham A. *The Eccentrics and Other Visionary Painters*. New York: E.P. Dutton, 1978.

Fort, Ilene Susan. "American Social Surrealism." *Archives of American Art Journal* 22, no. 3 (1982): 8–20.

Parker, Donald G. and Warren Herendeen. "An Interview with Peter Blume." *The Visionary Company: A Magazine of the Twenties* 1, no. 1 (Summer 1981): 56–76.

Soby, James Thrall. "Peter Blume's Eternal City." *Bulletin of the Museum of Modern Art* 10 (April 1943): 2–6.

Trapp, Frank Anderson. *Peter Blume*. New York: Rizzoli International Publications, Inc., 1987.

White, Mark Andrew. "Slicing and Dionysian: Peter Blume's *Vegetable Dinner*." *American Art* 14, no. 1 (Spring 2000): 80–91.

Whiting, Cécile. *Antifascism in American Art*. New Haven: Yale University Press, 1989.

Selected Public Collections

Art Institute of Chicago
Cleveland Museum of Art
Metropolitan Museum of Art, New York
Museum of Fine Arts, Boston
Museum of Modern Art, New York
Sheldon Memorial Art Gallery, Lincoln, Nebraska
Smithsonian American Art Museum, Washington, D.C.
Whitney Museum of American Art, New York

Ilya Bolotowsky (1907–81), painter and sculptor.

Known for his nonobjective imagery influenced by the Dutch de Stijl movement, Ilya Bolotowsky was among the first artists in America to paint fully abstractly. Privileging color and rational, geometric forms above all else, Bolotowsky employed art idealistically, aiming through a controlled art to find equilibrium in his paintings, sculptures, and murals. This desire for order partly relates to Bolotowsky's childhood challenges in St. Petersburg, Russia. As he explained: "After I went through a lot of violent upheavals in my early life, I came to prefer a search for ideal harmony and order which is still a free order, not militaristic, not symmetrical, not goose-stepping, not academic" (Bolotowsky, *Ilya Bolotowsky*, 32). Further, Bolotowsky reflected in 1969, "Nowadays, when paintings torture the retina, when music gradually destroys the eardrum, there must, all the more, be a need for an art that searches for new ways to achieve harmony and equilibrium" (Bolotowsky, "On Neoplasticism," 230).

Interested in art at a young age, Bolotowsky was drawing portraits and landscapes at five years old. At sixteen, Bolotowsky arrived in New York City (September 1923) via Constantinople, where his family had lived for two and a half years. He received some art training in Europe, followed by more extensive instruction at the National Academy of Design (1924–30) in New York. Dissatisfied with the traditional mode of instruction he received at the National Academy, Bolotowsky rebelled by adopting a modified Impressionist manner. Although he saw avant-garde works by Pablo Picasso, Vincent Van Gogh, and others during a 1932 trip in Europe for ten months (as well as some in America before he traveled abroad), he did not begin to explore abstraction until 1933, after he encountered the Neoplastic (or De Stijl) canvases of Piet Mondrian in New York. Following his initial reaction, which he described as "shock and even anger," Bolotowsky first explored Surrealist biomorphism (Ibid., 221), inspired by a Joan Miró exhibition he viewed soon after encountering Mondrian. By the 1940s, though, Bolotowsky favored Mondrian's example of tensions of pure color and simplified form in vertical and horizontal arrangements, a style he retained for the rest of his life.

He cofounded The Ten in 1935, a group of artists that included **Mark Rothko** and **Ben-Zion**. Committed to overthrowing the Whitney Museum's hegemony and promulgation of representational art of the American scene, the group exhibited together until 1939. Bolotowsky also cofounded the American Abstract Artists group in January 1937, an organization of painters and sculptors—including **Ibram Lassaw**—who collectively showed their art and advocated the ideals of abstraction to museums and a public reluctant to accept avant-garde work. Although he did not paint obvious Jewish subjects, Bolotowsky showed an abstract canvas at the first exhibition of the World Alliance for Yiddish Culture in 1938.

Hired by the government's Public Works of Art Project in 1934, Bolotowsky made realistic easel paintings of New York life. Later, as a Works Progress Administration (WPA) artist, Bolotowsky created one of the first abstract

murals, a largely biomorphic conception for the Williamsburg Housing Project in Brooklyn (1936–37). Another government-sponsored abstract mural followed, also primarily biomorphic, located in the Health Building in the Hall of Medical Science at the 1939 World's Fair in New York. His fifty-foot long mural for the Hospital for Chronic Diseases on Welfare Island (1939–40) in New York is an example of the evolution of Bolotowsky's style; biomorphic elements have been removed as the artist adopted a more Suprematist manner. Bolotowsky viewed his interest in mural making as related to his Neoplastic style, to use his words: "A Neoplastic style can be very helpful in designing murals that serve to improve the proportions of wall and rooms" (Bolotowsky, "On Neoplasticism," 228–229). For instance, although the mural for the Hospital for Chronic Diseases was not Neoplastic in conception, it was influenced by the style's ideology; designed for a circular room that patients' had earlier described as claustrophobic, after the geometric mural was completed, Bolotowsky reported, patients characterized the room as more open. Bolotowsky concluded that, "this leads me to believe in the correctness of Mondrian's idea that the 'freest' relationship is the one based on the right angle" (Ibid., 229). Years after the WPA, Bolotowsky executed several additional murals at such venues as Southampton College in New York (1968), North Central Bronx Hospital (1973), and the Social Securities Service Building in Chicago (1978).

While serving in the United States Army Air Corps (1943–45) as a translator stationed in Nome, Alaska during World War II, Bolotowsky compiled a Russian-English military dictionary. After the war Bolotowsky taught at various American universities, notably two years (1946–48) in Black Mountain College's well-known art program in North Carolina, followed by teaching stints at the University of Wyoming (1948–57), State Teacher's College in New Paltz, New York (1957–65), and the University of Wisconsin in Whitewater (1965–71). He also had his first one-person show in 1946 at New York's J.B. Neumann's New Art Circle Gallery. From 1947, Bolotowsky often used shaped canvases, diamond- and tondo-shaped, for example—at which time he also banned the diagonal from his art. Typical of his work is *Scarlet Diamond* (1981, Brauer Museum of Art, Valparaiso University, Indiana) (see figure), a geometric abstraction delineated on a triangular canvas balanced with ordered lines and painted with the primary colors of red, blue, and yellow.

Although he made some abstract stone carvings and a few relief constructions before World War II, such as *Construction* (1939, Grey Art Gallery, New York University) composed of angular and curved painted wood, Bolotowsky did not pursue three-dimensions in earnest until 1961. His sculptures, or columns as Bolotowsky preferred to call them, were a natural outgrowth of his interest in the architectonic forms of Neoplasticism. *Trylon: Blue, Yellow and Red* (1967, Hirshhorn Museum and Sculpture Garden, Washington, D.C.) stands just over ninety-six inches tall on its base. Like *Scarlet Diamond*, the thin wood construction is painted with minimal color and with the strictest of geometric means.

Bolotowsky made experimental films, including *Metanoia*, which won first prize in 1963 at the Midwest Film Festival at the University of Chicago; published articles about his work; and compiled the *Russian-English Dictionary of*

Ilya Bolotowsky, *Scarlet Diamond,* 1981. Acrylic on canvas, 26 × 26 inches. University Fund Purchase, Brauer Museum of Art, 81.05. Valparaiso University, Indiana © Brauer Museum of Art. Art © Estate of Ilya Bolotowsky/Licensed by VAGA, New York, New York.

Painting and Sculpture (1962). In 1974 he had a major retrospective at the Guggenheim. When asked his feelings about religion, Bolotowsky replied: "I'm an agnostic. I like Plato's ideas of the absolute, of the existence of the absolute someplace–whether this absolute has independent being [*sic*] or is a product of the human mind. According to Plato, you know, all these ideas are real. Not, of course, as physical existence, but they form a real, abstract world–the absolute" (Bolotowsky, *Ilya Bolotowsky,* 31).

Bibliography

Bolotowsky, Ilya. "On Neoplasticism and My Own Work: A Memoir." *Leonardo* 2, no. 3 (July–August 1969): 221–230.

———. *Ilya Bolotowsky: Paintings and Columns.* Albuquerque: University Art Museum, 1970.

———. *Ilya Bolotowsky.* Including an interview with the artist. New York: Solomon R. Guggenheim Foundation, 1974.

Cummings, Paul. "Adventures with Bolotowsky." *Archives of American Art Journal* 22, no. 1 (1982): 8–31.

Dervaux, Isabelle. *The Ten: Birth of the American Avant-Garde.* Boston, MA: Mercury Gallery, 1999.

Larsen, Susan Carol. "Going Abstract in the '30s: Interview with Ilya Bolotowsky." *Art in America* 64, no. 5 (September–October 1976): 70–79.

Mecklenburg, Virginia M. *The Patricia and Phillip Frost Collection: American Abstraction, 1930-1945.* Washington, D.C.: Smithsonian Institution Press for the National Museum of American Art, 1989.

Selected Public Collections

Albright-Knox Art Gallery, Buffalo, New York
Hirshhorn Museum and Sculpture Garden, Washington, D.C.
Metropolitan Museum of Art, New York
North Carolina Museum of Art, Raleigh
Philadelphia Museum of Art
San Francisco Museum of Modern Art
Smithsonian American Art Museum, Washington, D.C.
Whitney Museum of American Art, New York

Jonathan Borofsky (1942–), draftsman, sculptor, printmaker, painter, and conceptual artist.

An artist with a diverse body of work in several different media, Jonathan Borofsky's highly personal art employs recurring imagery in both two- and three-dimensional forms. Collaborating with workshops, personal assistants, and others, Borofsky's repertoire ranges from conventional lithographs to gallery environments complete with audio accompaniment to an hour-long video documentary titled *Prisoners* (1985), for which the artist interviewed thirty men and women in California prisons.

Born in Boston to an architect-painter mother and musician father, Borofsky's parents were supportive of his artistic interests. Indeed, they arranged for their son's private art lessons with Albert Alcay, a Holocaust survivor, when Borofsky was eight years old. Early questions about the number tattooed on Alcay's arm would later influence some of Borofsky's subject matter, and even more, his obsessive interest in counting.

Borofsky received a B.F.A. from Carnegie Mellon University (1964) and an M.F.A. from Yale University's School of Art and Architecture (1966), where he studied painting and sculpture. After moving to New York in 1966, Borofsky explored the more cerebral dimensions of art by creating very little and instead writing down his thoughts. In 1969 he started to write numbers on both sides of paper for up to three hours a day, with the goal of counting toward infinity and to focus his thoughts as a type of meditation. At a solo exhibition at the Paula Cooper Gallery (1975), Borofsky exhibited his most conceptual project: *Counting,* a thirty-four-inch stack of 8½ × 11-pages numbered from 1 to 2,346,502. What began as a pile of numbered paper ultimately evolved into an ongoing project that continues to the present time; instead of a traditional signature, Borofsky numbers all of his creations sequentially. In addition to functioning as his signature, the numbers can be read as coded references to the tattoos of Holocaust inmates. In an important full-length text on Borofsky, Mark Rosenthal observes: "He initially used numbers to balance the lunacy he found in himself and society. Counting was meditation and peace. But numbers were used to brand Jews, which ultimately confounds any notion of them as benign. In the Nazis' hands, numbers became a weapon" (21).

Moving beyond the rational activity of counting, dreams became Borofsky's source material in 1973, when he started recording text and image drawings of his nighttime reveries on scraps of paper and in a notebook that he would later translate to more public media and venues. The dream imagery often includes habitual figures such as the Hammering Man, Man with a Briefcase, and the Running Man. His multimedia site-specific installations employ myriad representations of these figures and additional signature subjects, presented as drawings on paper, wall drawings (Borofsky began to draw on walls at **Sol LeWitt**'s suggestion in 1974), sculptures, and paintings. First appearing around 1973, the anxiety-ridden Running Man serves, at times, as a surrogate self-portrait. Running Man has appeared in multiple venues and in several different media; among the most interesting running men was a version painted on the Berlin Wall (1982). Borofsky's 1977 drawing *Hitler Dream* (no. 2,454,568), subsequently drawn on a wall at the Paula Cooper Gallery in 1979 (no. 2,566,499) (see figure), shows a Running Man being chased by one of Hitler's soldiers accompanied by text that begins "I dreamed that some Hitler-type person was not allowing everyone to roller-skate in public places." Since this early overt reference to the Holocaust, Borofsky has readily identified as Jewish and often uses the Holocaust as a subject.

Hammering Man, a figure representing the worker, first appeared in 1979 at an installation at the Paula Cooper Gallery. That eleven-foot tall painted plywood figure with a motorized hammering arm has subsequently been dwarfed by outdoor aluminum hammering men in various venues, including a seventy-foot version in Frankfurt, Germany. In opposition to the average worker metaphorically represented by Hammering Man, the Man with a Briefcase—patterned after a newspaper ad for men's business suits—symbolizes the corporate figure. Initially appearing in a 1981 installation, the Man with a Briefcase also has autobiographical associations. As Borofsky explained: "I see myself as partly everyperson and vice versa. Therefore, no matter how personal I get about myself, my work is going to have meaning for somebody else. It has archetypal relevance. So, this figure is me too–the traveling salesman who goes around the world with his briefcase full of images and thoughts. The briefcase has always been a metaphor for my brain" (Rosenthal, 176).

In 1997 Borofsky supervised The GOD Project at Brandeis University's Rose Art Museum. During a ten-day residency, Borofsky invited students to express their feelings about spirituality and God in visual form. Borofsky guided the students in the manner he approaches his own art. As he explained the site-specific project before the students arrived at the museum: "Students might come with a pre-planned idea or even a rough pencil sketch, or they might arrive without any ideas at all. A painting might be completed in 10 minutes or it might take several hours each evening. Depending on the individual, ideas about GOD might be painted in a realistic manner, as an abstract form, a symbol, a word or a series of words, a poem, a shape, or even just a color. Whatever a student thinks and feels that he or she wants to paint, I will be in the museum to show them how to use the materials and how to realize their own painting" (Borofsky, *The GOD Project*, 3). Borofsky's sculpture

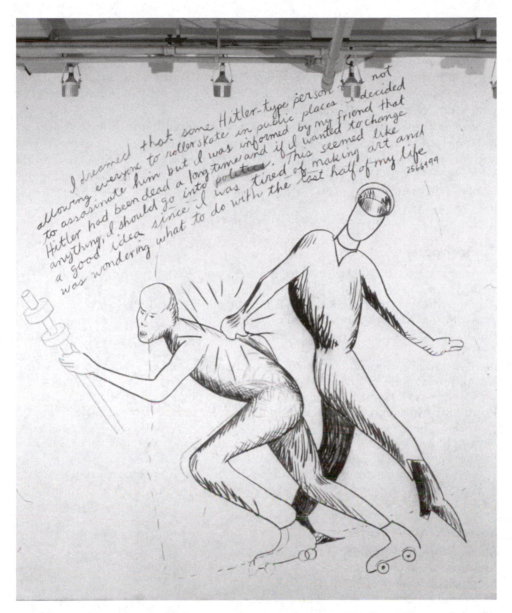

Jonathan Borofsky, *I dreamed that some Hitler-type person was not allowing everyone to roller skate in public places...at 2,566,499,* 1979. Ink on wall, 127 × 144 inches. Paula Cooper Gallery, New York, 1979. Photograph courtesy Paula Cooper Gallery, New York.

was featured in the installation along with the students' work; he contributed two 12-foot, 4-inch fiberglass figures that stood on opposite ends of the gallery. Each titled *Man with Heart,* the men had open cavities in the center of their chests filled in with an electric red light accompanied by the artist's audiotaped heartbeat.

Borofsky's engagement in projects that relate to his Jewish background do not emerge from a religious perspective. As the artist explains: "I'm not a fan

of any organized religion that separates itself out from other religions or peoples. As far as I'm concerned, all of us on the planet are connected together and that is the feeling (or religion) that I carry inside me" (E-mail correspondence). In answer to the question "What, if anything, do you consider Jewish about your art?" Borofsky again provides a universalist response: "Nothing, and everything" (Ibid.).

Solo exhibitions featuring Borofsky's work have been mounted at both national and international venues, including the Israel Museum (1984) and the Boston Museum of Fine Arts (2000). From 1969 to 1977 Borofsky taught at the School of Visual Arts in New York. In 1976 he moved to Los Angeles to teach at the California Institute of the Arts (1977–80). His homepage is www.borofsky.com.

Bibliography

Amishai-Maisels, Ziva. *Depiction and Interpretation: The Influence of the Holocaust on the Visual Arts.* New York: Pergamon Press, 1993.

Auping, Michael. *Drawing Rooms: Jonathan Borofsky, Sol LeWitt, Richard Serra.* Fort Worth, TX: Modern Art Museum of Fort Worth, 1994.

Borofsky, Jonathan. *The GOD Project.* Waltham, MA: Rose Art Museum, 1997.

———. E-mail correspondence with the author. December 16, 2005.

Cuno, James. *Subject(s): Prints and Multiples by Jonathan Borofsky, 1982-1991.* Hanover, NH: Hood Museum of Art, 1992.

Rosenthal, Mark and Richard Marshall. *Jonathan Borofsky.* New York: Harry N. Abrams, Inc., 1984.

Simon, Joan. "An Interview with Jonathan Borofsky." *Art in America* 69, no. 9 (November 1981): 156–167.

———. *Jonathan Borofsky: Dreams, 1973-81.* London: Institute of Contemporary Arts, 1981.

Selected Public Collections

Museum of Contemporary Art, Los Angeles
Museum of Fine Arts, Boston
Museum of Modern Art, New York
Philadelphia Museum of Art, Pennsylvania
San Francisco Museum of Modern Art
Tate Gallery, London
Walker Art Center, Minneapolis
Whitney Museum of American Art, New York

C

Alice Lok Cahana (1929–), painter and printmaker.

A Holocaust survivor who spent a year and a half in concentration and labor camps (1944–45), Alice Lok Cahana explains that she makes paintings to memorialize the Holocaust: "I feel that the survival and the rekindling of the Jewish spirit after the Holocaust should be remembered in the way we remember Passover: from generation to generation. My work cannot end with the Holocaust, but with the images of freedom and hope. With the survival of the human spirit" (Rose, 39). Indeed, Nancy Berman, director of the Skirball Museum, observes that Cahana's paintings "document tragic human events in a way which affirms life and transcends the specific horrors of the history she conveys" (Ibid., 9). Cahana also explains that she paints "about the Holocaust [because] it is my experience. I tell my story so that we can build bridges of understanding and avoid its occurrence in any shape and form to any people" (Written correspondence).

Born in Budapest, Hungary, Cahana was raised in the town of Sárvár by wealthy, Orthodox parents who owned a textile factory. At fifteen years old she was transported to Auschwitz with most of her family; her father escaped to Budapest with the aid of Raoul Wallenberg, a figure featured in several of Cahana's canvases. Many of Cahana's family members died in the Nazi camps, including her mother, grandfather, two brothers, and a sister. Cahana was in Bergen-Belsen at the liberation and was soon transported to a military hospital in Sweden.

While recuperating in Sweden, Cahana received notice that her father had also survived, and they were later reunited in Hungary. Living peripatetically, Cahana met her husband, an Orthodox rabbi, in Israel. The couple returned to Sweden and then immigrated to America in 1957. Although she took some art classes while living in Sweden (1952–57), after she moved to Houston in 1959, Cahana began to study art in earnest at the University of Houston (1962–66) and later at Rice University (1969–77). Initially, Cahana's work bore the influence of **Morris Louis**'s color field abstractions, and also was affected by **Mark Rothko** and **Helen Frankenthaler**. Cahana's attraction to abstraction was twofold: she enjoyed Louis' "mystical" qualities (Rose, 32), and she perceived abstraction as a style "about America, freedom, new-ness. It was democratic. There are no divisions or hierarchies in the abstract color painting [sic], just as there are no hierarchies in America, one religion is not

better than another" (Balakian, 13). Certainly an understandable reaction from a recent immigrant who had survived the Holocaust, and thus Cahana adopted this "democratic" mode, layering color on her canvases in the dominant style of that time.

A return visit to Sárvár in 1978 was an important turning point for Cahana. Deeply moved by the erasure of the Jewish community and disturbed that no one in her hometown remembered her mother, Cahana decided to memorialize the Holocaust and with her art pay tribute to those who died. For the next three years, Cahana worked on a series of paintings inspired by the book *I Never Saw Another Butterfly,* an anthology of poems and pictures by children in the Czechoslovakian concentration camp Theresienstadt. While simultaneously writing her own poems about the Holocaust, Cahana created collages incorporating fragments of poems from *I Never Saw Another Butterfly.* The top register of Cahana's collage *I Still Believe* (1978–79) includes the text of a 1944 poem by child inmate Hans Hachenberg that reads: "But anyway I still believe I only sleep today, That I'll wake up a child again and start to laugh and play." On the lower half of the dark canvas, Cahana painted a shape that recalls a nursery rhyme shoe as a metaphor for the home, a place where one finds security. The painting is meant to evoke the ever-present hope of children in the face of enormous adversity.

Cahana's "1940-1944" paintings comprise a series of canvases about Raoul Wallenberg, the Gentile Swedish diplomat who rescued an estimated 20,000 Hungarian Jews during the Holocaust. Partly influenced by Robert Rauschenberg's combine paintings, Cahana's *Where are Our Brothers the Strong Free Men? Silence was the Answer of the Free Man* (1980s, collection of the artist) (see figure) is a large (80 × 92 inches) acrylic and mixed-media image with a photograph of Wallenberg at the center. On the right side are photocopies of four Swedish passports, akin to those provided by Wallenberg to assist Hungarian Jews. These primary documents are meant, in part, to provide proof that the Holocaust occurred. Around the rest of the border are copies of archival photographs that show the dispersion of Jews and the havoc wrought by the Nazis. These border images are framed by black grids that recall the barbed wire fences in the camps. Cahana's use of heavily applied reds, suggesting blood, and grays, implying the smoke from ovens in the death camps, contributes to the atmosphere of tragedy. At the same time, the painting celebrates the triumph of righteousness by presenting Wallenberg at the center of the image. In other works from this series, Cahana uses more autobiographical elements, such as a picture of herself as a student at a Jewish school in Sárvár before the Nazis destroyed her peaceful childhood world, and also Hebrew letters and text from the Talmud. Recalling **Leon Golub**'s technique of brutalizing his canvases, some of the surfaces of Cahana's paintings—such as *Gmara II* (1982, collection of the artist)—are heavily worked over, even burned as a metaphor for the destruction of human life in the camps.

In the late 1990s, several of Cahana's paintings hung at university museums throughout the United States, including Colgate University (1998). Cahana was featured in *The Last Days* (1998), an Academy Award winning

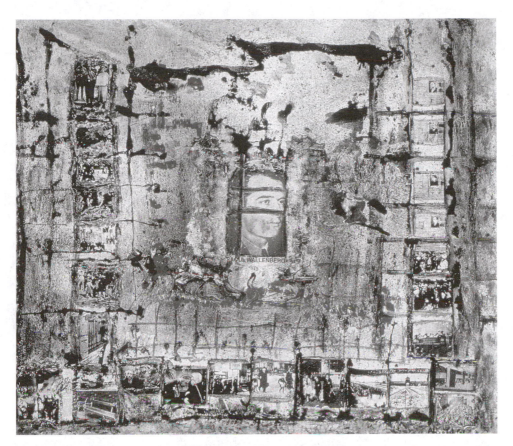

Alice Lok Cahana, *Where are Our Brothers the Strong Free Men? Silence was the Answer of the Free Man,* 1980s. Acrylic, mixed-media, and collage on canvas, 80 × 84 inches. Collection of the artist. Photo courtesy of the artist.

documentary about five Hungarian Holocaust survivors. More recently, Cahana has explored her memories and emotions about Judaism, in addition to the Holocaust, on canvases that she folds and rolls into the form of scrolls. She decorates the canvases with semiprecious stones, and paints them with abstract and representational elements, including Hebrew lettering.

Bibliography

Baigell, Matthew. *Jewish-American Artists and the Holocaust.* New Brunswick, NJ: Rutgers University Press, 1997.

Balakian, Peter. *Art Out of Atrocity: Works by Alice Lok Cahana and Robert Barsamian.* Hamilton, NY: The Picker Art Gallery, Colgate University, 1998.

Cahana, Alice Lok. Written correspondence with the author. April 4, 2006.

Halverson, Megan. ''Of War and Remembrance.'' *ARTnews* 98, no. 9 (October 1999): 132, 134.

Moll, James, dir. *The Last Days.* Steven Spielberg and the Shoah Foundation. New York: PolyGram Video, 1998 (87-minute videocassette).

Rose, Barbara. *From Ashes to the Rainbow: A Tribute to Raoul Wallenberg, Works by Alice Lok Cahana.* With an interview with Alice Lok Cahana. Los Angeles: Hebrew Union College Skirball Museum, 1986.
Soltes, Ori Z. *Fixing the World: Jewish American Painters in the Twentieth Century.* Hanover, NH: Brandeis University Press, 2003.

Selected Public Collections

Florida Holocaust Museum, St. Petersburg
Holocaust Museum Houston, Texas
Skirball Museum, Hebrew Union College, Cincinnati
United States Holocaust Memorial Museum, Washington, D.C.
Yad Vashem, Jerusalem

Solomon Nunes Carvalho (1815–97), photographer and painter.

One of a small number of known nineteenth-century Jewish American artists, Solomon Nunes Carvalho's work has been the subject of interest in the past few decades as attempts have been made to reconstruct his oeuvre. Born in Charleston, South Carolina to a Sephardic family active in religious activities—his father David Carvalho was one of the founders of the Reformed Society of Israelites, the first reform congregation in the United States—Carvalho lived a life in which he enjoyed the freedoms of democracy while retaining and propagating his religiocultural heritage. Residing at various times in Baltimore, Charleston, Philadelphia, Washington, D.C., and New York, the peripatetic and multitalented Carvalho made art, wrote books, and successfully patented two inventions, one of which was awarded the Medal of Excellence by the American Institute of New York.

Based on similarities in the artists' painting style, technique, and subject matter, it has been surmised that the well-known portraitist Thomas Sully may have trained Carvalho (Berman, 68–71; Sturhahn, 11). Carvalho's earliest extant work, a detailed portrait of the interior of the Beth Elohim synagogue in Charleston—painted from memory as the original structure burned down earlier that year—dates from 1838 (Beth Elohim Congregation Collection, Charleston, South Carolina). At twenty-five years old, Carvalho painted *Child with Rabbits* (c. 1840, private collection), a sentimental image of a chubby, angelic boy surrounded by a mother rabbit and her bunnies reproduced on United States currency. After the invention of daguerreotype photographs in 1839, Carvalho learned the process. During the 1940s and 1950s, Carvalho produced portraits, in oil and as daguerreotypes; some biblical paintings, such as a colorful, theatrical rendition of *Moses and the Battle of the Amalekites* (c. 1852, private collection); and at least one still life.

During the winter of 1853–54, Carvalho served as the official photographer of an exploratory expedition across the United States. The survey, the fifth led by Colonel John Charles Frémont, aimed to map out a transcontinental railway route between the Mississippi River and the Pacific Coast. In a letter

to the publisher of the *Photographic and Fine Art Journal*, Carvalho recounted the adverse conditions under which he made the pictures: "I succeeded beyond my utmost expectations in producing good results and effects by the Daguerreotype process, on the summits of the highest peaks of the Rocky Mountains, with the thermometer at times from 20° to 30° below zero, often standing to my waist in snow, buffing, coating, and merculializing [*sic*] plates in the open air....Notwithstanding the earnest prognostications of yourself and my professional friends, both in New York and in Philadelphia, that under the difficulties I was likely to encounter on the snow capped mountains,—I would fail, I am happy to state that I found no such word in my vocabulary" (124–125). Unfortunately, Carvalho's photographs and sketches of the trip were probably lost in an 1881 fire, although it is possible that a single, badly damaged picture survived and is presently located at the Library of Congress (Shlaer, "An Expeditionary Daguerrotype," 151; Sturhahn, 85). Important written evidence does exist; Carvalho's account of the expedition and the only record of the trip, *Incidents of Travel and Adventure in the Far West with Colonel Fremont's Last Expedition,* has been reprinted on several occasions, including four printings before 1860. First published in 1856, the volume discusses the rigors and the discoveries of the journey while also providing personal reflections and commentary, although Carvalho does not overtly discuss his Jewish background. For example, Carvalho refrains from explicitly referencing the laws of Kashrut, but noted that he refrained from eating meat until desperation drove him to partake "of the strange and forbidden food with much hesitation, and only in small quantities" (113). Falling ill, Carvalho remained in Utah while the expedition continued on to Los Angeles. Upon his recovery, Carvalho spent four months in Salt Lake City, where he painted several portraits of Mormons, including Brigham Young (c. 1854, Church of Jesus Christ of Latter Day Saints, Salt Lake City).

Inspired by the vast expanses of land that he saw while on the expedition, Carvalho began painting landscapes after his return to New York. Likely composed from sketches made while traveling with Frémont, *Western Landscape* (c. 1860, Oakland Museum, California) shows a panoramic view of a river and a large canyon capped by an ominous sky. In *Incidents of Travel and Adventure in the Far West*, Carvalho described his emotional response to landscape as a connection with God:

> After three hours' hard toil we reached the summit and beheld a panorama of unspeakable sublimity spread out before us....Standing as it were in this vestibule of God's holy Temple, I forgot I was of this mundane sphere; the divine part of man elevated itself, undisturbed by the influences of the world. I looked from nature, up to nature's God, more chastened and purified than I ever felt before (82–83).

Also a portraitist, the genre by which he earned most of his income, Carvalho painted members of the Jewish community; some well-known Gentiles, such as Frémont (c. 1856, Pennsylvania Academy of the Fine Arts, Philadelphia); and made allegorical portraits. One of four allegorical portraits of Lincoln (David Gilmour Blythe painted a rendition in 1862),

Carvalho's version (1865, Rose Art Museum, Brandeis University, Waltham, Massachusetts) (Color Plate 4) shows the sixteenth president sitting in front of an open curtain with a scroll in his hand bearing words from his second inaugural address: "with malice toward none, with charity for all." Behind the curtain appears the Capitol building, a metaphor for the union, and the ancient philosopher Diogenes clad in a toga. Known for his quest through Greece with a lantern in hand to guide his search for an honest man, Diogenes gazes at Lincoln in amazement, lantern dropped at his feet, for he has finally encountered one.

Carvalho wrote a theological text, *The Two Creations: A Scientific, Hermeneutic and Etymologic Treatise on the Mosaic Cosmogony from the Original Hebrew Tongue* (1884), wherein he tried to reconcile scientific theories of creation with the story in Genesis, and contributed articles to the American Jewish periodical, *The Occident.* Following the example set by his father, Carvalho was a leader in Jewish affairs, particularly the promotion of Jewish education; in Philadelphia he served as an officer of the Hebrew Education Society, and in Baltimore he was a member of the Hebrew Young Men's Literary Society. Beginning in 1867 he ran his own business, Carvalho Super-Heating Company, for which he patented lucrative heating inventions (1877 and 1878).

Bibliography

Berman, Elizabeth Kessin. "Transcendentalism and Tradition: The Art of Solomon Nunes Carvalho." *Jewish Art* 16–17 (1990–91): 64–81.

Carvalho, Solomon Nunes. "Daguerreotyping on the Rocky Mountains." *Photographic and Fine Art Journal* 8 (April 1855): 124–125.

———. *Incidents of Travel and Adventure in the Far West with Colonel Fremont's Last Expedition.* 1856. Reprint, Lincoln: University of Nebraska Press, 2004.

Shlaer, Robert. "An Expeditionary Daguerrotype by Solomon Carvalho." *The Daguerrian Annual* (1999): 151–159.

———. *Sights Once Seen: Daguerreotyping Frémont's Last Expedition through the Rockies.* Santa Fe: Museum of New Mexico Press, 2000.

Solomon Nunes Carvalho: Painter, Photographer, and Prophet in Nineteenth Century America. Baltimore: Jewish Historical Society of Maryland, 1989.

Sturhahn, Joan. *Carvalho, Artist-Photographer-Adventurer-Patriot: Portrait of a Forgotten American.* Merrick, NY: Richwood Publishing Company, 1976.

Turner, Justin G. *A Note on Solomon Nunes Carvalho and His Portrait of Abraham Lincoln.* Los Angeles: The Plantin Press, 1960.

Selected Public Collections

Cincinnati Museum of Art
Gilcrease Art Museum, Tulsa
Jewish Museum, New York
Library of Congress, Washington, D.C.
Maryland Historical Society, Baltimore
Oakland Museum, California
Pennsylvania Academy of the Fine Arts, Philadelphia
Rose Art Museum, Brandeis University, Waltham, Massachusetts

Judy Chicago (1939–), painter, draftswoman, sculptor, textile designer, and installation artist.

Born Judy Cohen, Chicago took her surname from her city of birth to eschew the patriarchal names she was given as an infant and later as a wife. This defiant act is one of many that define, arguably, the most pivotal artist of the feminist movement and the figure who coined the term feminist art. Her major projects, which combine art from several media and take years to conceive and execute, explore oppression from different viewpoints, while focusing especially on women.

The daughter of assimilated parents—her father descended from twenty-three generations of rabbis—at three years old she began drawing and at eight she attended classes at the Art Institute of Chicago. She received a B.F.A. (1962) and an M.F.A. (1964) from the University of California at Los Angeles, where she experimented with contemporary styles, such as Minimalism, in her painting and sculpture. After first neutralizing femininity in her art and then exploring female gender issues, Chicago began a Feminist Art Program at Fresno State College in 1970, and a year later she and **Miriam Schapiro** jointly founded the Feminist Art Program at the California Institute of the Arts in Valencia. The pair's project *Womanhouse* (1972) explored women's spaces in a mansion renovated by the artists and their students. For one month, on view within the house were performances and environments subverting ideas about stereotypical womanhood. *Menstruation Bathroom*, for example, conceived in an actual bathroom in the house, openly displayed tampons and sanitary napkin boxes as well as "used" red products in and around the trashcan. All of this could be seen from behind a gauze-covered doorway, thus commenting on the secret, veiled manner by which women are forced to deal with a natural biological function that makes a male-oriented society uncomfortable.

In 1974, Chicago began conceptualizing *The Dinner Party*, the purpose of which was to raise awareness of women's history and achievements. Executed between 1974 and 1979 with the assistance of more than 400 collaborators, this multimedia installation incorporated traditional women's work such as needlepoint and china painting. Each of the thirty-nine place settings at the forty-eight-foot per side triangular table incorporates an embroidered runner with the honoree's name in gold thread (e.g., Hatshepsut, Emily Dickinson, and Georgia O'Keeffe) and examples of her accomplishments. On the runner sits a ceramic plate, sometimes painted, sometimes sculpted, in a vulva-flower form uniquely designed to reflect the honoree's personality and the period during which she lived. An additional 999 names are painted in gold on the porcelain-tiled "heritage floor" inside the table. Over one million viewers in six countries have seen *The Dinner Party*, which found a permanent home at the Brooklyn Museum in 2002. Years after the work's conception, Chicago realized that her desire to fight against injustice, to effect a "transformation of consciousness through art" to use the artists words, relates to her religio-cultural background and the Jewish concept of *tikkun* (healing) (Chicago, *Holocaust Project*, 3–4). Similarly, in an essay for a catalog accompanying a

recent group exhibition focusing on Jewish feminist artists and in an important article, Gail Levin observes that many artists involved with feminism were of Jewish descent and had relatives who engaged in radical politics, including Chicago, Schapiro, **Eleanor Antin**, **Ida Applebroog**, **Audrey Flack**, and **Nancy Spero**. Levin argues that the daughters and granddaughters of these Jewish activists took up their own struggle: women's rights.

A growing interest in her Jewish heritage led to *Holocaust Project: From Darkness into Light* (1985–93), which first showed in October 1993 at the Spertus Museum in Chicago, and subsequently traveled throughout the United States until 2002. This installation culminated eight years of research and exploration, including extensive reading on the subject, visits to concentration camps, archival work on the subject in Eastern Europe, and a trip to Israel. The installation focuses on the Holocaust from all perspectives, not just from a Jewish one. Thus Chicago references other persecuted groups, such as homosexuals and gypsies, as well as additional subjugated peoples from the historical record. Moreover, although the project is about the entirety of the Holocaust, Chicago made a special effort to create imagery that addresses how the female experience differs from that of the male. Two stained-glass windows and a tapestry designed by the artist and executed by collaborators accompany thirteen tableaus comprised of combines of Chicago's paintings and her husband Donald Woodman's photography on photolinen (a photosensitive material that enabled the merger of their respective mediums). Information panels and an audiotape guide the viewer through the installation. First, the viewer encounters the stained-glass logo for the project: a rainbow-colored triangle based on the different colored badges Nazi's forced concentration camp inhabitants to wear surrounded by flames and soldered with wire to evoke the barbed wire of the camps. As Chicago described the symbol: "I used the color yellow twice to emphasize the particular suffering of the Jews and as a metaphor for the idea that the Holocaust 'began with the Jews, but it did not end with them.' I intended the design as a memorial to all those persecuted by Hitler and as a symbol of courage and survival" (Chicago, *Holocaust Project*, 137). Next, the viewer sees a 4½ × 18-foot tapestry—titled *The Fall*—which shows the disintegration of rationality through a variety of collage-like images, culminating with victims being forced into camp ovens. Chicago chose tapestry as one of the media for the work "to emphasize how the Holocaust grew out of the very fabric of Western civilization" (Ibid., 88). The tableaus that follow illustrate and interpret the events of the Holocaust and also expand to other abuses of power such as United States slavery and the Vietnam War. The project culminates with a second stained-glass triptych titled *Rainbow Shabbat* (Color Plate 5) that aims to end the viewer's journey on a hopeful note. Flanked on the left and the right by a yellow star akin to the badge worn by Jews with a rephrasing of a poem by a survivor from Theresienstadt, "Heal those broken souls who have no peace and lead us all from darkness into light," in Yiddish and in English, the larger center panel portrays a Shabbat service. On opposite ends of a table a wife blesses candles and a husband holds up his Kiddush cup in honor of his spouse—thus incorporating the actual ritual of Shabbat together with Chicago's overriding interest in the female

experience. Sitting around the table peoples from different creeds and races unite with their hands on each other's shoulders.

Several additional large installations comprise Chicago's oeuvre. *Birth Project* (1980–85), a needlework series that emerged after Chicago noticed the lack of imagery exploring birth, was followed by *Powerplay* (1982–87), a multimedia endeavor including weaving and oil painting that addressed the effects of male gender constructs. *Resolutions: A Stitch in Time* (1994–2000) again employed needlework, along with Chicago's paintings, to illustrate and interpret familiar proverbs in a novel way.

Chicago has authored seven books, including two autobiographies. *Holocaust Project: From Darkness into Light* (1993) chronicles her intellectual and artistic journey as she made the installation of the same name. The book contains what she terms her "Jewish Journal," a written dialogue begun in October 1985 and continuing until summer 1992 that describes her Holocaust explorations and odyssey into her own Jewishness. Explanations of the iconography of *The Holocaust Project* also help make the installation accessible, much as Chicago's descriptions in *The Dinner Party: A Symbol of Our Heritage* (1979) serve to clarify her visual language. When asked how she defines Jewish art, Chicago replied, "For me, Jewish art is not just art made by Jews but art that reflects Jewish identity in a clear way. It is not buried. Jewish art is similar to issues around feminist art. Jewish identity needs to be explored in Jewish art, not confined to the margins. And for scholarship on Jewish art to be accepted it will have to reach a critical mass, like feminist art history" (Telephone conversation). Her home page is www.judychicago.com.

Bibliography

Bloom, Lisa. "Ethnic Notions and Feminist Strategies of the 1970s: Some Work by Judy Chicago and Eleanor Antin." In *Jewish Identity in Modern Art History*. Edited by Catherine M. Soussloff, 135–163. Berkeley: University of California Press, 1999.

Broude, Norma and Mary D. Garrard, eds. *The Power of Feminist Art: The American Movement of the 1970s, History and Impact*. New York: Harry N. Abrams, Inc., Publishers, 1994.

Chicago, Judy. *The Dinner Party: A Symbol of Our Heritage*. Garden City, NY: Anchor Press/Doubleday, 1979.

———. *Holocaust Project: From Darkness into Light*. With photography by Donald Woodman. New York: Viking, 1993.

———. *Through the Flower: My Struggle as a Woman Artist*. 1975. Reprint, New York: Penguin Books, 1993.

———. *Beyond the Flower: The Autobiography of a Feminist Artist*. New York: Viking Books, 1996.

———. Telephone conversation with the author. January 6, 2006.

Jones, Amelia, ed. *Sexual Politics: Judy Chicago's Dinner Party in Feminist Art History*. Berkeley: University of California Press, 1996.

Levin, Gail. "Beyond the Pale: Jewish Identity, Radical Politics and Feminist Art in the United States." *Journal of Modern Jewish Studies* 4, no. 2 (July 2005): 205–232.

Lippard, Lucy. *Judy Chicago*. New York: Watson-Guptill Publications, 2002.

Lucie-Smith, Edward. *Judy Chicago: An American Vision.* New York: Watson-Guptill Publications, 2000.

Zalkind, Simon. *Upstarts and Matriarchs: Jewish Women Artists and the Transformation of American Art.* Essays by Gail Levin and Elissa Authur. Denver, CO: Mizel Center for Arts and Culture, 2005.

Selected Public Collections

Albuquerque Museum of Art, New Mexico
British Museum, London
Brooklyn Museum of Art
Los Angeles County Museum of Art
National Gallery of Art, Washington, D.C.
New Orleans Museum of Art
Pennsylvania Academy of the Fine Arts, Philadelphia
Virginia Museum of Fine Art, Richmond

Minna Citron (1896–1991), painter and printmaker.

During her long career, Minna Citron created an oeuvre embodying two different concerns: her early figurative work explores the predicament of her gender as well as the human condition, followed by decades of abstract experimentation. Born in Newark, New Jersey as Minna Wright, she married Henry Citron in 1916. Feeling the need to occupy a role beside wife and mother of two sons, at the age of twenty-eight Citron enrolled in art classes at the Brooklyn Institute of Arts and Sciences with Benjamin Kopman (1924–25) and then at the New York School of Applied Design for Women (1925–27). Over many years at the Art Students League (1928–35), Citron studied lithography with **Harry Sternberg**, and painting with John Sloan and Kenneth Hayes Miller, whose realistic portrayals of the human experience influenced her own artistic conception.

After small solo exhibitions at the New School for Social Research in New York (1930) and the Brownell-Lambertson Gallery (1932), Citron enjoyed a larger one-person show at the Midtown Galleries (1935). Under the title *Feminanities*, Citron exhibited paintings that explored and satirized modern female life and stereotypes; she portrayed women shopping and in beauty salons, exposing the superficiality of these activities. In the forward to the exhibition catalog, Louis Weitzenkorn observed that Citron's "satirical adventures into the dreadful results of modern civilization on human beings have a shattering effect upon one's complacency. In spite of the seeming cruelty of the characters, there is always apparent a tenderness and sympathy for the creatures, that once were men and women, whom she draws. Her attack upon the shallowness of the modern woman's vanity...should curl the hair of beauty experts and take the wave out of their victims" (Chapman, unpaged). At the same show, Citron exhibited a canvas of a woman engaging in labor. *She Earns an Honest Living* (see figure) (1934, Vassar College, Poughkeepsie, New York)

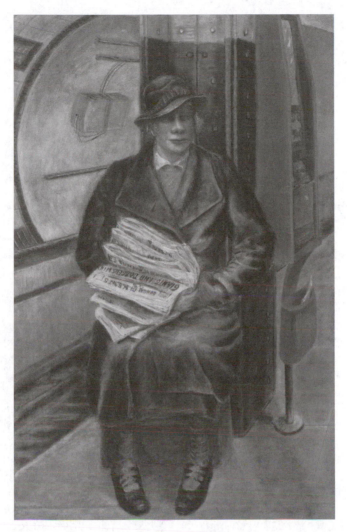

Minna Citron, *She Earns an Honest Living*, 1934. Oil on pressed wood, 25¼ × 16 inches. Frances Lehman Loeb Art Center, Vassar College, Poughkeepsie, New York. Gift of Mr. and Mrs. Thomas Wright Citron. Photo: B. Lorenzson. Art © Estate of Minna Citron/Licensed by VAGA, New York, New York.

depicts a woman sitting on a wooden box in a subway station selling newspapers. Even if selling newspapers is somewhat of a dead end job, I would argue that this single image encouraged women to move beyond frivolous activities like primping at the beauty parlor. Referencing *She Earns an Honest Living*, Citron later recalled of the period: "This was a tough time. It was especially tough for a woman. What else could she do–other than be a 'hausfrau.' Women had no options. This was a time of metamorphosis. Do butterflies suffer when they emerge from their cocoons? Because this is what we were really doing in the early 20th century. Women were changing from being housebound; from being chattels of their fathers and husbands.... The woman in this picture is

archetypal. She represents the psychology of many women of the day–without training–women who had to reevaluate their thinking and lives....She had to painfully adjust to the unknown and try to reach for the few opportunities that existed for her" (Ekedal and Robinson, 14).

The same year that she painted *She Earns an Honest Living*—an image about a woman emerging from her cocoon and adjusting to the unknown—Citron left her husband and comfortable upper middle-class existence in Brooklyn for life in Manhattan as a single woman with two children (1934). Citron took a studio in the Union Square area, affiliating with other members of what is termed the Fourteenth School artists, including **Raphael Soyer**, Isabel Bishop, and Miller, who also delineated the urban scene in a realistic fashion. To earn a living, Citron taught painting in New York under the auspices of the Works Progress Administration's Federal Art Project (1935–37) and completed two mural projects commissioned by the Treasury Section of Fine Arts (1938–40). The first, *T.V.A. Power*, comprises two panels (48 × 7½ feet) for the Newport, Tennessee post office with iconography that celebrates the work of the Tennessee Valley Authority, notably the installation of electricity to improve the daily life of the community's inhabitants. Citron also made several lithographs, oil paintings, and watercolors inspired by her visit to Tennessee. A second mural, for the Manchester, Tennessee post office (1941–42), is titled *Horse Swapping Day*. Rendered in earth tones, *Horse Swapping Day* presents a rural scene peopled with locals, a few horses, and country architecture.

Citron traveled to Reno, Nevada to obtain a divorce in the mid-1930s. While there she began to conceptualize the subjects of her second major group of canvases, titled *Gambling Series*. In contrast to *Feminanities*, *Gambling Series* presents an overwhelmingly male domain; the images depict men placing bets at a roulette wheel and surveying racing statistics, among other common activities in gambling establishments. With features and gestures exaggerated almost to the point of caricature, Citron's irreverent canvases subsequently appeared at the Midtown Galleries (1937). Soon thereafter, Citron served on jury duty, one of the first women in New York state to do so. Indeed, on several occasions from 1937 to 1939 Citron sat on juries and simultaneously observed the interworking of trials, resulting in the *Judges and Juries* series, which hung in 1939 at the Midtown Galleries.

Associating with Stanley William Hayter's graphic workshop Atelier 17—relocated from Paris to New York during World War II—Citron was privy to the latest printmaking developments. At this time, Citron's work became abstract, partly influenced by European avant-garde artists living in the United States to escape the War, including Jewish artists Marc Chagall and Jacques Lipchitz. *Whatever!* (1946), her first completely abstract print, is a tiny composition (1½ × 2½ inches) of swirling, calligraphic lines. Some of the titles of her abstractions reflect Citron's continuing interest in exploring the female experience; *Men Seldom Make Passes...* (1946), a semi-abstract, dual-toned print indicates a woman in glasses sitting at her easel. From around 1950 until 1960, Citron incorporated sand into her paintings and prints, producing highly textured compositions. By the mid-1960s, Citron began to employ collage elements in her work, like pieces of clothing and even paint can covers as

counterparts to the flatly rendered colors. Until her death, Citron constantly experimented with different materials and techniques such as photoetching.

Citron taught at the Brooklyn Museum School (1940–44) and at the Pratt Institute. She held a Yaddo Fellowship (1946–47) and a Ford Foundation Fellowship (1965), which funded her tenure as an artist-in-residence at the Roanoke Museum. In Citron's lifetime, her work was featured in one-person shows in the United States and beyond, including Paris (1947), Havana (1949 and 1952), and Madrid (1962). Citron was honored as Woman of the Year by the Women's Caucus for Art in 1985. Although her art does not embody any obvious Jewish content, Citron was included in a book on Jewish painters and sculptors, for which she provided an artistic credo, stating in part that, "Art begins with emotional expression, Creation involves the ordering of that emotion and involves the whole living creature towards the fulfilling of that experience. Once the sensory or feeling approach to art is granted, the conscious mind can be brought into play as a supplementary force" (Lozowick, 40).

Bibliography

Chapman, Max. *From the 80 Years of Minna Citron.* New York: Wittenborn Art Books, 1976.

Citron, Minna. *Minna Citron: A Survey of Paintings and Works on Paper (1931-1989).* New York: Susan Teller Gallery, 1990.

Ekedal, Ellen and Susan Barnes Robinson. *The Spirit of the City: American Urban Paintings, Prints, and Drawings, 1900-1952.* Los Angeles: Laband Art Gallery, 1986.

Francey, Mary. *American Women at Work: Prints by Women Artists of the Nineteen Thirties.* Salt Lake City: Utah Museum of Fine Arts, University of Utah, 1991.

Kotre, John and Elizabeth Hall. *Seasons of Life: Our Dramatic Journey from Birth to Death.* Boston: Little, Brown and Company, 1990.

Kup, Karl. *The Graphic Work of Minna Citron: 1945-1950.* New York: New School for Social Research, 1950.

Lozowick, Louis. *One Hundred Contemporary American Jewish Painters and Sculptors.* New York: YKUF Art Section, 1947.

Marling, Karal Ann and Helen A. Harrison. *7 American Women: The Depression Decade.* Poughkeepsie, NY: Vassar College Art Gallery, 1976.

Streb, Jennifer L. "Minna Citron: A Socio-Historical Study of an Artist's Feminist Social Realism in the 1930s." Ph.D. dissertation, The Pennsylvania State University, 2004.

Selected Public Collections

Art Institute of Chicago
Fogg Art Museum, Harvard University, Cambridge, Massachusetts
Hirshhorn Museum and Sculpture Garden, Washington, D.C.
Museum of Modern Art, New York
Philadelphia Museum of Art
Tel Aviv Museum of Art, Israel
Victoria and Albert Museum, London
Whitney Museum of American Art, New York

D

Jo Davidson (1883–1952), sculptor.

Described at various times as a "biographer in bronze" (*First Retrospective* unpaged), a "psychological portraitist of the highest order" (Ibid.), and a "plastic historian" (Davidson, 132), Jo Davidson executed sculptures of some of the best-known figures in the world. Davidson was born in the ghetto of New York's Lower East Side to immigrant parents who fled the Russian pogroms. Despite parental opposition, in his teens Davidson studied drawing in New York at the Educational Alliance's art school and at the Art Students League. On the weekends Davidson would walk from the Lower East Side to the Metropolitan Museum of Art to learn from the Old Masters with his friend Samuel Halpert, a coreligionist who went on to become a well-known painter. Urged by his parents, at eighteen-years old Davidson went to New Haven to prepare for entrance to Yale Medical School. While in New Haven an admirer of Davidson's work showed the young man's drawings to the director of the art school. Davidson soon began art classes at Yale free of charge. After accidentally walking into a sculpture room he realized the direction his art was to take, and returned to New York to study sculpture. Further studies were undertaken in Paris, although he only remained at the École des Beaux-Arts for three weeks. Davidson's lifelong love affair with Paris began at this time, and he intermittently lived in the city for the rest of his life.

Davidson received acclaim early on; Gertrude Vanderbilt Whitney, who later founded the Whitney Museum of American Art in New York, purchased a bust of a young girl as early as 1906. In 1909, Davidson's first one-man show was held in New York, and a year later his eight-foot nude *La Terre* (Muskegon Museum of Art, Michigan) was exhibited at the Salon d'Automne in Paris. He exhibited at the 1913 Armory Show, a watershed moment that introduced modernism to America.

Soon Davidson began making portrait busts of famous personalities, including military and political leaders. His subjects did not pose for him in a conventional fashion; rather, Davidson talked with them and observed their natural expressions and mannerisms, sometimes over an extended period. President Woodrow Wilson (1916, New Jersey State Museum, Trenton) sat for Davidson seven times, during which time the pair discussed the war.[11] In his autobiography *Between Sittings*, published a year before he died, Davidson described his working method: "My approach to my subjects was very simple.

I never had them pose but we just talked about everything in the world. Sculpture, I felt, was another language altogether that had nothing to do with words. As soon as I got to work, I felt this other language growing between myself and the person I was 'busting.' I felt it in my hands. Sometimes the people talked as if I was their confessor. As they talked, I got an immediate insight into the sitters" (86–87). During Davidson's sessions modeling *Gertrude Stein* (1920, Whitney Museum of American Art, New York) (see figure), she read her prose; one day she read a single sentence repeatedly, making Davidson among the first to hear Stein's famous dictum "a rose is a rose is a rose." Although he planned to sculpt a bust, Davidson felt it necessary to show Stein's entire body to fully capture her presence. The ensuing block-like appears akin to a Buddha, with Stein sitting cross-legged, her large shoulders slumped forward, and her arms resting in her lap. Staring downward in intense concentration, Davidson captured what he deemed the "eternal quality about her—she somehow symbolized wisdom" (Ibid., 175).

Akin to his Stein figure, in all of his portrait sculpture, Davidson provided a likeness of his sitter, while also exploring and distilling personality. His naturalistic approach combines with lively surface effects; the vigorous and rapid

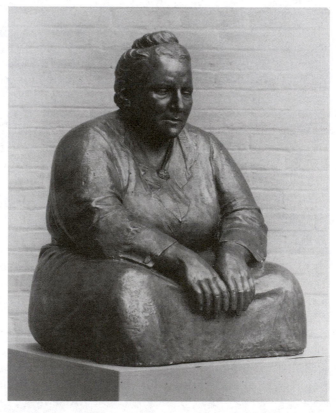

Jo Davidson, *Gertrude Stein*, 1920. Bronze, 31¼ × 23¼ × 24¼ inches. Whitney Museum of American Art, New York. Purchase 54.10. Photograph © Whitney Museum of American Art, New York.

modeling of clay remains apparent even after the sculpture has been cast in bronze. Art critic Edward Alden Jewell observed Davidson's 1933 retrospective at Knoedler Gallery: "Mr. Davidson has delved for character essentials, writing them down in a plastic language that intelligently selects as it proceeds" (19). Davidson explained his desire to find a characterization of his subject rather than simply to provide a straightforward portrait: "Some sitters give themselves with ease–others resist. I once said facetiously that some of my sitters were short stories, and others were novels. It takes two to make a bust. The important thing is the *rapport* between the artist and the sitter. Looking at a portrait, painting or piece of sculpture, you do not have to know the person represented, but you recognize the truth if the artist has stated it" (Davidson, 117).

Once established, Davidson traveled the world making bronze busts of figures as diverse as Mahatma Gandhi (1931, collection unknown), Benito Mussolini (1926, collection unknown), Albert Einstein (1937, Smithsonian Institution, National Portrait Gallery, Washington, D.C.), and Helen Keller. Unsatisfied with his 1942 bust of Keller (North Carolina Museum of Art, Raleigh), with whom he developed a close friendship, Davidson made a half-length portrait in 1945 to show her gesticulations—an element he felt intrinsic to understanding Keller's personality. If Davidson could not work from the sitter, he would try to access film footage of his subject. To that end, after Will Rogers died prematurely in 1935 Davidson made a commemorative full-length, eight-foot bronze sculpture by viewing film footage to assess Rogers' gestures, expressions, and gait, and employed a model to dress in Rogers' clothes, borrowed from the humorist's wife (Smithsonian Institution, National Portrait Gallery, Washington, D.C.).

A result of a commission from George Doran of Doubleday, Doran, and Company Publishing, Davidson made ten busts of famous authors, including James Joyce (1930, Los Angeles County Museum of Art). Inspired by the project, Davidson sought out other authors to model. In addition to those heads done for Doran, strongly modeled busts of George Bernard Shaw (1930, Los Angeles County Museum of Art) and James M. Barrie subsequently showed in a 1931 exhibition at Knoedler Galleries in New York City. His nine-foot, full-length bronze of the poet Walt Whitman (1936–39), located at Bear Mountain State Park in Stony Point, New York, was partially inspired by Davidson's study of biographies of the writer, and Whitman's letters and books, especially *Leaves of Grass*. Davidson first made a life-size armature constructed so that he could move Whitman's limbs, as he wanted the poet to be "afoot and lighthearted" (Ibid., 295). Davidson also had visitors to his studio pose so as to capture a sense of movement. Taking inspiration from Whitman's oft-cited line "Camerado, I give you my hand!...Will you come travel with me?" the final sculpture, which first showed at the 1939 New York World's Fair, portrays Whitman striding forward with his hand outstretched toward the viewer.

As a goodwill ambassador to South America in 1941 at the bequest of Nelson Rockefeller, Davidson made busts of ten South American presidents. After returning to the United States, Davidson cast the clay-modeled presidents of

Brazil, Uruguay, Peru, Ecuador, Columbia, and others, into bronze. Following an exhibition of the heads at the National Gallery of Art in Washington, they were presented to the South American republics as tokens of friendship.

After arriving in Israel in 1951 with a gift of a bronze bust of British states-man Lord Balfour (1918), the namesake and chief proponent of the Balfour Declaration which supported the return of Palestine to the Jews, Davidson made bronze sculptures of the country's major leaders, including Golda Meir (c. 1951, Jewish Museum, New York), Chaim Weizmann (1951, Los Angeles County Museum of Art), and David Ben-Gurion (1951, Los Angeles County Museum of Art). In addition to busts of Jewish figures, Davidson worked on a few other Jewishly inspired projects. In 1928 he designed the set—an abstract suggestion of the Western Wall—to accompany the Manhattan Opera House's presentation of Ernest Bloch's symphony "Israel." A 1942 sculpture group was executed on commission from the Writers' War Board to memorialize the Nazi massacre of Lidice, a small village in Czechoslovakia; Davidson portrayed a defiant man accompanied by a woman and child facing the Nazis, with dead victims already on the ground. After the war Davidson began preparing a United States memorial to the Jews killed in the Warsaw Ghetto. Although he traveled to Poland to see the tragedy first hand, and studied photographs of the vibrant Jewish community before Hitler, the memorial fell through. Recall-ing his trips to Warsaw and Israel, Davidson wrote: "After having seen what had been the Warsaw Ghetto, to see Israel confirmed my belief that life is eternal. It was like a phoenix rising out of the ashes after it had been consumed" (Ibid., 369).

Bibliography

Davidson, Jo. *Between Sittings: An Informal Autobiography of Jo Davidson.* New York: Dial Press, 1951.

First Retrospective Exhibition of One Hundred and Seventy Portrait Busts and Other Works by Jo Davidson. National Academy of Arts and Letters, 1947.

Jewell, Edward Alden. "Sculpture Shown by Jo Davidson." *New York Times* (December 19, 1933): 19.

Jo Davidson: American Sculptor, 1883-1952. New York: Hammer Galleries, 1983.

Sadik, Marvin. *Jo Davidson: Portrait Sculpture.* Washington, D.C.: National Portrait Gallery, Smithsonian Institution, 1978.

Young, Mahonri Sharp. "The American Houdon." *Apollo* (December 1982): 422–424.

Selected Public Collections

Fogg Art Museum, Harvard University, Cambridge, Massachusetts
Gilcrease Museum, Tulsa, Oklahoma
Jewish Museum, New York
Los Angeles County Museum of Art
Metropolitan Museum of Art, New York
National Portrait Gallery, Washington, D.C.
Pennsylvania Academy of the Fine Arts, Philadelphia
Whitney Museum of American Art, New York

Jim Dine (1935–), painter, sculptor, printmaker, draftsman, performance artist, illustrator, and stage designer.

A prolific artist who has experimented with many media, Cincinnati-born Jim Dine studied art at various venues, ultimately receiving his B.F.A. from Ohio University (1954–58). He burst onto the art scene as a purveyor of artist performances known as Happenings after moving to New York City in 1958. Influenced by Allan Kaprow, Dine performed the thirty-second *Smiling Workman* at the Judson Gallery in 1960. Painted in red face and wearing a long robe, the artist stood in front of a wall covered with paper bearing the painted sentence "I love what I'm doing," and a table with paint buckets. Dine drank from the buckets and poured the paint over his head. Soaked in paint, Dine then jumped through the paper wall. Dine's actions contrasted with the torment that was said to characterize the work of the then-prominent Abstract Expressionists, including **Mark Rothko** and **Barnett Newman**. Performances of *The Vaudeville Show* (1960), *Car Crash* (1960), and *Natural History (The Dreams)* (1965) followed. *Car Crash,* a reenactment of an actual car crash, was also explored in works on paper, paintings, and a series of lithographs, Dine's first prints to be published. Rather than a literal representation, *See the Car Talk Baby* (1960, private collection) shows a magnified eye peering from under layers of gesturally rendered strokes to convey the violence of the accident, and a superimposed line drawing of a car. Scrawled atop the single facial feature is the title of the work, painterly marks that convey the anxiety of the incident through their expressive application. At this time, Dine also began making assemblages—canvases that incorporate found materials. *Lawnmower* (1962, Aichi Prefectural Museum of Art, Nagoya, Japan) employs an actual lawnmower on a pedestal. The handlebars of the ordinary mower lean against a canvas mounted on the wall, painted with thick hues of green and yellow suggesting grass and the sun. Partly influenced by Robert Rauschenberg's combines (painting–sculpture fusions) of the late 1950s, the mixed-media *Lawnmower* is one of many works by Dine that utilize everyday objects.

During the 1960s Dine was associated with Pop Art, but the cold impartiality of the movement went against the artist's desire to imbue his work with subjective elements. As he explained in a 1963 interview: "Pop art is only one facet of my work. More than popular images I'm interested in personal images" (Swenson, 25). Dine explicitly allied his art and himself in 1980: "My work is like me, I think. Definitely it is me. I am it. I am the work. There is no question about that. I probably am as closely linked to my work as any artist I know. That is, if you know me, you know my work. I'm not closed off in that way" (Hennessy, 174).

Throughout the years, Dine has instilled new layers of meaning in the varied objects which preoccupy his art, including hearts, trees, tools, gates, the Venus de Milo, and robes. These motifs are reiterated and reinterpreted in different media and in different styles. Tools have been painted, drawn, and created as prints, as well as used in assemblages. Similarly, bathrobes have been rendered in many media since their first public showing at the Sidney Janis Gallery in

New York in 1964. Painted while in Jerusalem, *Painting Around Mount Zion* (1979, Akron Art Museum, Ohio) (see figure) is a large horizontal canvas entirely filled by four dark empty robes, the last one suffused with golden light. The empty robes are meant to be self-portraits, a genre more straightforwardly embraced in later images; for example, *Self-Portrait with Red Ears*, a mixed-media work on paper from 1975 (private collection), shows the artist fully frontal and without disguised symbolism. The recurring image of the gate entered Dine's visual vocabulary in 1981. Based on a gate outside the Parisian studio of printer Aldo Crommelynck, the arabesque form has occupied Dine's painting, prints, and sculptures. While the easily recognized heart might be a banal choice of subject, Dine invests the rounded symbol with differing and personal meanings. In 1981 Dine described the heart as "a prime object. Yes, the shape! It means a lot of things. It doesn't just mean love, it's anatomical, it's all kinds of things. It refers to all kinds of anatomy, too. But it also was a way for me to hang painting onto something" (Shapiro, 204).

Painting (Cruising) (La Chasse) (1981, private collection) is interesting for its enormous size, which comprises four panels measuring 72 × 243¾ inches, and its subject matter. Indeed, the image employs one symbol filling up each panel. While the third panel uses the oft-repeated heart, the second and fourth panels introduce the tree and gate for the first time. The first panel shows a heavily painted Star of David, which does not reappear in Dine's work. Three years after its conception Dine described the image: "I love this painting almost as much as anything I have ever done....The act of cruising was what I was doing here, cruising my themes and cruising as a painter. That is, I was taking chances with unknown things and literally, physically, taking chances in the painting" (Beal, 104). The Star of David motif, the artist explained, is "much too specific" (Ibid., 44) and did not become one of his standard symbols.

Ever restless and continually experimental, Dine designed the costumes and sets for the San Francisco Actor's Workshop production of *A Midsummer Night's Dream* (1966), the costumes for a version of Oscar Wilde's *Picture of*

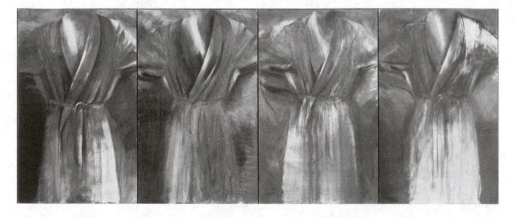

Jim Dine, *Painting Around Mount Zion*, 1979. Oil on canvas, 71 × 173 inches. Four panels. Collection of the Akron Art Museum, Ohio. Purchased with funds from an anonymous contribution and the Museum Acquisition Fund. © 2006 Jim Dine/Artists Rights Society (ARS), New York.

Dorian Gray that never reached the stage (1967–68), and the sets and costumes for the Houston Grand Opera's production of Richard Strauss' *Salome* (1986). The colorful costumes of Shakespeare's play boldly attempted to communicate elements of the characters' personalities and introduced the heart in the form of a stage prop, which soon thereafter became one of Dine's signature motifs. Dine has published three volumes of poetry: *Welcome Home Lovebirds* (1969), *Diary of a Non-Deflector* (1987), and *Kali* (1999). He also illustrated a version of Guillaume Apollinaire's *The Poet Assassinated* (1968) and Sigmund Freud's *The Case of the Wolf-Man* (1993), among other books.

Dine's Jewish identity has come more overtly to the forefront in recent years. In 1998 he designed a heart logo for the sixty-seventh General Assembly of the Jewish Council of Federations in Jerusalem, and in 2000 the Jerusalem Print Workshop published several of his prints, including the self-portrait *"Me" Printed on Jewish Steel.*

At the young age of thirty-five, Dine enjoyed a retrospective at the Whitney Museum of American Art and a print retrospective at the Kestner Gesellschaft in Hanover, Germany. Retrospectives at the Walker Art Center in Minneapolis (1984), the Galleria d'Arte Moderne Ca'Pesaro in Venice (1988), and the Isetan Museum of Art in Tokyo (1990) have followed. He also has taught at several schools, including Oberlin College (1965), Dartmouth College (1975), and the International Summer Academy in Salzburg, Austria (1993 and 1994). It has been estimated that the prolific Dine produced over 2,000 paintings, drawings, and sculptures, and nearly 1,000 editioned prints from the late 1950s to the mid-1990s (Livingstone, n. 1, 184).

Bibliography

Beal, Graham W.J. *Jim Dine: Five Themes.* Minneapolis: Walker Art Center; New York: Abbeville Press, 1984.

Carpenter, Elizabeth. *Jim Dine Prints, 1985-2000: A Catalogue Raisonné.* Minneapolis: Minneapolis Institute of the Arts, 2002.

Dine, Jim. "What is Pop Art? Part I." Interview with G.R. Swenson in *ARTnews* 62, no. 7 (November 1963): 25, 61–62.

———. *Designs for* A Midsummers Night's Dream: *Selected from the Drawings and Prints Collection of the Museum of Modern Art, New York.* New York: Museum of Modern Art, 1968.

Feinberg. Jean E. *Jim Dine.* New York: Abbeville Press, 1995.

Glenn, Constance W. *Jim Dine: Drawings.* New York: Harry N. Abrams, Inc., 1985.

Hennessy, Susie. "A Conversation with Jim Dine." *Art Journal* 39 (Spring 1980): 168–175.

Livingstone, Marco. *Jim Dine: The Alchemy of Images.* New York: Monacelli Press, Inc., 1998.

Shapiro, David. *Jim Dine: Painting What One Is.* New York: Harry N. Abrams, Inc., Publishers, 1981.

Selected Public Collections

Allen Memorial Art Museum, Oberlin College, Ohio
Guggenheim Museum, New York

Hirshhorn Museum and Sculpture Garden, Washington, D.C.
Museum of Fine Arts, Boston
Museum of Modern Art, New York
National Gallery of Art, Washington, D.C.
Smithsonian American Art Museum, Washington, D.C.
Tate Gallery, London

E

Alfred Eisenstaedt (1898–1995), photographer.

Often called "the father of modern photojournalism," Alfred Eisenstaedt was one of the four original staff photographers at *Life* magazine. Working for *Life* for forty years, the prolific and self-taught Eisenstaedt took pictures on approximately 2,500 assignments, and his work appeared on over ninety covers. Eisenstaedt is especially known for his ability to capture the salient moment in rich detail, whether the character of an important figure—like Albert Einstein—or a slice of everyday life, such as the reactions of women purchasing undergarments in a department store. In 1985, Eisenstaedt reflected on his pictures: "My style hasn't changed much in all these sixty years. I still use, most of the time, existing light and try not to push people around. I have to be as much a diplomat as a photographer. People often don't take me seriously because I carry so little equipment and make so little fuss. When I married in 1949, my wife asked me. 'But where are your real cameras?' I never carried a lot of equipment. My motto has always been, 'Keep it simple'" (Eisenstaedt, *Eisenstaedt on Eisenstaedt*, 116).

Born in Dirschau, West Prussia (now Poland), at the age of eight Eisenstaedt moved with his family to Berlin. Eisenstaedt received a camera as a fourteenth birthday gift from an uncle and immediately became enamored with picture taking. Three years later, he was drafted into the German army (1916–18). Wounded by shrapnel in both his legs, Eisenstaedt was the only member of his troop to survive. Eisenstaedt endured a year-long recuperation period, relying on crutches or a cane to walk. After he healed, Eisenstaedt worked as a belt and button salesman while pursuing photography as a hobby. Vacationing in Bohemia in 1927, Eisenstaedt photographed a woman playing tennis. Shot from above, the picture captured the woman's long shadow on the ground as she stretched her arm backward to return a shot. This pivotal image introduced Eisenstaedt to a new printing technique and was also the first picture that he ever sold, to an illustrated weekly periodical in Germany. As Eisenstaedt remembered: "I took only one picture of the scene, with a Zeiss Ideal camera, 9 × 12 with glass plates. I developed it back home in our bathroom. I was rather satisfied when I showed it to a friend of mine. 'Why don't you enlarge it?' he asked. And he showed me a contraption of a wooden box with a frosted light bulb inside attached to a 9 × 12 camera, same as mine. When I saw that one could enlarge and eliminate unnecessary details, the photo

bug bit me and I saw enormous possibilities" (Ibid., 8). By 1928 he was employed as a freelancer for the organization that would become known as the Associated Press, and a year later he began working as a full-time photographer.

As a photographer in Berlin, Eisenstaedt watched the Nazi party rise to power. In September 1933, Eisenstaedt shot an extraordinary, unguarded picture—which would become his forte—of Joseph Goebbels, Hitler's Minister of Propaganda. Sitting in a chair in Geneva awaiting attendance at a session of the League of Nations, Goebbels glared at the camera. Recalling that moment, Eisenstaedt said: "Suddenly he spotted me and I snapped him. His expression changed. Here are the eyes of hate. Was I an enemy?...I have been asked how I felt photographing these men [Nazis]. Naturally, not so good, but when I have a camera in my hand I know no fear" (Ibid., 61). The following year, Eisenstaedt went to Venice to take pictures of Hitler and Mussolini's first meeting. Not only did he document the event, but in his copious commentary accompanying many of the book compilations of his photographs, Eisenstaedt also provided fascinating personal commentary on the events that he witnessed. As Eisenstaedt remembered: "Der Führer and Il Duce met for the first time June 13, 1934, in Venice. Mussolini strutted like a peacock in his resplendent fascist uniform. Hitler, on his first visit outside Germany, wore a badly fitting suit and a shabby yellow raincoat. He was awkward and, it seemed to me, ill at ease in the presence of a man who immediately made it clear that he was the senior dictator–by ten years" (Eisenstaedt, *Witness to Our Time*, 65). For a book on his German photographs, in 1979 Eisenstaedt returned to his native country to gather additional material. A photograph titled *Jewish Cemetery in Weissensee, East Berlin, 1979* shows the destruction of tombstones and overgrown foliage. Another picture of the cemetery, which presents a girl sitting on a bench amid tombstones (see figure), bears a brief comment from the artist in his book *Eisenstaedt: Germany:* "My father is buried here" (49).

Of great interest, in Eisenstaedt's discussions about his pictures of Hitler, Goebbels, and Nazis, he says nothing about being Jewish, if his religiocultural heritage hindered his picture taking, or how he felt—as a Jew—about his subjects. Discussing Eisenstaedt's photographs of Germany in a 1981 interview, Barbaralee Diamonstein pressed Eisenstaedt as to why he did not return to Germany for so many years after his arrival in the United States. Diamonstein asked if it was "really true" that he did he not go back to Germany because no one had asked him to, as the photographer had explained earlier. Eisenstaedt tersely replied "yes." Diamonstein then queried if there were any "philosophical or other reasons." Eisenstaedt replied "No, no, no," saying nothing about his Jewish background (Eisenstaedt, *Visions and Images*, 43).

Eisenstaedt immigrated to the United States in 1935 and was employed by *Life* magazine before the publication of its first issue (1936). His pictures appeared in the premier issue of the magazine and the second installment featured the first of his many covers, a photograph of a young officer at West Point. Arguably the best-known picture to have appeared in *Life*, Eisenstaedt's iconic photograph of a sailor kissing a nurse in Time Square, *V.J. Day at Times Square, New York City, August 15, 1945*, also often called *The Kiss VJ Day*,

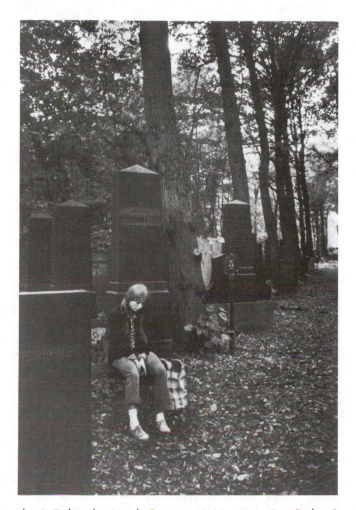

Alfred Eisenstaedt, *A Girl in the Jewish Cemetery, Weissensee, East Berlin, September 1979*, 1979. Photograph. Photo courtesy of Alfred Eisenstaedt/Time & Life Pictures/Getty Images.

encapsulates the joy felt by Americans after Japan's surrender. This photograph, capturing with his Leica camera a spontaneous, unstaged moment, is a fine example of why Eisenstaedt has been described as a master of the candid camera.

Over the years, Eisenstaedt produced photo-essays on diverse subjects, from Surinam's rain forest (1953) to Judaism (1955) to Sophia Loren's villa (1964). His portraits of celebrities and the world's great historical and artistic figures range from George Bernard Shaw (1932) to Ernest Hemingway (1952) to the Clinton family (1993). Eisenstaedt's work was included in the Museum of Modern Art's *Family of Man* exhibition (1955), a show comprised of over 500 photographs from sixty-eight countries and in its time the most popular exhibition in the history of photography. The year before, Eisenstaedt's first one-man show appeared at the George Eastman House in Rochester, New York.

It was not until the age of eighty-eight that Eisenstaedt enjoyed his first large-scale retrospective, a show of 125 photographs mounted at the

International Center of Photography. The recipient of many awards, in 1989 Eisenstaedt received the National Medal of Arts. Since 1998, the Alfred Eisenstaedt Awards for Magazine Photography (known as the Eisies after Eisenstaedt's nickname), funded by a grant from *Life,* have been administered by the Graduate School of Journalism at Columbia University.

Bibliography

Ang, Tom. "Eisenstaedt in London" (interview). *British Journal of Photography* 133, no. 9 (February 28, 1986): 244–247.

Davison, Karin, dir. *Eisenstaedt: Germany.* Chicago: Perspective Films, 1982 (29-minute videocassette).

Edey, Maitland. *Great Photographic Essays from Life.* Boston: New York Graphic Society, 1978.

Eisenstaedt, Alfred. *People.* New York: Viking Press, 1973.

———. *Witness to Our Time.* Rev. ed. New York: Viking Press, 1980.

———. *Eisenstaedt: Germany.* New York: Harry N. Abrams, Inc., Publishers, 1981.

———. Interview with Barbaralee Diamonstein. In *Visions and Images: American Photographers on Photography.* New York: Rizzoli International Publications, Inc., 1981: 39–54.

———. *Eisenstaedt–Aberdeen: Portrait of a City.* Edited by Gregory Vitiello. Baton Rouge: Louisiana State University Press, 1984.

———. *Eisenstaedt on Eisenstaedt: A Self-Portrait.* New York: Abbeville Press Publishers, 1985.

———. *Eisenstaedt: Remembrances.* Edited by Doris C. O'Neil; Introduction by Bryan Holme. Boston: Little, Brown and Company, 1990.

Loengard, John. *LIFE Photographers: What They Saw.* Boston: Little, Brown and Company, 1998.

Selected Public Collections

Art Gallery of Ontario, Toronto
Baltimore Museum of Art
Gibbes Museum of Art, Charleston, South Carolina
International Center of Photography, New York
Mississippi Museum of Art, Jackson
Museum of Photographic Arts, San Diego
National Portrait Gallery, Washington, D.C.
Nelson-Atkins Museum of Art, Kansas City, Missouri

Jacob Epstein (1880–1959), sculptor and draftsman.

A groundbreaking sculptor, Jacob Epstein modeled many bust-length portraits of well-known figures in bronze, including *Joseph Conrad* (1924, Manchester City Art Gallery, Manchester, England), *Albert Einstein* (1933, Hirshhorn Museum and Sculpture Garden, Washington, D.C.), and *George Bernard Shaw* (1934, Huntington Library, Art Collections and Botanical Gardens, San Marino, California). While Epstein's portraits are typically rendered in a naturalistic

fashion with heavily textured surfaces—and are arguably his best known images—most of his other sculptures reflect a more modernist bent derived from non-Western sources and ancient art, causing much controversy in the artist's own day.

Epstein's life trajectory differs from most other Jewish American artists; he was born in the United States and immigrated to Europe, becoming a British citizen in 1907 after living in London for two years. Raised on the Lower East Side of New York City by Eastern European immigrant parents who strictly practiced Judaism, Epstein's immediate environment provided a formative influence on his early work. Even when his parents moved uptown, Epstein remained on the Lower East Side and drew inspiration from his surroundings. In 1902, Epstein made fifty-two drawings and a cover design for Hutchins Hapgood's *Spirit of the Ghetto,* a book describing the Jewish world and immigrant life on the Lower East Side. Illustrating Hapgood's discourse, Epstein's drawings show his religiocultural brethren in this immediate environment; Epstein sensitively rendered such common scenes as a rabbi deeming food kosher, pushcart peddlers, and Orthodox Jews praying and studying, as well as aspects of Yiddish culture, such the ubiquitous Jewish café. Years later Epstein recalled in his autobiography: "The earnestness and simplicity of the old Polish-Jewish manner of living has much beauty in it, and an artist could make it the theme of very fine works. This life is fast disappearing on contact with American habits, and it is a pity that there is no Rembrandt of today to draw his inspiration from it before it is too late" (10). Perhaps Epstein laments his own eventual disregard for New York's Jewish world, for interest in his childhood community soon waned, and sculpture became his most pressing consideration.

Epstein studied drawing at the Educational Alliance as a boy and then drawing and sculpture at the Art Students League (c. 1894–1902). Continuing his artistic education after arriving in Paris in October 1902, Epstein attended the École des Beaux-Arts (1903) and the Académie Julian (1904). Soon after relocating to London in 1905, Epstein received an important commission to decorate the façade of the British Medical Association Building. At the urging of the building's architect, Epstein carved eighteen nude figures in stone (1907–08), modeled after classical sources and affected by the ever-present influence of Auguste Rodin. Deemed indecent, the sculptures were immediately maligned and subsequently destroyed in 1937. The uproar over the pieces was so great that until 1949 Epstein was only sporadically awarded major commissions.

A commission to design Oscar Wilde's tomb in Père Lachaise cemetery in Paris (1911) resulted in a rectilinear, stone-carved, naked male figure inspired by the Assyrian sculptures that Epstein saw at the British Museum. The winged male retains the shape of the original stone block, possesses stylized features, and has exposed genitalia. Epstein's fascination with non-Western art was augmented during a 1912 trip to Paris when he met Pablo Picasso and others interested in African sculpture (over the years Epstein amassed his own large collection of non-Western art). In 1913, Epstein showed a work at the Armory Show in New York and also had his first solo exhibition at

London's Twenty-One Gallery. Even more controversial was *Rock Drill* (1913–15), which integrated an actual drill on a tripod with a plaster sculpted robot-like figure wearing a visor. Appearing phallic and influenced by a then-popular British movement in art and literature known as Vorticism, which derived inspiration from the emerging machine-age, *Rock Drill* was called "hideous" by critics, among other soubriquets, and ultimately Epstein dismantled the piece. The remaining torso of the driller, cast in bronze, resides at the Tate Gallery in London.

Following a brief stint in a Jewish regiment of the British army (1917–18), Epstein suffered a nervous collapse. Soon after recovering Epstein sculpted a bronze, expressionistic *Risen Christ* (1917–19, Gallery of Modern Art, Edinburgh, Scotland), his first sculpture on a religious theme. This roughly modeled sculpture is characteristic of much of Epstein's work in bronze; unlike, for example, **William Zorach**, Epstein leaves traces of his presence. Zorach, a friend, admired Epstein, who he described as "the greatest sculptor of this age, just as Rodin was the greatest sculptor of his time" (136). A comment on the horrors of war, the over seven-foot tall *Risen Christ* was later vandalized with fascist and Nazi insignia, and critics questioned whether an artist of Epstein's religion was suited to sculpt such a subject. A memorial executed in relief for writer W.H. Hudson (1923–25) in Hyde Park, London—heavily affected by archaic art—provoked similar anti-Semitic attacks. In an important essay, Elizabeth Barker addresses the issue of Judaism in Epstein's early career, discussing the tendency of critics to equate his interest in Other or primitive cultures with the artist's own primitiveness, translated as Jewishness.

Indeed, even though Epstein never explicitly rendered Jewish subjects (his many biblical scenes may simply be explorations of a popular subject from the history of art, although future scholarship on these images could prove otherwise), comments tinged with anti-Semitism were frequently hurled at the artist. Moreover, Epstein endured some condemnation from the Jewish community for a perceived breaking of the Second Commandment in the choice of sculpture as his favored medium. As John Betjeman summarized in a 1934 essay on Epstein in a book on famous Jews from the era: "Ever since he first made his public appearance in 1907, Jacob Epstein has been accused of blasphemy, immorality, obscenity, sensationalism, perversion, delighting in ugliness, breaking the Ten Commandments, breaking the conventions, incompetence, decadence, adultery, treachery, lack of patriotism, and many others of the major crimes which it is possible to commit in the present state of society" (85). Betjeman also noted that Epstein's work derived from Judaism, although he does not provide concrete examples of why he read the sculptor's work as such. Instead, Betjeman implies that an inherent (and ambiguous) Jewishness in Epstein propelled his sculpture. This important quote is worth including at length (and also worth further exploration):

> Primarily Epstein is a Jew and proud of it. But unlike so many Jews who assimilate the customs and aesthetic standards of the country of their adoption, Epstein has chosen to get his inspiration from Jewry....His Jewish blood has stood him in good stead, for his sculpture has an Old

Testament quality that is a change from the Graeco-Roman [*sic*] efforts of Royal Academicians. This Biblical quality is, moreover, indigenous to him and his race, a more genuine source of inspiration than could be Greek or Roman sculpture to an Englishman. Yet we were told by the popular press that Epstein was blasphemous when he made Christ a beardless Jew. Certainly Epstein has been influenced by Rodin, African sculpture and Cubism; but they have been a means to an end: they have given the finish to his amazingly accomplished technique. They have not been his inspiration. Jewry has made him a poet (85–86).

One of several biblical stories sculpted by Epstein, the alabaster-carved, enormous *Jacob and the Angel* (1940–41, Tate Gallery, London) (see figure) depicts a nude, muscular, exhausted Jacob, his head tilted back in resignation, in a sensual embrace with the winged angel. This seven-foot high, four-foot square work was again not accorded respect or admiration from most critics or the general public. Many objected to the perceived sexual undertones of the piece as well as the style, which retained elements of the original material as seen, particularly, in the flat slab that delineates the angel's wings. Exhibited

Jacob Epstein, *Jacob and the Angel*, 1940–41. Alabaster, 84 × 43 × 46 inches. Tate Gallery, London. © Tate, London 2006.

in 1942 at the Leicester Galleries, the sculpture did not sell. For years, *Jacob and the Angel* was shown in ignominy at several unfortunate venues. From 1954 to 1961, *Jacob and the Angel,* accompanied by two other alabaster sculptures by Epstein, *Adam* (1938–39, Harewood House, Yorkshire) and *Consummatum Est* (1936, Scottish National Gallery of Modern Art, Edinburgh), were displayed at a sideshow in Blackpool, England.

Finally appreciated for his individuality and contributions to modern sculpture, Epstein was knighted in 1954, two years after a retrospective of his work was held at the Tate Gallery. Epstein's autobiography, *Let There Be Sculpture,* was published in 1940.

Bibliography

Barker, Elizabeth. "The Primitive Within: The Question of Race in Epstein's Career, 1917-1929." In *Jacob Epstein: Sculpture and Drawings,* Evelyn Silber and Terry Friedman, et al. Leeds, England: W.S. Maney and Son in association with The Henry Moore Centre for the Study of Sculpture, 1989. (In addition to Barker's essay, the entire book is excellent.)

Betjeman, John. "Jacob Epstein." In *Twelve Jews.* Edited by Hector Bolitho, 83–100. London: Rich and Cowan Limited, 1934.

Black, Robert. *The Art of Jacob Epstein.* Cleveland: World Publishing Company, 1942.

Buckle, Richard. *Jacob Epstein: Sculptor.* Cleveland: World Publishing Company, 1963.

Cork, Richard. *Jacob Epstein.* Princeton: Princeton University Press, 1999.

Epstein, Jacob. *Let There Be Sculpture.* New York: G.P. Putnam's Sons, 1940. A slightly expanded version was published as *Epstein: An Autobiography.* London: Hulton Press, 1955.

Epstein, Jacob and Arnold Haskell. *The Sculptor Speaks: A Series of Conversations on Art.* Garden City, NY: Doubleday, Doran, and Company, 1932.

Gardiner, Stephen. *Epstein: Artist Against the Establishment.* New York: Viking, 1993

Hapgood, Hutchins. *The Spirit of the Ghetto.* Cambridge, MA: The Belknap Press of Harvard University, 1902.

Rose, June. *Demons and Angels: A Life of Jacob Epstein.* New York: Carroll and Graf Publishers, 2002.

Silber, Evelyn. *The Sculpture of Epstein: With a Complete Catalogue.* Lewisburg, PA: Bucknell University Press, 1986.

Zorach, William. *Art is My Life: The Autobiography of William Zorach.* Cleveland: World Publishing Company, 1967.

Selected Public Collections

Albright-Knox Art Gallery, Buffalo, New York
British Museum, London
Corcoran Gallery of Art, Washington, D.C.
Los Angeles County Museum of Art
Museum of Modern Art, New York
Philadelphia Museum of Art
San Francisco Museum of Modern Art
Seattle Art Museum, Washington

Philip Evergood (1901–73), painter and printmaker.

A leading Social Realist painter who combined elements of fantasy with his artistic commentary, Philip Evergood was committed to, as he put it, "the prodigious feat of combining art, modernity, and humanity" (Evergood, 259). Born as Philip Blashki in New York City to a Jewish painter-father and a gentile mother, Evergood's artistic interests emerged at age four. While supportive of his endeavors, Evergood's parents also wanted him to be properly educated, and so in 1909 he went to London to attend boarding school. Plans to join the British Navy fell apart when Evergood's appendix burst, causing a lengthy hospital stay. Evergood also remembered that his father corresponded with Winston Churchill in 1914 about the possibility that his son was excluded from naval service because of his surname. Churchill responded that it would be advisable to change the family name to something less ethnic, which Evergood's father promptly did (Baur, 18–19).

Evergood remained in London for many years, beginning his professional training at the Slade School of Fine Art (1921–23). He returned to New York for additional art studies at the Art Students League (1923) and the Educational Alliance (1924), subsequently continued in Paris (1924–25). Back in New York City by 1926, Evergood enjoyed his first one-person show of fifty-three paintings and etchings, mostly biblical in nature, in November of the following year at the Dudensing Gallery. A final stint in Europe followed, where Evergood exhibited his first drypoint etching (a process he learned from **Harry Sternberg**), *Head of a Jew* (1924), at the Salon d'Automne in 1925 (Willard, 13).

After settling permanently in New York with his new wife (1931), Evergood continued to focus on biblical scenes. Upon gaining employment with the government's Public Works of Art Project and its offspring the Works Progress Administration (WPA), Evergood was assigned to the mural section (1936). Painted on over 150 square feet of wall at a public library in Richmond Hill, New York, *The Story of Richmond Hill* presents the fruits of a successful community in a tripartite construction. On the left side of the horizontal mural Evergood depicts a happy, vital group, which resulted from the hard work of the city's founders, shown at center, who eradicated the slums, on the far right. Later, he executed the murals *Cotton from Field to Mill* (1938) for a post office in Jackson, Georgia and *The Bridge of Life* (1940–42) at Kalamazoo College, where Evergood was an artist-in-residence.

It was during the Great Depression that Evergood turned his interests to subjects of social injustice. Evergood's liberal politics did not only manifest artistically as he was also personally active in the causes that interested him; on two occasions he was arrested for striking. The artist explained the correlation between his art and his convictions: "this is putting it a little crudely, or rather too simply, but I don't think that anybody who hasn't been really beaten up by the police badly, as I have, could have painted an *American Tragedy*" (Baur, 35). One of his best known canvases, the dogmatic *American Tragedy* (1936, Collection Mrs. Gerritt Pieter Van de Bovenkamp, New York City)—which takes its title from the Communist writer Theodore Dreiser's

well-known book—documents an encounter between striking workers and the
police in front of a Chicago steel mill on Memorial Day, 1937. Combining news-
paper photographs with his imagination, Evergood portrays a worker at center
protecting his pregnant wife amid police beatings and gunfire. Purposely
delineating his subjects in an awkward fashion and with deliberate color con-
trasts, the canvas is paradigmatic of Evergood's paintings made in the 1930s.

World War II incited Evergood to paint several works that commented on
both the destruction and the consequences of the years of combat. *The Quaran-
tined Citadel* (1945, private collection) satires war in general as Evergood exiles
a bevy of soldiers to an island, providing them only with toy weapons and an
amusement park airplane ride with which to carry out their battles. Blending
his earlier interest in biblical subjects with the contemporary, the oil painting
Doom of the Chariots (1942, collection unknown) shows Moses crossing the
Red Sea amid drowning Egyptians who the artist rendered as Nazi soldiers.
Evergood also addressed the war in his printwork; *Aftermath of War* (1945)
portrays an exhausted family resting on crates, the mother barely mustering
the energy to feed her child, and the father, with a blanket covering his head
like a prayer shawl, comforting his son. Behind the family grouping, far
in the background, two additional refugees walk away with their worldly
possessions in satchels slung over their backs.

By the mid-1940s, while occasionally still commenting on social issues, Ever-
good's sensibilities turned permanently toward fantasy, often imbued with
challenging symbolism. *The New Lazarus* (Whitney Museum of American Art,
New York) (see figure), for example, a painting started in 1927, enlarged

Philip Evergood, *The New Lazarus*, 1927–54. Oil on plywood, 48 × 83¼ inches. Whitney
Museum of American Art, New York. Gift of Joseph H. Hirshhorn, 54.60. Photograph © Whitney
Museum of American Art, New York.

around 1940, and worked on intermittently until 1954, combines diverse elements. Comprised of dozens of boldly rendered figures ranging from soldiers to Jesus on the cross to a lynched black man and a ghost playing the violin, the large canvas affirms the potential of humanity as at front Lazarus re-rises amid flowers symbolizing hope.

Well-regarded in his own day, Evergood enjoyed a retrospective of fifty-eight works in 1946 at the ACA Gallery. A major retrospective staged at the Whitney Museum of American Art (1960) traveled to six other venues, showcasing Evergood's various subjects, and increasingly decorative and complex approach to his compositions.

Bibliography

Amishai-Maisels, Ziva. *Depiction and Interpretation: The Influence of the Holocaust on the Visual Arts.* New York: Pergamon Press, 1993.

Baur, John I.H. *Philip Evergood.* New York: Harry N. Abrams, Inc., Publishers, 1975.

Evergood, Philip. "Sure, I'm a Social Painter." *Magazine of Art* 36, no. 7 (November 1943): 254–259.

Hills, Patricia. "Philip Evergood's *American Tragedy*: The Poetics of Ugliness, The Politics of Anger." *Arts Magazine* 54, no. 6 (February 1980): 138–142.

Larkin, Oliver. *Twenty Years of Evergood.* New York: ACA Gallery and Simon and Schuster, 1946.

Lippard, Lucy R. *The Graphic Work of Philip Evergood: Selected Drawings and Complete Prints.* New York: Crown Publishers, Inc., 1966.

Noverr, Douglas A. "The Midwestern Industrial Landscapes of Charles Sheeler and Philip Evergood."*Journal of American Culture* 10, no. 1 (1987): 15–25.

Shapiro, David, ed. *Social Realism: Art as a Weapon.* New York: Frederick Ungar, 1973.

Taylor, Kendall. *Philip Evergood: Never Separate from the Heart.* Lewisburg, PA: Bucknell University Press, 1987.

Valente, Alfredo. *Philip Evergood: A Painter of Ideas.* South Brunswick, NJ: A.S. Barnes, 1969.

Willard, Charlotte. Moses Soyer. Foreword by Philip Evergood. Cleveland: The World Publishing Company, 1962.

Selected Public Collections

Boston Museum of Fine Arts
Hirshhorn Museum and Sculpture Garden, Washington, D.C.
Los Angeles County Museum of Art
Metropolitan Museum of Art, New York
Pennsylvania Academy of the Fine Arts, Philadelphia
Rose Art Museum, Brandeis University, Waltham, Massachusetts
Smithsonian American Art Museum, Washington, D.C.
Whitney Museum of American Art, New York

Moses Jacob Ezekiel (1844–1917), sculptor.

Born in Richmond, Virginia, Moses Jacob Ezekiel was the first Jewish American artist to earn international acclaim. Despite discouragement at various times due to lack of patronage, Ezekiel persevered because, he wrote in his autobiography *Memoirs from the Baths of Diocletian* (published post-humously in 1975), "the race to which I belong had been oppressed and looked down upon through so many ages, [that] I felt that I had a mission to perform. That mission was to show that, as the only Jew born in America up to that time who had dedicated himself to sculpture, I owed it to myself to succeed in doing something worthy in spite of all the difficulties and trials to which I was subjected" (281).

Ezekiel's sculpture is imbued with elements of both his Southern and his Jewish roots. As a youth he modeled *Cain Receiving the Curse of the Almighty* and *Moses Receiving the Law on Mount Sinai*, and made a large drawing in crayon he called *The Revolt of the Children of Israel in the Desert and the Stoning of Moses*. All three works are now lost. He attended the Virginia Military Institute (1862–66) and served in the Confederate army during the American Civil War. After the war he studied art in Cincinnati, where his parents had relocated in 1868, and at the Berlin Academy of Art (1869–71).

His bas-relief *Israel* (1873) represents Israel allegorically (Hebrew Union College Collection, Skirball Museum, Cincinnati) (see figure). At the center of the panel Israel is shown in the manner of Jesus at the crucifixion, arms upraised and feet nailed to a tree stump. To this muscular figure's left a seated woman wearing the crown of Jerusalem represents Israel's patience, and on the right side a strong, unconquered man symbolizes Israel hopeful. At the feet of Israel crucified, Israel in despair bows his head in defeat. The panel won the Michael Beer Prix de Rome. The first foreigner to receive the prize, Ezekiel embarked on two years of study in Rome beginning in 1874, where he then settled permanently. His studio in the ruins of the Baths of Diocletian became a fashionable gathering place for artisans of all persuasions, as well as royalty and politicians.

The B'nai B'rith provided Ezekiel with his first major commission in 1874 on the occasion of the upcoming 1876 Centennial Exposition. His subsequent marble group *Religious Liberty* (National Museum of American Jewish History, Philadelphia) rises twenty-five feet tall. Allegorical in conception, the monument presents the classicized Liberty as an eight-foot woman wearing a cap with a border of thirteen stars to symbolize the original colonies. In one hand she holds a laurel wreath and the other hand extends protectively over the idealized young boy at her right, a personification of Faith who holds a flaming lamp. At Liberty's feet an eagle representing America attacks a serpent symbolizing intolerance, and Faith steps on the serpent's tail. The group stands on a pedestal that bears the inscription "Religious Liberty, Dedicated to the People of the United States by the Order B'nai B'rith and Israelites of America." Even though the B'nai B'rith reneged on some payment because of financial difficulties, Ezekiel continued working on the sculpture, living in

Moses Jacob Ezekiel, *Israel,* 1873. Bronze cast relief, 44 × 66 inches. Hebrew Union College Collection, Skirball Museum, Cincinnati, Ohio.

poverty and borrowing money to pay for materials because, he wrote, "it was the first monument that any Jewish body of men had ever wanted to place in the world; the matter had been published to the world, I had received the commission without ever seeking it, an it would have been an eternal disgrace upon every Jewish community in America if the work had been abandoned" (Ibid., 185). This was one of the earliest of several monuments Ezekiel made for the United States as well as for European countries. Among others are bronze statues of Stonewall Jackson, a commission from the Charleston, West Virginia chapter of the United Daughters of the Confederacy (1909, Virginia Military Institute Parade Grounds), and Edgar Allen Poe, commissioned by the Women's Literary Club of Baltimore for Wyman Park in Baltimore (1915), now located at the University of Baltimore.

Ezekiel received one of his biggest commissions in 1877 when William Corcoran requested that the artist make eleven marble sculptures of famous artists for the niches of the original Corcoran Gallery in Washington, D.C. (now the Renwick Gallery). All but one of the sculptures, which included *Raphael, Albrecht Dürer, Rembrandt,* and *Phidias,* are now in the Norfolk Botanical Gardens (*Thomas Crawford* is in the Virginia Museum).

Over the years, Ezekiel occasionally addressed biblical stories. Several are mentioned in his autobiography, but few are extant. He depicted Jesus several

times, including a presentation titled *Christ in the Tomb* (1896, Chapelle de Notre Dame de Consolation, Paris) that shows Jesus with Semitic features. Destroyed by a fire in 1972, Ezekiel designed a memorial window at Temple Knesseth Israel in Philadelphia (1908) for Isaac Mayer Wise, a leader of Reform Judaism and the founder of Hebrew Union College. At the center of the window was Judas Maccabeus, symbolizing the endurance of Wise, and the bottom bore an inscription from Daniel 12:3. A torso of *Judith* (1881) and the life-size bronze *Eve Hearing the Voice* (1876) are both located at the Cincinnati Art Museum. *Eve Hearing the Voice* depicts a nude Eve after she has been tempted by the serpent and eaten from the Tree of Knowledge (Gen. 3:8). The naturally modeled Eve averts her head and painfully attempts to hide her face with her left arm. Interestingly, Eve is portrayed without a navel, for Ezekiel literally interpreted the biblical text that says that Eve was fashioned from one of Adam's ribs (Ibid., 181). At Eve's feet, the serpent coils around the rock on which she cowers.

In 1876, Ezekiel discussed his views on Jewish art and the categorization Jewish artist:

> I must acknowledge that the tendency of the Israelites to stamp everything they undertake with such an emphasis [Jewish art] is not sympathetic with my taste. *Artists* belong to no country and to no sect–their individual religious opinions are matters of conscience and belong to their households and not to the public. In reference to myself, this is my standpoint. Everybody who knows me knows that I am a Jew–I never wanted it otherwise. But I would prefer as an artist to gain first a name and reputation upon an equal footing with all others in art circles. It is a matter of absolute indifference to the world whether a *good artist* is a Jew or a Gentile and in my career I do not want to be stated with the title of "Jewish sculptor" (Philipson, 9–10).

Ezekiel designed the seal for the recently established Jewish Publication Society of America in 1888. Inscribed in the seal, which shows Jerusalem with a shield of David, is the motto "Israel's mission is peace." He also executed portrait busts, including bronze heads of *Rabbi Isaac Mayer Wise* (1899, Hebrew Union College, Cincinnati), who he modeled from life, and *Robert E. Lee* (c. 1886, Virginia Military Institute Museum, Lexington), a figure that encouraged Ezekiel to pursue an art career, but who the artist sculpted posthumously. While accurate likenesses, Ezekiel was not interested in probing the psychology of his sitters like **Jo Davidson**.

Internationally known, Ezekiel received the cavalier's cross of merit for art and science from the grand duke of Saxe-Meiningen in 1887, was honored by the emperor of Germany in 1893, visited Theodore Roosevelt at the president's request in 1902, and was knighted by the king of Italy in 1907. Although he lived most of his adult life in Rome, Ezekiel's will specified that his body return to America after his death. In 1921, he was buried at the foot of the thirty-two and half foot confederate memorial he designed for Arlington National Cemetery (1914). A eulogy by President Warren Harding was read at the ceremony.

Bibliography

Ezekiel, Moses Jacob. *Moses Jacob Ezekiel: Memoirs from the Baths of Diocletian.* Edited by Joseph Gutmann and Stanley F. Chyet. Detroit: Wayne State University Press, 1975.

Greenwald, Alice M., ed. *Ezekiel's Vision: Moses Jacob Ezekiel and the Classical Tradition.* Philadelphia: National Museum of American Jewish History, 1985.

Philipson, David. "Moses Jacob Ezekiel." *Publications of the American Jewish Historical Society* 28 (1922): 1–62.

Soria, Regina. "Moses Ezekiel's Studio in Rome." *Journal of the Archives of American Art* 4, no. 2 (April 1964): 6–9.

Selected Public Collections

Arlington National Cemetery, Virginia (public sculpture on grounds)
Cincinnati Art Museum
Hebrew Union College Collection, Skirball Museum, Cincinnati
National Museum of American Jewish History, Philadelphia (public sculpture on grounds)
Skirball Cultural Center, Los Angeles
University of Baltimore (public sculpture on grounds)
University of Virginia, Charlottesville (public sculpture on grounds)
Virginia Military Institute Museum, Lexington

F

Herbert Ferber (1906–91), sculptor and painter.

Primarily an abstract sculptor during the years of the American ascension in the art world, Herbert Ferber's work can be found in museums, in outdoor settings, on facades of buildings, and as decoration for synagogues. A native of New York City, Ferber was born Herbert Ferber Silvers. While studying at the City University of New York and Columbia University, where he received a B.S. (1927) and a D.D.S. (1930), respectively, Ferber also took classes at the Beaux Arts Institute of Design (1927–30) and the National Academy of Design (1930).

His early direct carvings in wood employed techniques akin to that of **William Zorach** and **Chaim Gross**. These small figurative sculptures engaged social justice themes, popular with painters such as **Ben Shahn**. Indeed, during the 1930s Ferber belonged to several groups committed to social justice causes, including the John Reed Club. Two small sculptures titled *Wrestlers* (1934, Rutgers University Art Gallery, New Brunswick, New Jersey; 1936, private collection, New York) employ nude male figures locked in an embrace as a metaphor for life's struggles (Agee, 10–11). These works earned Ferber his first solo exhibition, mounted by the Midtown Galleries in 1937. More overt Social Realist themes surface in the granite *To Fight Again* (1937, Metropolitan Museum of Art, New York) and bronze *Shadow of a Hero (Alter Ego)* (1943, private collection). In both the human figure remains at the core of the work, but in the latter fifteen-inch sculpture the two figures have lost their monolithic quality. Instead, Ferber portrays attenuated, distorted men that anticipate the artist's equal focus on positive and negative space in his nonobjective work.

Influenced by Henry Moore's simplified sculptural technique and the "transparent," architectonic sculptures of Jacques Lipchitz, by the late 1940s, Ferber eschewed illusionism and began welding bronze, lead, copper, and brass. As he developed his mature open-form abstract style, Ferber first used a gas torch and then a blowtorch, until 1954 when he discovered the oxyacetylene torch, an inexpensive, portable torch that reached high temperatures. Akin to Abstract Expressionist painters, early on Ferber derived inspiration from Surrealist imagery and ancient myth.

Ferber enjoyed several public commissions, including the decor for Congregation B'nai Israel, Millburn, New Jersey (1951); Temple Anshe Chesed, Cleveland, Ohio (1956); Temple of Aaron, St. Paul, Minnesota (1956); and the

Kennedy Office Building, Boston (1966). A twelve-foot tall abstractly rendered burning bush made of jagged lead-coated copper adorns a wedge-shaped panel projecting from the facade of Congregation B'nai Israel (see figure). Titled *And the Bush was not Consumed*, this symbolic representation evokes the impression of flames through an open biomorphic style that incorporates snaking vertical and spiral forms. Ferber's textured sculpture identifies the building and serves as a metaphor for the Jewish people. Indeed, the rabbi of the congregation felt that, like the Jewish people, the bush was burned but not consumed (Kampf, 79). While initially *And the Bush was not Consumed* was allowed to stand on its own as an abstract testimonial, at some point after the installation the title was added below the sculpture, prompting Ferber's

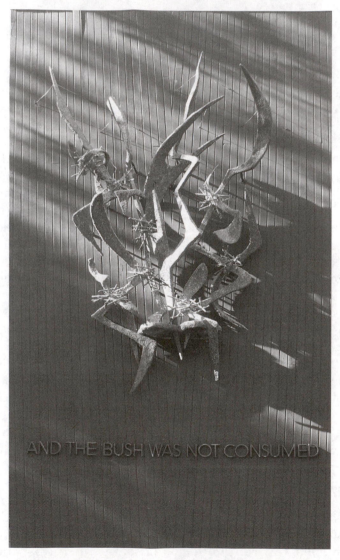

Herbert Ferber, *And the Bush was not Consumed,* 1952. Copper, brass, and lead facade sculpture, 12 × 8 feet. Congregation B'nai Israel, Milburn, New Jersey. Photo: Barry P. Allen.

biographer E.C. Goossen to observe that such a "vulgarism... indicates how little chance abstract art has to make its own kind of statement" (*Hebert Ferber*, 75). This commission was the impetus for several other sculptures designed specifically for walls.

During the 1950s, Ferber experimented with placing "roofs" on his sculptures, a practice that was replaced in the early 1960s by a series titled *Homage to Piranesi* in which he enclosed rhythmic, calligraphic forms in open wire cages. In March 1961, Ferber's *Sculpture as Environment* was temporarily installed in a room at the Whitney Museum of American Art. One of the first sculptures designed to encompass indoor space on a large scale, the work helped to stimulate a widespread movement of installation art in the early 1970s. Filling the entire room with abstract, undulating forms that encompassed the walls, floor, and ceiling, Ferber described his environmental, site-specific sculpture as the integration of "sculpture and a space each of which would be meaningless if one were removed" (71). Lori Verderame understood Ferber's work similarly: "Ferber's interest in the way Abstract Expressionist paintings function as environments with their minimal imagery is similar to the manner in which he wanted viewers to experience his sculptures. The artist wanted viewers to understand, conceive and enjoy his sculptures from a place within the middle of the piece. He made works that forced viewers to consider the entire context and environment of the sculpture, from the inside out" (19). A modified version of *Sculpture as Environment* is in the permanent collection at Rutgers University in New Brunswick (1968).

Lesser known are Ferber's canvases and works on paper. These abstract images typically show the influence of color field painting as exemplified by **Mark Rothko** and **Barnett Newman**, established Abstract Expressionist artists with whom Ferber associated. Many of Ferber's paintings employ abstract, simplified, boldly colored shapes rendered with a painterly stroke. Stimulated by the three-dimensions of sculpture, in 1977 Ferber began cutting triangles into his canvases, creating a raised area. Termed "constructions" by the artist, these paintings create shadow and animation through their three-dimensionality while blurring the distinctions between painting and sculpture (Goossen, *Hebert Ferber*, 194).

Ferber's first major retrospective was shown at the Walker Art Gallery in Minneapolis (1962), and in 1981 the Museum of Fine Arts in Houston held another retrospective. While these accomplishments are significant, Ferber's art has been critically neglected, as has the sculpture of other artists of the New York School, including **Ibram Lassaw** and **Seymour Lipton**.

Bibliography

Agee, William C. *Hebert Ferber: Sculpture, Painting, Drawing, 1945-1980*. Houston: Museum of Fine Arts, 1983.

Anderson, Wayne. *The Sculpture of Herbert Ferber*. Minneapolis: Walker Art Center, 1962.

Faison Jr., S.L. "Sculpture of Herbert Ferber." *Art Journal* 17, no. 4 (Summer 1958): 363–371.

Ferber, Herbert. "Sculpture as Environment." *Art International* 4 (May 1960): 71.

Goossen, E.C. *Hebert Ferber*. New York: Abbeville Press, 1981.

Goossen, E.C., R. Goldwater, and I. Sandler. *Three American Sculptors: Ferber, Hare, and Lassaw*. New York: Grove Press, 1959.

Kampf, Avram. *Contemporary Synagogue Art: Developments in the United States, 1945-1965*. New York: Union of American Hebrew Congregations, 1966.

Phillips, Lisa. *The Third Dimension: Sculpture of the New York School*. New York: Whitney Museum of American Art, 1984.

Polcari, Stephen. *Herbert Ferber: Calligraph, Emblem of Motion*. New York: Knoedler & Company, 2001.

Tuchman, Phyllis. "An Interview with Hebert Ferber." *Artforum* 9, no. 8 (April 1971): 52–57.

Verderame, Lori. *The Founder of Sculpture as Environment: Hebert Ferber (1906-1991)*. Hamilton, NY: The Picker Art Gallery, Colgate University, 1998.

Selected Public Collections

Albright-Knox Art Gallery, Buffalo
Hirshhorn Museum and Sculpture Garden, Washington, D.C.
Metropolitan Museum of Art, New York
Museum of Fine Arts, Houston
Museum of Modern Art, New York
National Gallery of Art, Washington, D.C.
Whitney Museum of American Art, New York
Yale University Art Gallery, New Haven, Connecticut

Audrey Flack (1931–), painter and sculptor.

Unlike typical photorealist artists such as Richard Estes, who coolly paint neutral content derived from photographs, Audrey Flack's intensely illusionist canvases plumb personal and feminist issues replete with complex symbolic iconography. Born in New York City to Eastern European immigrant parents, Flack knew that she wanted to be an artist as a child; among her early works is a watercolor of rabbis in a synagogue done when she was around fourteen years old. She studied at the High School of Music and Art and Cooper Union (1948–51), later receiving her B.F.A. from Yale University (1952) where she apprenticed with the modernist Josef Albers. Through the early 1950s Flack painted canvases in a gestural style influenced by Abstract Expressionism, as exhibited at a solo show at the Roko Gallery (1959) in New York. Additional studies at the Art Students League confirmed her desire to paint in a representational fashion.

During the 1960s Flack began to utilize photographs as the inspiration for her paintings. Initially she used black-and-white news photographs as source material, most notably for painting public figures such as John D. Rockefeller (1963, Greater Lafayette Museum of Art, Indiana) and Adolf Hitler (1963–64, Allen Memorial Art Museum, Oberlin, Ohio) in subdued colors. A canvas of John F. Kennedy (1964, private collection) was her first painting in this vein from a media-generated color photograph. In the mid-1970s, Flack started the

large-scale still lifes for which she is best known. Comprised of three paintings all eight feet square, her early *Vanitas* series (1976–78) drew inspiration from Baroque still life allegories that comment on the transience of life. Based on configurations of objects arranged by Flack in her studio and then photographed, the *Vanitas* canvases were executed with an airbrush from a slide projected on a wall.

The first of the group, *World War II (Vanitas)* (1976–77, Private collection, Pennsylvania) (Color Plate 6), combines a magnified, sharply delineated still life with a reproduction of *Life* photographer Margaret Bourke-White's famous photograph of the liberation of Buchenwald. Rendered in black-and-white, the exhausted and stunned prisoners behind the barbed wire fence contrast with the rich, glowing colors of the pastries. Among the array of objects in front of Bourke-White's duplicated photograph are a red candle dripping like blood, a rose, shiny pearls, a Star of David from Flack's keychain, and a book open to a quote about faith from a Hasidic rabbi. Flack explained why she amalgamated such diverse elements: "My idea was to tell a story, an allegory of war...of life...the ultimate breakdown of humanity...the Nazis....to create a work of violent contrasts, of good and evil. Could there be a more violent contrast than that?" (exact transcription from original; *Audrey Flack on Painting*, 78). Holocaust survivors at a luncheon honoring the painting noted the contrast. Flack remembered that one survivor said, "I know why you put sweets there—because I would imagine the little bread that I ate before I was in the camp was sweet like that" (Telephone conversation). Reviews of *World War II (Vanitas)* were not always favorable and so such comments meant a lot to Flack, who "felt redeemed" (Ibid.). Indeed, critic Vivien Raynor completely misunderstood the painting, calling it "horrendous" and noting "this reviewer can only recoil from the vulgarity of [Flack's] literal mindedness" (C22). Other reviewers were more empathetic. John Perreault described the canvas as "breathtaking" and observed that it is "more about survival than about horror. It is a painting that is difficult to forget" (151).

Using similar lush, intense colors, and a high gloss surface, *Marilyn (Vanitas)* (1977, University of Arizona Art Museum, Tucson) explores stereotypes of femininity. Amid matter of decided feminine content, such as the perfume bottles, makeup, and jewelry that defined her, Marilyn appears young and not yet corrupted in a black-and-white photograph before she became the harsh, brittle blond of Hollywood. Flack aimed to comment on the sex symbol's ephemerality by presenting these objects and the woman along with a burning candle, a shifting hourglass, and a shriveling orange, much in the manner of seventeenth-century memento mori still lifes. Moreover, the image also evokes the artist's own vulnerability as she includes a photograph of herself as a young girl.

Flack painted a portrait of Anwar Sadat for the cover of *Time* magazine's January 2, 1978, issue on the leader as man of the year. Her composition presents Sadat in three-quarter's view against a brightly colored background. The background incorporated symbolism, described by Flack: "I guess it's too subtle but it had to be to get it through. It's the sky. The blue and white sky represents Israel – the Israeli flag – and below it are the colors of

the Egyptian flag. It was the best I could do under the circumstances" (E-mail correspondence).

In the early 1980s Flack began to make landscape watercolors and to execute large indoor and outdoor bronze sculptures, some on commission, of female goddesses such as Diana, Medusa, and Athena, as well as invented deities. Sculpted after posed models in her studio, Flack depicts these women as strong heroines rather than as stereotypically feminine, objectified figures. *Egyptian Rocket Goddess* (1990, private collection, Ontario), a semi-nude bronze with a taught body, stands forty-two inches high on her base. Striding forward, the goddess' arms—around which snakes are wrapped—thrust out. The snakes recall ancient Minoan snake goddesses whose reptiles symbolized fertility. Coalescing the modern with the ancient, the sculpture features a rocket appearing on the drapery around the goddesses' waist and on her head-dress. Critic Susan P. Casteras characterizes Flack's sculptures as "not eroti-cized images of the female body on display for men to enjoy; instead they are often pared down paragons of supple musculature and strength, feminine, and even androgynous in some cases. In essence, she has deployed male signi-fiers of body strength and assertiveness with the female body, inverting and eroding past prejudices and misconceptions about female submissiveness and male supremacy" (Gouma-Peterson, 126, 129).

When asked how she defines Jewish art, Flack replied: "I guess Jewish art is specifically religious art like Christian art and like Muslim art. It's a catchy thing because Jews aren't supposed to make images. Jewish art is probably humanist. Is *World War II* Jewish? I don't think that it's Jewish art. I think *World War II* is art that has a universal subject – war, death, evil, goodness, morality, and mortality. Jews represent humanism – to life, to life, *l'chaim*. With Jews there's a celebration of life. I think Minimalism is the opposite of Jewish art. One green pea on a piece of roast beef" (Telephone conversation).

Bibliography

Brigham, David R. "The New Civic Art: An Interview with Audrey Flack." *American Art* 8, no. 1 (Winter 1994): 2–21.

Flack, Audrey. *Audrey Flack on Painting.* Introduction by Lawrence Alloway. New York: Harry N. Abrams, Inc., Publishers, 1981.

———. *Art and Soul: Notes on Creating.* New York: E.P. Dutton, 1986.

———. *Saints and Other Angels: The Religious Paintings of Audrey Flack.* New York: Cooper Union, 1986.

———. *Audrey Flack: The Daily Muse.* New York: Harry N. Abrams, Inc., Publishers, 1989.

———. Telephone conversation with the author. May 10, 2005.

———. E-mail correspondence with the author. September 14, 2005.

Gouma-Peterson, Thalia, ed. *Breaking the Rules: Audrey Flack, A Retrospective, 1950-1990.* New York: Harry N. Abrams, Inc., Publishers, 1992.

Nemser, Cindy. *Art Talk: Conversations with 12 Women Artists.* New York: Charles Scribner's Sons, 1975.

Perreault, John. "A Painting that is Difficult to Forget." *ARTnews* 77 (April 1978): 150–151.

Raynor, Vivien. "Audrey Flack." *New York Times* (April 14, 1978): C22.

Selected Public Collections
Metropolitan Museum of Art, New York
Miami University Art Museum, Oxford, Ohio
Museum of Modern Art, New York
National Gallery of Australia, Canberra
Saint Louis Art Museum
San Francisco Museum of Modern Art
Smithsonian American Art Museum, Washington, D.C.
Whitney Museum of American Art, New York

Robert Frank (1924–), photographer and filmmaker.

Born in Zurich, Robert Frank was fifteen years old when World War II began. Although safe in neutral Switzerland, Frank later observed, "being Jewish and living with the threat of Hitler must have been a very big part of my understanding of people that were put down or who were held back" (Codrescu and Pitts, 86). During the war, Frank apprenticed with two photographers in Zurich. He moved to New York City in March 1947 and was soon hired to take fashion photographs for *Harper's Bazaar* and *Junior Bazaar.* Unhappy with the restrictions of magazine work, Frank resigned in October 1947. From 1948 until 1953 Frank traveled extensively through Europe and South America, taking photographs as a freelancer for *Harper's* and other magazines, and making pictures for his personal portfolio. Some of this work was exhibited in a group exhibition at the Museum of Modern Art in 1950. Frank applied for and won a Guggenheim Fellowship in 1954, the first European photographer to win the award. During 1955 and 1956, when the award was renewed for an additional year, Frank, his wife Mary, and their two children drove across the country to create, according to his Guggenheim Fellowship project proposal, "a broad, voluminous picture record of things American, past and present....What I have in mind, then, is observation and record of what one naturalized American finds to see in the United States that signifies the kind of civilization born here and spreading elsewhere" (Tucker and Brookman, 20).[12] At the end of his journey, Frank had shot 687 rolls of film (over 20,000 frames) that he pared down to eighty-three images, methodically arranged in book form, influenced in part by Walker Evans' canonical book *American Photographs* (1938).

Unable to find a publisher in the United States, the result of the expedition was first published in France as *Les Américains* (1958) with text by Alain Bosquet and then released in America in 1959 as *The Americans.* Filled with dark photographs, both stylistically and conceptually, the book was not well-received by the general public; reviews characterized *The Americans* as "warped," "sinister," "perverse," and "anti-American." Indeed, Frank's pictures exposed American life in the shadows, but not all viewers interpreted Frank's viewpoint as a negative. In Beat writer Jack Kerouac's introduction to the text he poetically observed: "After seeing these pictures you end up finally

not knowing any more whether a jukebox is sadder than a coffin.... With that little camera that he raises and snaps with one hand he sucked a sad poem right out of America onto film, taking rank among the tragic poets of the world" (i). Taken with a 35-mm Leica camera, Frank's shots of quintessentially American fare—parades, flags, jukeboxes, and political events—appeared to casually record and criticize his adopted country. Frank did not intend to condemn the American way, only to show a people that are "'strangers in a strange land' – bewildered, lonely despairing, angry, isolated even when caught in an embrace. What unites the young and the old, the rich and the poor, the Black people and the White people in Frank's photographs is their isolation" (Burger-Utzer and Grissermann, 88).

No doubt, Frank exposes the divisions and alienation of the era, as opposed to the sentimental and celebratory photographs of America popular at that time. Augmented by the snapshot aesthetic—a then-unconventional style deliberately employing odd angles, occasional blurriness, and seemingly spontaneous scenes—pictures such as *Political Rally, Chicago* (1956) convey a mood that critics now more popularly understand as "not harsh or bitter, but romantic, sad, and elegiac. They show that *The Americans* was not born out of hatred and disgust, not out of a desire to destroy, but rather it was a passionate cry" (Greenough and Brookman, 116). *Political Rally, Chicago* (1956), which depicts a man overwhelmed and rendered anonymous by his large tuba, is an ironic, unglamorized view of a scene that could have been pictured as quintessential Americana. *Yom Kippur–East River, New York City* (1956), cropped at an odd angle, depicts a group of observant Jews from behind. At the left side of the quiet picture the viewer sees only the top of one figure's hat, partially blurred. During Rosh Hashanah, the Jewish new year, Jews perform a ritual called *Tashlich*, which entails saying a few prayers and tossing crumbs into a body of water as a symbolic gesture indicating the casting away of sins. Possibly, Frank took the picture on Rosh Hashanah, preceding Yom Kippur by ten days, and mislabeled the image. Interested in the Others of America, Frank's picture of Jews is accompanied in *The Americans* by several images of African Americans. Frank's innovative style influenced several important photographers, including **Diane Arbus**, **Lee Friedlander**, and **Garry Winogrand**.

Following his photographic journey through America, Frank worked on a few more still image projects, only to reject photography for filmmaking. Codirected with artist Alfred Leslie, Frank's first film, the black-and-white short *Pull My Daisy* (1959), was written and voiced-over by Kerouac, and cast with Beat poets and friends of the group, including Allen Ginsberg and **Larry Rivers**. Originally titled "The Beat Generation," the twenty-eight minute film takes place in a Lower East Side, New York apartment and recounts a visit by a Swiss bishop to the home of a Beat couple who are also in the company of their bohemian friends. Friendly with **George Segal**, who he knew from the Hansa Gallery, Frank used the sculptor's chicken farm for six months as the locale for his second film, *The Sin of Jesus* (1961). Based on a short story by the Jewish writer Isaac Babel, the thirty-seven minute black-and-white film recounts the tale of an unfulfilled woman working on a chicken farm. Jesus

gives the woman an angel to curb her loneliness, but while seducing him she rolls onto the angel and kills it. In the end, Jesus condemns the woman to her gloomy earlier existence, thereby committing his own sin. Among Frank's many other films is *Cocksucker Blues,* a ninety-minute documentary about the Rolling Stones 1972 tour through the United States.

Increasingly private, Frank moved to Nova Scotia in 1970. In 1972, he revisited still images, completing a twenty-five-year retrospective book of his photography, *The Lines of My Hand.* He began to make new photographs in 1974, often addressing personal subjects. Among his many experimentations from this period are Polaroid shots, sometimes with words scratched coarsely on the surface. Several other works comprise multiple prints; in a sense Frank attempted to create with still imagery something akin to his films, which transcended the static limitations of his original medium.

Frank established an archive of his work at the National Gallery of Art in Washington, D.C., in 1990. The Whitney Museum of American Art held a Frank film retrospective in 1980. A broader retrospective exhibition comprising 159 photographs and 21 films and videos was mounted at the National Gallery of Art in 1994. Over the years, Frank has taught at several institutions, including the Nova Scotia College of Art and Design (1973) and the University of California at Davis (1975).

Bibliography

Alexander, Stuart. *Robert Frank: A Bibliography, Filmography, and Exhibition Chronology, 1946-1985.* Tucson: Center for Creative Photography in association with the Museum of Fine Arts, Houston, 1986.

Baier, Lesly K. "Visions of Fascination and Despair: The Relationship Between Walker Evans and Robert Frank." *Art Journal* 41, no. 1 (Spring 1981): 55–63.

Brookman, Philip and Amy Brookman, dirs. *Fire in the East: A Portrait of Robert Frank.* A co-production of the Museum of Fine Arts, Houston and KUHT/ Houston. Distributed by Houston: The Museum of Fine Arts, 1986.

Burger-Utzer, Brigatta and Stefan Grissermann, eds. *Frank Films: The Film and Video Work of Robert Frank.* Zurich: Scalo, 2003.

Codrescu, Andrei and Terence Pitts. *Reframing America.* Tucson: Center for Creative Photography, 1995.

Cotkin, George. "The Photographer in the Beat-Hipster Idiom: Robert Frank's *The Americans.*" *American Studies* 26, no. 1 (Spring 1985): 19–33.

Frank, Robert. *The Americans.* With an introduction by Jack Kerouac. 1959. Reprint, New York: Grossman Publishers, 1969.

———. *Robert Frank.* New York: Pantheon Books, 1985.

———. *The Lines of My Hand.* New York: Pantheon Books, 1989.

Greenough, Sarah and Philip Brookman. *Robert Frank: Moving Out.* Washington, D.C.: National Gallery of Art, 1994.

Papageorge, Tod. *Walker Evans and Robert Frank: An Essay on Influence.* New Haven: Yale University Art Gallery, 1981.

Rice, Shelley. "Some Reflections on Time and Change in the Work of Robert Frank." *The Photo Review* 13, no. 2 (Spring 1990): 1–9.

Tucker, Anne Wilkes and Philip Brookman, eds. *Robert Frank: New York to Nova Scotia.* Boston: Little, Brown and Company; Houston: Museum of Fine Arts, 1986.

Selected Public Collections

Art Institute of Chicago
Fotomuseum Winterthur, Switzerland
Los Angeles County Museum of Art
Museum of Fine Arts, Houston
Museum of Modern Art, New York
National Gallery of Art, Washington, D.C.
Philadelphia Museum of Art
Smithsonian American Art Museum, Washington, D.C.

Helen Frankenthaler (1928–), painter and printmaker.

One of the most important artists of the second generation of Abstract Expressionists, New York–born Helen Frankenthaler earned a B.A. from Bennington College (1946–49), after which she returned to New York City. She first won public recognition after art critic Clement Greenberg selected her for a New Talent Show at New York's Kootz Gallery (April 1950). After meeting Greenberg, the pair began an association that greatly influenced her art. For three weeks in the summer of 1950, Frankenthaler studied with the avant-garde painter and teacher Hans Hoffman in Provincetown, Massachusetts. By 1951 she had developed friendships with the major abstract expressionist artists; that year Frankenthaler visited Jackson Pollock and **Lee Krasner** at their Long Island home on several occasions. She had a ten-painting one-person exhibition at the Tibor de Nagy Gallery at the end of the year. Several additional solo shows at the Tibor de Nagy Gallery followed throughout the 1950s.

Employing thinned-down oil paint on an unprimed canvas, *Mountains and Sea* (1952, National Gallery of Art, Washington, D.C.) marked Frankenthaler's discovery of her signature approach to painting when she was only twenty-three years old after several years of experimenting with Cubist- and Surrealist-inspired imagery. Influenced by Jackson Pollock, Frankenthaler eschewed the paintbrush and the easel, instead placing a large canvas on the floor and pouring pigment from coffee cans on to the raw canvas. Known as stain painting, Frankenthaler's watercolor-like technique emphasized the flat canvas
while suggesting moods that are often described as lyrical. Her paint, mixed with turpentine to create a translucent effect, absorbs into the canvas, in opposition to Pollock's gestural paint, which rests on the surface of his canvas. Creating negative and positive space by leaving some of the canvas empty of pigment, the pale greens, peaches, and blues shapes on the seven by ten-foot *Mountains and Sea* evoke "the totally abstract memory of the landscape" (Elderfield, *Frankenthaler*, 66). The importance of *Mountains and Sea* transcends Frankenthaler's own development as the canvas is well known for influencing **Morris Louis** and Kenneth Noland; after seeing the painting in the spring of 1953 both artists adopted a staining technique. Indeed, Louis viewed

Frankenthaler as "a bridge between Pollock and what was possible" (Elderfield, *Morris Louis*, 13). John Elderfield, in his important book on Frankenthaler, called the painting "a transitional, albeit seminal, step between Abstract Expressionism and the Color Field abstraction of the 1960s" (65).

Although her paintings are abstract, they often find inspiration from reality. Frankenthaler described the genesis of *Mountains and Sea*: "I painted *Mountains and Sea* after seeing the cliffs of Nova Scotia. It's a hilly landscape with wild surf rolling against the rocks. Though it was painted in a windowless loft, the memory of the landscape is in the paining, but it also has equal amounts of Cubism, Pollock, Kandinsky, Gorky....I often go back to nature, the figure, or still life in order to trigger a leap into the unknown" (Frankenthaler, 34–35).

Her first retrospective exhibition was held in 1960 at the Jewish Museum, New York, the same year that *Time* magazine featured Frankenthaler in an article titled "Vocal Girls" describing the most successful second-generation Abstract Expressionists. Among the nineteen paintings shown at the Jewish Museum was *Jacob's Ladder* (1957, Museum of Modern Art, New York), a 9½ × nearly 6-foot abstract vertically oriented canvas soaked with floating organic forms of red, blue, green, and peach. Previously, *Jacob's Ladder* won first prize at the First Biennale de Paris (1959) and was also shown at the 1958 Pittsburgh International Exhibition of Contemporary Painting and Sculpture at the Carnegie Institute. Other images, all abstract, with names that evoke elements of Jewishness, include the canvases *Eden* (1956, private collection) and *Holocaust* (1955, Rhode Island School of Design, Providence), and the eleven-foot tall lithograph *Lot's Wife* (1971). The latter work, an image composed of a vertical gray shape on the left paralleled by red, green, and blue on the right and underscored by yellow, was drawn on three stones and printed on three sheets of white Japanese handmade paper. Frankenthaler described the titling of *Lot's Wife* in 1975: "I did *Lot's Wife* in one shot. I went back to do something to it and then I thought, no, don't turn back, don't look at it, leave it, it's good. That's why I called it *Lot's Wife*, because she turned and became a pillar of salt. This [sic] is sort of a pillar of salt on the left of it" (Goldman, 30).

Prints such as *Lot's Wife* play a significant yet underrated role in Frankenthaler's oeuvre. As innovative a printmaker as a painter, Frankenthaler has made lithographs, screenprints, etchings, and woodcuts. From her first published print in 1961, a lithograph appropriately titled *First Stone*, Frankenthaler has integrated abstraction—mostly through fluid shapes rather than the rigid lines typical of printmakers—with vital color that merges with the paper's surface. Between 1961 and 1995 Frankenthaler created 235 prints (Harrison, 12). Judith Goldman explains Frankenthaler's contribution to printmaking when describing the artist's first woodcut, executed in 1973: "*East and Beyond* became to contemporary printmaking in the 1970s what Frankenthaler's staining of paint into the raw unprimed canvas of *Mountains and Sea* (1952) had been to the development of color-filed painting twenty years earlier....*East and Beyond* shows how abstract, painterly aims can be translated into the

recalcitrant woodcut medium. Contemporary painters, seeing the potential of the medium, turned their attention to it. A small woodcut revival followed" (10).

Among other venues, retrospectives have been held at the Whitney Museum of American Art (1969) and New York's Museum of Modern Art (1989). A 1993 retrospective of Frankenthaler's prints (1961–93) opened at the National Gallery of Art in Washington, D.C., and traveled to San Diego, Boston, Cincinnati, and Japan. In 1998 Frankenthaler addressed her universalist view on art: "My concern was and is for good art: not female art, or French art, or black art, or Jewish art, but good art" (Frankenthaler, 28). While atypical, Frankenthaler did design a ten by six-foot torah curtain decorated with a pillar of fire (1957) for Temple B'nai Aaron in St. Paul, Minnesota.

Bibliography

Belz, Carl. "Helen Frankenthaler's *Eden*: A 'Joyously Involved Creativity.'" *ARTnews* 80, no. 5 (May 1981): 156–157.

Carmean Jr., E.A. *Helen Frankenthaler: A Paintings Retrospective.* New York: Harry N. Abrams, Inc., Publishers; Fort Worth: Modern Art Museum of Fort Worth, 1989.

Elderfield, John. *Morris Louis.* New York: Museum of Modern Art, 1986.

———. *Frankenthaler.* New York: Harry N. Abrams, Inc., Publishers, 1989.

Frankenthaler, Helen. *After Mountains and Sea: Frankenthaler 1956-1959.* With essays by Julia Brown and Susan Cross, and an interview with Helen Frankenthaler. New York: Guggenheim, 1998.

Geldzahler, Henry. "An Interview with Helen Frankenthaler." *Artforum* 4, no. 2 (October 1965): 36–38.

Goldman, Judith. *Frankenthaler: The Woodcuts.* New York: George Braziller, 2002.

Harrison, Pegram. *Frankenthaler: A Catalogue Raisonné, Prints 1961-1994.* With an introduction by Susan Boorsch. New York: Harry N. Abrams, Inc., Publishers, 1996.

Helen Frankenthaler: Paintings. Essay by Frank O'Hara. New York: Jewish Museum, 1960.

Kampf, Avram. *Contemporary Synagogue Art: Developments in the United States, 1945-1965.* New York: Union of American Hebrew Congregations, 1966.

Rose, Barbara. *Frankenthaler.* Rev. ed. New York: Henry N. Abrams, Inc., Publishers, 1979.

Solomon, Deborah. "An Interview with Helen Frankenthaler." *Partisan Review* 51, no. 4 (1984–1985): 793–798.

Selected Public Collections

Ackland Art Museum, Chapel Hill, North Carolina
Hirshhorn Museum and Sculpture Garden, Washington, D.C.
Museum of Fine Arts, Houston
Museum of Modern Art, New York
National Gallery of Art, Washington, D.C.
San Francisco Museum of Modern Art
Smithsonian American Art Museum, Washington, D.C.
Virginia Museum of Fine Arts, Richmond

Lee Friedlander (1934–), photographer.

A street photographer interested in the "American social landscape," Lee Friedlander is best known for his precise, improvised black-and-white images that show diverse subjects and sites in unusual, and often witty, ways. Indeed, Friedlander's cluttered photographs present commonplace subjects and objects in a purposefully ambiguous and contradictory fashion that leaves the viewer to interpret the meaning of the world he portrays. Early in his career, Friedlander was influenced by the vernacular, thematic pictures of the French photographer Eugène Atget; the ironic vision of Walker Evans, who Friedlander knew during his early years in New York City; and **Robert Frank**, a personal friend whose book, *The Americans*, Friedlander owned in its French version in 1958. To be sure, Friedlander's photographs suggest the authority of tradition—working in series, employing black-and-white film, and addressing themes with a venerable history—while transforming the lessons of the past into his own unique aesthetic. His larger body of images includes landscapes that nod toward Ansel Adams and nudes that evoke E.J. Bellocq, in addition to Friedlander's best-known views of America inspired by both Evans and Frank. Dozens of books feature Friedlander's unmanipulated, improvised, frequently offbeat photographs, which number at nearly 60,000.

Born in Aberdeen, Washington to a Finnish Lutheran mother and a German Jewish father both born abroad, Friedlander was raised without religion. His mother died when Friedlander was young, and after being shuffled around he eventually lived with his father, who was assisted in raising his son by a sister who had survived a concentration camp. When asked if he considers anything Jewish about his art, Friedlander succinctly replied "nothing" (written correspondence). From a young age Friedlander knew that he wanted to be a photographer, and so after graduating from high school he moved to Los Angeles to enroll at the Art Center School of Design. Quickly bored by his studies, Friedlander quit, opting instead to study privately with Edward Kaminski, one of the school's teachers (1953–55). Friedlander moved to New York in 1955, where he worked as a freelancer for commercial magazines such as *Esquire, Sports Illustrated,* and *Art in America.* A lover of jazz, Friedlander was hired by Atlantic Records to take photographs of musicians for album covers. Success came quickly for Friedlander, who won a John Simon Guggenheim Foundation Fellowship in 1960, followed by a second award in 1962. His first one-person exhibition hung at the George Eastman House in 1963. In 1967, he sold his first picture to **Jim Dine**, who he would later collaborate with on a limited edition portfolio of photographs and etchings (also published in book form). That same year, thirty of Friedlander's pictures were included in the formative *New Documents* show at New York's Museum of Modern Art, which included two other up-in-coming photographers, **Diane Arbus** and **Garry Winogrand**, the latter of whom was a close friend and colleague with a similar interest in contemporary, everyday America until his untimely death.

Friedlander's first book, *Self-Portrait* (1970), presents forty-three pictures (including the cover) taken over ten years in which he allowed his shadow or

reflection to become part of the larger subject of his photographs. Typically considered a blunder made by an amateur who does not have control of the photographic act, Friedlander's self-conscious acknowledgment of his presence makes the viewer aware of the artist's position as a maker of an image that is not an objective, or mechanical, representation. As Rod Slemmons astutely observes, with this series of pictures "Friedlander set a precedent of disrupting the normal rules of photography – which he has continued to do throughout his career....[He] continues to insist on the simple aesthetic position of making pictures about the world, not of the world" (112, 117). No doubt, taking pictures on the street with his portable viewfinder 35-mm camera, Friedlander makes us question what we see and what we know while consistently asserting the two-dimensionality of the photograph to the same end—to remind the viewer that the photograph is a creation. *Cincinnati, Ohio* (1963, Museum of Modern Art, New York) presents a bedroom in a store window with several piles of consumer products at the foot of the bed. A reflection of the street, including a lamppost and church spire, appears above the bedroom model. Then, at the center of the image, a small neon sign is also reflected, which says, "cashier." The amalgamation of these incongruous details coalesce into an elusive and playful image that exploits the contradictions inherent in a churchgoing yet materialistic America. Another common technique in Friedlander's work is a distancing of the viewer from the world captured in his frame by fragmenting our vision. He achieves this effect by including obstructions—such as tree branches, window frames, hair, and chain-link fences—in front of the larger subject in the photographs.

Free from the confines of commercial work, in the early 1970s, Friedlander embarked on a series of pictures of American monuments, subsequently published in his book *The American Monuments* (1976).[13] Taken in forty states and in Washington, D.C., the monuments range from a statue of George Washington in Milwaukee, Wisconsin (1974) to Plymouth Rock (1974). The pictures range from straightforward shots of the memorials, but others are imbued with Friedlander's sly wit. For instance, *General Andrew Jackson, Lafayette Park, Washington, D.C.* (1973, Smithsonian American Art Museum, Washington, D.C.) (see figure) captures the general sitting atop his trusty, rearing stead, waving his hat above his head—shooing away pigeons. In the afterward of *American Monuments,* Leslie George Katz observes, "Each photograph depicts the intended effect and the unintended result, the ideal and the actual, together" (unpaged). The book includes 213 plates, which were acquired as a whole by the Smithsonian American Art Museum in 2003.

Having made a name for himself, Friedlander was awarded several commissions, including a 1979 request from the Akron Museum of Art to make photographs of midwestern industrial sites. He also explored many new themes, ranging from flowers to the nude female form. Beginning in the early 1990s, Friedlander started to use a Superwide Hasselblad camera, known for its large square-format pictures and ability to capture details and richer tones. His new camera was perfect for the Western landscapes that he started to shoot at this time, which are more sensuous than his earlier street photographs. With his new camera, Friedlander returned to many of his favorite subjects.

Lee Friedlander, *General Andrew Jackson, Lafayette Park, Washington, D. C.,* 1973. Gelatin silver print on paper, 7½ × 11⅜ inches. Smithsonian American Art Museum, Washington, D.C. Museum purchase through the Luisita L. and Franz H. Denghausen Endowment, Margery and Edgar Masinter, Kevin and Lisa McGovern, and Bernie Stadiem 2003.42.926.

Peter Galassi observes that Friedlander's Hasselblad photographs result in "a pictorial circus of baroque fullness and grandeur, as if a Tintoretto or a Tiepolo had been invited to remake Friedlander's earlier work from scratch" (61).

In 1989, the Seattle Art Museum mounted a touring retrospective of thirty years of Friedlander's work. Over 500 photographs showed in a 2005 retrospective at New York's Museum of Modern Art, the largest show the museum has ever given to a single photographer. Among Friedlander's many prizes is an award from the prestigious MacArthur Foundation (1990).

Bibliography

Allison, Sue. "Lee Friedlander" (interview). *American Photographer* 12, no. 3 (March 1984): 52–61.

Friedlander, Lee. *The American Monument.* New York: Eakins Press Foundation, 1976.

———. *Lee Friedlander: Photographs.* New City, NY: Haywire Press, 1978.

———. *Flowers and Trees.* New City, NY: Haywire Press, 1981.

———. *Lee Friedlander: Portraits.* Foreword by R.B. Kitaj. Boston: Little, Brown and Company, 1985.

———. *Nudes.* Afterword by Ingrid Sischy. New York: Pantheon Books. 1991.

———. *Lee Friedlander at Work.* New York: D.A.P./Distributed Art Publishers, Inc., 2002.

———. *Sticks & Stones: Architectural America.* Essay by James Enyeart. San Francisco: Fraenkel Gallery; New York: D.A.P./Distributed Art Publishers, 2004.

————. *Self-Portrait: Photographs by Lee Friedlander.* 1970. Rev. ed. New York: Museum of Modern Art, 2005.

————. Written correspondence with the author. May 6, 2005.

Friedlander, Lee and Jim Dine. *Work from the Same House: Photographs and Etchings.* London: Trigram Press, 1969.

Galassi, Peter. *Friedlander.* New York: Museum of Modern Art, 2005.

Slemmons, Rod. *Like a One-Eyed Cat: Photographs by Lee Friedlander, 1956-1987.* New York: Harry N. Abrams, Inc., Publishers in association with the Seattle Art Museum, 1989.

Selected Public Collections

Cleveland Museum of Art
Metropolitan Museum of Art, New York
Montclair Art Museum, New Jersey
Museum of Fine Arts, Boston
Museum of Modern Art, New York
National Gallery of Art, Washington, D.C.
San Francisco Museum of Modern Art
Victoria and Albert Museum, London

G

Ruth Gikow (1913–82), painter and printmaker.

A painter of social issues and contemporary existence ranging from teeny-boppers to civil rights demonstrators, Ruth Gikow's art presents American life in various incarnations. Born in Ukraine to a portrait photographer and a homemaker who hurriedly left their native land to escape pogroms, at the age of five Gikow immigrated with her parents to the United States. After a challenging two years of travel to reach her new homeland, Gikow and her family settled on New York City's Lower East Side, a bustling, crowded environment that instigated the artist's subsequent interest in depicting crowds and city types. At Washington Irving High School, Gikow took art classes with the intention of becoming a commercial artist. Encountering difficulties finding employment, at seventeen years old Gikow supplemented her art education at the Cooper Union with John Steuart Curry, and she also studied privately with **Raphael Soyer**.

Through the 1930s, Gikow continued to hone her craft, sometimes painting canvases with a Social Realist inclination and at other periods experimenting with more modern forms. For four years Gikow received support from the Works Progress Administration, including commissions for several murals; murals for the children's ward of Bronx Hospital and the nurse's residence at Riker's Island were conceived at the end of the decade. Although Gikow's interest in painting murals faded, lessons she learned about creating dynamic compositions on a large scale would affect her subsequent oil paintings. During this period, Gikow cofounded the American Serigraph Society, a group that produced prints at reasonable prices to enable the average art buyer to purchase them. Gikow's contributions were sometimes modern in conception, akin to the jazz-influenced, Cubist-inspired rhythmic shapes of Stuart Davis. Indeed, avant-garde and expressionist renderings dominated Gikow's artistic production through the 1940s and 1950s, until she found her mature style.

In 1946, Gikow married **Jack Levine**, a fortuitous union of two artists committed to humanism in art. Inspired by her husband's dedication to his craft, after her marriage Gikow focused on oil painting and enjoyed her first one-person exhibition at New York's Weyhe Gallery (1946). The following year, Gikow illustrated an edition of Dostoevsky's *Crime and Punishment* (1947) with black-and-white drawings. Travels abroad in 1947 and 1948, which included over twelve months in Italy, strengthened Gikow's interest in figuration and

painting current events. As she recalled: "After . . . Europe and seeing the great art of the past and present, I've become increasingly interested in the human aspect of painting. An artist must constantly refer to life to get a living, growing art" (Josephson, 18). At several one-person exhibitions through the 1950s, Gikow showed increasingly colorful, populated canvases exploring youthful life. Freely executed, *Jitterbugs* (1952, private collection) portrays five figures, three posturing teenage girls in then-contemporary clothing huddled together while approached by two young men. Painted in vivid colors, *Jitterbugs* is one example of many in which Gikow explored mid-century youth culture. In contrast to the more upbeat scene of *Jitterbugs*, Gikow also painted images addressing how young people cope with society's ills. *Black Balloons* (1969, collection unknown) depicts a group demonstrating against the Vietnam War. Filling up the lower third of the horizontally oriented canvas, the teens wear brightly patterned clothing, which contrasts with their somber expressions. Shown at the moment that the group releases over a dozen black balloons into a dismal gray sky, the painting conveys the angst of the tumultuous and confusing historical period. Other socially conscious subjects include *Elegy-Kent 1970* (c. 1973, Kent State Art Gallery, Ohio), a subdued, large-scale composition of a group of mourners painted to commemorate the shootings at the school. In addition to the canvas, Gikow made several charcoal drawings delineating both the victims and the survivors of the tragedy. The murders deeply affected Gikow, who began working on the image soon after she heard the report of the shootings on the radio. She explained that: "I tried to make the scene solemn and sedate to counteract the violence of the murders" (Cochrane, 49). On the second anniversary of the slayings, the large canvas and six related drawings were presented to Kent State University during a ceremony attended by both Gikow and Levine.

A number of works with Jewish content appear in the 1960s, perhaps partly influenced by Levine's focus on biblical subjects, an interest that permeated his art from the early 1940s and continues to the present day. Gikow painted several biblical figures, such as *Queen Esther II* (1952, Saginaw Museum, Saginaw, Michigan) (Color Plate 7) and *King Solomon and His Wives* (1961, private collection), two canvases that take full advantage of Gikow's command of shimmering color application in her representation of the figures' orientalized clothing. Her largest composition, a haunting triptych titled *The Burial* (1964, collection unknown), is conceived on the scale of a history painting, measuring 180 × 140 inches. Gikow portrays a Jewish funeral in dark hues and reduced details that take on an atmospheric quality as the figures blend with each other and the opaquely rendered sky. Always keeping the human figure at the center of her work, Gikow eloquently articulated her artistic philosophy in 1973: "I decided the only art worth painting was the human drama" (Ibid., 45).

Bibliography

Cochrane, Diane. "Ruth Gikow: Chronicler of our Times." *American Artist* 37, no. 366 (January 1973): 44–50, 73.

Dostoyevsky, Fyodor. *Crime and Punishment*. Translated by Constance Garnett. Illustrated by Ruth Gikow. Cleveland: The World Publishing Company, 1947.

Gikow, Ruth. *Ruth Gikow: Recent Work.* New York: Kennedy Galleries, 1976.
———. *Ruth Gikow, Kennedy Galleries.* New York: The Galleries, 1979.
Josephson, Matthew. *Ruth Gikow.* New York: Maecenas Press, 1970.
Kent State Art Gallery curatorial files, Ruth Gikow.
Soltes, Ori Z. *Intimations of Immortality: Jack Levine, Ruth Gikow and Susanna Levine Fisher.* Washington, D.C.: B'nai B'rith Klutznick National Jewish Museum, 1995.

Selected Public Collections

Butler Institute of American Art, Youngstown, Ohio
Metropolitan Museum of Art, New York
Museum of Modern Art, New York
Philadelphia Museum of Art
Portland Museum of Art, Maine
Rose Art Museum, Brandeis University, Waltham, Massachusetts
Smithsonian American Art Museum, Washington, D.C.
Whitney Museum of American Art, New York

Leon Golub (1922–2004), painter and printmaker.

A neo-expressionist painter whose consistent subject was war and man's inhumanity to man, Chicago-born Leon Golub received a B.A. in art history from the University of Chicago (1942), and a B.F.A. (1949) and an M.F.A. (1950) from the Art Institute of Chicago. Although he did not encounter combat, his experience in the army during World War II as a cartographer of reconnaissance maps influenced his art during the postwar years, which frequently focused on the abuse of power and victimization. Based on newspaper photographs of Holocaust victims, the expressionistic lithograph *Charnel House* (1946) (see figure) shows a mass of anguished figures twisting helplessly in ambiguous space. Retrospectively, Golub noted "I think the first paintings I was doing when I started school were concentration-camp scenes. There is one around called *Evisceration Chamber,* and there were others based on Buchenwald. It was something I guess I had to get at" (Marzorati, 166). *Damaged Man* (1955, private collection) from the *Burnt Man* series (1954–55; 1960–61) references the Holocaust; the painting presents a single flayed human figure isolated at the center of the canvas. Golub described the *Burnt Man* series as an attempt "to visualize what is virtually unrepresentable, the Holocaust.... What I sought to project in the 50's, a sense of humans obliterated and surviving under extreme circumstances is still a basic concern of my work" (Obrist, 49). Indeed, since this period, Donald Kuspit observes, "one can interpret Golub's art as Jewish revenge on modern Western civilization, revenge exacted by depicting that civilization's victims, its savagery. Through Golub's work, our time will live in memory as monstrous and rotten. This art can also be interpreted as reflecting Jewish determination never again to become a victim of history, in part knowing the oppressor so well that one can equal the oppressor's strength" (38).

Leon Golub, *Charnel House,* 1946. Lithograph, 15 × 19 inches. Art © Estate of Leon Golub/ Licensed by VAGA, New York, New York.

Finding the United States inhospitable to his figurative, socially conscious work, Golub and his artist-wife **Nancy Spero** moved to Paris in 1959, where the couple remained until 1964 when they took up permanent residence in New York City. The pair, who shared a studio from 1977 until Golub's death, critiqued each other's work, exchanged source photographs, and in general enjoyed creative reciprocity. Their work deals with similar material but from different gendered positions; Spero addresses the subjugation of women and the effects of male aggression on her sex, while Golub, as he put it, "hooked into all phases of how men act out aggression and violence, power moves" (Kline and Posner, 13).

His style and subject work together; beginning in the early 1950s, Golub frequently scraped down and reworked his heavily applied paint, often brutalizing the surface of his large canvases as deeply as the oppressed figures he painted. In addition to using contemporary news photographs as source material, Golub based some of his figures on classical art. He often employed several artworks or photographs for single figures, amalgamating data to create the most effective composite of gestures, postures, and expressions to convey a theme. For example *Gigantomachy III* (1966, private collection, Chicago), which depicts four nude male figures attacking a man writhing on the ground and another man running away from the violent group, is based on the Altar of Zeus at Pergamon and a photograph of rugby players. In 1970 Golub ceased placing his canvases on stretchers, instead nailing

the unstretched canvas on a wall of his studio. At this time he also began cutting out portions of the canvas to draw attention to aspects of the composition.

Golub typically produced cycles of paintings on a theme, including the *Combat* (1962–65), *Vietnam* (1972–73), and *Interrogation* (1981) series, all of which explored the condition of victims and tyrants through the successive wars and struggles of his era. Beginning with the *Vietnam* series, Golub shifted from general commentary to specificity. To be sure, Golub started to incorporate contemporary uniforms and weaponry in his imagery, which previously pictured violence in a more universal fashion (e.g., the classicized *Gigantomachies*, 1965–68) that perhaps made such disturbing imagery more palatable. From 1976 to 1979, Golub continued to address the contemporary world with over one hundred portraits of unambiguous power figures, such as Henry Kissinger, Ho Chi Minh, and Fidel Castro, often in several versions. John Bird interprets the portraits as emphasizing "the performative aspect of identity – that is, he paints subjects enacting the roles that are normatively prescribed: statesman, corporate leader, dictator. In their recognition of the viewer's presence, these works reflect back at us the culture's *imagos,* as if to assert: 'We are what you want us to be'" (76).

The enormous 120 × 168-inch canvas *Interrogation II* (1981, Art Institute of Chicago) includes all of the signature themes and techniques of Golub's postmodern history paintings. This disturbing image presents four oppressors torturing a naked, hooded man bound to a chair. The two larger-than-life interrogators on the right side of the deep red canvas make direct eye contact with the viewer. By bringing these posturing male aggressors into the viewer's space, Golub "not only poses questions about witnessing such heinous acts, but about the viewer's possible passive complicity" (Gumpert and Rifkin, 55). Even if Golub portrays the horrific actions of man he tries, to use the artist's words, "to expose both victimizer and victim, the psychic circumstances, their looks, and so on" (Kline and Posner, 43).

Golub taught art at Rutgers University from 1970 to 1991. The recipient of many honors, Golub received a Jewish Cultural Achievement Award in the visual arts from the National Foundation for Jewish Culture (1995). He enjoyed a retrospective at the Irish Museum of Modern Art in Dublin in 2000; a much-reduced version of the show traveled to the Albright-Knox Art Gallery in Buffalo and the Brooklyn Museum of Art (2001).

Bibliography

Amishai-Maisels, Ziva. *Depiction and Interpretation: The Influence of the Holocaust on the Visual Arts.* New York: Pergamon Press, 1993.

Baigell, Matthew. "'The Mercenaries': An Interview with Leon Golub." *Arts Magazine* 55, no. 9 (May 1981): 167–169.

Bird, Jon. *Leon Golub: Echoes of the Real.* London: Reaktion, 2000.

Dreiss, Joseph. "Leon Golub's Gigantomachies: Pergamon Revisited." *Arts Magazine* 55, no. 9 (May 1981): 174–176.

Gumpert, Lynn and Ned Rifkin. *Golub.* New York: New Museum of Contemporary Art, 1984.

Horodner, Stuart. *Leon Golub: While the Crime is Blazing, Paintings and Drawings, 1994-1999*. Including an interview with Golub. Lewisburg, PA: Bucknell Art Gallery, 1999.

Kline, Katy and Helaine Posner. *Leon Golub and Nancy Spero: War and Memory*. Including an interview with Golub and Spero. Cambridge, MA: MIT List Visual Arts Center, 1994.

Kuspit, Donald. *Leon Golub: Existential/Activist Painter*. New Brunswick, NJ: Rutgers University Press, 1985.

Marzorati, Gerald. *A Painter of Darkness: Leon Golub and Our Times*. New York: Viking, 1990.

Obrist, Hans-Ulrich, ed. *Leon Golub: Do Paintings Bite? Selected Texts (1948-1996)*. Ostfildern: Cantz, 1997.

Sandler, Irving. "Interview: Leon Golub Talks with Irving Sandler." *Journal of the Archives of American Art* 18, no. 1 (1978): 11–18.

Selected Public Collections

Art Institute of Chicago
Hirshhorn Museum and Sculpture Garden, Washington, D.C.
Israel Museum, Jerusalem
Jewish Museum, New York
Los Angeles County Museum
Museum of Modern Art, New York
Smithsonian American Art Museum, Washington, D.C.
Tate Gallery, London

Adolph Gottlieb (1903–74), painter, sculptor, and printmaker.

Best known for his abstract expressionist paintings, New York–born Adolph Gottlieb studied at the Art Students League with John Sloan and Robert Henri (1920–21). After traveling through Europe for two years and attending life-drawing class at the Académie de la Grande Chaumière in Paris, Gottlieb returned to New York for additional art instruction (1923). Among the venues he took classes was the Educational Alliance, where he met **Barnett Newman**, an artist also later associated with Abstract Expressionism. His first solo exhibition was held at the Dudensing Gallery in New York in 1930.

In 1935, Gottlieb cofounded "The Ten," a group of artists committed to progressive tendencies in art that also included **Mark Rothko** and **Ilya Bolotowsky**. The Ten exhibited together regularly until 1939. Working under the Works Progress Administration's Federal Art Project since 1936, Gottlieb executed a mural for the Yerington, Nevada Post Office (1939). During this period, Gottlieb retained figuration, but was clearly influenced by modernism, especially the work of Milton Avery. Simplifying forms in portraits and landscapes, Gottlieb's flat, painterly shapes portend his subsequent interest in abstraction.

Influenced by European surrealists who settled in New York before World War II; non-Western art, which he collected since 1935; and Southwest Indian

art, introduced to him in Arizona where he lived from 1937 to 1939; Gottlieb created his first pictograph in 1941: *The Eyes of Oedipus* (private collection). Several works from this period focus on the Oedipus myth, stimulated by Gottlieb's reading of Freud and also because, Mary Davis McNaughton notes, "as America plunged into war, Gottlieb was pulled toward the Oedipus myth because he found in it a powerful statement of man's tragic nature. Through Freud he saw Oedipus as a symbol of man's eternal conflict within himself and against society. He also may have seen Oedipus's quest for truth through the personal unconscious as a metaphor for his won search for meaning during this world crisis....Since the truth of the Oedipus myth was timeless, Gottlieb could use it as the basis for his own modern expression" (35–36). An amalgamation of abstraction and the subjectivity of Surrealist inspired automatism, the *Pictograph* series is composed of irregular grid compartments in which Gottlieb placed stylized iconography (e.g., arrow, head, hand, eye) that sometimes draw on his interest in ancient myths. For the next ten years, Gottlieb explored variations on this theme while expanding his palette, at times employing a more painterly technique and developing a vocabulary of ambiguous symbols.

In a June 1943 letter written by Gottlieb and Rothko to art critic Edward Alden Jewell of the *New York Times*, they delineated their perspective on art: "We favor the simple expression of the complex thought. We are for the large shape because it has the impact of the unequivocal. We wish to reassert the picture plane. We are for flat forms because they destroy illusion and reveal truth" (9). Indeed, Abstract Expressionism employed open-ended iconography that asserted the primacy of the picture plane while retaining subject matter in abstract art.

The *Pictographs* (1941–51) were followed by two other major series in which Gottlieb varied simplified compositions: *Imaginary Landscapes* (1951–57) and *Bursts* (1957–74). *Imaginary Landscapes* such as *The Frozen Sounds, No. 1* (1951, Whitney Museum of American Art, New York) (Color Plate 8) are characterized by a horizontal line across the center of a canvas, above which Gottlieb painted different geometric shapes reduced in color from the *Pictographs*. In the lower half of the canvas he applied a dense array of gestural marks. *Bursts,* introduced at a 1957 exhibition at New York's Jewish Museum, marked the beginning of Gottlieb's work on oversized canvases; that year two canvases were sixteen feet long. Gottlieb typically placed one or more disks floating on the top half of the image contrasting with an exploding mass of black textured gestures on the lower half. These paintings have been likened to war and the atom bomb. Similar shapes comprise sculptures executed in the 1960s.

Gottlieb felt abstraction was a liberation from representation, for which he paid the price of uncertain financial stability and reception in the art world. He likened his ability to deal with this insecurity to his Jewish background: "As for me, I'd rather be an artist today, for all this lack of status, than at any other time in history. Even in the Middle Ages. Security would be nice, but I wouldn't exchange it for my loss of freedom. I happen to be a Jew. In the Middle Ages I'd have had to live on the fringe, and take orders. I'd like more

status then I have now, but not at the cost of closing the gap between artist and public" (Rodman, 89–90).

In addition to painting, Gottlieb designed an ark curtain for Congregation B'nai Israel in Millburn, New Jersey (1951) (for which **Herbert Ferber** executed a facade sculpture), and a tapestry for the prayer hall as well as the valance of the ark curtain for Beth El in Springfield, Massachusetts (1953) (for which **Ibram Lassaw** made a facade sculpture). Gottlieb also designed and supervised the fabrication of a thirty-five foot wide, four-story high stained-glass facade for the Milton Steinberg Center at New York's Park Avenue Synagogue (1954). Using compartmentalization similar to his *Pictographs* series, thirty-one compositions are repeated and interspersed in ninety-one panels displaying partly abstracted Jewish symbols, biblical stories, religious rituals, and holidays. For example, an arrow (found in some of his canvases) is meant to symbolize a Torah pointer, a serpent symbolizes phylacteries, and twelve calligraphic signs delineate the twelve tribes of Israel. Although rationally arranged, in one of Gottlieb's many verbal and written statements he explained his desire to convey his unconscious by way of the essential forms of abstract art: "Subjective imagery is the art which I have been exploring. . . . I reject the outer world—the appearance of the natural world. . . . The subconscious has been my guiding factor in all my work. I deal with inner feeling" (Gruen, 258).

In 1968, the Whitney Museum of American Art and the Solomon R. Guggenheim Museum staged a retrospective exhibition of Gottlieb's art. Gottlieb was elected a member of the National Institute of Arts and Letters in 1972. Established in 1976, the Adolph and Esther Gottlieb Foundation offers grants to artists and holds an archive about Gottlieb's work and life. The Foundation also supports exhibitions about its namesake; a recent exhibition of Gottlieb's early prints (2006–07) traveled to the Allen Memorial Art Museum in Oberlin, Ohio, the Milwaukee Art Museum, and the Art Museum of the University of Memphis.

Bibliography

Alloway, Lawrence and Mary Davis MacNaughton. *Adolph Gottlieb: A Retrospective*. New York: The Arts Publisher, Inc., in association with the Adolph and Esther Gottlieb Foundation, Inc., 1981.

Dervaux, Isabelle. *The Ten: Birth of the American Avant-Garde*. Boston, MA: Mercury Gallery, 1999.

Doty, Robert and Diane Waldman. *Adolph Gottlieb*. New York: Frederick A. Praeger, Publishers, 1968.

Gottlieb, Adolph and Mark Rothko. Letter to the Editor in "The Realm of Art: A New Platform and Other Matters: 'Globalism Pops into View,'" by Edward Alden Jewell. *New York Times* (June 13, 1943): 9.

Grossman, Emery. *Art and Tradition*. New York: Thomas Yoseloff, 1967.

Gruen, John. *The Party's Over Now: Reminiscences of the Fifties*. New York: The Viking Press, 1967.

Kampf, Avram. *Contemporary Synagogue Art: Developments in the United States, 1945-1965*. New York: Union of American Hebrew Congregations, 1966.

Polcari, Stephen. "Adolph Gottlieb's Allegorical Epic of World War II." *Art Journal* 47, no. 3 (Fall 1998): 202–207.

Rodman, Seldon. *Conversations with Artists.* New York: Capricorn Books, 1961.

Sylvester, David. "Adolph Gottlieb: An Interview with David Sylvester." *Living Arts* 1 (June 1963): 2–10.

Selected Public Collections

High Museum of Art, Atlanta
Museum of Modern Art, New York
National Gallery of Art, Washington, D.C.
North Carolina Museum of Art, Raleigh
Sheldon Art Gallery, Lincoln, Nebraska
Smithsonian American Art Museum, Washington, D.C.
Tate Gallery, London
Tel Aviv Museum of Art, Israel

William Gropper (1899–1977), cartoonist, painter, book illustrator, and printmaker.

Primarily known as a satirist in the vein of Honoré Daumier and George Grosz, William Gropper aptly summarizes his artistic aims and describes the world events that affected him in a 1947 credo written for a book on Jewish painters and sculptors. It is worth quoting him at length: "My art has been called 'Social Realism,' 'Social Conscious,' and 'Left Wing.' ...Years before Hitler came into power, when Mussolini created fascism in Italy and before that, when Intervention against the Soviet people in Russia took place, I was against reaction and fascism. I drew pictures and cartoons against these evils for any publication that would publish them....Like my cartoons, my paintings are an expression of the life in which we live, with the joy and sorrow, the injustices, greed, racial hatred, persecution of minorities, ignorance; I feel for the downtrodden, the innocent, the Jew and the Negro, the exploited, the dreamer, and the heroic men and women who are helping make this world a better place to live in" (Lozowick, *One Hundred,* 72).

New York–born Gropper studied at parochial school while growing up in poverty on the Lower East Side. This early existence heightened Gropper's sensitivity to social inequality, and indeed he used his art to comment on the human condition. Gropper's studies with Robert Henri and George Bellows at the Ferrer School (1912–15) cemented his desire to make art focusing on contemporary life, and by 1917 he regularly contributed incisive cartoons for the *New York Tribune.* In the 1920s he also created political satire for such left-wing publications as *The Liberator; New Masses,* for which he was a founding editor (1926) along with **Louis Lozowick**; and the Communist, Yiddish language *Morning Freiheit.* By 1948, when he gave up cartooning upon his resignation from the *Morning Freiheit,* Gropper had made thousands of line drawings, often of a vitriolic nature, indicting the injustices of his era.

His caricatures for mainstream journals such as *Dial, Bookman,* and *Vanity Fair* were often just as biting; in fact, a 1935 caricature of Japan's Emperor

Hirohito led to an international incident. Titled *Japan's Emperor Gets the Noble Peace Prize* for a section partially titled "unlikely historical situations," the clever cartoon shows the tiny emperor in military regalia pulling an oversized rickshaw carrying the proclamation of his award. Upon the drawing's publication the Japanese government demanded that the United States provide an apology, which they did. Gropper's cartoon, which would have been noticed by few, became nationally known.

Throughout these years Gropper painted, but he did not have his first one-person show of oils until 1936. Paintings such as *The Senate* (1935, Museum of Modern Art, New York) and *Hostages* (c. 1937, Newark Museum) address similar propagandistic themes as Gropper's cartoons. *The Senate* is one of many works in which Gropper critiques congress, politicians, and committees. In this early version of the subject a pompous senator flamboyantly orates to a nearly empty chamber. Those present are absorbed in mundane tasks; one senator rests his feet on his desk and another reads the newspaper. Here Gropper questions the effectiveness of government, certainly apropos during the trials of the Great Depression. Some paintings from the 1940s concentrate on American folklore and other indigenous themes. These works include dramatic images of *Paul Bunyan* (1944, collection unknown) and *Rip Van Winkle* (1945, collection unknown), paintings rendered in antinaturalistic color with a vigorous brushstroke.

He executed several murals for the Works Progress Administration, including *Construction of a Dam* (1938–39) for the Department of the Interior in Washington, D.C., which addresses the struggle of laborers. The center panel, which measures nearly 9 × 14½ feet, shows several hard-working, strongly muscled, crisply rendered men witnessing the arrival of a monumental piece of equipment hanging from a crane for the completion of their construction project.

During the war years he made cartoons, war bond posters, and pamphlets, often with overt anti-Nazi themes, as well as a few paintings expressing his horror at the incoming news of Nazi barbarism. As early as 1934 Gropper pictured his disgust at Hitler. In a *New Masses* cartoon "the worker," symbolized by an enormous clenched fist arising from murky water filled with skulls and bones, upsets a rickety raft (see figure). On the raft, which flies a tattered flag emblazoned with a swastika, a frantic, gun totting, distorted Hitler is accompanied by a well-fed figure symbolizing capitalism. This didactic and optimistic image clearly provides the message that the worker will conquer the oppressors. Later, his war images become more particularized on the Jewish experience. In 1943 he published a portfolio of prints titled *Your Brother's Blood Cries Out*. Gropper explained, "Hitler and fascism made me aware that I was a Jew. I think all intellectuals who were never concerned with their faith were thrown into an awareness by these atrocities. I put out a portfolio, *Your Brother's Blood Cries Out*, lithographs of the Nazi atrocities against Jews" (William Gropper Papers, roll 3502, frame 6).[14] Indeed, the images show the battle of subjugated Jews against Nazis; one pictures refugees boarding a train, another the struggle of resistance fighters. The oil painting *De Profundis* (1943, collection unknown) presents an elderly praying Jew with a *tallit*

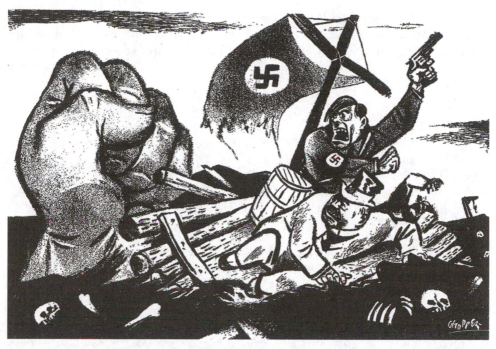

William Gropper, untitled illustration in *New Masses* 12 (July 1934).

draped over his head and shoulders and wearing phylacteries gazing upward to the dark foreboding heavens. As did **Ben-Zion** in his series of the same name, Gropper depicts a lamenting Jew as the epitome of all human suffering. Gropper's 1948 visit to the ruins of the Warsaw Jewish Ghetto made a deep impression on him, and from that year on he made one painting annually in memory of those who died in the Warsaw Ghetto.

A map designed by Gropper employing many of the folklore figures in his paintings (e.g., Paul Bunyan, Cowboy Pecos Bill) prompted a subpoena from Senator Joseph McCarthy's Senate Investigations Subcommittee in 1953. While the map did not contain "subversive" material, the fact that the left-wing artist's work was owned by several government agencies precipitated the inquiry. Although he was not a Communist, Gropper refused to answer the subcommittee's questions and he was branded a "Fifth Amendment Communist." Soon thereafter several galleries refused to show his art. In reaction he designed a series of fifty lithographs titled *Capriccios* (1953–56; after Francisco Goya's *Los Caprichos*—Gropper deliberately spelled the title differently). Each lithograph concentrates on the hypocrisy of society, rendered in a nightmarish vocabulary reminiscent of Goya. *Uprooted*, for example, shows several attenuated figures of varying sizes floating ominously through undifferentiated space, including two who desperately grasp an uprooted tree. As Norma Steinberg explains, "his plunging figures are unable to defend themselves against the circumstances of their surroundings, as the winds of fate literally toss people and full-grown trees" (33).

Gropper also designed five stained-glass windows on biblical themes from Genesis for Temple Har Zion in River Forest, Illinois (1965–67) and illustrated several books. He had numerous solo exhibitions in the United States and abroad, including shows in Poland (1948), Czechoslovakia (1948), Paris (1950), and Mexico City (1957).

Bibliography

Baigell, Matthew. *Jewish Artists in New York: The Holocaust Years.* New Brunswick, NJ: Rutgers University Press, 2002.

Brace, Ernest. "William Gropper." *Magazine of Art* 30, no. 8 (August 1937): 467–471.

Freundlich, August L. *William Gropper: Retrospective.* Los Angeles: Ward Ritchie Press, in conjunction with the Joe and Emily Lowe Art Gallery of the University of Miami, 1968.

Gahn, J. Anthony. "William Gropper–A Radical Cartoonist: His Early Career, 1897-1928." *The New-York Historical Society Quarterly* 54, no. 2 (April 1970): 111–144.

Gropper, William. *Gropper.* New York: A.C.A. Publications, 1941.

———. *Lidice.* Washington, D.C.: Coordinator of Inter-American Affairs, 1942.

———. *William Gropper: Fifty Years of Drawing, 1921-1971.* New York: ACA Galleries, 1971.

Lozowick, Louis. *One Hundred Contemporary American Jewish Painters and Sculptors.* New York: YKUF Art Section, 1947.

———. *William Gropper.* Philadelphia: Art Alliance Press; New York: Cornwall Books, 1983.

Phagan, Patricia. "William Gropper and *Freiheit*: A Study of his Political Cartoons, 1924-1935." Ph.D. dissertation, CUNY, 2000.

Steinberg, Norma S. "William Gropper's *Capriccios.*" *Print Quarterly* 11, no. 1 (March 1994): 29–36.

William Gropper Papers. Archives of American Art, Smithsonian Institution, Washington, D.C.

Selected Public Collections

Arizona State University Art Museum, Tempe
Butler Institute of American Art, Youngstown, Ohio
Hirshhorn Museum and Sculpture Garden, Washington, D.C.
Los Angeles County Museum of Art
Lowe Art Museum, Coral Gables, Florida
National Gallery of Art, Washington, D.C.
Smithsonian American Art Museum, Washington, D.C.
Walker Art Center, Minneapolis

Chaim Gross (1904–91), sculptor, watercolorist, draftsman, printmaker, and textile designer.

A versatile artist best known for his direct wood carvings, Chaim Gross, along with **William Zorach**, helped to renew interest in the antiquated technique of

wood sculpture. As Gross accurately asserts in *The Technique of Wood Sculpture* (1957), a book by the artist for students that details the process of making wood sculpture and also provides a brief autobiography: "I am credited with having been instrumental in the awakening of modern sculptors to the potentialities of this half-forgotten medium" (41–42). Gross' diverse oeuvre includes sculptures in wood, and then later in stone and bronze, several of which include Jewish subject matter, as well as works on paper that often explore Jewish themes. Despite Gross' turbulent childhood and the pervading angst in much of modern art, a joyous, playful vitality permeates much of his work.

Born in Austrian Galicia (now part of Poland) into a religious family versed in the teachings of Hasidism, Gross was the youngest of ten children, of whom only five survived. His father, a lumberer, raised his offspring in a rural village in the Carpathian Mountains, and the forests where Gross spent his childhood would later influence the media he chose for his art. Indeed, although the family ultimately moved to a larger Galician town, Gross' formative years in the mountains made a lasting impact on him. Gross claimed that "my love of wood reaches back to my childhood....I endlessly watched the processes of lumbering....How I enjoyed the delicious, pungent smell of newly cut wood. Every evening after the day's work our household was a busy one with the peasants carving religious ornaments, household objects and utensils" (*The Technique of Wood Sculpture*, 43). During these early years, though, Gross was unaware of wood's sculptural potential, and instead copied illustrations in religious books.

Following a Cossack attack on the family because of their Jewish heritage in 1914, during which Gross' parents were nearly beaten to death in front of the children, the family was separated and forced to wander the country as refugees. Gross, a brother, and a sister lived in Budapest in the late 1910s, where the youngest sibling apprenticed with a jeweler and began to learn gold- and silversmithing. He won a scholarship to a Hungarian art school at age fifteen, but political unrest sent Gross and his brother back to Austria, at which time they reunited with their parents. Unstimulated in his provincial environment, Gross spent a year in Vienna at an arts and crafts school. With money sent from his brother Naftoli, who was already living in New York, at seventeen Gross immigrated to America (1921).[15]

While working menial jobs during the day, Gross attended night classes at the Educational Alliance (1921–27), mostly drawing. Nearly simultaneously, Gross enrolled at the Beaux-Arts Institute of Design (1922–26), briefly studying clay modeling with **Elie Nadelman**, followed by two months at the Art Students League (1927) taking classes in direct carving for the first time. From the moment Gross took up a mallet and chisel, he reveled in the natural grains and textures of his materials.

During the Great Depression, Gross enjoyed support from the Public Works of Art Project and the Works Progress Administration. He won the first of twelve federal commissions in 1936, for which he made a sculpture of a postal carrier for the post office in Washington, D.C., under the auspices of the Treasury Department's Section of Painting and Sculpture. *Alaskan Mail Carrier*

(1936), cast in aluminum, accompanied Zorach's large-scale sculpture of Benjamin Franklin. Sculptures for high schools in New York followed, as did a commission for a fourteen-foot tall four-figure group for the 1939 World's Fair.

Gross simplified his forms, often executing sculptures exploring bodies in action, circus figures, and maternal themes. The twenty-five-inch tall *Tumblers* (1933, private collection, New York) offers two solid, rounded figures unified as one. Carved in lignum vitae, Gross' favorite wood because its density challenged him physically, one curved figure supports an upside-down contoured acrobat on his back. Like his companion, the second tumbler—who balances a ball on his feet—retains the original color of the wood and a sense of the material's original blocky shape. Gross noted his attraction to the subject of performers because of the "many possibilities of variations in forms and movement. My acrobats allow me to combine and interlock forms and permit a flow of one form into another. In addition, this subject matter lends itself to spiraling which aids me in achieving a three-dimensional effect.... The eye is carried upwards and thus gives a monumental effect to even a small piece of sculpture" (Lozowick, 74).

Stone carving began to interest the artist in earnest in the 1940s. Although he had occasionally experimented with bronze throughout his career, in the early 1950s Gross engaged the material more consistently. Rather than casting modeled clay, Gross built up his forms with plaster, a harder matter that he then carved away and cast. Several portrait heads comprise his bronze body of work, including visages of his close friend **Moses Soyer** (1970, collection unknown); Chaim Weizmann (1949, Haifa Museum of Art, Israel), Israel's first president; and the Yiddish poet Nochum Yod (1924, private collection).

Following World War II, Gross learned of the death of his brother, sister, brother-in-law, and niece by Nazi hands. An impetus to revisit the religio-cultural heritage he left behind in Eastern Europe, Gross designed several sculptural heads of biblical figures, such as *Naomi and Ruth* (1956, private collection) and *Judith* (c. 1965, Smithsonian American Art Museum, Washington, D.C.). He visited Israel for the first time in 1949, the same year that he submitted a sketch for a proposed monument in memory of the Jews murdered in Europe slated for New York's Riverside Drive. Like Zorach's submission, Gross' plaster model *Memorial to the Six Million* (1949, Chaim Gross Studio Museum, New York) was shown at the Jewish Museum (1949). Gross' version presents a semicircular wall capped on the right end by a forlorn European group and a more prosperous American group on the left. At the center of the composition a giant menorah stands tall, topped by an allegorical figure representing freedom.

For Gross, the process of conceiving each sculpture began on paper, and many studies survive as interesting independent works of art. He also made a prodigious body of works on paper independent of sculpture. Around 1943 he started his self-termed "fantasy drawings," subsequently published in a volume (1956). He began these dynamic line drawings without a subject in mind, using his subconscious to guide his hand. Several drawings relate to

the Holocaust. Of some of these often disturbing drawings, employing dichotomous iconography including birds and bound human figures, Gross commented in a 1981 oral interview: [I] "cut them [Nazis] in pieces" (Chaim Gross Papers, reel 3197, frame 1234). Watercolors of Israel's landscape and people – he first visited the country in 1949 and subsequently returned several times – also comprise the artist's oeuvre.

Gross fabricated sculptures for several public institutions, including *The Ten Commandments* (1970–71), commissioned for the International Synagogue at New York's Kennedy Airport. These ten stylized relief panels each measures 42 × 30 inches and symbolically characterizes a commandment. For example, the Eighth Commandment, "Thou shalt not steal," is boldly represented by the hand of a thief being grabbed by another hand, with coins dropping out of the thief's hand (see figure). Rabbi Israel Mowshowitz interprets the panel as conveying "a great truth. What [Gross] is saying is not only that man should not steal, but that, indeed, man cannot steal. The coins are falling from the hand to show that the thief has gained nothing. Gains through dishonesty are not kept for long" (unpaged). Among many other synagogue commissions, Gross made a large menorah sculpture for Temple Sinai in Pittsburgh, Pennsylvania (c. 1960) and designed a 6 × 19-foot stained-glass window for Temple Emanu-El in Englewood, New Jersey (c. 1974).

Gross taught at the New School of Social Research for forty years and the Educational Alliance Art School for over six decades (1927–89), where both

Chaim Gross, *Eighth Commandment (Thou shalt not steal)*, 1970–71. Bronze with gold overleaf, 42 × 30 inches. The International Synagogue, John F. Kennedy Airport, Jamaica, New York. © 2006 Artists Rights Society (ARS), New York. Photo: Karina Correa Romero.

Leonard Baskin and **Louise Nevelson** took classes with him. Lewis Jacobs produced a film about the artist, "The Sculptor Speaks," in 1957. The Renee and Chaim Gross Foundation, established in 1974, maintains a large collection of Gross' work as well as archival materials. Located in Greenwich Village, the Chaim Gross Studio Museum was founded by the Foundation in 1989. In addition to *The Technique of Wood Sculpture,* which includes photographs of Gross at work, he cowrote *Sculpture in Progress* (1972) and illustrated a translation of the *Book of Isaiah* (1973).

Bibliography

Book of Isaiah: A New Translation. Drawings by Chaim Gross. Philadelphia: Jewish Publication Society of America, 1973.

Chaim Gross Papers. Archives of American Art, Smithsonian Institution, Washington, D.C.

Flint, Janet A. *Chaim Gross: Sculpture and Drawings.* Washington, D.C.: Smithsonian Institution Press, 1974.

Getlein, Frank. *Chaim Gross.* New York: Harry N. Abrams, Inc., Publishers, 1974.

Gross, Chaim. "A Sculptor's Progress." *Magazine of Art* 31, no. 12 (December 1938): 694–698.

———. *Fantasy Drawings.* New York: Beechhurst Press, 1956.

———. *The Technique of Wood Sculpture.* 1957. Reprint, New York: Arco Publishing Company, Inc., 1966.

Gross, Chaim and Peter Robinson. *Sculpture in Progress.* New York: Van Nostrand-Reinhold Company, 1972.

Grossman, Emery. *Art and Tradition.* New York: Thomas Yoseloff, 1967.

Lombardo, Josef Vincent. *Chaim Gross: Sculptor.* New York: Dalton House, Inc., 1949.

Lozowick, Louis. *One Hundred Contemporary American Jewish Painters and Sculptors.* New York: YKUF Art Section, 1947.

Mowshowitz, Israel. *The Sculpture Reliefs of the Ten Commandments by Chaim Gross at International Synagogue, John F. Kennedy International Airport, New York.* Jamaica, NY: International Synagogue, 1973.

Tarbell, Roberta K. *Chaim Gross: Retrospective Exhibition, Sculpture, Paintings, Drawings, Prints.* New York: Jewish Museum, 1977.

———. "Chaim Gross's Pictorial Works." *American Art Review* 4 (January 1978): 32–39, 98–100.

Werner, Alfred. *Chaim Gross: Watercolors and Drawings.* New York: Harry N. Abrams, Inc., Publishers, 1979.

Selected Public Collections

Art Institute of Chicago
Chaim Gross Studio Museum, New York
Delaware Art Museum, Wilmington
Metropolitan Museum of Art, New York
Nelson-Atkins Museum of Art, Kansas City, Missouri
Smithsonian American Art Museum, Washington, D.C.
Tel Aviv Museum of Art
Whitney Museum of American Art, New York

Philip Guston (1913–80), painter.

Equally known for his abstract and figurative works, Guston was born Philip Goldstein in Montreal, Canada. When he was seven years old, Guston moved with his Russian immigrant parents to Los Angeles, where he attended Jewish day school. Manifesting an interest in art by age thirteen with teenage doodles resembling the comic section of the newspaper, Guston's mother enrolled him in a correspondence course with the Cleveland School of Cartooning. Although he was soon bored with the course, cartoons influenced his later work. While largely self-taught, he did attend Manual Arts High School (1927–28) in Los Angeles with fellow student Jackson Pollock, and also took classes at the Otis Art Institute for three months (1930).

Amalgamating the influences of the Mexican muralists and Italian Renaissance painters such as Piero della Francesca and Paolo Uccello, Guston executed several murals for the Works Progress Administration's Federal Art Project. His murals include works for the 1939 World's Fair, the Queensbridge Housing Project in New York City (1940), and the Social Security Building in Washington, D.C. (1942). These images, along with socially conscious paintings such as the anti-Ku Klux Klan canvas *The Conspirators* (1932, collection unknown), display a precise realist technique, intricate illusionism, and deep spatial recession.

From 1941 to 1945 Guston was an artist-in-residence at the State University of Iowa in Iowa City, followed by two years teaching at the School of Fine Arts at Washington University at Saint Louis. During this time, Guston assimilated aspects of abstraction and Cubism, as in *Porch II* (1947, Munson-Williams-Proctor Institute, Utica, New York). Also partially influenced by the work of the artist Max Beckmann, who was also teaching at Washington University after escaping Nazi Germany, *Porch II* shows a group of flatly rendered, barely modeled carnival entertainers behind a series of bars. Using a restricted, darkened palette, Guston's composition of frail figures in a crowded, shallow space, Robert Storr observes, evokes "the piles of doll-like corpses that Guston saw in newsreel footage documenting Nazi war crimes. Though not a depiction of the Holocaust, it is a painting conceived in its shadow" (19).

Soon after the war, Guston explored pure abstraction. By the 1950s, Guston's entirely nonobjective paintings were characterized by critics as "Abstract Impressionist" based on his heavily laid paint and lyrical use of limited color on canvases composed of short brushstrokes often in hatched configurations, such as *Painting* (1954, Museum of Modern Art, New York). This gestural technique allied Guston with other Abstract Expressionists, such as Pollock and Franz Kline, labeled by art critic Harold Rosenberg as "Action Painters." Guston's abstractions from the mid-1950s onward employed irregular, bolder brushstrokes, for which the artist began to give suggestive rather than generic names. *The Clock* (1956–57, Museum of Modern Art, New York), for example, is made of dense, textured colors, including red, orange, and green, atop a light blue ground of less heavily laid, although still agitated paint.

After retrospectives at the Guggenheim Museum (1962) and New York's Jewish Museum (1966), Guston boldly returned to figuration. Expressing a desire "to tell stories" (Berkson, 54) Guston made blocky, cartoon-inspired narratives using a limited palette of pale colors, particularly salmon pink, white, black, and gray. In several of these large-scale paintings, such as *The Studio* (1969, private collection), Guston rendered a hooded figure, often employed as a surrogate self-portrait. While he painted hooded Ku Klux Klan members in social realist works from the 1930s, the hooded figures that emerged in the late 1960s, Storr argues, were a "metaphor for creation" influenced by the Jewish legend of the clay-sculpted golem (60). Cabbalistic rabbis from the Middle Ages to the nineteenth century believed that sculpting an effigy of the golem reenacts God's making of Adam. Storr notes, however, that "in a culture that prohibited graven images as a usurpation of God's power to make living things, the Golem thus represented an act of faith and an act of hubris. In symbolic terms, Guston's reintroduction of imagery into his work constituted a similar defiance of the formalist prohibition against figuration" (60). From this period also come cartoonish renderings of tablets recalling the Tablets of the Law (e.g., 1968, Fogg Art

Philip Guston, *To I.B.*, 1977. Oil on canvas, 67¼ × 80 inches. Private collection. © The Estate of Philip Guston. Photo courtesy of McKee Gallery, New York.

Museum, Harvard University). Guston's stylistic experimentations were precipitated by his doubts about the meaning of painting, which he described in the year of his death: "I have an uneasy suspicion that painting really doesn't have to exist at all–I mean, it didn't come down from Mount Sinai; it's not written in the ten commandments–*unless* it questions itself constantly" (Weber, 15).

At the urging of **David Aronson**, in 1973 Guston was appointed a professor of art at Boston University. His interactions with Aronson further stimulated his interest in Jewish subjects; as Guston recalled, "David caused me to remember and made me a witness too" (Aronson, 3). Guston's identification with his Eastern European Jewish heritage stimulated his painting *To I.B.* (1977, private collection) (see figure), a canvas referencing Isaac Babel, a Russian Jew who wrote stories about his persecuted coreligionists in his hometown of Odessa. *To I.B.* is composed of three major cartoon-like elements: a pile of bloody body parts on the left under which is printed "Odessa," a clock right of center, and the backside and legs of a horse on the right. Judith Bookbinder observes that *To I.B.* evidences Guston's "return to his spiritual home in Odessa and a confrontation with the violence that had caused his parents and so many other Jews to flee" (257).

Bibliography

Aronson, David. *David Aronson: A Retrospective.* With an introduction by Philip Guston. Boston: Pucker/Safrai Gallery, 1979.

Ashton, Dore. *A Critical Study of Philip Guston.* Berkeley: University of California Press, 1990.

Auping, Michael. *Philip Guston: Retrospective.* With essays by Dore Ashton et al. Fort Worth: Modern Art Museum of Fort Worth; Thames & Hudson, 2003.

Berkson, William. "Dialogue with Philip Guston, November 1, 1964." *Art and Literature: An International Review* 7 (Winter 1965): 56–69.

Bookbinder, Judith. *Boston Modern: Figurative Expressionism as Alternative Modernism.* Durham, NH: University of New Hampshire Press; Hanover: University Press of New England, 2005.

Brach, Paul. "Looking at Guston." *Art in America* 68, no. 9 (November 1980): 96–101.

Guston, Philip. "Piero della Francesca: The Impossibility of Painting." *ARTnews* 64 (May 1965): 38–39.

Hopkins, Henry T. and Ross Feld. *Philip Guston.* With statements by Philip Guston reproduced. New York: George Braziller; San Francisco: San Francisco Museum of Art, 1980.

Hunter, Sam, Harold Rosenberg, and Philip Guston. *Philip Guston: Recent Paintings and Drawings.* New York: Jewish Museum, 1966.

Mayer, Musa. *Night Studio: A Memoir of Philip Guston by His Daughter.* New York: Viking-Penguin, 1988.

Sichel, Kim and Mary Drach McInnes. *Philip Guston: 1970-1980, Private and Public Battles.* Seattle: University of Washington Press, 1994.

Storr, Robert. *Philip Guston.* New York: Abbeville Press, 1986.

Weber, Joanna. *Philip Guston: A New Alphabet, The Late Transition.* New Haven, CT: Yale University Art Gallery, 2000.

Selected Public Collections

Art Institute of Chicago
Hirshhorn Museum and Sculpture Garden, Washington, D.C.
Museum of Fine Arts, Boston
Museum of Modern Art, New York
National Gallery of Canada, Ottawa
San Francisco Museum of Modern Art
Smithsonian American Art Museum, Washington, D.C.
Tate Gallery, London

H

Eva Hesse (1936–70), sculptor, draftswoman, and painter.

A professional artist for only ten years (of which less than six were devoted to three-dimensional work) because of her tragic death from a brain tumor at thirty-four years old, Eva Hesse is best known for her original sculptures made of unconventional materials such as fiberglass and latex.

Born in Hamburg, Hesse and her older sister escaped from Nazi Germany in late 1938 on a children's train. After reuniting with their parents in Amsterdam, the family moved to New York City in 1939 to begin a new life and to mourn the death of all of their relatives, including grandparents who were exterminated in concentration camps. Tragedy persisted for Hesse, as her parents divorced in 1945 and her mother committed suicide in January 1946. While Hesse's art is often read in relation to her life—an approach of which the artist would approve as she was a consummate diary keeper from her teenage years until her death and spoke about her work in personal terms—sensitive scholars caution not to get too mired down in the mythology of her calamities to the detriment of her artistic output.

Knowing that she wanted to pursue art as a career, in her teens Hesse attended the High School of Industrial Arts, the Pratt Institute of Design (1952–53), and the Art Students League (1954). In 1954, Hesse also interned at *Seventeen* magazine; an article featuring Hesse includes reproductions of two of her watercolors, a gouache, a drawing, and her first lithograph, as well as a short profile. The author paraphrases Hesse's remarks, explaining that the young artist's interest in transcending the superficial related to her status as a Holocaust survivor: "She thinks that growing up with people who went through the ordeal of those years makes her look very closely – very seriously – beneath the surface of things" ("It's All Yours," 161). Her art training continued in earnest at the Cooper Union (1954–57) in New York, working with **Will Barnet**, among others, followed by two years studying painting on a scholarship at Yale University (1957–59), notably with Josef Albers. Returning to New York with a B.F.A., Hesse developed a friendship with minimalist and conceptual artist **Sol LeWitt**, whose encouragement proved important to her subsequent development, and also briefly worked for a textile-designing firm. Some two-dimensional pieces showed in 1961 at a few group exhibitions, the same year that she married sculptor Tom Doyle (the marriage ended in 1966), who converted to Judaism after he met Hesse. At her first solo show

at the Allan Stone Gallery in New York (1963), Hesse exhibited abstract works on paper.

Hesse's signature preoccupations emerged in 1964 when she and Doyle spent a year in Germany living rent-free in a factory due to the generosity of a wealthy art patron. Unhappy with her painting and drawing, at Doyle's suggestion she began to utilize cast-off materials in the factory, such as wire, plaster, and string. In December 1964 she made her first three-dimensional piece, a now-lost mesh screen threaded with plaster-covered cords. Also made in Germany, the highly vertical *Ishtar* (1965, JNN Collection, Switzerland) is a wood plank covered with upraised hemispheres that Hesse wrapped with cords. From the center of each circular shape, which number ten in each of the two rows, additional cords emerge that hang loosely over the entire painted conception. Some critics read this piece and others from the period in relation to Hesse's gender, interpreting the shapes she used as phallic or resembling breasts. Accordingly, after her death Hesse became a model for some feminist artists.

After returning to the United States, Hesse devoted herself to sculpture, fusing the then-dominant Minimalism—known for its detachment—with a more personal approach. For instance, *Accession II* (1967, Detroit Institute of

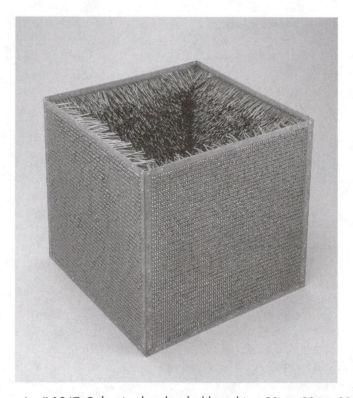

Eva Hesse, *Accession II,* 1967. Galvanized steel and rubber tubing, 30¾ × 30¾ × 30¾ inches. The Detroit Institute of Arts. Founders Society Purchase, Friends of Modern Art and Miscellaneous Gifts Fund. © The Estate of Eva Hesse. Hauser & Wirth Zürich London. Photograph © 1998 The Detroit Institute of Arts.

Arts) (see figure) recalls minimalist art in form and material, but the artist was heavily involved with the making of the piece. Weaving rubber tubing through over 30,000 holes that comprise a commercially fabricated galvanized steel box, Hesse created a work of art rife with her signature contradictions. As Hesse's biographer and friend Lucy Lippard described, "the bristles are soft, but the associations are thorny, and with its hard exterior, there is an unavoidably defensive quality" (104). Indeed, a major appeal of Hesse's sculpture is the dichotomies inherent in them. Curator Helen Cooper and others have observed, "Hesse built on the internal oppositions with each work: the geometric and the organic, order and chaos, repetition and difference, hard and soft, permanence and change. The tension between these various positions, once considered absolutes, animates her work and gives it its intellectual, psychological, and sensory edge" (9).

One of Hesse's favorite materials was latex rubber because of its inherent malleability, thus betraying the artist's presence. Eight vertically oriented lengths of cheesecloth covered with fiberglass and latex comprise *Contingent* (1969, National Gallery of Australia, Canberra), which hangs from the ceiling in a parallel row that nearly reaches the floor. *Contingent* adorned the cover of *Artforum* magazine, in part famously for its deviation from the artistic norm because of Hesse's expressionistic use of minimalist repetition and in part because it appeared the month she died (May 1970). Works such as *Accession II* and *Contingent* were a critical success, and some major public collections acquired Hesse's sculptures in her lifetime. In 1972, the Guggenheim Museum mounted a posthumous retrospective. More recently, the San Francisco Museum of Modern Art (2002) exhibited over 150 pieces by the artist, and New York's Jewish Museum held a major Hesse retrospective in 2006.

Bibliography

Barrette, Bill. *Eva Hesse, Sculpture: Catalogue Raisonné*. New York: Timken Publishers, 1989.

Cooper, Helen A., ed. *Eva Hesse: A Retrospective*. New Haven: Yale University Press, 1992.

"It's All Yours." *Seventeen* (September 1954): 140–141, 161.

Johnson, Ellen H. *Eva Hesse, A Retrospective of the Drawings*. Oberlin, OH: Allen Memorial Art Museum, Oberlin College, 1982.

Lippard, Lucy R. *Eva Hesse*. New York: New York University Press, 1976.

Nemser, Cindy. *Art Talk: Conversations with 12 Women Artists*. New York: Charles Scribner's Sons, 1975.

Nixon, Mignon, ed. *Eva Hesse*. Cambridge, MA: MIT Press, 2002.

Sussman, Elisabeth, ed. *Eva Hesse*. San Francisco: San Francisco Museum of Modern Art; New Haven: Yale University Press, 2002.

Wagner, Anne Middleton. *Three Artists (Three Women): Modernism and the Art of Hesse, Krasner, and O'Keeffe*. Berkeley: University of California Press, 1996.

Wilson, William S. "Eva Hesse: On the Threshold of Illusions." In *Inside the Visible: An Elliptical Traverse of 20th Century Art, in, of, and from the Feminine*. Edited by M. Catherine de Zegher, 426–433. Cambridge, MA: MIT Press, 1996.

Selected Public Collections

Art Institute of Chicago
Hirshhorn Museum and Sculpture Garden, Washington, D.C.
National Gallery of Australia, Canberra
Nelson-Atkins Museum of Art, Kansas City, Missouri
San Francisco Museum of Modern Art
Solomon R. Guggenheim Museum, New York
Tate Gallery, London
Whitney Museum of American Art, New York

K

Tobi Kahn (1952–), painter, sculptor, and printmaker.

Concerned with the relationship between art and the sacred, Tobi Kahn creates work in several media prompted by his Jewish heritage but in many cases broadly accessible to the spiritual needs of all peoples. Kahn eloquently elucidates his inspiration and perspective: "Since my consciousness, sensibility, and visual acuity all derive from a self that is profoundly Jewish, my art inevitably comes from that place. Which does not mean that I represent Jewish symbols or narratives in my paintings and sculpture. Recognizable Jewish symbols do not particularly engage me as an artist. Nevertheless, I consider my work, which is abstract and conceptual, deeply Jewish. I would not call myself a Jewish artist, just as I would not call myself a male artist, a married artist, a father artist, or an American artist. And yet, everything I see, touch and make is imbued with my love of Judaism and the way it has shaped me. My interest in art as healing, in sacred spaces, in art's spiritual dimension, in the unique individuality of work marked by the hand of the artist are inseparable from my being a Jew. Similarly, my ceremonial art—which is, of course, Judaica—is not distinct in its artistic intent or execution from my paintings and sculpture, even if its purpose is Jewish" (Telephone conversation).

Born in New York to a family of Holocaust survivors, Kahn was named after an uncle killed by the Nazis. As a boy Kahn attended Jewish day school, after which he spent a year studying acting at Tel Aviv University (1970–71) and three years studying at a yeshiva outside of Jerusalem. Returning to the United States, Kahn earned a B.A. from Hunter College (1974–76), where he studied photography, and an M.F.A. from the Pratt Institute (1976–78), focusing on painting.

He began making small sculptures in the late 1970s of painted wood shrines encasing tiny, single figures in shapes reminiscent of the human body. Each of these shrines, like his subsequent paintings, is titled with invented words (the words frequently sound Hebrew in inspiration), as Kahn aims to evade specific titles that may lead a viewer to a forgone conclusion. Of the stimulus for this series Kahn explains: "When I conceived this series of sculptures in 1978, I was fascinated by the depiction in Leviticus of the Holy of Holies, a space within a space that housed a sacred object in its innermost chamber. Throughout my travels I noticed that it was the

space surrounding the sacred object in various cultures that interested me. In these sculptures I try to replicate the aura of a chosen object in communion with its own constructed space" (Nahas, 14–15). His work increased dramatically in size in 1993 when Kahn received a commission for a granite and bronze outdoor sculpture in New Harmony, Indiana. Titled *Shalev,* the 12½-foot arched structure, reminiscent of ancient structures such as *Stonehenge* (3000–1800 B.C.E., Wiltshire, England), sits in a large grassy area. A considerably smaller bronze figure stands within the open area of the construction.

Following experimentations with various styles in two-dimensions, around 1984 Kahn began to paint floating forms that suggest landscape in subdued colors on canvases (and sometimes on wood) such as *Iza II* (1984, Solomon R. Guggenheim Museum, New York). Emerging from that type of image, since 1987 Kahn has worked on his signature Sky and Water paintings, like *Ya-Ir XX* (1999, private collection, New York) (Color Plate 9), a series that conveys landscape through color rather than by representational means. Part of a larger American tradition of Romantic landscapes by artists such as Albert Pinkham Ryder, Kahn builds up layers of modeling paste and hand-mixed paint to create textured surfaces glowing with subtly nuanced hues. Evoking a sense of horizon and sky, and sometimes suggestions of other landscape elements like hills, Kahn aims to create paintings that encourage a sense of tranquility. As with his nonassociative titles, the imagery in his quiet landscapes remains ambiguous enough so that individuals can reach their own understanding of what the work means, thereby—ideally—achieving personal transcendence. Through the 1990s Kahn experimented with other abstract forms derived from nature, painted with a similar technique of dense, layered paint covered with washes that reveal the shimmering colors underneath. In 2000, nine of Kahn's Sky and Water canvases appeared in the Albright-Knox Art Gallery's "Landscape at the Millennium" show. Eighty Sky and Water paintings hung at the Neuberger Museum of Art in 2003. When asked which works he feels exemplify his Jewishness, Kahn includes the Sky and Water series, "which represents the lyrical time of *bein ha-shmashot*—that time of day between day and night when the Western day ends but the Jewish day is born" (Telephone conversation).

After his marriage in 1986, Kahn started making furniture (e.g., cupboards and baby cradles) for his and his wife's home, and then wood-carved ceremonial objects related to the Jewish life cycle, such as a wedding canopy (*chuppah*) and Chanukah lamp. Some of these diverse building projects are painted with similar forms found on his canvases and others are cast in metal. Emily Bilski observes the connection between Kahn's artistic interests: "Kahn's works have straddled the ever murkier boundary between painting and sculpture. Indeed, his paintings have the quality of 'thingness,' of constructed three-dimensional objects, which usually hang on the wall but, in the case of the smaller pieces, can sit just as comfortably on a shelf or surface. It is this physicality that facilitated the adaptation of the technique for objects" (16). Kahn has titled his output of ritual objects "Avoda" (Hebrew for both work and worship). Since 1999 forty-two of these works have traveled to various venues. As part of a program developed by Kahn and Carol Brennglass Spinner, Avoda Arts,

the Avoda installation is accompanied by workshops designed for participants of any ideology to create their own ceremonial objects.

In addition to *Shalev,* Kahn has received several more public commissions. At New York City's HealthCare Chaplaincy administrative headquarters, Kahn designed a nondenominational area for contemplation in the vein of **Mark Rothko**'s Rothko Chapel in Houston, Texas. To be sure, Rothko has provided an important influence on Kahn, who asserts, "I love Mark Rothko's work, which embodies an idea of sacredness to me" (Telephone conversation). Titled *Meditative Space* (2002), three walls of the room are covered with enormous Sky and Water paintings, accompanied by wood furniture built and painted by the artist. He has also executed bronze sculptures for Holocaust memorial gardens at Jewish Community Centers in Tenafly, New Jersey (1997) and San Diego, California (2000).

Kahn does not believe in the larger category of Jewish art, observing that "Art can be made by Jews or non-Jews, but no denomination or orientation can define art. Very few people who come from my Jewish world have made art the center of their lives, but I have begun to see younger Jews who are making that choice. And I'm thrilled about it" (Telephone conversation). Among Kahn's other interesting projects are an edition of thirty-six etchings commissioned by the Jewish Theological Seminary of America (1986) and the creation of sets for dance and theater productions. Kahn was the recipient of a 2004 Jewish Cultural Achievement Award in the visual arts from the National Foundation for Jewish Culture. Since 1986 he has taught at the School of Visual Arts in New York.

Bibliography

Bilski, Emily D. *Objects of the Spirit: Ritual and the Art of Tobi Kahn.* New York: Avoda Institute, Ltd.; Hudson Hills Press, 2004.

Dreishpoon, Douglas. *Landscape at the Millennium: Installations by Tobi Kahn and Pat Steir.* Buffalo, NY: Albright-Knox Art Gallery, 2000.

Goodman, Susan. *Jewish Themes/Contemporary American Artists II.* New York: Jewish Museum, 1986.

Götz, Stephan. *American Artists in their New York Studios: Conversations About the Creation of Contemporary Art.* Edited by Craigen W. Bowen and Katherine Olivier. Cambridge, MA: Center for Conservation and Technical Studies, Harvard University Art Museums; Stuttgart: Daco-Verlag Günter Bläse, 1992.

Kahn, Tobi. Telephone conversation with the author. July 5, 2006.

Nahas, Dominque. *Sacred Spaces.* Syracuse, NY: Everson Museum of Art, 1987.

Prescott, Theodore L. "Tobi Kahn: A Profile." *Image: A Journal of the Arts and Religion* 33 (Winter 2001–2002): 31–42.

Selz, Peter. *Tobi Kahn: Metamorphoses.* Lee, MA: Council for Creative Projects, Inc.; Distributed by the University of Washington Press, 1997.

White, Mark Andrew. *Tobi Kahn: Correspondence.* Wichita, KS: Edwin A. Ulrich Museum of Art, Wichita State University, 2001.

Young, Dede. *Tobi Kahn: Sky and Water.* With an essay by Donald Kuspit. Purchase, NY: Neuberger Museum of Art, Purchase College, State University of New York, 2003.

Selected Public Collections

Jewish Museum, New York
Minneapolis Institute of Arts
Museum of Art, Fort Lauderdale, Florida
Museum of Fine Arts, Houston
Neuberger Museum of Art, Purchase, New York
Skirball Cultural Center, Los Angeles
Solomon R. Guggenheim Museum, New York
Ulrich Museum of Art, Wichita, Kansas

Jacob Kainen (1909–2001), printmaker and painter.

Jacob Kainen straddled two sides of the art world: as a printmaker and painter as well as an influential curator of graphic arts at the Smithsonian Institution. During his long curatorial career, Kainen mounted exhibitions on artists such as **Louis Lozowick** and Josef Albers. His own artistic production oscillated between figuration and abstraction.

Born in Waterbury, Connecticut to Russian immigrant parents, Kainen was interested in art since childhood; as a boy he would copy art reproductions from the Yiddish periodical *The Forward*. The family moved to the Bronx around 1918, and at sixteen years old Kainen started studying art at the Educational Alliance and Art Students League. Further training ensued at the New York Evening School of Industrial Art (1926–29) and the Pratt Institute (1927–30). At Pratt, Kainen focused on painting, making representational canvases that adopted the stylistic concerns of past artists; his portraits resembled those by Rembrandt with their warm tonalities, and his still lifes occasionally recalled the work of Paul Cézanne. When Pratt reconfigured the curriculum into a commercial art program, Kainen refused to take the new classes. This incident and others led to his expulsion three weeks before graduation (**Max Weber** was also expelled from Pratt); however, Kainen received a backdated Pratt diploma in 1942, the same year that his first canvas was purchased by a museum (The Phillips Collection).

Committed early on to a socially involved art and attendant outlook on life, in 1934 Kainen joined the John Reed Club, an American Communist organization composed of writers and artists. He exhibited with the Club, most notably contributing a now lost image (either a painting or a drawing) titled *Nazi Torture Chamber* to the 1933–34 show "Hunger, Fascism, and War." While trained primarily as a painter, at the suggestion of Stuart Davis, Kainen worked as a Works Progress Administration artist in the Graphic Arts Division (1935–42). Kainen had made a few prints as a student, but it was not until the WPA years that he consistently created prints and had the opportunity to hone a personal graphic style. His early lithographs are Social Realist scenes, such as *Tenement Fire* (1935, Philadelphia Museum of Art). Only his second lithograph, *Tenement Fire* conveys the energy of the moment through a variety of expressive lines and textures. A canvas of the same name (1934, Smithsonian American Art

Museum) utilizes heightened color and a strongly expressionist application of paint. In his important and informative essay about the development of the WPA Graphic Arts Division, Kainen recalled: "As one who joined the graphic arts division in its first month, I can testify to the enthusiasm and good will felt by participating artists. Aside from the relief at being able to survive economically, we were grateful to the government for recognizing that art was a public concern" (O'Connor, 164, 166).

He made his first color lithograph in 1937, *Cafeteria* (Smithsonian American Art Museum, Washington, D.C.) (see figure), a solidly rendered scene of Depression-era life with a waitress cleaning a table and customers eating, talking, and reading the newspaper. *Cafeteria* differs from Kainen's earlier printmaking efforts as here he begins to reduce and simply forms. Constantly experimenting with different printmaking techniques, Kainen worked in drypoint, etching, and woodcut. During these trying years he wrote articles for *Art Front* and *The Daily Worker,* and published cartoons in *The Daily Worker* and *New Masses.* He also organized an artist group, the New York Group, including Alice Neel and others. The group's first show at the ACA Gallery was mounted in 1938, followed by a second the following year before they disbanded. Kainen enjoyed his first solo show at the ACA Gallery in 1940.

In an effort to find some financial stability, in 1942 Kainen moved to Washington, D.C., to work as an aide in the Division of Graphic Arts at the

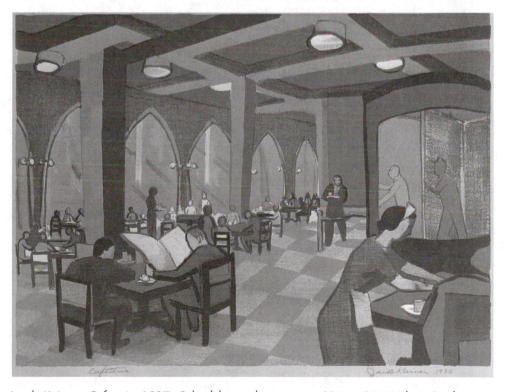

Jacob Kainen, *Cafeteria,* 1937. Color lithograph on paper, 11⅞ × 16⅛ inches. Smithsonian American Art Museum, Washington, D.C. Gift of the artist 1966.69.7.

Smithsonian's United States National Museum (currently the National Museum of American History). From 1946 to 1966, Kainen was curator of the Division of Graphic Arts, and then later he was curator of the Department of Prints and Drawings at the Smithsonian's National Collection of Fine Arts (1966–69). During his tenure at these institutions Kainen acquired many important prints for the collections and published books, articles, and exhibition catalogs. Beginning in 1947, Kainen taught painting and printmaking at the Washington Workshop Center of the Arts, where he remained until 1954. These efforts limited the time Kainen spent on his own art, although he did continue to exhibit both prints and paintings in solo exhibitions and groups shows. Works from this period maintain Kainen's interest in city life, and he also added portraits and landscapes to his repertoire, while brightening his palette. Kainen also explored abstraction in the late 1940s, precipitated in part by a friendship initiated in the early 1930s with Arshile Gorky, whose artistic ideas about nonobjective art and the importance of the creative subconscious influenced his work. Even when working abstractly, Kainen felt that the human experience should remain at the center of his art. As Kainen explained in 1973: "However abstract the forms and colors seem, they should somehow give off an aura of human experience" (quoted in Hopps, 21). Around 1957, Kainen returned to representational imagery. However, his experimentations with abstraction influenced these conceptions, which were delineated with a highly gestural paintstroke and nonnaturalistic colors.

After his retirement from the Smithsonian in January 1970, Kainen worked on large, entirely abstract canvases such as *Night Attack* (1970, collection unknown), often exploring motifs in series such as *The Way* (1978–88), which includes over one hundred paintings. Strong, sharply delineated shapes atop flatly rendered grounds of intense color characterize *Night Attack,* an approach Kainen simultaneously explored in color lithographs. William Agee observes that *Night Attack* employs "aggressive shapes, in keeping with the antiwar mood suggested by the title. Be it the Spanish Civil War or Vietnam thirty years later, Kainen has never lost his sense of despair and outrage over the evils of war. Now, however, he had found an abstract language to embody his feelings" (Hopps, 52). In the late 1970s and early 1980s, Kainen demarcated more severe, linear, stoic forms in paintings such as *Barrier III* (1984, collection unknown). Ever experimental, by the mid-1980s Kainen returned to painting organic shapes floating on richly colored canvases layered with paint. In 1993, the first major retrospective of Kainen's art appropriately originated at the National Museum of American Art (now the Smithsonian American Art Museum).

Bibliography

Flint, Janet A. *Jacob Kainen: Prints, A Retrospective.* Washington, D.C.: Published for the National Collection of Fine Arts by the Smithsonian Institution Press, 1976.

Hopps, Walter. *Jacob Kainen.* With essays by William C. Agee and Avis Berman. New York: Thames and Hudson; Washington, D.C.: National Museum of American Art, Smithsonian Institution, 1993.

Kainen, Jacob. "The Graphic Arts Division of the WPA Federal Art Project." In *The New Deal Art Projects: An Anthology of Memoirs.* Edited by Francis V. O'Connor, 155–175. Washington, D.C.: Smithsonian Institution Press, 1972.

Langa, Helen. *Radical Art: Printmaking and the Left in 1930s New York.* Berkeley: University of California Press, 2004.

Rand, Harry. "Notes and Conversations: Jacob Kainen." *Arts Magazine* 53, no. 4 (December 1978): 135–145.

Reynolds, Jock, et al. "Jacob Kainen: An Appreciation." *Art on Paper* 4, no. 2 (November–December 1999): 29–33.

Scott, William P. "Sidestepping the Mainstream." *Art in America* 82 (September 1994): 106–109.

Sundell, Michael G. *Jacob Kainen, Four Decades: Paintings.* Cleveland: New Gallery of Contemporary Art, 1978.

Selected Public Collections

Ackland Art Museum, Chapel Hill, North Carolina
Baltimore Museum of Art
British Museum, London
Indianapolis Museum of Art, Indiana
The Phillips Collection, Washington, D.C.
Portland Art Museum, Oregon
Smithsonian American Art Museum, Washington, D.C.
Whitney Museum of American Art, New York

Alex Katz (1927–), painter, sculptor, and printmaker.

Although painting from nature in a representational fashion, Alex Katz utilized oversized canvases and focused on style first then on subject in an effort to compete with the large-scale, abstract paintings of his time and to create an art viewed as modern. As Whitney curator Richard Marshall observed: "Katz's astonishing achievement is to have reconciled abstraction and realism in post-World War II America" (13). Indeed, Katz primarily paints in the traditional mode of portraiture in a detached manner, often eschewing perspective and flattening bright colors. Katz described his conundrum after achieving success: "It seemed questionable whether you could make a valid painting that was a portrait–a modern painting, so to speak" (36).

Born in Brooklyn to newly immigrated parents from Eastern Europe, Katz joined the Navy a month before the end of World War II. After a year in the Pacific he returned home and began his art studies, initially at the Cooper Union Art School (1946–49) training to be a commercial artist. This early exposure to the style of billboards, magazine advertisements, and comic strips would affect his later artistic production. Katz decided to focus on the fine arts in his last year at which time he studied with, among others, the Jewish painter Morris Kantor. In the summer after graduating from Cooper Union, Katz took classes at the Skowhegan School of Painting and Sculpture in Maine. The following summer he attended the school again, honing his skills and his

interest in working from nature. From this period on he would spend summers in Maine painting. During 1950–51 Katz painted many landscapes in a loose, sketchy style encouraged by Jackson Pollock's allover canvases. The first show in which he exhibited a group of works was New York's Tanager Gallery (1953). In 1955 he began to make small, simplified landscape collages, which were also exhibited at the Tanager Gallery (October 1957). At the opening of this show he met Ada Del Moro, who would become his wife four months later and figures as a model in many of his portraits.

To be sure, in the late 1950s Katz began painting Ada as he started to develop his mature style and to discover his overriding interest in portraiture. The following year he also made his first cutouts—freestanding, double-sided figures painted on wood or aluminum. By the early 1960s Katz's canonical style of large-scale, cropped portraits painted with sharp, crisp contours in strident colors began to evolve. *The Red Smile* (1963, Whitney Museum of American Art, New York) exemplifies the works of this period, showing an impersonal, precisely delineated three-quarter's view of Ada against a monochrome red background. Painted with thinned-out oil paint, Katz explored form and color much as the Fauvist Henri Matisse did in the earlier part of the century. Interest in these works was high despite the prevalence of abstraction, as shown by Katz's seven one-person exhibitions staged between 1964 and 1970. A portrait rendered in his signature style, *Eli* was acquired by the Whitney Museum of Art in 1964. Unlike Social Realist artists of a generation earlier, who emphasized their humanist intentions (e.g., **Moses Soyer** and **Harry Sternberg**), Katz repeatedly asserts that these works and others "deal mostly with appearance. Style and appearance are the things that I'm more concerned about than what something means. I'd like to have style take the place of content, or the style be the content. It doesn't have to be beefed up by meaning. In fact, I prefer it to be emptied of meaning, emptied of content" (Strand, 124, 129). Katz engages this approach in his self-portraits as well, including *Passing* (1962–63, Museum of Modern Art, New York) (see figure), a large ($71\frac{3}{4} \times 79\frac{5}{8}$ inches) bust length portrait of himself in a black hat and suit staidly confronting the viewer. In his early portraits, Katz worked directly on the canvas from life, but in the 1960s, as his portraits grew in size, he began making studies in preparation for the final version. Irving Sandler observes, "the very bigness of his portraits mythologizes them" (55).

While continuing to paint portraits Katz also made a series of enlarged flower paintings that press to the front of the picture plane, filling up the canvas (1966–67). Beginning in 1960, Katz designed sets and costumes for choreographer Paul Taylor's dance performances in addition to sets for other productions. His set for Kenneth Koch's off-Broadway play *George Washington Crossing the Delaware* incorporated around twenty almost life-size wood cutouts, including Washington in his rowboat, army officers, and props such as a cherry tree all rendered in Katz's straightforward style. Starting in 1965, Katz has been making prints, some of which were executed as illustrations for published books of poetry by leading writers such as John Ashbery.

Over the years Katz has experimented with including background details omitted in earlier canvas portraits, painting group portraits often of family

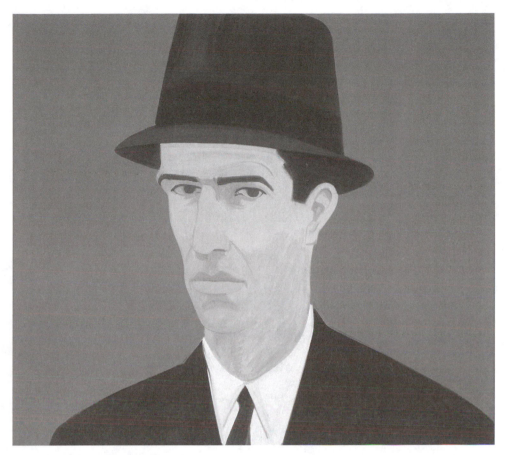

Alex Katz, *Passing,* 1962–63. Oil on canvas, 71¾ × 79⅝ inches. The Museum of Modern Art, New York. Gift of the Louis and Bessie Adler Foundation, Inc., Seymour M. Klein, President (233.19). Art © Alex Katz/Licensed by VAGA, New York, New York. Digital Image © The Museum of Modern Art/Licensed by SCALA/Art Resource, New York.

and friends in social situations, and landscapes. In all cases Katz's smooth, even paint and stylized technique contrasts with abstraction as well as with the work of many of the expressionist figurative painters of the late twentieth century, like **Jack Levine**.

Katz continues to garner acclaim. In fall 2001 he enjoyed five exhibitions in New York, including "Alex Katz: Large Paintings" at the PaceWildenstein Gallery, "Alex Katz: Small Paintings" at the Whitney Museum of American Art, and "Alex Katz: The Complete Woodcuts and Linocuts" at the Peter Blum Gallery. His website is www.alexkatz.com.

Bibliography

Ashbery, John. *Fragment: Poem.* Illustrated by Alex Katz. Los Angeles: Black Sparrow Press, 1969.

Beattie, Ann. *Alex Katz.* New York: Harry N. Abrams, Inc., Publishers, 1987.

Enright, Robert. "The Years of Figuring Restlessly: An Interview with Alex Katz." *Border Crossings* 21, no. 3 (August 2002): 50–67.

Hunter, Sam. *Alex Katz*. New York: Rizzoli International Publications, 1992.

Katz, Alex. "Starting Out." *The New Criterion* 21, no. 4 (December 2002): 4–8.

Maravell, Nicholas P. *Alex Katz: The Complete Prints*. Interview with Carter Ratcliff. New York: Alpine Fine Arts Collection, 1983.

Marshall, Richard. *Alex Katz*. With an essay by Robert Rosenblum. New York: Whitney Museum of American Art in association with Rizzoli International Publications, 1986.

Sandler, Irving. *Alex Katz*. New York: Harry N. Abrams, Inc., Publishers, 1979.

———. *Alex Katz: A Retrospective*. New York: H.N. Abrams, Inc., Publishers, 1998.

Sheets, Hilarie M. "Cool and Hot." *ARTnews* 103, no. 3 (March 2004): 116–119.

Strand, Paul, ed. *Art of the Real: Nine American Figurative Painters*. New York: Clarkson N. Potter, Inc., 1983.

Selected Public Collections

Art Institute of Chicago

Cleveland Museum of Art, Ohio

Colby College Museum of Art, Waterville, Maine (a wing of the museum showcases Katz's work. The museum holds over 400 pieces by Katz)

Hirshhorn Museum and Sculpture Garden, Washington, D.C.

Los Angeles County Museum of Art

New Orleans Museum of Art

Rose Art Museum, Brandeis University, Waltham, Massachusetts

Tate Gallery, London

Whitney Museum of American Art, New York

R.B. Kitaj (1932–), painter and printmaker.

An artist who paints highly personal subjects, often of a Jewish nature, R.B. Kitaj assimilates various artistic influences and literary allusions in his expressionistic, figurative allegories. Born in Cleveland as Ronald Brooks, Kitaj took his surname from his stepfather, a Viennese refugee from the Nazi regime. From 1956 to 1958 Kitaj served in the Army as an illustrator, immediately after which he settled in England to study under the G.I. Bill at the Ruskin School of Art (1958–59). Before this time he received art training at the Cooper Union in New York (1950) and the Academy of Fine Arts in Vienna (1951–52). In 1959 Kitaj transferred to the Royal College of Art in London, graduating in 1962. During this early period Kitaj experimented with a number of styles, including Surrealism and Abstract Expressionism, while taking life-drawing classes. His work often incorporates collage elements and also a sense of collage through the painted juxtaposition of diverse subjects in canvases such as *The Murder of Rosa Luxemburg* (1960, Tate Gallery, London). Combining text and image, *The Murder of Rosa Luxemburg* commemorates the Jewish radical who was killed for her revolutionary endeavors. In 1963 Kitaj had his first one-person

exhibition at the Marlborough New London Gallery, the same year that he began printmaking. From the late 1960s to the early 1970s Kitaj experimented with screenprints in such projects as his collaboration with the poet Robert Creeley on *A Day Book* (1971).

The recurrent figure of Joe Singer, Kitaj's representative wandering Jew, appears for the first time in *The Jew, Etc.* (1976–79, collection of the artist), a sparsely rendered oil and charcoal on canvas portrait of Singer on a train. The figure of Singer resonates autobiographically as in the 1930s Kitaj's mother dated a man named Joe Singer. Kitaj later made the association: "I happened to chance upon a dimly remembered name from childhood to give to a character I would draw and paint and imagine, a figure who would offer a certain secular impression of Jewishness…and, behold, the guy almost became my dad and I almost became R.B. Singer!" (Livingstone, 34). Marco Livingstone observes: "Singer is for Kitaj what K. was to Kafka in *The Trial* and *The Castle*: an archetype representing a condition of man, and more specifically of the Jew, in the twentieth century, the anxious uncertainty of his fate made all the more urgent through the artist's identification with him" (33).

The exilic condition preoccupies Kitaj who wrote a book on the subject, *First Diasporist Manifesto* (1989). Here Kitaj constructed the concept of the "Diasporist painter" to refer to artists, such as himself, who paint "in two or more societies at once" (19). A Diasporist painter can be any Other, for, according to Kitaj, "if a people is dispersed, hurt, hounded, uneasy, their pariah condition confounds expectation in profound and complex ways. So it must be in aesthetic matters" (25). Kitaj explains his life as a Diasporist: "Painting is a great idea I carry from place to place. It is an idea full of ideas, like a refugee's suitcase, a portable Ark of the Covenant" (11).

Seeking a symbol for Jews akin to the Christian cross, in 1985 Kitaj began to utilize a chimney in reference to the ovens in which Nazis burned Jews. The eight pictures in the series that explored this iconography bear the overarching title *Passion*. One of the best-known *Passion* images, a picture of a train passenger titled *The Jewish Rider* (1984–85, Astrup Fearnley Collection, Oslo, Norway) (see figure), plays on Kitaj's knowledge of art history; the canvas is based partly on *The Polish Rider* (c. 1655, Frick Collection, New York), a work once attributed to Rembrandt. Kitaj quotes the rider's pose for his Jewish counterpart and even includes the horse's head behind the passenger. Employing bright, contrasting colors, applied with a painterly brushstroke, Kitaj evokes the discomfort of the traveler who sits awkwardly in his seat, and indeed the train functions as a symbol of the homelessness of the Diaspora Jew. Kitaj layers the painting with further meaning by converting the fire at the back of the Dutch canvas into a chimney seen outside the train window in *The Jewish Rider*. Connecting the chimney to a cross by the angle of the exiting smoke, Kitaj creates additional symbolism, interpreted by Vivianne Barsky as "an accusing finger, suggest[ing] an unholy alliance between the church and Nazism" (171). A conductor in the back aisle menacingly wielding a baton furthers the Holocaust connotations of the painting. Other works by Kitaj that adapt an artistic precedent include *The Jewish School (Drawing a Golem)* (1980, private collection, Monte Carlo), a painting derived from the German George

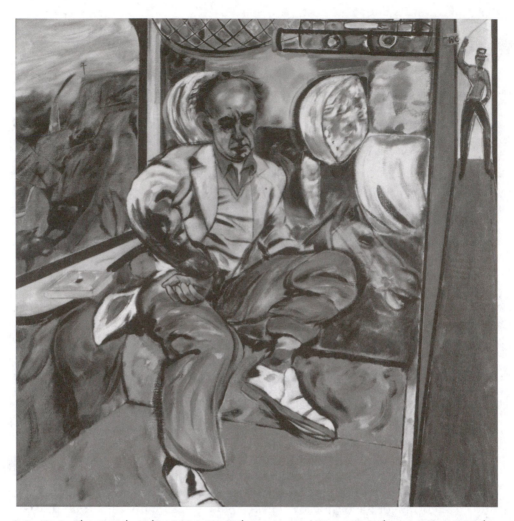

R.B. Kitaj, *The Jewish Rider,* 1984–85. Oil on canvas, 60 × 60 inches. Astrup Fearnley Collection, Oslo, Norway. Photo: Tore H. Royneland.

Emanuel Opitz's nineteenth-century caricature *Die Judenschule.* Kitaj's canvas depicts three students and a teacher. The teacher's inkwell spills blood; one student hits his head against a wall—perhaps trying to escape the Nazis or maybe in reference to the futility of the situation. Another student reads, symbolic of the Jews as the people of the book, and the figure at the right of Kitaj's canvas is in the process of drawing a golem (an entity also imaged by **Philip Guston**), a mythical being in Kabbalistic thought that comes to life after creation by human hands. Because the boy has not completed his drawing, Marco Livingstone observes, the golem will not come to life and thus will be unable to protect the Jews from their Nazi oppressors (35).[16]

Following scathing reviews of his 1994 retrospective at the Tate Gallery, London and the death of his wife soon after, Kitaj left England and moved to Los Angeles in 1997. In 2004, Kitaj published a list of his favorite Jewish painters, including the Americans **Mark Rothko** and Guston, in

addition to himself. Kitaj justifies his own inclusion: "I seem to be the only well-known painter to put the Jewish Question at the heart of my work. The Jewish Question is, for me, what trees are for a landscape painter. It mesmerizes me" (Kitaj, *Kitaj's List*, 7). Among Kitaj's impressive accolades, in 1985 he became the first American since John Singer Sargent elected to the Royal Academy in London.

Bibliography

Aulich, James and John Lynch, eds. *Critical Kitaj: Essays on the Work of R.B. Kitaj.* New Brunswick, NJ: Rutgers University Press, 2001.

Barsky, Vivianne. "'Home is Where the Heart Is': Jewish Themes in the Art of R. B. Kitaj." In *Art and Its Uses: The Visual Image and Modern Jewish Society.* Edited by Ezra Mendelsohn and Richard I. Cohen, 149–185. New York: Oxford University Press, 1990.

Gilman, Sander L. "R. B. Kitaj's 'Good Bad' Diasporism and the Body in American Jewish Postmodern Art." In *Complex Identities: Jewish Consciousness and Modern Art.* Edited by Matthew Baigell and Milly Heyd, 223–237. New Brunswick, NJ: Rutgers University Press, 2001.

Kinsman, Jane. *The Prints of R. B. Kitaj.* Afterword by R.B. Kitaj. Aldershot: Scolar Press, 1994.

Kitaj, R.B. *First Diasporist Manifesto.* New York: Thames and Hudson, 1989.

———. *R. B. Kitaj: How to Reach 67 in Jewish Art, 100 Pictures.* New York: Marlborough Gallery, 2000.

———. "Kitaj's List." *The Jewish Quarterly Review* 94, no. 1 (Winter 2004): 6–7.

Livingstone, Marco. *R. B. Kitaj.* London: Phaidon Press, 1999.

Morphet, Richard, ed. *R. B. Kitaj.* New York: Rizzoli International Publications, Inc., 1994.

Rios, Julián. *Kitaj: Pictures and Conversations.* Wakefield, RI: Moyer Bell, 1997.

Salus, Carol. "R.B. Kitaj's *The Murder of Rosa Luxemburg*: A Personal Metaphor." *Jewish Art* 16–17 (1990–1991): 130–138.

Selected Public Collections

Cleveland Museum of Art
High Museum of Art, Atlanta
Jewish Museum, New York
Los Angeles County Museum of Art
Museum of Modern Art, New York
National Gallery of Art, Washington, D.C.
National Portrait Gallery, London
Tate Gallery, London

Lee Krasner (1908–84), painter.

The only female member of the first generation of Abstract Expressionists, Lee Krasner's work engages in an artistic interchange with other avant-garde

artists and offers a critique of her own art as she often reworked and changed her style.[17] Born Lena Krassner in Brooklyn, New York to Orthodox, Russian immigrant parents, early on she studied art at the Women's Art School at Cooper Union (1922–25), Art Students League (1928), and National Academy of Design in New York (1929–32). Beginning in 1935 she worked as a Works Progress Administration artist. While the single mural she designed—for the WNYC radio station building—was never executed, Krasner did work as an assistant to the muralist Max Spivak on additional murals. During the 1930s Krasner experimented with various styles and forms, including Social Realism and Giorgio de Chirico's mysterious perspectives. By the later half of the decade she changed her name to Lee from Lenore, a name she adopted as a child, and later Americanized her surname to Krasner.

Resuming her art studies in 1937 with the avant-garde, German expatriate Hans Hofmann, Krasner absorbed aspects of Pablo Picasso's Cubism and Henri Matisse's heightened color. She showed her Cubist inspired still lifes, semi-abstracted from nature, in the annual group exhibitions of the American Abstract Artists from 1940 to 1943.

In 1941 Krasner met Jackson Pollock, soon to be recognized as the pioneer Abstract Expressionist, when the pair were asked to show their work at the McMillen Gallery in a group exhibition early the following year. She and Pollock married in 1945, the same year that the pair moved to the Hamptons. Throughout their relationship, Krasner and Pollock participated in an aesthetic dialogue as Krasner schooled Pollock in European modernism while she adopted Pollock's synthesis of abstraction and automatism, and of color and line, elements viewed as discreet by her mentor Hoffman. During their courtship and early artistic interactions Krasner and Pollock shared a studio, at which time she reworked and scraped her canvases until they became muddy, gray slabs (Glueck, 59–60). Robert Hobbs argues that the gray paintings (1943–47) "were subliminal reactions to the mass murders of Jews in Nazi-occupied Europe" (*Lee Krasner*, 1999, 65).

Her *Little Image* paintings (1946–49) adopted and reinterpreted Pollock's allover technique in three types of works, categorized by Barbara Rose as mosaic or divisionist (dabs of thick color that cover the entire surface of the canvas), webbed (layers of paint that interlace on the canvas), and grid or hieroglyph (a network of calligraphic shapes covering the entire canvas resembling indecipherable letters) (54). During this time Krasner also promoted Pollock's career, sometimes to the detriment of her own artistic development. Robert Hobbs interprets the hieroglyph paintings such as *Composition* (1949, Philadelphia Museum of Art) (see figure) as "an abstract language to work out her own complex feelings regarding her largely neglected Jewish heritage" (*Lee Krasner*, 45). Although Krasner knew Hebrew as a child, she forgot how to write it as an adult. In the hieroglyphs, though, Marcia Tucker observes, Krasner renewed this orientation as she worked on the hieroglyphs from right to left in the manner Hebrew is written (16). Hobbs understands this "reenactment" as connoting "a significant tension between wanting to bring Hebrew (and, by extension, her Jewish identity) to consciousness and trying to keep it repressed" (*Lee Krasner*, 1993, 45).

Lee Krasner, *Composition,* 1949. Oil on canvas, 38 1/16 × 27 13/16 inches. Philadelphia Museum of Art. Gift of the Aaron E. Norman Fund, Inc., 1959. Photo: Eric Mitchell. © 2006 The Pollock-Krasner Foundation/Artists Rights Society (ARS), New York.

Beginning in 1939 Krasner employed collage techniques, sometimes on a large scale as the years progressed. For *Black and White* (1953, Robert Miller Gallery, New York), Krasner utilized her own cut up drawings rearranged in the new, abstract work. In the mid-1950s she also cut up several of Pollock's discarded canvases and used them in collages. Her collage paintings first showed at New York's Stable Gallery (1955) to acclaim.

After Pollock's 1956 death in a car accident, Krasner began her *Earth Green* series (1957–59), an energetic, colorful, rhythmic group of images exploring growth and nature. The gloomier *Night Journey* series (1959–62; also known as the *Umber* series) followed, promoted by her turbulent state and also bouts of insomnia. In these images Krasner reduced her palette to gradations of blacks, whites, and browns so that the artificial light she was working in would not undermine her color choices. At times, aspects of figuration appear in these paintings. Throughout her career, Krasner continued to reinvent herself and her style. She consistently reacted to the current trends

in the artworld, absorbing and modifying the work of artists such as **Morris Louis**, **Philip Guston**, and Frank Stella, much as she had done with Pollock's example. Indeed, in the 1970s Krasner eschewed her spontaneous working method, instead creating hard edge paintings in the vein of Stella.

Throughout her life Krasner asserted that her art and her life were interconnected: "My painting is so autobiographical if anyone can take the trouble to read it" (Nemser, 100). She also alleged that art may have acted as a replacement for the religion of her youth: "It is possible that what I found later on – art – would be a substitute for what religion had been for me earlier" (Munro, 109).

Solo exhibition of Krasner's work have been staged in several major venues; the first was a retrospective at the Whitechapel Art Gallery in London (1965). More recently a retrospective of over sixty paintings was held at the Los Angeles County Museum of Art (1999), subsequently traveling to the Des Moines Art Center, the Akron Art Museum, and the Brooklyn Museum. Her will endowed the Pollock-Krasner Foundation, an organization that has provided millions of dollars of financial assistance to artists.

Bibliography

Glueck, Grace. "Scenes from a Marriage: Krasner and Pollock." *ARTnews* 80, no. 10 (December 1981): 57–61.

Hobbs, Robert. *Lee Krasner.* New York: Abbeville Press, 1993.

———. *Lee Krasner.* New York: Henry N. Abrams, Inc., Publishers, 1999.

Hobbs, Roberts and Gail Levin. *Abstract Expressionism: The Formative Years.* New York: Whitney Museum of American Art and the Herbert F. Johnson Museum of Art, 1978.

Landau, Ellen G. "Lee Krasner's Early Career, Part One: 'Pushing in Different Directions.'" *Arts Magazine* 56, no. 2 (October 1981): 110–122.

———. "Lee Krasner's Early Career, Part Two: 'The 1940s.'" *Arts Magazine* 56, no. 3 (November 1981): 80–89.

———. "Lee Krasner's Past Continuous." *ARTnews* 83, no. 2 (February 1984): 68–76.

———. *Lee Krasner: A Catalogue Raisonné.* New York: Henry N. Abrams, Inc., Publishers, 1995.

Munro, Eleanor. *Originals: American Women Artists.* New York: Simon and Schuster, 1979.

Nemser, Cindy. *Art Talk: Conversations with 12 Women Artists.* New York: Charles Scribner's Sons, 1975.

Rose, Barbara. *Lee Krasner: A Retrospective.* Houston: Museum of Fine Arts; New York: Museum of Modern Art, 1983.

Tucker, Marcia. *Lee Krasner: Large Paintings.* New York: Whitney Museum of American Art, 1973.

Wagner, Anne Middleton. "Lee Krasner as L.K." In *The Expanding Discourse: Feminism and Art History.* Edited by Norma Broude and Mary D. Garrard, 425–436. New York: IconEditions, 1992.

———. *Three Artists (Three Women): Modernism and the Art of Hesse, Krasner, and O'Keeffe.* Berkeley: University of California Press, 1996.

Selected Public Collections
Lowe Museum of Art, Miami
Metropolitan Museum of Art, New York
Museo Thyssen-Bornemisza, Madrid
Museum of Contemporary Art, Los Angeles
Museum of Modern Art, New York
Smithsonian American Art Museum, Washington, D.C.
Tate Gallery, London
Whitney Museum of American Art, New York

Leon Kroll (1884–1974), painter and printmaker.

Although in his day Abraham Leon Kroll was an esteemed realist artist, he has since been largely forgotten. Best known for his female nudes, Kroll actually features subjects spanning a large spectrum, including cityscapes, landscapes, portraits, and still lifes, in addition to his mural making and lithographs. Committed to representation, until his death Kroll would set up his easel outdoors and paint *un plein air*. He was never interested in socially conscious art, but in finding beauty around him. As Kroll explained: "During the Depression, I didn't put any social content into my work. It never interested me. I don't know what's the matter with me, but it never interested me to paint those sad pictures. I always have a happy view of life, and I think life is beautiful. I think people are beautiful" (Hale and Bowers, 117).

New York-born, Kroll studied at the Art Students League (1901) with John H. Twatchman, the National Academy of Design (1903–08), and on a National Academy funded scholarship at the Académie Julien (1908–09) in Paris. Returning to New York in 1910, Kroll had his first solo exhibition at the National Academy the same year, which included eighty-five works. At this time, Kroll began painting New York cityscapes such as *Broadway (Looking South) in Snow* (1914, private collection, New York), an unglorified bird's eye view of the city's architecture and inhabitants delineated with a loose brushstroke. One of Kroll's cityscapes caught the eye of the celebrated city painter George Bellows, who introduced Kroll to his friends Robert Henri and Edward Hopper, artists also interested in urban subject matter and known as the Ashcan School. Kroll exhibited with the group on several occasions, beginning in 1911; notably, in 1924 Kroll and Bellows simultaneously enjoyed one-person shows at the Chicago Art Institute, each exhibiting twenty-four pictures. Like these contemporaries, Kroll exhibited his works in diverse locales, including a canvas at the revolutionary Armory Show (1913), after which his work appeared consistently to great acclaim.

Through the 1910s, Kroll expanded his repertoire, notably introducing more bucolic landscapes into his oeuvre after visiting Camden, Maine during the summer of 1916 with Bellows. With a brighter palette, Kroll also painted

figures inhabiting landscapes, especially women, in such paintings as *In the Country* (1916, Detroit Institute of Arts). A canvas of the Bellows family enjoying the serene outdoors, including Bellows himself in the background standing under a tree, the figural *In the Country* ultimately led Kroll to his best-known paintings of sensual female nudes. *Nita Nude* (1925, Denver Art Museum) (see figure), for example, depicts a Rubenesque nude woman seated in a chair, gazing contemplatively down at the floor. In a transcribed oral memoir Kroll described his devotion to the female nude: "I love to paint the nude. I really like it. I don't paint nudes, though, with any idea except almost a reverence, a sort of adoration of the wonder of it all" (Ibid., 74). During a brief period Kroll's forms became increasingly geometric, reflecting the influence of Paul Cézanne, whose work he had seen while in Paris. Indeed a trip to Santa Fe, New Mexico with Bellows and Henri resulted in landscapes such as *Santa Fe Hills* (1917, Museum of New Mexico, Santa Fe), a stylized, tonally warm image that partially eschewed Kroll's academic training.

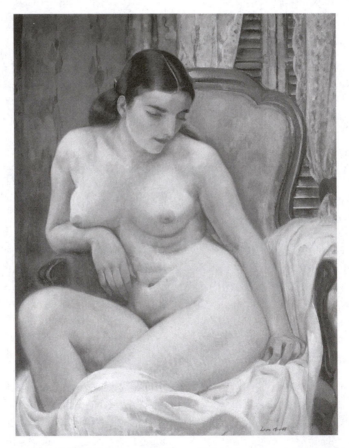

Leon Kroll, *Nita Nude,* 1925. Oil on canvas, 36 × 27 inches. Denver Art Museum. The Edward and Tullah Hanley Memorial Gift to the People of Denver and the Area, 1974.414. Photograph courtesy of The Denver Art Museum.

Throughout the 1920s he visited Europe on several occasions, and during 1927 and 1928 he traveled with Marc Chagall and Robert Delaunay. In 1931 Kroll was elected president of the American Society of Painters, Sculptors and Gravers, a position he held until 1935, the same year of his retrospective at the Carnegie Institute in Pittsburgh, Pennsylvania.

In all, Kroll made fifteen murals at such venues as the Justice Building in Washington, D.C. (1935–37), the Worcester War Memorial in Worcester, Massachusetts (1938–41), and Shriver Hall at Johns Hopkins University (1954) as well designing a mosaic ceiling for a memorial chapel at Omaha Beach in Normandy, France (1952–53). He approached his mural commissions by first thinking about the function of the building and then working on his design. Appropriately, Kroll painted the "Famous Beauties of Baltimore" at Johns Hopkins. The patron chose the beauties and provided photographs, which enabled Kroll to paint accurate faces, but the artist used models for the various body parts. Kroll first painted the figures as nudes based on models and then dressed them in historically appropriate clothes.

Over the years Kroll taught at various venues, including the National Academy of Design, the Pennsylvania Academy of the Fine Arts, and the Maryland Institute College of Art. Among his numerous awards, Kroll was elected a member of the American Academy of Arts and Letters (1954) and received the president's Medal from the National Academy of Design (1971) for a lifetime of distinguished service to American art.

Bibliography

Davis, Kenneth Morton. "The Life and Work of Leon Kroll with a Catalogue of his Nudes." Two volumes. Ph.D. dissertation, Ohio State University, 1993.

Gutman, Walter. "Leon Kroll." *Art in America* 18 (October 1930): 299–303.

Hale, Nancy and Fredson Bowers, eds. *Leon Kroll: A Spoken Memoir.* Charlottesville: University of Virginia Press, 1983.

Kroll, Leon. *Leon Kroll.* New York: American Artists Group, Inc., 1946.

———. *The Rediscovered Years: Leon Kroll.* New York: Bernard Danenberg Galleries, Inc., 1970.

Lane, James W. "Leon Kroll." *Magazine of Art* 30 (April 1937): 219–223.

Leeds, Valerie Ann. *Leon Kroll Revisited.* New York: Gerald Peters Gallery, 1998.

O'Leary, Elizabeth L. *Leon Kroll: Etchings and Related Drawings.* Charlottesville: The University, 1988.

Selected Public Collections

Carnegie Museum of Art, Pittsburgh
Denver Art Museum
Los Angeles County Museum of Art
Museum of Fine Arts, Boston
Oklahoma City Museum of Art
Pennsylvania Academy of the Fine Arts
Smithsonian American Art Museum, Washington, D.C.
Whitney Museum of American Art, New York

Barbara Kruger (1945–), conceptual artist.

Appropriating photographs from mass media, Barbara Kruger strategically deconstructs the manipulations of the very medium from which she borrows. Born in Newark, New Jersey, Kruger studied at Syracuse University (1964–65) and the Parsons School of Design (1965–66) where her teachers included the photographer **Diane Arbus** and Marvin Israel, a graphic designer and the art director of *Harper's Bazaar* in the early 1960s. After a year Kruger stopped taking classes and began to work as a designer at *Mademoiselle* magazine. By the age of twenty-two Kruger was the head designer for the magazine, a position she held for four years.

Early forays into the artworld include experimentations with fiber art—stereotypical "women's work"—and then painting large abstract canvases. The mid-1970s were an important period of transition when, while living and teaching in Berkeley, California, Kruger became interested in feminist criticism and theoretical writings by Roland Barthes, among others. She also began writing poetry, reviewing films, and taking photographs. In 1978 Kruger published *Picture/Readings,* a book of photographs of California residential buildings accompanied by narratives describing her imaginings of the inhabitants' thoughts and activities. This interest in photography and text initiated the works for which she is best known.

Kruger's experience as a graphic designer influences her economy of means and the direct confrontation of her signature style: a format of glossy black-and-white found photographs, cropped and enlarged, overlaid with catchy phrases, and surrounded by trademark red enamel frames that the artist characterizes as "the most effective packaging device" (Squiers, 84). Indeed, through a juxtaposition of text and image, Kruger uses photographs to examine, question, and exploit power relations—frequently gender and consumer—beginning in such works as the photomontage *Untitled (Your Gaze Hits the Side of My Face)* (1981, private collection). The black-and-white words of the work's title are collaged on the left side of this appropriated image of a woman's profile in stone. The terse caption employs an accusatory tone directed at the masculine viewer (Your) who has objectified the woman (My) for centuries. In other works identification with the pronoun shifts according to the viewer's construction of the photograph's meaning. Kruger explains that "With the question of You I say there is no You; that it shifts according to the viewer; that I'm interested in making an active spectator who can decline that You or accept it or say, It's not me but I know who it is" (Ibid., 85). Characteristic images such as *Untitled (Your Gaze Hits the Side of My Face)* first showed in a group exhibition at the Annina Nosei Gallery (1981). The following year Kruger exhibited her cultural critiques at the Venice Biennale. In 1986 Kruger became the first woman artist represented by the influential Mary Boone Gallery in New York City.

Kruger's political messages can be found in traditional gallery spaces as well as in the more general public domain, including matchbook covers, posters,

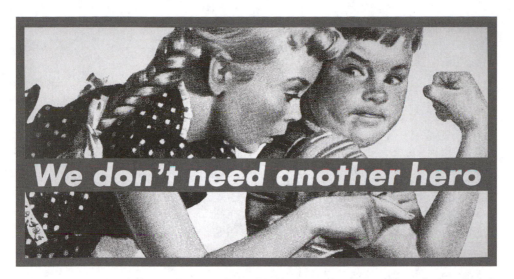

Barbara Kruger, *Untitled (We don't need another hero),* 1987. Photographic silkscreen/vinyl, 109 × 210 inches. Fisher Landau Center for Art, Long Island City, New York. Courtesy: Mary Boone Gallery, New York.

T-shirts, tote bags, and billboards. In 1983 Kruger contributed a large-scale artwork to the Spectacolor Board in New York City's Times Square. For a month the billboard, which is typically emblazoned with advertisements, instead read "I'm not trying to sell you anything." Two years later a billboard design in London read *We don't need another hero,* a motto placed in a red banner across a photographic image of a wholesome, young girl examining the flexed bicep of a posturing, defiant boy. Without the text a viewer might interpret the work as one of a female admiring the strength of a male, but the words complicate the image. To be sure, *We don't need another hero* has enjoyed several incarnations in various venues and languages (see figure), including a Hebrew version of the message (1987) in poster form. Depending on the site of the work, the meaning changes. For instance, an adaptation of *We don't need another hero* hung in Derry in Northern Ireland, a politically charged locale. Hence, the image transforms from a commentary on gender stereotypes to a dialogue on the conflict between the Unionist and the Nationalist communities in Derry.

Starting in 1985 Kruger designed lenticular images. By placing two photographs behind a lenticular lens screen the images shift depending on the viewer's angle, allowing Kruger to make works that employ two messages and to create an illusion of three-dimensionality. Textured pictures entered Kruger's repertoire in 1989. These tactile messages incised on magnesium plates continue to expose and critique media manipulations.

In addition to *Picture/Readings,* Kruger has written critical articles and television and film reviews, notably in her position as regular film critic for the journal *Artforum* beginning in 1981. A 1999 retrospective at the Museum of Contemporary Art in Los Angeles was received with much acclaim.

Bibliography

Feinstein, Rochelle. "The Revenge of Capital: Barbara Kruger and the Fine Art of Selling." *Arts Magazine* 63 no. 4 (December 1988): 46–49.

Kruger, Barbara. *We Won't Play Nature to Your Culture.* London: Institute of Contemporary Arts and Basel: Kunsthalle, 1983.

———. *Barbara Kruger.* Wellington, New Zealand: National Art Gallery, 1988.

———. *Barbara Kruger.* Organized by Ann Goldstein, with essays by Rosalyn Deutsche et al. Los Angeles: Museum of Contemporary Art; Cambridge, MA: MIT Press, 1999.

Linker, Kate. *Love for Sale: The Words and Pictures of Barbara Kruger.* New York: Harry N. Abrams, Inc., Publishers, 1990.

Mitchell, W.J.T. "An Interview with Barbara Kruger." *Critical Inquiry* 17 (Winter 1991): 434–448.

Owens, Craig. "The Medusa Effect Or, The Spectacular Ruse." *Art in America* 72, no. 1 (January 1984): 97–105.

Squiers, Carol. "Diversionary (Syn)tactics: Barbara Kruger Has Her Way with Words." *ARTnews* 86, no. 2 (February 1987): 76–85.

Selected Public Collections

Allen Memorial Art Museum, Oberlin College, Oberlin, Ohio
Guggenheim Museum of Art, New York
Israel Museum, Jerusalem
Los Angeles County Museum of Art
Musée National d'Art Moderne, Centre Georges Pompidou, Paris
Museum of Modern Art, New York
National Art Gallery, Wellington, New Zealand
Smithsonian American Art Museum, Washington, D.C.

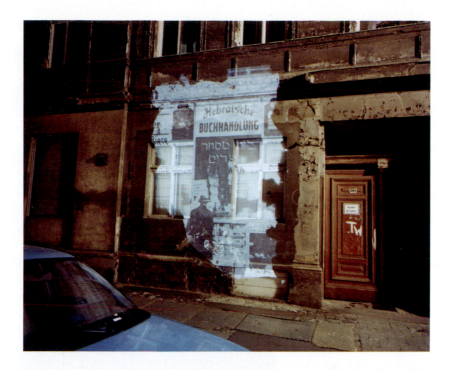

Plate 1 Shimon Attie, *Almstadtstrasse 43, Berlin* 1992. Photograph of slide projection. Photo courtesy of Jack Shainman Gallery, New York.

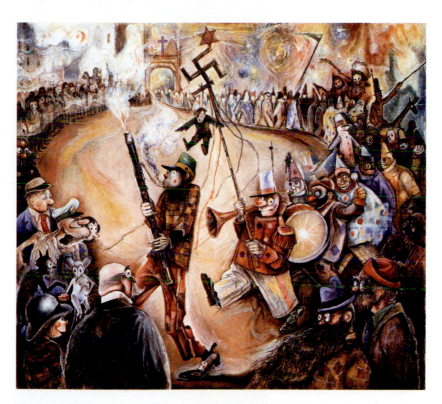

Plate 2 Albert Bloch, *March of the Clowns,* 1941. Oil on canvas mounted on composition board, 35 9/16 × 39 7/16 inches. The Jewish Museum, New York. Purchase: Oscar and Regina Gruss Memorial Fund, 2001-42. Photo: The Jewish Museum/Art Resource, New York.

Plate 3 Hyman Bloom, *The Syna-
gogue,* c. 1940. Oil on canvas, 65¼
× 46¾ inches. The Museum of
Modern Art, New York. Acquired
through the Lillie P. Bliss Bequest.
Digital Image © The Museum of
Modern Art/Licensed by SCALA/
Art Resource, New York.

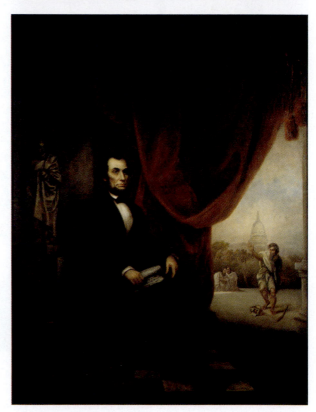

Plate 4 Solomon Nunes Carvalho,
Abraham Lincoln and Diogenes,
1865. Oil on canvas, 44 × 34
inches. Rose Art Museum, Brandeis
University, Waltham, Massachu-
setts. 1958.108. Gift of John J.
and Celia Mack, Maurice and Rose
Turner, Justin G. and Gertrude
Turner. Courtesy Rose Art Museum,
Brandeis University, Waltham,
Massachusetts.

Plate 5 Judy Chicago, *Rainbow Shabbat,* 1992. Stained glass, 54 × 192 inches. Fabricated by Bob Gomez and hand painted by Dorothy Maddy from Judy Chicago's design. Collection of the artists and Through the Flower Corporation. Art © 2006 Judy Chicago/Artists Rights Society (ARS), New York. Photograph courtesy of Through the Flower.

Plate 6 Audrey Flack, *World War II (Vanitas),* 1976–77. Oil over acrylic on canvas, 96 × 96 inches. Private collection, Pennsylvania. *World War II (Vanitas)* by Audrey Flack, incorporating a portion of the photograph 'Buchenwald, April 1945' by Margaret Bourke-White, copyright Time Inc.

Plate 7 Ruth Gikow, *Queen Esther II,* 1952. Oil with gold and silver leaf on masonite, 36 × 20 inches. #1954.5.1. Saginaw Art Museum, Saginaw, Michigan. Gift of American Academy of Arts and Letters, Childe Hassam Fund.

Plate 8 (below) Adolph Gottlieb, *The Frozen Sounds, No. 1,* 1951. Oil on canvas, 36 × 48 inches. Whitney Museum of American Art, New York. Gift of Mr. and Mrs. Samuel M. Kootz 57.3. Image: Whitney Museum of American Art. Art © The Adolph and Esther Gottlieb Foundation/ Licensed by VAGA, New York, New York.

Plate 9 Tobi Kahn, *Ya-Ir XX,* 1999. Acrylic on canvas over wood, 60 × 88 inches. Private collection, New York. Photograph courtesy of the artist.

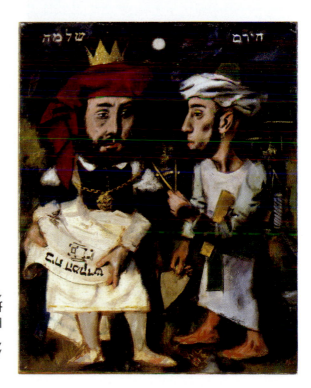

Plate 10 Jack Levine, *Planning Solomon's Temple,* 1940. Oil on masonite, 10 × 8 inches. Gift of Rebecca Shulman, New York. Collection, The Israel Museum, Jerusalem. Photo © The Israel Museum, Jerusalem by Avshalom Avital. Art © Jack Levine/ Licensed by VAGA, New York, New York.

Plate 11 (above) Roy Lichtenstein, *Tel Aviv Museum Mural*, 1989. Oil-based acrylic on canvas, two panels, 23 × 54 feet. Gift of the artist. Realization sponsored by the McCrory Corporation, New York, 1989.

Plate 12 (left) William Meyerowitz, *Marriage Trio*, 1952. Oil on canvas, 28 × 14 inches. Girard Jackson collection, Sugar Land, Texas. Photo courtesy of Girard Jackson.

Plate 13 (facing page, top) Abraham Rattner, *Job No. 2*, 1948. Oil on canvas, 38½ × 51½ inches. Leepa-Rattner Museum of Art, St. Petersburg College, Tarpon Springs, Florida. 1997.1.1.56. © Leepa-Rattner Museum of Art, St. Petersburg College.

Plate 14 (facing page, bottom) Miriam Schapiro, *My History*, 1997. Acrylic, fabric and xerox on paper, 35 × 26¼ inches. Collection Eleanor and Leonard Flomenhaft, Long Island, New York. Photo courtesy of the artist.

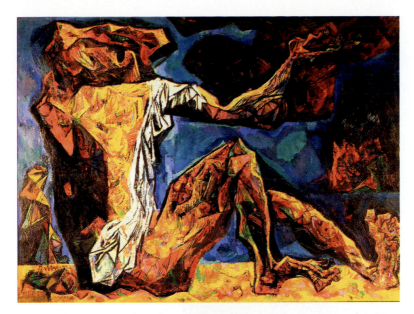

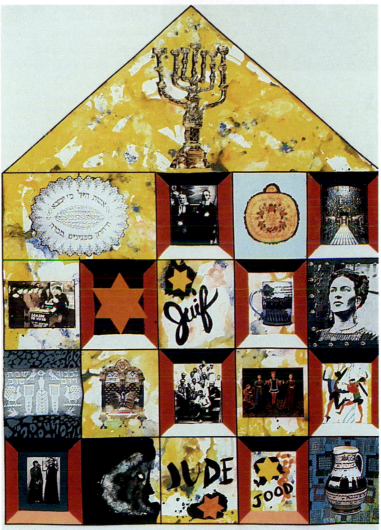

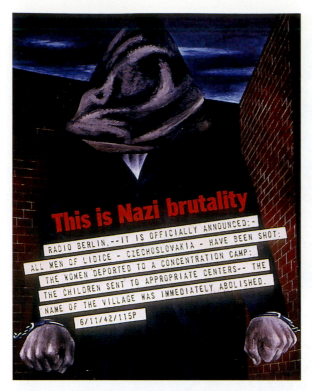

Plate 15 Ben Shahn, *This is Nazi Brutality,* 1942. Poster, 37⅛ × 28¼ inches. Hoover Institution Archives, Stanford University, California. Art © Estate of Ben Shahn/Licensed by VAGA, New York, New York.

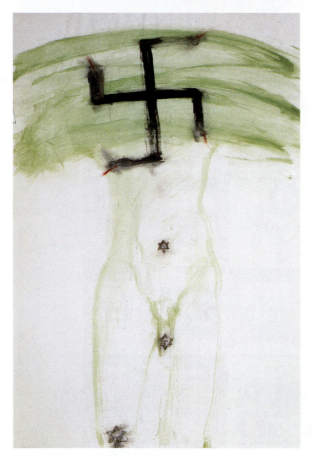

Plate 16 Nancy Spero, *Male Bomb/ Swastika,* 1968. Gouache and ink on paper, 35⅞ × 23⅞ inches. Private collection. Photo courtesy of the artist.

L

Ibram Lassaw (1913–2003), sculptor, painter, and draftsman.

One of the first Americans to sculpt abstractly, Ibram Lassaw was born in Alexandria, Egypt to Russian immigrant parents. In 1921 Lassaw arrived in the United States, and in 1926 he began his formal art training in a sculpture class at the Brooklyn Children's Museum. Additional study was undertaken at the Clay Club (1928–32) and the Beaux-Arts Institute of Design in New York (1930–31). His early work in clay was figurative and conventional in appearance.

Following experimentations with abstraction on paper, Lassaw began sculpting entirely nonrepresentationally in 1933. As an employee of the Works Progress Administration's Federal Art Project from 1935 to 1942, Lassaw worked on his art and taught at the Young Men's Hebrew Association on 92nd Street. During this period his plaster sculptures molded onto wire showed the influence of Surrealist biomorphism. At times Lassaw revealed the wire armature, which he then coated in bronze, and he also began to apply colors to the plaster and wire. Lassaw's belief in the power of abstraction was so strong that in 1937 he cofounded the American Abstract Artists (he served as the group's president from 1946 to 1949), an organization whose genesis occurred in his studio the prior year. Lassaw was one of two sculptors showing work in the group's first exhibition. He first welded sculpture in 1938. *Sculpture in Steel* (1938, Whitney Museum of American Art, New York) is composed of a piece of sheet metal topped by a thin iron frame. Two biomorphic shapes of hammered and brazed steel project from the open metal frame, and another shape is welded to the base of the work.

While serving in the United States Army (1942–44), Lassaw learned how to weld with an oxyacetylene torch, a technique that would later influence his signature style. Upon returning to New York, Lassaw's sculpture became increasingly rectilinear, but it was not until he purchased his own oxyacetylene torch with the proceeds from his first one-man show at the Kootz Gallery (1951) that he could take his sculpture to the level he wanted. Lassaw retained his rectilinear format, but with the high-temperature torch he added texture by liquefying and encrusting the open forms of metal with drips of alloys until his sculpture possessed tactility.[18] Scholars frequently term Lassaw's work—such as *Procession* (1955–56, Whitney Museum of American Art, New York)— "open-space sculpture" because of his recurrent intertwined, geometric web

designs that allow the viewer access to the voids created by the sculpture as much as the solid metal designs. Lassaw's interest in vast spaces was strengthened by his interest in galaxies as well as his reading and thinking about philosophy, science, myth, and religion. Some of his sculptures bear the names of galaxies and stars.

Beginning in 1953, at times Lassaw added colorful minerals such as quartz and semiprecious stones like turquoise to his delicate mazes of metal. Believing that color was an important part of sculpture, Lassaw also built up metals of various colors. As he explained: "Red copper, rusted iron, corroded green bronzes, bright gold, lead, chromium, silver and all colors of mineral

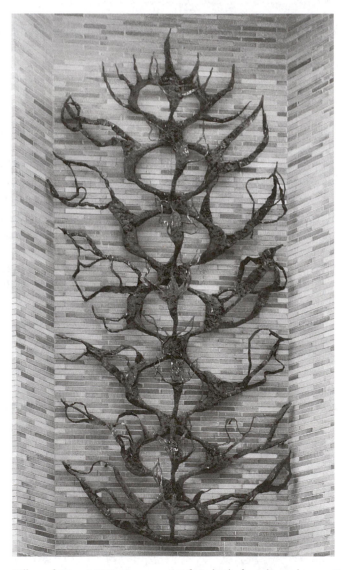

Ibram Lassaw, *Pillar of Fire,* 1953. Bronze, 19 feet high facade sculpture. Beth El Temple, Springfield, Massachusetts. Photo: Norman Michaels.

and gem stones play their parts. . . .Color is inherently a part of my sculpture" (Miller, 65). Chemicals applied to the welded metals also added hues to Lassaw's palette. Lassaw did not plan his sculptures before he began working on them but rather, he explained in a comprehensive statement about his influences and working methods, "The work is a 'happening' something independent of my conscious will. The unconscious mind undoubtedly is a participant in the process. The work uses the artist to get itself born" (*Perspectives*, 361).

From this period on Lassaw enjoyed acclaim, including invitations to display his ornate sculptures at the Venice Biennale (1954), the Museum of Modern Art in New York (1956, among other years), and the Sao Paulo Bienal (1957). He received several architectural commissions, most frequently synagogue sculpture. His hammered and welded nineteen-foot tall bronze *Pillar of Fire* (1953) (see figure), a highly textured, dynamic interpretation of curling, wiry flames, is installed on the facade of Beth El Temple in Springfield, Massachusetts. Lassaw also designed a bronze menorah (1954) for the synagogue, among other interior sculptures. Additional synagogues that commissioned Lassaw's work include Temple Beth El, Providence, Rhode Island; Temple B'nai Aaron, St. Paul, Minnesota; Temple Anshe Hesed, Cleveland, Ohio; and Kneses Tifereth Israel Synagogue, Port Chester, New York. Lassaw also made a wall sculpture, *The Clouds of Magellan,* for the architect Philip Johnson's Glass House in New Canaan, Connecticut.

Although best known for his sculptures, Lassaw made abstract drawings and "projection paintings." After dyeing 2×2-inch slides between 1946 and 1949, Lassaw projected the slides on a wall. These early projection paintings were not exhibited publicly, although he did show them to artist friends such as Willem de Kooning. When projected, the colored, vibrant light fills space and engulfs the viewer. Twenty projection paintings were first showed publicly in 1992 at the Center for Contemporary Art at the University of Kentucky, the same year that Lassaw resumed the process after forty-three years.

Bibliography

Anderson, Wayne. *American Sculpture in Process, 1930-1970.* Boston: New York Graphic Society, 1975.

Arbury, Steve, ed. *Ibram Lassaw: Deep Space and Beyond.* Radford, VA: Radford University Foundation Press, 2002.

Campbell, Lawrence. "Lassaw Makes a Sculpture." *ARTnews* 53 (March 1954): 24–27, 66–67.

Goossen, E.C., R. Goldwater, and I. Sandler. *Three American Sculptors: Ferber, Hare, and Lassaw.* New York: Grove Press, 1959.

Grossman, Emery. *Art and Tradition.* New York: Thomas Yoseloff, 1967.

Hunter, Sam. *The Sculpture of Ibram Lassaw.* Detroit: Gertrude Kasle Gallery, 1968.

Ibram Lassaw: Space Explorations, A Retrospective Survey (1929-1988). East Hampton, NY: Guild Hall Museum, 1988.

Kampf, Avram. *Contemporary Synagogue Art: Developments in the United States, 1945-1965.* New York: Union of American Hebrew Congregations, 1966.

Larsen, Susan C. "The American Abstract Artists: A Documentary History, 1936-41." *Archives of American Art Journal* 14, no. 1 (1974): 2–7.

Lassaw, Ibram. "Color for Sculpture." *Art in America* 49, no. 3 (1961): 48–49.

———. "Perspectives and Reflections of a Sculptor: A Memoir." *Leonardo* 1, no. 4 (October 1968): 351–361.

Miller, Dorothy C, ed. *12 Americans.* New York: Museum of Modern Art, 1956.

Wong, Janay Jadine. "Synagogue Art of the 1950s: A New Context for Abstraction." *Art Journal* 53, no. 4 (Winter 1994): 37–43.

Selected Public Collections

Baltimore Museum of Art, Maryland
Birla Museum, Calcutta, India
Fogg Art Museum, Harvard University, Cambridge
Israel Museum, Jerusalem
Metropolitan Museum of Art, New York
Museum of Modern Art, New York
Nelson-Atkins Museum of Art, Kansas City, Missouri
Smithsonian American Art Museum, Washington, D.C.
Whitney Museum of American Art, New York

Jack Levine (1915–), painter and printmaker.

Although better known for his biting representational works of social conscience, Levine is also a painter and printmaker of Jewish sages and biblical stories. Ever influenced by the techniques of Old Master painters such as Rembrandt and Titian, Levine has defied conventions of mid- to late twentieth-century American art in both style and subject. He aims, to use his words, "to develop some kind of iconography about my Jewish identity" (Frankel, 125).

Born on Boston's South End, Levine was the youngest of Lithuanian immigrants Mary and Samuel Levine's eight children. A poor shoemaker and Hebrew scholar, the elder Levine enrolled his son in children's art classes at a Jewish Community Center, and later at a settlement house in Roxbury. There Levine met Harold Zimmerman, who became his first mentor, and **Hyman Bloom**, who also went on to become a painter of Jewish subjects. At fourteen, Levine became acquainted with Denman Waldo Ross, an art professor at Harvard University. Ross provided financial assistance for Zimmerman, Levine, and Bloom, and arranged Levine's first public exhibition, a small showing of his drawings at Harvard's Fogg Art Museum in 1932 when Levine was only seventeen years old.

Levine's unique, expressionistic style complemented his satirical eye, which recorded social and political injustices on canvas and on paper. Among his best-known works in this genre is *The Feast of Pure Reason* (1937, Museum of Modern Art, New York), a painting completed while Levine was employed by the Works Progress Administration's Federal Art Project. Deriving his

title from James Joyce's novel *Ulysses* as a metaphor for the misfortunes of protagonist Stephen Daedalus at the hands of over zealous constables, Levine created a group composition of two corrupt, bloated politicians conspiring with a crooked policeman. Distorting his figures' features, Levine employs dramatic lighting to enhance the narrative of this moralistic canvas. Levine's didactic approach and sharp, indignant commentaries rendered with a vigorous brushstroke include subjects ranging from the McCarthy hearings of the 1950s, the desegregation of the South, and Mayor Daley at the 1968 Chicago Convention.

Although as an adolescent Levine created a chalk drawing titled *Jewish Cantors in the Synagogue* (1930, Fogg Art Museum, Harvard University), he first explored Jewish subjects in earnest, specifically biblical subjects, in 1940 when he painted *Planning Solomon's Temple* (Israel Museum, Jerusalem) (Color Plate 10), a small, 10 × 8-inch homage to his recently deceased father. Hebrew labels identifying the expressionistically executed, robed figures of Solomon and Hiram hover above the pair's heads. Such finely rendered Hebrew letters soon became a staple of Levine's biblical paintings and prints. Levine's biblical works number in the hundreds even though after an early exhibition of these religiocultural images he was unfortunately labeled a painter of "thickly racial designs" (Zabel, 260).

Beginning in 1942, a three and a half-year stint in the army interrupted Levine's art making. A year after his 1945 move to New York, Levine married the Ukrainian-born artist **Ruth Gikow**. During his time in the service, Levine's reputation was sealed when in 1943 the Metropolitan Museum of Art purchased *String Quartette* (1936–37), a boldly colored tempera and oil image of four musicians painted when the artist was nineteen years old.

While he made a few prints in the 1940s and 1950s, Levine took up the medium in earnest in the early 1960s. Levine's lithograph, *Cain and Abel II* (1969), employs the Cain and Abel story as an allegory for the Holocaust (a 1961 oil painting of this subject is in the Vatican Museum's Gallery of Modern Religious Art). While in an earlier print (1964) Levine used the theme "to capture the male mood in action" (Prescott and Prescott, xxii), the second version explores the symbolism of the Holocaust by showing the brothers' legs intertwined to form a swastika. The lithograph was published by the Anti-Defamation League, to whom Levine donated the print to assist with fund-raising.

In 1976, Levine participated in a seminar titled "The Influence of Spiritual Inspiration on American Art," sponsored by the Vatican Museums and the Smithsonian Institution. His contribution was quite different from that of the other participants, in part because Levine was one of the few Jews asked to speak (**Will Barnet** was also in attendance). Levine's paper, which spent more time lamenting the prominence of abstraction than issues of spirituality, described the power of the religious image:

> I think we may begin, then, with the high purpose of the artist priest. The survival of his people, the success of the hunt or the crop, the glory of God, sermons on ethics, morality, the joy of life, and the tragedy of death – all of

these have been manifest at various times in human history by the artist. The public need for meaningful symbols, then, whether in a cave or cathedral, gave rise to this substantive character which arose from the artist's mind (56).

Levine's work has been exhibited at numerous venues, including his first retrospective exhibition at the Institute of Contemporary Art in Boston (1952–53), a show that traveled to five other museums, including the Phillips Collection in Washington, D.C., and the Whitney Museum of American Art. Another retrospective was organized by New York's Jewish Museum, which subsequently traveled to five other American cities (1978–80). Always forthright about his Jewish identity, in 1956 Levine remarked: "I'm a Jew of the American seaboard, looking east. I've never managed to feel fully indigenous. I've been part of a tolerated minority. That has affected the subject matter as well as the style of my painting" (Rodman, 202). More recently, when asked how he defines Jewish art, Levine said: "I don't think it's necessary to define it. There's not supposed to be any Jewish art. It persists though, in spite of heavy theologians. I'm one of the few American artists that do Judaica or Hebraica. It doesn't happen organically. You need to want to express yourself that way" (Levine, Telephone conversation).

Bibliography

Bookbinder, Judith. *Boston Modern: Figurative Expressionism as Alternative Modernism.* Durham, NH: University of New Hampshire Press; Hanover: University Press of New England, 2005.

Frankel, Stephen Robert, ed. *Jack Levine.* Commentary by Jack Levine; Introduction by Milton W. Brown. New York: Rizzoli International Publications, Inc., 1989.

Getlein, Frank. *Jack Levine.* New York: Harry N. Abrams, Inc., Publishers, 1966.

Grossman, Emery. *Art and Tradition.* New York: Thomas Yoseloff, 1967.

Henry, Gerrit. "Jack Levine: 'If I were doing anything else, I'd be bored to tears.'" *ARTnews* 78, no. 4 (April 1979): 46–49.

Levine, Jack. "Man is the Center." *Reality: A Journal of Artists' Opinions* 1, no. 1 (Spring 1953): 5–6.

———. "In Praise of Knowledge." In *The Influence of Spiritual Inspiration on American Art*, 55–71. Rome: Liberia Editrice Vaticana, 1977.

———. Telephone conversation with author. January 9, 2006.

Prescott, Kenneth W. *Jack Levine: Retrospective Exhibition, Paintings, Drawings, Graphics.* New York: Jewish Museum, 1978.

Prescott, Kenneth W. and Emma-Stina Prescott. *The Complete Graphic Work of Jack Levine.* With commentary by Jack Levine. New York: Dover Publications, 1984.

Rodman, Selden. *Conversations with Artists.* New York: Capricorn Books, 1961.

Sutherland, David, dir. *Feast of Pure Reason.* David Sutherland Productions, 1986 (59-minute videocassette).

Zabel, Morton Dauwen. "Chirico, the Etruscans, and Others." *The Nation* 154, no. 9 (February 28, 1942): 259–261.

Selected Public Collections

Butler Museum of American Art, Youngstown, Ohio
Haifa Museum of Art, Israel
Hirshhorn Museum and Sculpture Garden, Washington, D.C.
Museum of Fine Arts, Boston
Museum of Modern Art, New York
San Francisco Museum of Modern Art
Smithsonian American Art Museum, Washington, D.C.
Whitney Museum of American Art, New York

Sol LeWitt (1928–), sculptor, printmaker, draftsman, photographer, and conceptual artist.

Often working serially, Sol LeWitt explores the same concept in several media: books, prints, wall drawings, works on paper, and structures (the artist's preferred terminology for the "sculptures" he designs). LeWitt's June 1967 essay "Paragraphs on Conceptual Art" serves as his manifesto and has since been recognized as seminal for conceptual artists in general. Here LeWitt explains: "In conceptual art the idea or concept is the most important aspect of the work. When an artist uses a conceptual form of art, it means that all of the planning and decisions are made beforehand and the execution is a perfunctory affair. The idea becomes a machine that makes the art" (80). For LeWitt, the artist's ideas (or concepts) are more important than the execution of the work.

Born in Hartford, Connecticut to Russian immigrant parents, LeWitt showed an interest in art as a child. He received a B.F.A. from Syracuse University (1945–49), where he focused on figurative painting and drawing. During the Korean War he served in the United States Army overseas (1951–52), after which he moved to New York, attending the Cartoonists and Illustrators School (now the School for Visual Arts). A decisive experience of this early period was a year working as a graphic designer for the architect I.M. Pei (1955–56). LeWitt learned the value in having others implement his designs, a working method he continues to practice to this day. In these years he experimented with painting in an Abstract Expressionist style and making pencil or ink figurative drawings, sometimes after Old Master paintings.

While employed as a receptionist at the Museum of Modern Art (MoMA) in New York (1960), LeWitt began to rethink the direction of his art. Rejecting the traditional canvas and illusionistic imagery, he created his first abstract sculptural reliefs, and monochrome freestanding, three-dimensional forms, including the minimalist, geometric, yellow *Floor Structure* (1963, LeWitt collection). His earliest modular pieces were completed in the mid-1960s, several of which he combined serially. The white *Modular Cube* (1969, Art Gallery of Ontario, Toronto) retains the artist's ratio of 1:8.5 between the material, in this case baked enamel on aluminum, and the open spaces between the cubes. A straightforward work of art, precise in form and conception and pared down to essentials, *Modular Cube* is one of many structures composed of varied

arrangements of cubes in an objective manner. Indeed, LeWitt believes that art must be neutral to allow the viewer access to the larger form and idea of the piece rather than to elicit emotion. Thus, until recent years LeWitt's working materials were abstract, geometric, and if not always colorless, executed with limited primary colors.

Another staple in LeWitt's oeuvre emerged in the 1960s when he developed his first wall drawing at New York's Paula Cooper Gallery (October 1968). Akin to an architect who presents plans to a builder, LeWitt provides a set of detailed directions delineating all aspects of line and form for a draftsperson that produces the wall drawing. Over the years, LeWitt has designed more than 1,000 wall drawings. These temporal works evolve from the artist's thoughts about the flatness of art and the rationality of eliminating the canvas, an unnatural construction: "I wanted to do a work of art that was as two-dimensional as possible. It seems more natural to work directly on walls than to make a construction, to work on that, and then put the construction on the wall" (Legg, 169). LeWitt's engagement of the wall as a venue for artistic expression has been viewed as seminal. According to critic Bernice Rose, "LeWitt's move was catalytic, as important for drawing as Pollock's use of the drip technique had been for painting in the 1950s" (Ibid., 31).

Several projects with Jewish themes comprise LeWitt's oeuvre, including the monument *Black Form Dedicated to the Missing Jews* (1989) (see figure), now located in Hamburg, Germany after the city of Münster rejected the piece in

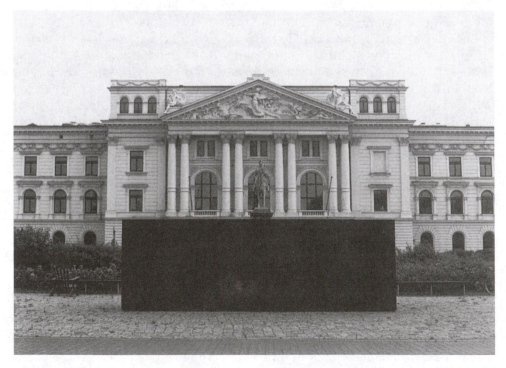

Sol LeWitt, *Black Form Dedicated to the Missing Jews,* 1989. Hamburg-Altona, Germany. © 2006 Sol LeWitt/Artists Rights Society (ARS), New York. Photo courtesy of James E. Young.

1988.[19] A 97½-inch high and 195-inch long staid cinder block wall stands in front of the city's white neoclassical town hall. LeWitt's painted black monument, erected without an inscription, is meant to evince the absence of the Jewish community. His wall painting at the United States Holocaust Memorial Museum, ominously titled *Consequence* (1993), is part of the museum's permanent collection. In 2005, LeWitt installed *Lost Voices,* a temporary site-specific sculpture accompanied by audio of Rosh Hashanah and Yom Kippur liturgy for an abandoned synagogue in Pulheim, Germany (**Richard Serra**'s sculpture *The Drowned and the Saved* appeared in this synagogue in 1992). LeWitt does not feel that "there is anything Jewish about my art (nor Chagall, Modigliani, Rothko etc.)," and indeed he does not believe that Jewish art exists (Written correspondence). He is, however, "interested in subjects that involve Jewish history and the Holocaust particularly" (Ibid.). In addition to his more publicized Jewish projects, LeWitt helped design the new building for his synagogue, Beth Shalom, in Chester, Connecticut as well as the door of the synagogue's ark.

Recently, LeWitt's typically stoic art has entered a more colorful and less geometric phase with the production of curved and colorful larger than life sculptures and related wall drawings (late 1990s). LeWitt's diverse body of work has been shown at hundreds of venues, most notably in retrospectives at MoMA (1978) and the San Francisco Museum of Modern Art (2000), an exhibition that subsequently traveled to the Museum of Contemporary Art in Chicago and the Whitney Museum of American Art. Like several other Jewish artists (e.g., **Maurice Sterne** and **William Zorach**) and artists in general, LeWitt wrote his autobiography (1980). In true LeWitt fashion, however, the text is devoid of the printed word. Instead, this autobiography contains over 1,000 uniformly sized black-and-white photographs of the objects in the artist's apartment and studio, typically arranged in grids of nine pictures a page, ranging from his plumbing to his library.

Bibliography

Auping, Michael. *Drawing Rooms: Jonathan Borofsky, Sol LeWitt, Richard Serra.* Fort Worth, TX: Modern Art Museum of Fort Worth, 1994.

Garrels, Gary, ed., *Sol LeWitt: A Retrospective.* San Francisco: San Francisco Museum of Modern Art; New Haven: Yale University Press, 2000.

Legg, Alicia, ed. *Sol LeWitt.* New York: Museum of Modern Art, 1978.

LeWitt, Sol. "Paragraphs on Conceptual Art." *Artforum* 5, no. 10 (June 1967): 79–83.

_____. "Sentences on Conceptual Art." *Art Language* 1, no. 1 (May 1969): 11–13.

_____. *Autobiography.* New York: Multiples, Inc.; Boston: Lois and Michael K. Torf, 1980.

_____. *Sol LeWitt, Lost Voices: Synagoge Stommeln, 2005.* Pulheim: Stadt Pulheim, 2005.

_____. Written correspondence with the author. April 22, 2005.

Young, James E. *The Texture of Memory: Holocaust Memorials and Meaning.* New Haven: Yale University Press, 1993.

Zevi, Adachiara, ed. *Sol LeWitt: Critical Texts.* Rome: Libri de AEIUO, 1995.

Selected Public Collections

Albright-Knox Art Gallery, Buffalo, New York
Baltimore Museum of Art
Hirshhorn Museum and Sculpture Garden, Washington, D.C.
Israel Museum, Jerusalem
Museum of Modern Art, New York
Museum of Fine Arts, Boston
National Gallery of Art, Washington, D.C.
Tate Gallery, London

Roy Lichtenstein (1923–97), painter, printmaker, and sculptor.

One of the leading figures of the Pop Art movement, Roy Lichtenstein was born in New York. He briefly studied with Reginald Marsh at the Art Students League in New York (Summer 1939), and then pursued a B.F.A. (1947) and an M.F.A. (1949) at Ohio State University (1940–43; 1946–49), his progress interrupted by several years in the Army. Early in his career, Lichtenstein experimented with Cubism, Abstract Expressionism, and other modern styles. In the late 1950s he rendered the comic subjects that would become synonymous with his name in a loose, painterly fashion.

Lichtenstein derived his initial paintings based on comic images from his childrens' bubblegum wrappers. For example, *Look Mickey* (1961, National Gallery of Art, Washington, D.C.)—a painting reproducing a scene of Mickey Mouse and Donald Duck fishing—did not yet simulate newsprint techniques and remains closely allied with the original source in color and composition. Within a year Lichtenstein delineated enlarged reproductions of comic book scenes with thick black outlines, an imitation Benday dot technique akin to newsprint, and in primary colors without modulation. Many of the paintings utilize a characteristic comic balloon filled with words to elucidate the figure's thoughts. *Oh, Jeff…I Love You, Too…But…* (1964, private collection) presents a crestfallen woman on the telephone with the words of the title in a blurb to illuminate the story line encapsulated in the single frame. According to Lichtenstein, the subjects of his paintings from approximately 1961 to 1965—the melodrama of his heartbroken beauties and the violent deaths of his war heroes—were not of interest to him. Rather, he said, the comics were used for their formal qualities. Art historian Bradford Collins, however, refutes Lichtenstein's claim that he only cared about formal values, equating the artist's interest in kitschy subjects of love and war with the heartbreak and "private war" of his divorce (61–62, 75–80). Notably, Lichtenstein's preoccupation with these themes ended as his divorce was finalized.

Lichtenstein's banal, ironic comic book imagery challenged the contemporary art scene, which had been infiltrated by the seriousness of Abstract Expressionism for over a decade. *Life* magazine critic Dorothy Seiberling questioned the goals and long-term implications of Lichtenstein's comic paintings in 1964: "He leaves the viewer wondering if his paintings are only

parodies, ironic gestures, or if they will outlast their shock and give a new shape to art?" (83).

In the mid-1960s Lichtenstein began quoting well-known works of art and also paraphrasing popular art forms in his signature comic book style. The "Brushstroke" paintings of 1965–66, such as *Little Big Painting* (1965, Whitney Museum of American Art, New York), depict enlarged gestural marks that mock Abstract Expressionism by the very dichotomy of Lichtenstein's lucid, flat technique and the thick, dripping oil paint he reproduces. Lichtenstein found great success with his comic-styled works, enjoying his first retrospective at the Pasadena Art Museum in 1967, followed by a retrospective on the east coast at the Guggenheim Museum two years later.

During the 1970s and early 1980s, Lichtenstein continued to use the history of art as his source material, quoting major paintings by the German Expressionists, the Surrealists, and other avant-garde artists. *Artist's Studio, "Dancers"* (1974, Museum of Modern Art, New York) draws on Henri Matisse's famous *Still Life with "Dance"* (Hermitage Museum, St. Petersburg), and Lichtenstein's *Cubist Still Life* (1974, National Gallery of Art, Washington, D.C.) is a play on the Cubists' pictorial language. The last decades of Lichtenstein's life were marked by several series, sometimes executed with an expanded palette, including a cycle of "Interiors" derived from advertisements.

Also an active printmaker, Lichtenstein made many screenprints, lithographs, woodcuts, and etchings that exploit the same comic-styled Pop subjects as his paintings. On occasion Lichtenstein would execute public sculptures such as the steel *Mermaid* (1979) that lounges on the grass in front of the Jackie Gleason Theater for the Performing Arts on Miami Beach, and the 25-foot tall aluminum brushstroke at the Port Columbus International Airport in Columbus, Ohio, appropriately titled *Brushstrokes in Flight* (1984). Several public murals have been installed, including a four-wall mural (two walls measure 12 × 35 feet, and two walls measure 12 × 25 feet) of the artist's famous brushstrokes (1970) at the School of Medicine at the University of Düsseldorf and a two-paneled 23 by 54-foot mural for the entrance hall of the Tel Aviv Museum of Art (1989) (Color Plate 11). The collage-like design of the latter mural incorporates an amalgamation of imagery, including an appropriation of one of Marc Chagall's flying fiddlers in the upper center portion. Lichtenstein also designed a lithograph based on the mural, titled *Tel Aviv Museum Print* (1989), which was sold to benefit the American Friends of the Tel Aviv Museum of Art. In 1996 Lichtenstein received an honorary fellowship from the Tel Aviv Museum.

The Roy Lichtenstein Foundation, in association with Yale University Press, plans to publish a seven-volume, color, catalogue raisonné of Lichtenstein's full body of work in 2006.

Bibliography

Alloway, Lawrence. *Roy Lichtenstein.* New York: Abbeville Press, 1983.
Collins, Bradford R. "Modern Romance: *Lichtenstein*'s Comic Book Paintings." *American Art* 17, no. 2 (Summer 2003): 60–85.

Coplans, John, ed. *Roy Lichtenstein.* New York: Praeger Publishers, 1972.

Corlett, Mary Lee. *The Prints of Roy Lichtenstein: A Catalogue Raisonné (1948-1997).* New York: Hudson Hills Press, 2002.

Cowart, Jack. *Roy Lichtenstein, 1970-1980.* New York: Hudson Hills Press, 1981.

Lichtenstein, Roy. *Some Kind of Reality: Roy Lichtenstein interviewed by David Sylvester in 1966 and 1997.* London: Anthony d'Offay, 1997.

Lobel, Michael. *Image Duplicator: Roy Lichtenstein and the Emergence of Pop Art.* New Haven: Yale University Press, 2002.

Rose, Bernice. *The Drawings of Roy Lichtenstein.* New York: Museum of Modern Art, 1987.

Seiberling, Dorothy. "Is He the Worst Artist in the U.S.?" *Life* 56 (January 31, 1964): 79–83.

Waldman, Diane. *Roy Lichtenstein.* New York: Guggenheim Museum, 1993.

Selected Public Collections

Art Institute of Chicago
Hirshhorn Museum and Sculpture Garden, Washington, D.C.
Los Angeles County Museum of Art
Metropolitan Museum of Art, New York
Museum of Fine Arts, Boston
Smithsonian American Art Museum, Washington, D.C.
Tate Gallery, London
Whitney Museum of American Art, New York

Seymour Lipton (1903–86), sculptor.

Chronologically and stylistically associated with Abstract Expressionism, New York–native Seymour Lipton showed a predilection for art as a child. His parents, however, discouraged his ambitions, and he received a D.D.S. degree from Columbia University in 1927. While practicing as a dentist, the self-taught Lipton carved stylized sculptures with Social Realist themes out of wood and stone. He displayed early work at the Communist-based John Reed Club group show titled "The World Crisis Expressed in Art: Sculpture, Drawings, and Prints on the Theme, Fascism and War" (1933–34) and had a solo exhibition of wood sculpture in 1938 at the ACA Gallery in New York. Two years later, Lipton started teaching sculpture at the New School for Social Research in New York (1940–65). In 1955 Lipton ceased practicing dentistry and focused entirely on his sculpture.

The events of World War II influenced Lipton's subject matter and materials, which evolved from specific representational themes in wood to more timeless abstract comments on the human condition in metal. Figuration seemed inadequate to describe the devastation of war, and in 1942 Lipton began to work nonfiguratively in alloys. One of his last representational sculptures responded to the news of Nazi persecution of the Jews. Titled *Let My People Go* (1942, collection unknown) based on an utterance by God in Exodus 8:16, Lipton's

sculpture portrayed a bust of a pious Jewish male wearing a prayer shawl. By the mid-1940s Lipton was welding biomorphic, Surrealist-inspired forms out of lead, using steel starting in 1947, and in 1955 the rustproof Monel metal. *Exodus #1* (1947, private collection) (see figure), a lead, horizontal, abstract construction composed of pointed, geometric forms, references the Bible and also implies a mass departure, perhaps the Jews' exodus from Eastern Europe. Lipton described the series: "The *Exodus* pieces were part of a tragic mood of history and reality that has always concerned me....It is possible that Israeli history and emergence entered....The underlying mood is tragedy, and the main concern was for a model for an outdoor wall 30 or 40 feet long, a kind of wailing wall monument to human suffering" (Elsen, 27). Matthew Baigell believes that Lipton's comment that the work *may* be related to Israeli history is disingenuous, for why else would the sculptor reference the holiest site in Judaism—the Western Wall—and even mention a Jewish undercurrent (151)?

Lipton worked in stages, conceptualizing a sculpture on paper, making a maquette (miniature model), and then fabricating the metal sculpture. Influenced by non-Western art, myth, and "the sense of the dark inside, the evil of things" (Elsen, 20), to use the artist's words, Lipton constructed Surrealist-inspired bronzes such as *Moby Dick #2* (1948, private collection) in the 1940s. This abstraction of Herman Melville's whale appears fierce with spikes or possibly teeth projecting from rounded forms. Lipton relates his attraction to Moby Dick to the whale's position as a "symbol of destruction and...evil" (Ibid., 28). Similar predatory imagery would recur at various times throughout Lipton's career. Ziva Amishai-Maisels argues that Lipton's

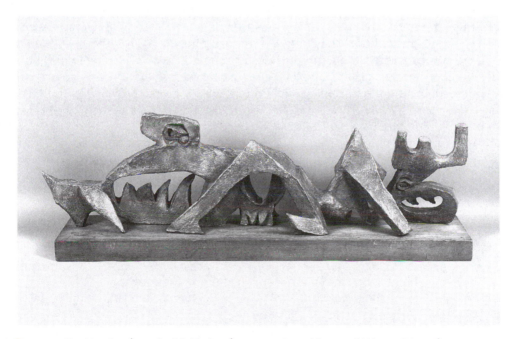

Seymour Lipton, *Exodus #1*, 1947. Lead construction, 10⅜ × 39½ × 6½ inches. Private collection. Courtesy of Michael Rosenfeld Gallery, New York, New York.

transition from rounded forms to aggressive, spiked shapes after the war was influenced by the horrors of the Holocaust (132–133).

Around 1948 Lipton started exploring cage themes in works such as *Imprisoned Figure* (1948, Museum of Modern Art, New York). This dynamic, vertical sculpture shows an abstracted, angular, sheet lead form entrapped in a wood construction. Akin to **Herbert Ferber** and **Ibram Lassaw**, as Lipton reached his signature style he welded with an oxyacetylene torch. This high-temperature torch, purchased in 1949, allowed Lipton to braze alloys onto sheet metal and to shape the more flexible metals into curves as well as expand the colors and textures of his sculpture. Experiencing a sense of renewal with the war several years in the past, in the 1950s Lipton welded dynamic vertical or horizontal pieces exhibiting traces of organic life such as *Jungle Bloom* (1954, Yale University Art Gallery, New Haven), a bronze on steel sculpture from the Bloom series. The open forms of *Jungle Bloom* reveal the seed within and extend outward—perhaps symbolizing growth or evolution.

His sculptures decorate several buildings in the United States, including *Archangel* (1962–63) for Lincoln Center's Philharmonic Hall, New York; five sculptures for Temple Beth-El, Gary, Indiana (1955); and three sculptures for Temple Israel, Tulsa, Oklahoma (1953): *Menorah, Eternal Light,* and *Fruitful Vine*. The angular *Eternal Light* is an abstract construction, and *Fruitful Vine* refers to the tree of life and capitalizes on the botanical and natural forms that Lipton explored in the Bloom series.[20] While Lipton clearly engaged his Jewish identity in his art he objected to the terminology "Jewish artist": "The idea of being a so-called professional Jewish artist is like being a professional Jew. I think art is international and should transcend any racial, ethnic, religious, or national boundaries....I don't practice the formal credo of Judaism, although I am deeply aware of my position as a Jew, both nostalgically, as to my parents, and politically, as one of a minority group" (Grossman, 47, 96).

Lipton represented the United States at the Sao Paolo Biennale (1957) and the Venice Biennale (1958), and has enjoyed large solo exhibitions at several venues, including the Phillips Collection in Washington, D.C. (1955), the Jewish Museum in New York (1979), and the Palmer Museum of Art at Pennsylvania State University (2000).

Bibliography

Amishai-Maisels, Ziva. *Depiction and Interpretation: The Influence of the Holocaust on the Visual Arts.* New York: Pergamon Press, 1993.

Elsen, Albert. *Seymour Lipton.* New York: Henry N. Abrams, Inc., Publishers, 1970.

Grossman, Emery. *Art and Tradition.* New York: Thomas Yoseloff, 1967.

Kampf, Avram. *Contemporary Synagogue Art: Developments in the United States, 1945-1965.* New York: Union of American Hebrew Congregations, 1966.

Lipton, Seymour. "Some Notes on My Work." *Magazine of Art* 40 (November 1947): 264–265.

———. "Experience and Sculptural Form." *College Art Journal* 9, no. 1 (Autumn 1949): 52–54.

———. "Extracts from a Notebook." *Arts Magazine* 45 (March 1971): 34–36.

Miller, Dorothy C, ed. *12 Americans.* New York: Museum of Modern Art, 1956.

Phillips, Lisa. *The Third Dimension: Sculpture of the New York School.* New York: Whitney Museum of American Art, 1984.

Rand, Harry. *Seymour Lipton: Aspects of Sculpture.* Washington, D.C.: Smithsonian Institution Press, 1979.

Tarbell, Roberta K. "Seymour Lipton: A New Anthropology for Sculpture." *Arts Magazine* 54 (October 1979): 78–84.

Verderame, Lori. *An American Sculptor: Seymour Lipton.* Introduction by Irving Sandler. New York: Hudson Hills Press, 1999.

Selected Public Collections

Albright-Knox Art Gallery, Buffalo, New York
John and Mable Ringling Museum of Art, Sarasota, Florida
National Gallery of Art, Washington, D.C.
Oklahoma City Museum of Art
Palmer Art Museum, Pennsylvania State University, University Park
The Phillips Collection, Washington, D.C.
San Francisco Museum of Modern Art
Whitney Museum of American Art, New York

Morris Louis (1912–62), painter.

A major figure of the Washington Color School and a movement coined as Post Painterly Abstraction by art critic Clement Greenberg, Morris Louis Bernstein, who changed his name in 1938, was born in Baltimore to immigrant parents. While studying on a four-year scholarship at the conservative Maryland Institute of Fine and Applied Arts (1929–32), Louis consulted avant-garde art in books and at museums in Baltimore and Washington, D.C. He worked for the Public Works of Art Project in Baltimore (1934) and then in New York City, where he lived from 1936 to the early 1940s. As an assistant for a mural project for a Baltimore public school, Louis researched ancient scripts (including Hebrew) for the mural *The History of the Written Word.* Under the auspices of the Works Progress Administration, Louis also designed easel paintings with Social Realist themes in a figurative manner, influenced by the German painter Max Beckmann. Louis returned to Baltimore in the early 1940s and lived in Washington, D.C., from 1952 until his premature death.

As he began to experiment with abstraction, Louis executed compositions in the vein of Jackson Pollock's drip paintings. A series of seven small black canvases covered with whirlpools of dripped white paint, the *Charred Journal* paintings (1950–51), and a related image, *Untitled (Jewish Star)* (1951, Jewish Museum, New York) (see figure), appropriate Pollock's allover technique and Surrealist automatism. Some of the calligraphic signs in these early paintings insinuate Hebrew letters, characters also explored in drawings from the same period. According to Louis, and indicated by the series title, these paintings

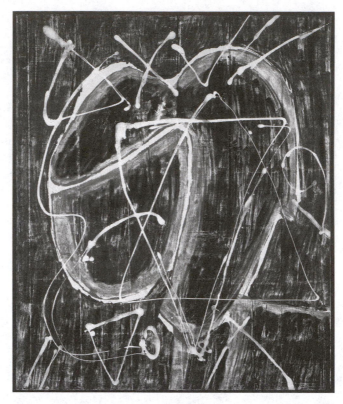

Morris Louis, *Untitled (Jewish Star)*, c. 1951. Acrylic on canvas, 34 × 28½ inches. The Jewish Museum, New York. Gift of Ruth Bocour in memory of Leonard Bocour, 1997-126. Photo: John Parnell. Courtesy of The Jewish Museum/Art Resource, New York. © 1951 Morris Louis.

refer to Nazi book burnings. Appropriating abstraction to convey the horrors of the Holocaust was common among artists of the period, including sculptor **Seymour Lipton** and painter **Barnett Newman**. Louis' *Untitled (Jewish Star)* shows the Star of David superimposed on a heart, a juxtaposition Mira Goldfarb Berkowitz interprets as a transformation of "the symbol of Jewish sacrifice into one of survival" (199). Berkowitz reads the painting as Louis turning the tables on the Nazis, who tried to appropriate a positive Jewish symbol into one that almost certainly meant impending slaughter. Louis' painting instead takes back the symbol and exploits it as one of hope. These youthful images, exhibited at Louis' first one-person show at the Washington Workshop Art Center Gallery (April 1953), are among the few given descriptive titles. Because he died with the majority of his images unnamed, Louis' wife posthumously titled most of his paintings based on a precedent the artist set shortly before his demise when he identified two canvases with letters from the Greek alphabet. Subsequent untitled paintings were thus named with additional Greek letters and then later with transliterations of Hebrew letters.

 After seeing **Helen Frankenthaler**'s seminal painting *Mountains and Sea* (1952, National Gallery of Art, Washington, D.C.) in April 1953, Louis

changed his working method. Influenced by Frankenthaler's thin veils of color staining the unprimed canvas, Louis began to saturate his paintings in three major series: Veils (1954 and 1958–59), Unfurleds (1960–61), and Stripes (1961–62).[21] Interwoven colors characterize Veil paintings such as *Blue Veil* (1958, Fogg Art Museum, Harvard University, Cambridge). To make these large, often mural-sized images, Louis poured diluted paint down the angled canvas to create a wavelike effect of blended, layered color that covers nearly the entire surface. Louis did not rely on gravity alone; he directed the paint by shifting the canvas or guiding the paint with a stick. Typically, Louis would lay down the bolder colors first and the darker upper layers of paint second to create his delicate, lyrical sweeps of color. In contrast to Pollock, Louis achieved a sense of painterliness without touching a paintbrush to a canvas. As E. A. Carmean observes: "His central insight was to recognize that the staining technique would allow his application of paint and his vocabulary of forms to be as painterly as he pleased, while the surface characteristics would be those closer to a linear style. It was *malerisch* without impasto; fluid forms of unembodied color" (unpaged).

Unfurled paintings such as *Beta Kappa* (1961, National Gallery of Art, Washington, D.C.) show colorful, thin rivulets of paint running diagonally down and inward from the top corners of the canvas leaving large central portions of the painting white. The Unfurled works differ in number, colors, and width of rivulets, and the colors are not poured onto the canvas in layers. Straight bands of color varying in thickness and arranged horizontally or vertically across the white canvas characterize the Stripe paintings. While the explorations of colors in Louis' Veil and Unfurled series' align his art with the Abstract Expressionists, the more staid juxtaposition of colors of the Stripe paintings, Diane Upright observes, herald the Minimalist style that came to prominence in the late 1960s (33). In all of his series, Louis emphasized the flat ground, eschewing illusions of depth.

The three series of paintings that have earned Louis a place among the pantheon of twentieth-century abstract artists were completed in an approximately five-year period. Soon after his death, Louis' work was featured in a memorial exhibition at the Guggenheim Museum (1963).

Bibliography

Berkowitz, Mira Goldfarb. "Sacred Signs and Symbols in Morris Louis: The *Charred Journal* Series, 1951." In *Complex Identities: Jewish Consciousness and Modern Art*. Edited by Matthew Baigell and Milly Heyd, 193–205. New Brunswick, NJ: Rutgers University Press, 2001.

Carmean Jr., E. A. *Morris Louis: Major Themes and Variations*. Washington, D.C.: National Gallery of Art, 1976.

Elderfield, John. *Morris Louis*. New York: Museum of Modern Art, 1986.

Fried, Michael. *Morris Louis*. New York: Harry N. Abrams, Inc., Publishers, 1970.

Godfrey, Mark. "Burnt Books and Absent Meaning: Morris Louis's *Charred Journal: Firewritten* Series and the Holocaust." In *Image and Remembrance: Representation*

and the Holocaust. Edited by Shelley Hornstein and Florence Jacobowitz, 175–200. Bloomington: Indiana University Press, 2003.

Louis, Morris. *The Drawings of Morris Louis.* Washington, D.C.: Smithsonian Institution Press, 1979.

Upright, Diane. *Morris Louis: The Complete Paintings, A Catalogue Raisonné.* New York: Harry N. Abrams, Inc., Publishers, 1985.

Selected Public Collections

Ackland Art Museum, Chapel Hill, North Carolina
Art Institute of Chicago
Metropolitan Museum of Art, New York
Museum of Modern Art, New York
National Gallery of Art, Washington, D.C.
Smithsonian American Art Museum, Washington, D.C.
Tate Gallery, London
Whitney Museum of American Art, New York

Louis Lozowick (1892–1973), painter, draftsman, textile designer, and printmaker.

For many years the Russian immigrant Louis (born Leib) Lozowick privileged the city in his art, rendering the urban landscape of factories, skyscrapers, and mills with a linear, economy of means. In his autobiography, Lozowick recalled his impression of New York upon his arrival: "To a product of the *shtetl*, Manhattan was a phenomenon as fantastic and improbable as Istanbul might have been" (14). At this time, Lozowick also changed his first name to the more American sounding Louis.

Lozowick decided to become an artist as a young boy in Russia while attending yeshiva. Discouraged by his pious father, Lozowick contented his artistic longing by lettering signs for his synagogue. At nine years old he lived with his brother in Kiev, where he attended secular school and took his first art classes at the Kiev Art School (1903–05). When his brother moved to the United States in 1906, Lozowick, age fourteen, joined him in Newark, New Jersey.

After studying at the National Academy of Design in New York (1907–08 and 1912–15) with **Leon Kroll** and others, Lozowick went to Ohio State University, graduating Phi Beta Kappa in 1918. He served in the United States Army for a year (1918–19) before traveling around the United States and then embarking on an extensive stay in Europe. Lozowick spent a year in Paris and then lived in Berlin for three years, befriending other Russian artists in Germany, including the Jewish artist El Lissitzky. With Lissitzky, Lozowick traveled to Moscow where he became acquainted with Constructivist principles through associations with Vladimir Tatlin and Andre Malevich, gaining admiration for a machine aesthetic that highlighted the potential of the urban landscape. Encouraged by European admiration of American industry, from 1919 to 1928 Lozowick made a series of canvases of ten American cities

rendered in a precisionist idiom. Lozowick shows city architecture as a grand, geometric, ordered, and rational environment devoid of inhabitants in works such as *Minneapolis* (1926–27, Hirshhorn Museum and Sculpture Garden, Washington, D.C.). Some of these paintings were exhibited at two well-received one-man shows in Berlin, the first at the Twardy Gallery (1922) and then the following year at the Heller Gallery. In 1923 Lozowick began making lithographs, often of the cities he had rendered in paint. He returned to America in 1924.

From 1922 to 1927, Lozowick worked on a series of pen and ink drawings called *Machine Ornaments*. These hard-edged images of imagined technology in ambiguous space were exhibited at Neumann's New Art Gallery in New York in 1926 and at the Machine Age Exposition in New York (1927), for which Lozowick also made the poster advertising the show and wrote the introduction to the exhibition catalog. Lozowick incorporated three movable machine ornaments as the set design for the 1926 stage production of Georg Kaiser's play *Gas* in Chicago. That same year Lord and Taylor department store asked Lozowick to design the set for a fashion show and a window display. Lozowick again used the forms of his machine ornaments, as well as a cityscape of New York, creating over life-size Constructivist-inspired architectonic backdrops.

Lozowick began contributing drawings for the leftist periodical *New Masses* in the late 1920s and also designed advertisements for the magazine, for which he was a founding editor. Around 1930 Lozowick admitted human figures into his art, often picturing laborers of the metropolis, as did **Saul Baizerman**. *Birth of a Skyscraper*, a lithograph from 1930, shows a lone worker atop an uncompleted building with the progress of other industrial projects in the distance. His social imagery described injustices facing the workers and others; the lithograph *Lynching* (1936), wherein the face of the man being lynched is that of Lozowick, appeared in the December 1936 American Artists' Congress print exhibition "America Today." Lozowick also worked as a Works Progress Administration artist (1934–37), making lithographs and murals. His two murals for New York City's post office on 33rd street (1937) delineate the construction of the Triborough Bridge and the skyline of New York.

Later in life Lozowick moved away from Cubist-inspired industrial subjects. With a more supple line and often increased color, Lozowick made increasingly realistic prints of still lifes, landscapes of natural topography, and also Jewishly inspired imagery. Lozowick traveled extensively, recording his impressions as lithographs. Trips to Israel in 1954, 1964, and 1968 produced several images of the land including pictures of Safed and the Western Wall. On a commission from the United Jewish Appeal, Lozowick executed a lithograph of a pious Jew in synagogue entitled *Lone Worshipper* (1966) (see figure).

A prolific writer, Lozowick authored *Modern Russian Art* (1925), the first book on Russian avant-garde art published in the United States and for which he designed the cover akin to his machine ornaments; wrote a monograph on **William Gropper**; and contributed art criticism to several magazines, including *The Nation* and the Jewish periodical *The Menorah Journal*. Particularly interested in the question of Jewish art, in 1924 Lozowick wrote an article that praised the work of Jewish artists. He described some artists, such as **Theresa**

Louis Lozowick, *Lone Worshipper,* 1966, printed 1972. Lithograph, 12 inch diameter. Smithsonian American Art Museum, Washington, D.C. Gift of Adele Lozowick 1981.119.16.

Bernstein, who did not (at least up to 1924) paint Jewish subject matter. Lozowick observed that few of the names he lists devoted their art "to the expression of Jewish theme and a Jewish spirit," and noted that there "can be Jewish artists, but no Jewish art, unless there be a social need for it" (282). In so claiming, Lozowick expresses his belief that a Jewish artist means an artist who is born a Jew, an ethnic identification, not necessarily an artist who painted parochial subjects or even imagery influenced by the Jew's ethnocultural heritage. Lozowick also wrote the introductory essay for the first text to focus on Jewish American artists: *One Hundred Contemporary American Jewish Painters and Sculptors,* published by the Yiddisher Kultur Farband (1947). For his own entry he supplied an artistic credo, stating in part: "From the innumerable choices which our complex and tradition-laden civilization presents to the artist, I have chosen one which seems to suit my training and temperament.

I might characterize it thus: Industry Harnessed by Man for the Benefit of Mankind. Obviously this is not in itself art but raw material in the sense that religious fervor was raw material for the Medieval artist…When Giotto painted St. Francis, faith and conviction came first; problems of form and color followed. We could do no more with a contemporary theme; and we should attempt no less" (*One Hundred Contemporary*, 126). He penned his autobiography, *Survivor from a Dead Age*, from around 1945 until his death. The chronicle focuses on Lozowick's childhood experiences in a religious family in Russia through his art training in the early 1920s and provides as much information about his life as a burgeoning artist as on the social circumstances and religious experiences of Jews in early twentieth-century Europe.

Bibliography

Bowlt, John. *Louis Lozowick: American Precisionist Retrospective.* Long Beach, CA: Long Beach Museum of Art, 1978.

Flint, Janet. *The Prints of Louis Lozowick: A Catalogue Raisonné.* New York: Hudson Hills Press, 1982.

Lozowick, Louis. "Jewish Artists of the Season." *Menorah Journal* 10, no. 3 (June–July 1924): 282–285.

———. *One Hundred Contemporary American Jewish Painters and Sculptors.* New York: YKUF Art Section, 1947.

———. "What, Then, is Jewish Art?" *Menorah Journal* 35, no. 1 (January–March 1947): 103–110.

———. *Survivor from a Dead Age: The Memoirs of Louis Lozowick.* Edited by Virginia Hagelstein Marquardt; foreword by Milton W. Brown; prologue by John E. Bowlt. Washington, D.C.: Smithsonian Institution Press, 1997.

Marquardt, Virginia Hagelstein. "Louis Lozowick: From 'Machine Ornaments' to Applied Design, 1923-1930." *Journal of Decorative and Propaganda Arts* 8 (Spring 1988): 40–57.

Singer, Esther Forman. "The Lithography of Louis Lozowick." *American Artist* 37 (November 1973): 36–41, 78, 83.

Zabel, Barbara. "Louis Lozowick and Urban Optimism of the 1920s." *Archives of American Art Journal* 14, no. 2 (1974): 17–21.

———. "The Precisionist-Constructivist Nexus: Louis Lozowick in Berlin." *Arts Magazine* 56, no. 2 (October 1981): 123–127.

Selected Public Collections

Hirshhorn Museum and Sculpture Garden, Washington, D.C.
National Gallery of Art, Washington, D.C.
Nelson-Atkins Museum of Art, Kansas City, Missouri
Philadelphia Museum of Art
Saint Louis Art Museum
Smithsonian American Art Museum, Washington, D.C.
Walker Art Center, Minneapolis
Whitney Museum of American Art, New York

M

William Meyerowitz (1887–1981), painter and printmaker.

A prodigious printmaker and an artist who experimented with a variety of styles and subjects, William Meyerowitz achieved acclaim in his lifetime but since has been largely ignored by critics. Various sources cite the year of Meyerowitz's birth as ranging from 1887 to 1898, but Jonathan Bober, who consulted the artist's naturalization papers, confirms that Meyerowitz was indeed born in 1887 (3).[22] Raised in Russia, Meyerowitz was influenced by his cantor father, Gershon, who was also an avid Zionist. Gershon encouraged his son to pursue a career in music, and the younger Meyerowitz trained at the Imperial Conservatory in Russia and often sang at synagogue. Showing an interest in art at age ten, Meyerowitz worked for a sign painter in Russia. Around 1908 Meyerowitz and his father immigrated to the United States to escape pogroms and anti-Semitism in their native land, settling on the Lower East Side. While studying painting with William Merrit Chase and etching with Charles Mielatz at the National Academy of Design in New York (1912–16), Meyerowitz supported himself by singing in the Metropolitan Opera's chorus.

His work made its public debut in 1918 at the Brooklyn Museum of Art's third annual exhibition. A year later Meyerowitz had his first solo exhibition at the Milch Gallery in New York City. These early images were Lower East Side urban scenes made in a realistic fashion, such as the black-and-white etchings *The Knife Grinder* (1916, Jack S. Blanton Museum of Art, Austin, Texas) and *The Immigrant* (1918, collection unknown). In 1918, Meyerowitz first experimented with color etching. His technique was so well respected that he was featured in the Fox Film Company's educational film "The Etcher's Needle" (1925). In 1930, a solo show of Meyerowitz's prints was mounted at the Corcoran Gallery in Washington, D.C., the same year that his paintings and prints appeared in his one-person exhibition at the Baltimore Museum of Art.

Meyerowitz married **Theresa Bernstein** in 1919. Bernstein wrote the main source of information about her husband, a short biography, *William Meyerowitz: The Artist Speaks* (1986). Her other books, including Bernstein's published journal and a book of poems, also help place Meyerowitz's life and art in context. Admittedly, Bernstein estimated the dates of Meyerowitz's imagery, as he rarely dated his paintings and prints (*William Meyerowitz*, 97).

These sometimes arbitrary assignations have made it difficult to clearly ascertain the trajectory of Meyerowitz's artistic development. Nevertheless, Bernstein's books reveal the myriad subjects explored in her husband's art—ranging from biblical scenes to images of fisherman and harbors to abstractions.

After Meyerowitz and Bernstein married, they spent their summers in Gloucester, Massachusetts. In Gloucester, Meyerowitz worked on his paintings and prints, making many landscapes in the different styles that he adopted at various times in his career. A 1922 trip to Europe and a long-standing friendship with avant-garde artist Marcel Duchamp, his chess partner, confirmed Meyerowitz's propensity to modernist developments; from this period many of his canvases and prints were rendered with an increasingly painterly touch. While early works such as *The Knife Grinder* are realistic in subject and conventional in style, *Chromatic Scale* (1929, Girard Jackson collection, Sugar Land, Texas) reflects the influence of Synchromism, *Plum Street* (1925, collection unknown) recalls the solidity of Paul Cézanne's canonical work, and *The Clarinetist* (1958, Terra Foundation for American Art, Chicago) adopts Cubist elements. A large portion of Meyerowitz's work is Expressionist in conception. The heavily painted *Marriage Trio* (1952, Girard Jackson collection, Sugar Land, Texas) (Color Plate 12) depicts three Hasidic Jews enrapt in a musical trance; one traditionally dressed Jewish figure dances to the music played by a fiddler and a flutist. This rhythmic image painted with lyrical color derives, in part, from Meyerowitz's musical training as well as his lifelong love of music. As Bernstein accurately observed, Meyerowitz "has a deep belief in the things around him–in life, motion, rhythm, and growth. His horses are always galloping, his trees always growing, his musicians always playing, and his dancers always dancing. He gets movement into his paintings" (Movalli, 65).

At times, Meyerowitz reverted to a more conventional manner, as evidenced by his Works Progress Administration post office mural in Clinton, Connecticut (1923), a peaceful scene of village life. Over the years, Meyerowitz also made portraits of many prominent figures in a straightforward fashion. He etched Albert Einstein in 1923 (collection unknown) and Justice Louis Brandeis in 1939 (Rose Art Museum, Brandeis University). This latter portrait was one of several commissions Meyerowitz received to etch Supreme Court justices.

Meyerowitz created almost 1,000 etchings, including many on Jewish subjects. A portrait of *Moses* (1933, Jack S. Blanton Museum of Art, Austin, Texas) was made in three impressions as a color print, and dozens of images portray Jews at prayer; recent Jewish immigrants on the Lower East Side; Zionist events and themes; and the sights of Israel. As his wife recalled, some of these etchings "represent the search for answers to the living problems that Jews faced throughout their pilgrimage toward their roots. The *Exodus* series was completed in the Nazi era of Jewry's uprooting and destruction. The Exodus, William said, represented not only Moses's rescue and freeing of the Jews from Egyptian bondage, but an exodus of the two thousand-year pilgrimage after the destruction of the temple" (*The Journal*, 63). One of Meyerowitz's *Exodus*

images showed at the 1938 exhibition of the World Alliance for Yiddish Culture. Admiring of Meyerowitz's commitment to his heritage, Bernstein recalled that her husband sang Kol Nidre (one of the central prayers of the Yom Kippur service) at their synagogue in Gloucester "with enormous feeling and pathos; he got that low, meditative quality with the nuance of the sorrowful raconteur, interspersed with the cries of anguish at the injustices Jews had endured through the centuries" (*The Journal*, 118–119). After the establishment of the State of Israel, Meyerowitz and Bernstein visited the country thirteen times, liberally recording the people and the country in their respective media. During these visits they met Israeli artists, including Reuven Rubin and Marcel Yanco, and they once spent a week at Ain Hod, an artist's colony near Haifa. In an article written for the Jewish periodical *The Menorah Journal*, Meyerowitz urged Jewish patrons "to utilize the many Jewish artists now in this country, both Americans and refugees, for the strengthening and beautifying of Judaism....Many of them [Jewish artists], both American and refugee, are eager to put their talents at the service of American Judaism" (60).

Elected to membership in the National Academy of Design (1943) and elected president of the American Zionist organization Friends of Zion II (1952), in his lifetime Meyerowitz had achieved prominence in his two areas of interest: art and Judaism. The Mongerson Galleries in Chicago, Illinois are currently working on a catalog raisonné of Meyerowitz's work.

Bibliography

Bober, Jonathan. *The Etchings of William Meyerowitz*. Austin, TX: Archer M. Huntington Art Gallery, 1996.

Hall, David. "William Meyerowitz: Modernist." *American Art Review* 13, no. 1 (January–February 2001): 148–155.

Lozowick, Louis. *One Hundred Contemporary American Jewish Painters and Sculptors*. New York: YKUF Art Section, 1947.

Meyerowitz, Theresa Bernstein. *William Meyerowitz: The Artist Speaks*. Philadelphia: The Art Alliance Press; New York: Cornwall Books, 1986.

———. *The Poetic Canvas*. New York: Cornwall Books, 1989.

———. *The Journal*. New York: Cornwall Books, 1991.

Meyerowitz, William. "On the Need of Art." *The Menorah Journal* 32, no. 1 (April–June 1944): 55–60.

Movalli, Charles. "A Conversation with William Meyerowitz and Theresa Bernstein." *American Artist* 44, no. 450 (January 1980): 62–67, 90–92.

Selected Public Collections

Brooklyn Museum of Art, New York
Butler Institute of American Art, Youngstown, Ohio
Cape Ann Historical Museum, Gloucester, Massachusetts
Columbus Museum, Columbus, Georgia
Jack S. Blanton Museum of Art, University of Texas at Austin
Peabody Essex Museum, Salem, Massachusetts
Smithsonian American Art Museum, Washington, D.C.
Washington County Museum of Fine Arts, Hagerstown, Maryland

Henry Mosler (1841–1920), painter and printmaker.

Resurrected from near obscurity when a 1995 retrospective exhibition mounted by the Skirball Cultural Center reconstructed his oeuvre and life, Henry Mosler made a name for himself in his own time with detailed genre compositions and narratives of Breton customs painted in a literal style.

Although in his lifetime Mosler claimed to have been born in America, he emigrated from Germany at the age of eight with his parents, settling in New York. Two years later the family moved to Cincinnati. For years the Mosler family led a peripatetic life, living in several venues as Gustave Mosler, Henry's father and an artist himself, tried to find work.[23] The younger Mosler received his first art instruction from a lithographer in Nashville, Tennessee (1853). He then studied painting in Cincinnati (1859–61) with a genre and portrait painter named James Henry Beard, whose subject matter and straightforward storytelling style on canvases composed of small-scale figures influenced Mosler's early imagery. By 1860 Mosler had his own studio. During the Civil War, Mosler worked as an artist-correspondent for *Harper's Weekly*, which published thirty-four of his drawings (1861–63). These images show battles as well as the daily life of Union Army soldiers. Later, three paintings explored war themes.

In 1863 Mosler began studying in Düsseldorf, Germany, a celebrated artistic center attractive to American artists. Mosler's schooling in Germany strengthened his propensity for genre scenes and recording the niceties of his subjects. The Düsseldorf Academy also encouraged its students to make preparatory drawings and sketches before rendering larger canvases, and several of Mosler's studies for his painted compositions survive. Six months at the École des Beaux-Arts in Paris completed Mosler's extended training. The nomadic pattern of his youth brought Mosler back to Cincinnati (1866–74)—interrupted by less than a year in New York in 1870—where Reform Judaism initially gained prominence under the guidance of Rabbi Isaac Mayer Wise. Apparently of his own volition and without a commission, Mosler painted *Plum Street Temple* (c. 1866, Hebrew Union College Collection, Skirball Museum, Cincinnati) (see figure), a canvas detailing the exterior of Wise's newly built temple, Bene Yeshurun. Painted in natural hues against a cloudy sky, Mosler precisely delineates the Moorish style architecture, which dominates the canvas, dwarfing the well-dressed congregants who stand in front of the structure. A reproduction of the painting adorned the cover of a musical score, "Progress March," written to commemorate the building a year later. Portraits commissioned by the Jewish community include a likeness of Wise's wife Therese Bloch Wise (c. 1867, Hebrew Union College Collection, Skirball Museum, Cincinnati).

After eight years living in cities in the United States, Mosler returned to Europe, continuing his artistic apprenticeship at various times. Mosler started visiting Brittany in the summer of 1878, at which time he made paintings of Breton peasants, a subject that preoccupied his art until the 1890s. Interest in Breton life achieved popularity in the late nineteenth-century; the French

Henry Mosler, *Plum Street Temple,* c. 1866. Oil on canvas, 29½ × 24¾ inches. Hebrew Union College Collection, Skirball Museum, Cincinnati, Ohio.

Post-Impressionist Paul Gauguin painted rural Brittany, as did the Dutch Jew Jacob Meijer de Haan, among others. Mosler meticulously recorded Breton dress, customs, and domestic interiors, and he painted Breton wedding traditions on several occasions, such as *The Wedding Feast* (c. 1892, collection unknown), shown at the 1892 Paris Salon. Interested in accurate representations and fascinated by the exotic, Mosler collected Breton costumes and

objects to ensure his paintings' authenticity. Art historian Albert Boime argues that Mosler's attraction to the traditional, spiritual lifestyle of the Bretons relates to the artist's admiration of the French group's ability to retain traditional customs in a rapidly modernizing world (Gilbert, 113). Moreover, Boime observes, by painting Breton life Mosler was able to reconcile his desire to express aspects of his attachment to tradition without producing imagery of parochial Jewish subjects. As Boime puts it: "Mosler solved for himself the problem of participating in a non-Jewish social environment without surrendering his sense of distinctive identity and claims to a harmonious and vigorous ancestral past" (Ibid., 122).

Mosler contributed entries to the French Salon from 1878 to 1897; his 1879 entry, *Le Retour* (Musée Départmental Breton-Quimper, France), received Honorable Mention from the Salon jury and was purchased for the Musee du Luxembourg, making the canvas the first by an American artist to be bought by the French government. *Le Retour* recounts the oft-told biblical story of the Prodigal Son in a Breton setting. In tattered clothes, the errant yet still pious son returns to his mother's deathbed, submitting himself to his parent who lays in an authentic, intricately carved oak Breton bed. Rendered in a dark palette, Mosler contrasts the anguished son kneeling in dirt in threadbare clothes and accompanied by a mournful clergyman with his mother who rests peacefully in white surrounded by two lit candles.

During his years in Paris, Mosler achieved a great deal of success, certainly more recognition that he had received in the United States. He ran a popular studio where students took private lessons and renowned artists visited him, including the sculptor **Moses Jacob Ezekiel**. Returning permanently to the United States in 1894 after living in Munich (1874–77) and Paris (1877–94), Mosler spent the remainder of his days in New York and painted scenes from American colonial history and genre works, employing a similar formula of attention to details and extensive research. While Mosler's painting of Temple Bene Jeshurun and his portrait commissions indicate a continued relationship to the Jewish community, he characterized his art and view of nature as his spiritual connection: "I am an eternal worshipper of the Creator. When I transfer a beautiful model to the canvas, I am engaged in an act of divine worship. When I go out for a breath in the Park [*sic*] and look at the trees and flowers, I am worshipping; when at night I see the stars, I am worshipping again. God is great, mighty and good, and beautiful" (Gilbert, 52).[24]

Bibliography

American Artists in Düsseldorf, 1840-1865. Framingham, MA: Danforth Museum of Art, 1982.

Foley, Brigitte M. "Henry Mosler: Figure Drawings for Narrative Paintings." *American Art Review* 8, no. 3 (June–August 1996): 100–103.

Gilbert, Barbara C. *Henry Mosler Rediscovered: A Nineteenth-Century Jewish-American Artist.* With an essay by Albert Boime. Los Angeles: Skirball Museum, 1995.

Myers, Julia Rowland. "The American Expatriate Painters of the French Peasantry: 1863-1893." Ph.D. dissertation, University of Maryland, 1989.

Selected Public Collections

Butler Institute of American Art, Youngstown, Ohio
Cincinnati Art Museum, Ohio
Los Angeles County Museum of Art
Metropolitan Museum of Art, New York
Museum of Fine Arts, Boston
Nelson-Atkins Museum of Art, Kansas City, Missouri
Princeton University Art Museum, New Jersey
Smithsonian American Art Museum, Washington, D.C.

N

Elie Nadelman (1882–1946), sculptor, draftsman, and printmaker.

Even if he engaged varied materials, including bronze, marble, plaster, and wood, Elie Nadelman privileged formal elements, notably the curve, over material and subject. As Nadelman himself explained in a 1910 statement: "I employ no other line than the curve, which possesses freshness and force. I compose these curves so as to bring them in accord or in opposition to one another. In that way I obtain the life form, i.e., harmony.... The subject of any work of art is for me nothing but a pretext for creating significant form" (Kirstein, *Elie Nadelman*, 265).[25] He most famously worked on a small scale creating intimate and charming sculptures that fused graceful, crisply contoured, classically inspired forms with contemporary subject matter while retaining references to the natural world.

Born in Warsaw, Poland to cultivated and wealthy parents, Eliasz Nadelman's early exposure to art was from his father, a successful jeweler. Nadelman attended the Warsaw Art Academy (1899 and 1901), interrupted by a brief tenure in the Russian Imperial Army. Travels through Europe, notably six months in Munich (1902) where he encountered antique sculpture at the Glyptothek, influenced Nadelman's style and subject matter. His European youth not only affected his style but also his subsequent focus on form over all else. Critic Barbara Haskell connects Nadelman's anti-Semitic experiences in Poland with his generalized forms: "His attraction as a young Jewish artist in Poland to an aesthetic divorced from references to the personal and the particular can be seen as a reaction to the country's predominantly nationalist–and, by extension–largely anti-Semitic art community. Nadelman found in modernism's exclusive emphasis on formal values a license to ignore subject matter and thereby obliterate reminders of the ethnic, religious, and social distinctions upon which nationalism rests" (9). Certainly, Nadelman's sculptures merge diverse formal qualities to create archetypal sculptures with his favorite modern subject of performers (circus, vaudeville, dancers, and others), and at times animals, particularly stags and does.

Achieving a measure of success in his native land, Nadelman settled in Paris (1904–14), where he enjoyed friendships with members of the avant-garde and the patronage of Leo and Gertrude Stein. He primarily exhibited bronze, marble, and plaster classically idealized female heads, and curvaceous, simplified full-length nudes at the Salon des Indépendants and at the Salon d'Automne.

Receiving excellent reviews at his initial one-man show in 1909 at Paris' Galerie Druet (followed by a solo exhibition in London in 1911 and a second show at the Galerie Druet in 1913), Nadelman was recognized as an important modern artist. Across the ocean, twelve drawings and two plaster sculptures were chosen for the revolutionary Armory Show (1913), which introduced European avant-garde work to New York. The outbreak of World War I encouraged Nadelman to immigrate to America (October 1914), and soon thereafter he had several one-person exhibitions, including a show of drawings and sculpture from December 8, 1915 to January 8, 1916 at **Alfred Stieglitz**'s celebrated 291 Gallery.

In New York, Nadelman merged subject matter from popular culture with the directness of American folk carvings while preserving the elongated proportions and clear lines of ancient classicism. He began designing wood sculptures in 1917 that he subsequently painted with gesso to indicate facial features and clothing. One of many sculptures depicting the theme of dancing, the small, stylized painted *Tango* (c. 1919, Whitney Museum of American Art, New York) (see figure) is devoid of excessive detail. The tubular, flowing curves of the well-dressed dancing couple seem to defy the cherry wood material from which they are derived, suggesting movement that takes place and the implied motion to come. Also portraying the entertainment world, the tuxedo-clad *Orchestra Conductor* (c. 1920–24, Hirshhorn Museum and Sculpture Garden, Washington, D.C.) is similarly composed of elegant lines that effectively capture and freeze the maestro's gestures through minimal means. Sculptures such as *Tango* and *Orchestra Conductor*—folk-inspired, culturally attuned, and austere in detail—were also fortified by Nadelman's friendship with **Florine Stettheimer**, who was pursuing similar themes and techniques in her paintings. In addition, during this period Nadelman experimented with galvanoplastique, a method whereby a plaster sculpture is dipped in liquid metal and then subjected to an electric current that fuses the two materials. The final product appears as if it has been executed in metal, yet at a substantially lower cost. Nadelman utilized this technique to make large sculptures of women that did not achieve the popularity of his tinier wood works.

His personal financial success combined with his 1919 marriage to a wealthy widow, Viola Spiess Flannery, enabled Nadelman to work on his sculpture uninterrupted by monetary concerns and to indulge his bent for collecting American folk art and attendant European works that served as source material. Viola and Nadelman traveled extensively in the 1920s, amassing an enormous body of work—nearly 15,000 pieces—for a museum they built on their estate in Riverdale, New York. Known first as the Museum of Folk and Peasant Arts and later the Museum of Folk Arts, it was the first museum of its kind in the United States.

The Great Depression and subsequent market collapse devastated the Nadelman's financially, forcing the couple to sell their beloved art collection as well as their homes. Distraught by the turn of events, while also worried about the fate of Polish relatives in Poland with the rise of fascism, Nadelman withdrew from the New York art scene, declining to show or sell his sculptures and refusing to apply for assistance from the Works Progress Administration's

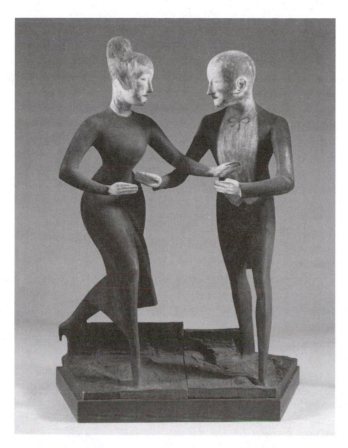

Elie Nadelman, *Tango,* c. 1919. Painted cherry wood and gesso, three units, 35⅞ × 26 × 13⅞ inches overall. Whitney Museum of American Art, New York. Purchase, with funds from the Mr. and Mrs. Arthur G. Altschul Purchase Fund, the Joan and Lester Avnet Purchase Fund, the Edgar William and Bernice Chrysler Garbisch Purchase Fund, the Mrs. Robert C. Graham Purchase Fund in honor of John I.H. Baur, the Mrs. Percy Uris Purchase Fund and the Henry Schnakenberg Purchase Fund in honor of Juliana Force 88.1a-c. Photograph © Whitney Museum of American Art, New York.

art projects. A rare source of income was two lucrative architectural commissions (1935); Nadelman designed a reclining Aquarius for the Bank of Manhattan and an Art Deco limestone frieze of construction workers for the Fuller Building on 57th Street and Madison Avenue. Sequestered in his Riverdale home, rebought in 1936, Nadelman made hundreds of often-erotic miniature plaster figures that defied his more characteristic sensibilities of finish and clarity. Instead these late works distort the human form and leave the surfaces of his figures rough and irregular, an artistic response, Haskell observes, that directly relates to feelings of uncertainty and irrationality instigated by the distress of World War II (197–198).

Although highly influential at the height of his career, Nadelman was largely forgotten at the time of his death by suicide. Curator Lincoln Kirstein reestablished Nadelman's reputation with a posthumous retrospective at the

Museum of Modern Art in New York in 1948. At this time Kirstein mined Nadelman's attic in Riverdale—where the sculptor had stored hundreds of his works—restoring many of them and having several posthumously cast in bronze. Nadelman was also honored with a retrospective of 103 sculptures and forty-one drawings at the Whitney Museum of American Art in 1975 (the show then went to the Hirshhorn Museum and Sculpture Garden). Two recent exhibitions attest to a renewed interest in Nadelman: a 2001 survey of the artist's sculptures and drawings at the Marion Koogler McNay Art Museum in San Antonio and a retrospective at the Whitney in 2003, encouraged by the museum's 1997–99 acquisition of sixty-seven works by the sculptor.

Bibliography

Antliff, Allan. "Cosmic Modernism: Elie Nadelman, Adolf Wolff, and the Materialist Aesthetics of John Weichsel." *Archives of American Art Journal* 38, no. 3–4 (1998): 20–29.

Baur, John I.H. *The Sculpture and Drawings of Elie Nadelman.* New York: Whitney Museum of American Art, 1975.

Birnbaum, Martin. "Elie Nadelman: Sculptor." *Menorah Journal* 11 (October 1925): 484–488.

Goodman, Jonathan. "The Idealism of Elie Nadelman." *Arts Magazine* 63 (February 1989): 54–59.

Haskell, Barbara. *Elie Nadelman: Sculptor of Modern Life.* New York: Whitney Museum of American Art; Distributed by Harry N. Abrams, Inc., 2003.

Kirstein, Lincoln. *The Dry Points of Elie Nadelman.* New York: Curt Valentin, 1952.

———. *Elie Nadelman: Drawings.* New York: H. Bittner, 1949. Rev. ed. New York: Hacker Art Books, 1970.

———. *Elie Nadelman.* With statements by the artist. New York: Eakins Press, 1973.

Ramljak, Suzanne. *Elie Nadelman: Classical Folk.* New York: American Federation of Arts, 2001.

Selected Public Collections

Hirshhorn Museum and Sculpture Garden, Washington, D.C.
Jewish Museum, New York
Museum of Fine Arts, Houston
Museum of Modern Art, New York
Smithsonian American Art Museum, Washington, D.C.
Wadsworth Atheneum Museum of Art, Hartford, Connecticut
Walker Art Center, Minneapolis, Minnesota
Whitney Museum of American Art, New York

Louise Nevelson (1900–88), sculptor and printmaker.

Known for her large-scale monochrome wall sculptures composed of wooden fragments, the Russian-born Leah Berliawsky mesmerized the art world in the late 1950s with her alluring and original assemblages. Unlike **Seymour Lipton** and **Ibram Lassaw**, Nevelson eschewed the more popular technique

of torch-sculpted metal because, she explained, "The noise and the masquerade offended me, and I didn't like the execution. It was too mechanical for me. Because I was creating every second, with this great intensity and great energy. And I just automatically went to wood. I wanted a medium that was immediate. Wood was the thing that I could communicate with almost spontaneously and get what I was looking for. For me, I think the textures and the livingness.... when I'm working with wood, it's very alive" (Nevelson, *Dawns and Dusks*, 78).

Arriving in the United States with her family in 1905, Nevelson grew up in Rockland, Maine, encouraged by her Orthodox parents to pursue her artistic interests. Her father owned a lumberyard and worked as a contractor, important influences on her mature sculpture when Nevelson adopted wood as her most significant material. She took her husband's surname after their marriage in 1920, the same year that the couple moved to New York. Her artistic apprenticeship spanned several years, including private painting and drawing lessons with **William Meyerowitz** and **Theresa Bernstein**, and studies at the Art Students League (1928–31; 1932–33). Nevelson's drawings and canvases from this period are figurative, colorful, and expressionistic in nature. After the dissolution of her marriage in 1931, Nevelson spent a year in Europe, first in Munich studying with the avant-garde artist Hans Hoffman where she became familiar with the tenets of Cubism—which would later prove essential for her signature sculptures—and then traveling and working as an extra in films in Berlin and Vienna. In 1932 Nevelson, along with **Ben Shahn**, assisted Diego Rivera with his Rockefeller Center mural.

Nevelson made her first sculpture around 1933, at which time she took classes at the Educational Alliance with **Chaim Gross**. Under the auspices of the Works Progress Administration she also taught sculpture at the Educational Alliance in 1937. Working mostly in terracotta and plaster, Nevelson executed blocky, figurative sculptures. Her first solo show was held at the Nierendorf Gallery in New York in 1941, where she exhibited paintings and sculpture influenced by Cubism and Surrealism. In the 1940s she started to make sculptural environments around themes, such as *The Circus-The Clown Is the Center of the World*, which showed at the Norlyst Gallery in New York (1943). Along with stylized circus figures designed in wood and metal, Nevelson placed marbles and sand on the floor, and the gallery owners hung antique circus posters on the walls of the exhibition space, encouraging the viewer's theatrical experience of the environment. Her sculptures grew increasingly abstract through the 1940s, influenced in part by non-Western art. In 1947 she also started making etchings, drypoints, and aquatints.

Around 1954, Nevelson began designing large wood, Cubist-inspired abstract constructions. In 1956, Nevelson made her first wall sculptures. The dramatic *Moon Garden +One* (1958) established Nevelson's reputation. Open-faced, stacked wood boxes filled with disparate found objects, such as furniture legs, broom handles, spindles, and other wooden abstract shapes, covered the walls of the Grand Central Moderns Gallery. The installation, which included the enormous *Sky Cathedral* (Museum of Modern Art,

New York), was painted a uniform black in an effort to occlude the original identity of the objects and to unite them. Exhibited in a darkened room, the vertical sculptural collages with elusive titles mysteriously enveloped the viewer.

Subsequent reliefs retained a monochrome appearance, painted entirely in either black, white, or gold. The all-white installation *Dawn's Wedding Feast*—which featured the sixteen-foot long assemblage *Dawn's Wedding Chapel* (Whitney Museum of American Art, New York)—appeared in 1959 at the Museum of Modern Art's "Sixteen Americans" exhibition, and gold sculptures showed at *The Royal Tides* exhibition at the Martha Jackson Gallery in 1961. Biographer Arnold Glimcher understood these works as "destroy[ing] the boundaries between painting and sculpture" by Nevelson's "extension of sculpture into the realm of illusion, a territory previously reserved for painting" (181, 86). Nevelson represented the United States at the 1962 Venice Biennale, the same year that she became the first female president of the National Artists Equity. She was the subject of a major retrospective at the Whitney Museum of American Art in 1967.

In 1964 Nevelson made the Holocaust memorial *Homage to 6,000,000* (collections unknown) (see figure), a curved wall sculpture, using her iconic stacked boxes filled with collage elements composed of wood scraps. The first version was painted black, but a second version, installed at the Israel Museum in Jerusalem in 1965, was painted white. For the dedication ceremony Nevelson

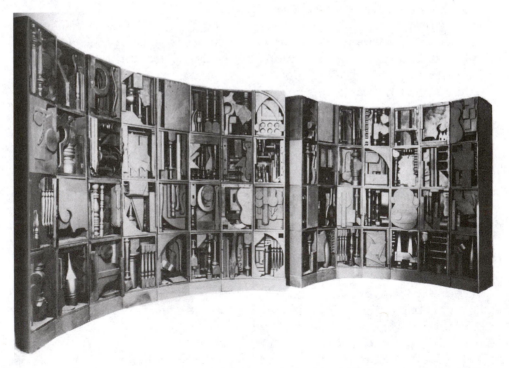

Louise Nevelson, *Homage to 6,000,000,* 1964. Wood painted black, approx. 9 × 18 feet. Collection unknown. © 2006 Estate of Louise Nevelson/Artists Rights Society (ARS), New York.

declared that her wall would be "a living presence of a people who have triumphed. They rose far and above the greatest that was inflicted upon them. I hear all over this earth a livingness and a presence of these peoples....We will be with them side by side forever and forever" (Lisle, 20). Expanding her materials in the second half of the 1960s, Nevelson created sculptures out of aluminum, Plexiglas, and Cor-ten steel. Sculptures designed with these new materials were often more geometric and ordered in appearance than Nevelson's wood sculptures.

Nevelson received several important commissions in the early 1970s, including a fifty-five-foot wall for Temple Beth-El in Great Neck, New York (1970); a Cor-ten steel sculpture titled *Sky Covenant* for Temple Israel in Boston (1973); and seven metal sculptures for the Louise Nevelson Plaza in Lower Manhattan (1979). During the last years of her life Nevelson was honored with a gold medal for sculpture from the American Academy of Arts and Letters (1983), and a National Medal of the Arts (1985).

Bibliography

Baro, Gene. *Nevelson: The Prints.* New York: Pace Editions, 1974.

Glimcher, Arnold B. *Louise Nevelson.* 2nd ed., revised and enlarged. New York: E.P. Dutton and Co., Inc., 1976.

Gordon, John. *Louise Nevelson.* New York: Whitney Museum of American Art and Praeger Publishers, Inc., 1967.

Lipman, Jean. *Nevelson's World.* Introduction by Hilton Kramer. New York: Hudson Hills Press, 1983.

Lisle, Louise. *Louise Nevelson: A Passionate Life.* New York: Summit Books, 1990.

Louise Nevelson: Atmospheres and Environments. Introduction by Edward Albee. New York: Clarkson N. Potter, Inc., Publishers, in association with the Whitney Museum of American Art, 1980.

Munro, Eleanor C. *Originals: American Women Artists.* Boulder, CO: Da Capo Press, 2000.

Nemser, Cindy. *Art Talk: Conversations with 12 Women Artists.* New York: Charles Scribner's Sons, 1975.

Nevelson, Louise. "Nevelson on Nevelson." *ARTnews* 71 (November 1972): 66–68.

———. *Dawns and Dusks: Taped Conversations with Diana MacKown.* New York: Charles Scribner's Sons, 1976.

Wilson, Laurie. *Louise Nevelson: Iconography and Sources.* New York: Garland Publishing, Inc., 1981.

Selected Public Collections

Detroit Institute of Arts, Michigan
Museum of Fine Arts, Boston
Museum of Modern Art, New York
National Gallery of Art, Washington, D.C.
San Francisco Museum of Modern Art
Smithsonian American Art Museum, Washington, D.C.
Tate Gallery, London
Whitney Museum of American Art, New York

Arnold Newman (1918–2006), photographer.

Considered the originator of "environmental photography," also known as "environmental portraiture," for over seven decades Arnold Newman has made photographs of some of the most famous personalities in the world. Indeed, his sitters include artists, politicians, and writers, ranging from Prime Minister of Israel Golda Meir (1970) to President Bill Clinton (1999), Marc Chagall (1942) to Jackson Pollock (1949), and Truman Capote (1977) to Woody Allen (1996). In all cases, Newman aimed to establish a working relationship with his sitters (analogous to **Jo Davidson**'s philosophy of portrait sculpture) while also photographing his subjects in their natural environment. This approach allows the sitter to feel comfortable and thereby the end result does not appear posed. In addition, Newman created a situation where the possessions and milieu of the sitter convey something of his or her personality. Influenced by his most significant mentor, **Alfred Stieglitz**, who took an interest in Newman's work when the younger artist was in his early twenties, Newman also paid great attention to the formal aspects of a picture. Newman's photograph of Woody Allen, for example, portrays the writer seemingly casually lying on his bed—where he typically writes—pen in hand and a notepad with ideas jotted on in front of him. Momentarily glancing up from his work, head on his hand, Allen's horizontal pose creates an interesting juxtaposition with the askew pad, striped sheets, and highly vertical orientation of the picture.

Born in New York, at two years old Newman moved with his parents to Atlantic City and then at sixteen the family moved again, to Miami Beach. His artistic interest manifested in painting, and among Newman's early works are images of rabbis conceived during the Depression years (Telephone conversation). He studied art the University of Miami (1936–38) on a working scholarship, but was forced to leave college because of financial difficulties. Although versed in painting and draftsmanship, at twenty years old Newman lived in Philadelphia and worked in a portrait studio, his first exposure to the camera. After learning the fundamentals, Newman traveled to branch studios in West Palm Beach, Philadelphia, and Baltimore (1938–40) where in his spare time he made his earliest photographs outside of the studio. Taken in a social documentary vein akin to the photographers employed by the Farm Security Administration, whom Newman cites as influential, these initial pictures show the indigent in their own neighborhoods and homes, harbingers of Newman's mature portrait style.

Beginning in 1941, Newman shot photographs of well-known artists. This body of work consists of photographs of more than fifteen artists in this book, including black-and-white prints of **Louise Nevelson** (1972), **Adolph Gottlieb** (1953), and a double portrait of **Raphael Soyer** and **Moses Soyer** (1942). One of his most recognized artist pictures depicts Piet Mondrian (1942) standing in his studio, a hand draped over his empty easel, with two monochrome compositions tacked to the wall behind him. In rich gradations of black and white, Mondrian appears confined into one of his own signature, abstract, grid-like

paintings. As Philip Brookman, the Corcoran Gallery's curator of photography, aptly notes: "This metaphor of Mondrian's environment, a reflection of his own aesthetic principles, links his personality to his art. This is the innovation that became Newman's trademark" (19). Some of the early artist photographs were on view at Newman's first public exhibition, a two-person show at the A.D. Gallery in New York (fall 1941). A watershed moment for the artist, the show was attended by Beaumont Newhall, curator of photographs at the Museum of Modern Art, who acquired a print for the museum's collection. Newman ran his own studio from 1942 to 1945 in Miami Beach, but the resounding response to his 1945 one-person exhibition of artist photographs at the Philadelphia Museum of Art—the museum purchased the entire show—prompted him to move permanently to New York City (1946). Once settled in New York, Newman regularly took photographs on assignment for magazines such as *Life* (including twenty-four covers), *Holiday, Esquire,* and the *Saturday Evening Post,* and in 1946 he opened the studio that he continues to work at to this day.

When asked how he defines Jewish art, Newman replied: "Take a look at Chagall, who I knew. He's painting about Jewish subjects and Jewish life. Photographing Jewish subjects does not make Jewish art. I took lots of photographs of objects in the Israel Museum. I don't think that's Jewish art. Being a Jewish artist sometimes leads you into a path of following the Torah, the Bible, the whole thing. It's a dead end sometimes. For Chagall it was a means of taking off." At the same time, Newman feels that his Jewish background affected some of his artmaking: "My Jewish knowledge and my heart influenced the way I photographed Israel. The prime ministers, who I photographed, are history more than anything else. I put together a show of fifty-seven photographs of Jews from all around the world that influenced Jewish history and culture. Can you call that Jewish art? I don't know" (Telephone conversation).

As the photography advisor for the Israel Museum in Jerusalem since 1965, Newman visited the country twenty-one times. He made several photographic essays about Israel; one of his best-known nonportrait photographs presents a rabbi praying at the Western Wall (1967). The rabbi asked not to be photographed and so Newman's color composition shows the partial figure of the holy man with his angled shadow extending along the bottom of the deeply textured, enormous wall. Other nonportrait photographs include collages, still lifes, and abstractions.

Several books of Newman's photographs have been published, the first of which is a compendium of photographs of Bravo Stravinsky, ending with a picture of the maestro's grave (1967). His initial photograph of Stravinsky (1946) was made on commission from *Harper's Bazaar* when Newman was only twenty-eight years old (*Harper's* did not want the picture, which was picked up by *Holiday* magazine). Presenting Stravinsky dwarfed by his grand piano, the picture is arranged with the piano lid up, thus materializing into as an enormous, slanting, black musical note. Over one hundred of Newman's photographs are in the permanent collection of the National Portrait Gallery in Washington, D.C.

Bibliography

Brookman, Philip. *Arnold Newman*. Essay by Arnold Newman. Köln: Taschen, 2000.

Newman, Arnold. *Bravo Stravinsky*. Text by Robert Craft; foreword by Francis Steegmuller. Cleveland: World Publishing Company, 1967.

————. *One Mind's Eye: The Portraits and Other Photographs of Arnold Newman*. Foreword by Beaumont Newhall; introduction by Robert A. Sobieszek. Boston: David R. Godine, 1974.

————. Interview with Barbaralee Diamonstein. In *Visions and Images: American Photographers on Photography*. New York: Rizzoli International Publications, Inc., 1981, 143–158.

————. *Arnold Newman: Five Decades*. Introduction by Arthur Ollman; with an afterward by Arnold Newman. San Diego: Harcourt Brace Jovanovich, 1986.

————. *Arnold Newman's Americans*. Essays by Alan Fern and Arnold Newman. Washington, D.C.: National Portrait Gallery, in association with Boston: Bulfinch Press, 1992.

————. Telephone conversation with author. October 3, 2005.

Weber, Bruce. *Arnold Newman in Florida*. West Palm Beach, FL: Norton Gallery of Art, 1987.

Selected Public Collections

Art Institute of Chicago
Israel Museum, Jerusalem
Metropolitan Museum of Art, New York
Museum of Modern Art, New York
National Gallery of Canada, Ottawa
National Portrait Gallery, London
National Portrait Gallery, Smithsonian Institution, Washington, D.C.
Norton Simon Museum of Art, Pasadena, California

Barnett Newman (1905–70), painter, sculptor, and printmaker.

A central Abstract Expressionist contemporaneous with **Mark Rothko** and **Adolph Gottlieb**, Barnett Newman most famously painted large canvases with vertical stripes (termed by Newman himself as "zips") running down fields of monochromatic color. By purging his paintings of past artistic associations and creating work devoid of objective imagery, Newman aimed to design an intellectual art composed of limited elements that conveyed the universal rather than the particular. As he wrote in 1947: "It is only the pure idea that has meaning. Everything else has everything else" (O'Neill, 108). For years, scholars have described and analyzed Newman's art as "Jewish," an interpretation the artist took pains to distance his work from in his lifetime. In a 1975 exhibition catalog for the Jewish Museum's landmark show *Jewish Experience in the Art of the Twentieth Century*, Avram Kampf wrote: "If there were a Jewish art, Newman's work would be regarded as its most authentic and classic expression" (46).

Born on New York's Lower East Side to Eastern European immigrant parents, Newman grew up in a Jewish and Zionist environment. He studied philosophy at the City College of New York (1923–27) while taking classes at the Art Students League (1922–24), where he first met Gottlieb. This early intellectual training served Newman well, as he was extremely verbal about his artistic ideas, producing copious essays, notes, and other documents, many now collected in a book of his writings. Newman's paintings from the 1930s, destroyed by the artist, have been described as expressionist in conception. For several years Newman stopped painting, but in the mid-1940s he renewed his artistic aspirations and worked in a Surrealist, biomorphic style until he reached his signature mode.

The first painting that employed a "zip" in the manner that would dominate his mature work is *Onement I* (Museum of Modern Art, New York), completed in January 1948. On a small canvas, a thin, orange, vertical zip runs down a reddish-brown color field. In *Onement I,* the color field is variegated, but later the color fields become solid and flat. Basing his analysis on mystical interpretations of scripture and other Jewish concepts—known as Kabbalah and material that Newman was familiar with—scholar Thomas Hess interpreted *Onement I* as "a complex symbol, in the purest sense, of Genesis itself. It is an act of division, a gesture of separation, as God separated light from darkness, with a line drawn in the void. The artist, Newman pointed out, must start, like God, with chaos, the void: with blank color, no forms, textures or details. Newman's first move is an act of division, straight down, creating an image. The image not only re-enacts God's primal gesture, it also presents the gesture itself, the zip, as an independent shape – man – the only animal who walks upright, Adam, virile, erect " (56). Hess continues, describing the color field as the earth based on Newman's hue, and explains that Adam, the first man created by God, derives from *adamah,* the Hebrew word for earth. What Hess says here is that Newman acts as God, the ultimate creator, in his choice of color and form.

Building on Hess' discussion of Newman's interest in Kabbalah, Matthew Baigell further suggests that Newman's Kabbalistic knowledge assisted his abstract conception, one that rejected all art that came before his zip canvases: "With his [Newman's] readings both in and about the Kaballah [*sic*], he decided to act like God by creating, in effect, forms out of nothing, out of the chaos before human creation and before Creation Itself, as in his stripe paintings" (*Jewish Artists in New York,* 130, 137). Six more *Onement* paintings followed Newman's initial conception; the second canvas in the "Onement" series was nearly titled atonement, in reference to Yom Kippur (Day of Atonement), the holiest day of the year during which Jews repent for their sins.

Newman had his first solo exhibition in 1950 at the Betty Parsons Gallery. Reviews of the show were not good and only one painting sold—to a friend of Newman's wife. At a second solo show at the Betty Parsons Gallery the following year, Newman exhibited one of his best-known paintings, *Vir Heroicus Sublimus* (1950–51, Museum of Modern Art, New York), and his first sculpture, the wood and plaster *Here I* (1950, Los Angeles County Museum of Art), which he subsequently cast in bronze. Five zips, carefully placed on the pure red

surface of the extremely large (8 × 18 feet) *Vir Heroicus Sublimus* (Man, Heroic and Sublime), help to modulate the vast expanse of color. Each vertical affects the way the viewer perceives sections of the painting, making it impossible for the beholder to perceive the canvas in a single glance. *Here I* consists of two zips, one textured and the other smooth, translated into three-dimensions. Once more, the show was not well received, and until 1955 Newman did not again exhibit his works publicly. Several years later, when the artist garnered recognition, his hard-edge color proved an important influence on Minimalist artists of the 1960s, such as Frank Stella.

The year 1958 was a turning point for Newman; he enjoyed a one-man show at Bennington College in Vermont, accompanied by a catalog with an essay by the influential art critic Clement Greenberg, and he began what some scholars view as his most important paintings: *The Stations of the Cross* (1958–66). Subtitled "Lema Sabachthani," Aramaic for "Why have You forsaken me?," the words uttered by Jesus from the cross to God (Matthew 27:46), this series of fourteen, identically sized canvases retains the raw white canvas, which is bisected by expressive black zips. Within the rigid confines of a restricted palette, the zips in the series vary remarkably in hue and tonality, demonstrated even in individual canvases such as *First Station* (1958, National Gallery of Art, Washington, D.C.) (see figure). The subject of much scholarly debate, Mark Godfrey reads *The Stations of the Cross* as a Holocaust memorial, understanding the cry of "lema sabachthani" as referring to the ultimate Jewish question of why God forsook the Jews during the Holocaust. When the series hung at the Solomon R. Guggenheim Museum in 1966, Newman's first solo museum exhibition, many critics panned the show.

In 1963, Newman designed a synagogue model for a Jewish Museum exhibition, titled "Recent Synagogue Architecture." The only nonarchitect included in the show, Newman created a model that invoked a baseball field, with the bema (the platform where the rabbi conducts services) rendered as a pitcher's mound. Newman explained his design: "Here in this synagogue, each man sits, private and secluded in the dugouts, waiting to be called, not to ascend a stage, but to go up on the mound, where, under the tension of that 'Tzim-Tzum' that created light and the world, he can experience a total sense of his own personality before the Torah and His Name" (O'Neill, 181).[26] Ann Temkin observes that Newman's concept "articulated the ongoing negotiation of joint identities as Americans and Jews" (64).

All conceived with a zip-color field formula, several of Newman's paintings are titled with biblical names, such as *Abraham* (1949, Museum of Modern Art, New York)—both his father's name (his father died two years before the painting's conception) and the name of the first Jew—and *Eve* (1950, Tate Gallery, London). Other titles clearly indicate a Jewish origin, such as *Covenant* (1949, Hirshhorn Museum and Sculpture Garden, Washington, D.C.) and *Day One* (1951–52, Whitney Museum of American Art, New York).

During his final decade, Newman embarked on several projects that explored new modes of expression. For example, he painted four canvases with rich fields and zips of primary colors titled *Who's Afraid*

Barnett Newman, *First Station,* 1958. Magna on canvas, 77⅞ × 60½ inches. National Gallery of Art, Washington, D.C. Robert and Jane Meyerhoff Collection. © 2006 Barnett Newman Foundation/Artists Rights Society (ARS), New York.

of Red, Yellow and Blue?, and he also made a portfolio of eighteen color lithographs, *18 Cantos* (1963–64), and several etchings (e.g., the *Notes* series from 1968). While Newman's work did not receive the recognition that it deserved in his lifetime, since then he has been acknowledged as a pivotal twentieth-century painter. In 2002, the Philadelphia Museum of Art and the Tate Modern in London organized a major exhibition of Newman's work.

Bibliography

Baigell, Matthew. "Barnett Newman's Stripe Paintings and Kabbalah: A Jewish Take." *American Art* 8, no. 2 (Spring 1994): 32–43.

———. *Jewish Artists in New York: The Holocaust Years.* New Brunswick, NJ: Rutgers University Press, 2002.

———. "Newman's The Stations of the Cross: Lema Sabachthani, A Jewish Take." *Art Criticism* 19, no. 1 (2004): 52–64.

Bauer, J. Edgar. "Barnett Newman: Iconoclasm, Heilsgeschichte and the 'Modern Mythology.'" *Cesnur International Conference* (2001): 1–9.

Buchwald, Nancy Nield. "Anxious Embodiments: Remnants of Post-WWII American Jewish Masculinities in Barnett Newman's Stations of the Cross." Ph.D. dissertation, University of Chicago, 2004.

Godfrey, Mark. "Barnett Newman's *Stations* and the Memory of the Holocaust." *October* 108 (Spring 2004): 35–50.

Hess, Thomas. *Barnett Newman.* New York: Museum of Modern Art, 1971.

Ho, Melissa, ed. *Reconsidering Barnett Newman.* New Haven: Yale University Press, 2005.

Kampf, Avram. *Jewish Experience in the Art of the Twentieth Century.* New York: The Jewish Museum, 1975.

O'Neill, John P, ed. *Barnett Newman: Selected Writings and Interviews.* Berkeley: University of California Press, 1990.

Rosenberg, Harold. *Barnett Newman.* New York: Harry N. Abrams, Inc., Publishers, 1978.

Shiff, Richard, Carol C. Mancusi-Ungaro, and Heidi Colsman-Freyberger, eds. *Barnett Newman: A Catalogue Raisonné.* New Haven: Yale University Press, 2004.

Temkin, Ann, ed. *Barnett Newman.* Philadelphia: Philadelphia Museum of Art in association with Yale University Press, 2002.

Selected Public Collections

Art Institute of Chicago
Dallas Museum of Art
Hirshhorn Museum and Sculpture Garden, Washington, D.C.
Museum of Modern Art, New York
San Francisco Museum of Modern Art
Tate Gallery, London
Wallrof Richartz Museum, Koln, Germany
Whitney Museum of American Art, New York

O

Jules Olitski (1922–), painter, sculptor, and printmaker.

An artist who has explored abstraction in several media, Jules Olitski is best known for his experimentations with various modes of color-field painting. Born Jules Demikovsky in Snovsk, Russia a few months after his commissar father's execution by the Communist Party, Olitski immigrated to the United States in 1923 with his mother and grandmother. He grew up in New York, where he also studied painting and drawing at the National Academy of Design (1940–42), and sculpture at the Beaux-Arts Institute of Design (1940–42). During World War II Olitski served in the Army (1942–45), before which he became an American citizen and adopted his stepfather's surname.

Following the war, Olitski studied sculpture at the Educational Alliance with **Chaim Gross** (1947), where he made some semiabstract sculptures, and also wood carvings and figurative clay sculptures. Under the G.I. Bill, Olitski received additional art training at the Académie de la Grande Chaumière (1949–50) and with sculptor Ossip Zadkine (1949) in Paris. In an effort to transcend his academic training, for several months Olitski made a series of vigorously rendered paintings while blindfolded. He had his first solo exhibition in Paris (1951), where he showed partially abstract paintings executed in bright colors. Upon his permanent return to the United States he received a B.S. (1952) and an M.A. (1955) in art education from New York University. Responding to his vibrantly hued Parisian works, during this transition period Olitski made several monochrome abstractions and experimented with heavily impastoed works in the late 1950s.

Throughout Olitski's career he has explored varied modes of color-field painting. Adapting a technique made popular by **Helen Frankenthaler** and **Morris Louis**, in the early 1960s Olitski eschewed thick impasto and started to stain large canvases with hard-edge, pigmented oblong shapes; *Born in Snovsk* (1962, Art Institute of Chicago) (see figure), one of several works in the Core series, shows asymmetrical colored circles dominating the vertical canvas. Thinned purple paint comprises the outside circle, which cradles a pink ovoid that strains the sides and top of the canvas. Within the pink circle, a broken purple, orange, and green ring hovers on the canvas. In 1964 Olitski began to apply paint to canvases with spray cans and later with

Jules Olitski, *Born in Snovsk,* 1962. Magna acrylic on canvas, 11 × 7′6 inches. Art Institute of Chicago. Gift of the Ford Foundation, 1964.72. Art © Jules Olitski/Licensed by VAGA, New York, New York. Reproduction: The Art Institute of Chicago.

a spray gun. Allover color mists float atop the canvas and subtle, modulated hues of pink dissolve into each other in *Ishtar Melted* (1965, Princeton University Art Museum, New Jersey), a large canvas exemplifying Olitski's desire to create "a spray of color that hangs like a cloud, but does not lose its shape" (Olitski, "How My Art Gets Made," 617). During the 1970s, Olitski reacted against his atmospheric, luminous spray technique with abstractions composed of tactile, dense, often dull-colored paint. Iridescent paintings followed, in which he applied gobs of paint with mittened hands. *Temptation Temple* (1992, collection unknown) exemplifies his work of this period with the energetic texture and sense of relief created by the thick metallic brown interwoven with highlights of green, purple, and blue. In 1995, Olitski surprised the artworld when he began painting figurative landscapes in watercolor, pastel, acrylic and other media. Olitski connected his abstract

works with his newer figurative canvases in an interview from 1999, explaining that when working wholly abstractly he would step outside to "see if nature could maybe give me a hint, a color or something and frequently I'd find myself doing that, but the painting was completely abstract" (Ganis, 46).

Olitski began making prints in 1954, when he designed his first woodcut. These initial forays into printmaking yielded a wide range of imagery from representational self-portraits to abstractions made with a variety techniques, particularly etching. His colored silkscreens from the early 1970s are pure abstractions of color akin to his paintings of the period. In 1968, Olitski designed his first sculptures to receive national attention— aluminum abstractions that he sometimes colored with a spray gun. His sculptures are typically produced in series, such as the Ring series (1970–73), a group of works composed of concentric circles of thin sheet steel. Later sculptures from the 1970s consist of stacked sheets of unpainted Cor-ten steel.

While Olitski's art does not overtly reference Jewish subjects, a 1985 statement addresses his belief in the divine. Olitski recalled that at age eleven he was preoccupied with the Bible and harbored ambitions of becoming a rabbi: "The book I was reading and had been reading night after night while my parents and brothers slept was the Old Testament. Somehow I had found my way to that book so full of wonders. I say somehow, because I had had no religious instruction – neither at home nor at school. Nonetheless, my belief in the God of the Old Testament was absolute. I dreamed of becoming a rabbi when I grew up" (Berman, 145). The news of the Holocaust, shook his beliefs: "At the time, 1933 or thereabout, an evil, so horrible as to be beyond a child's comprehension, was making itself known to the world. I had a newspaper delivery route. Every now and then in a short paragraph on a back page of the newspaper, I read some words, rumors usually, that spoke of Jews being persecuted in Germany: beatings, disappearances, concentration camps, death camps. Was it possible?...Where was the good FDR, so beloved by the Jews? And God, the God of us all, surely He would not turn His face away from such a *schrecklichkeit* [evil]....I long ago stopped believing in the God of my ancestors, but if He exists, this great and awful God who can look with equanimity or a tolerant smile upon horrors unspeakable – if He does exist, then I must not look upon His face" (Ibid., 146–147). Despite this disavowal of God, Olitski concludes that his creativity derives from a "divine source" and that he "believe[s] in a Creator" (Ibid., 151–152).

Olitski's work has been publicly exhibited on numerous occasions. Notably, he represented the United States at the 1966 Venice Biennale; he was the first living American artist to have a one-person show at Metropolitan Museum of Art (1969); and in 1973, Olitski enjoyed a retrospective at the Museum of Fine Arts in Boston. More recently, Olitski was honored with a three-decade retrospective at the Buschlen-Mowatt Gallery in Vancouver (1990). For over a decade Olitski taught art, first at C.W. Post College of Long Island University (1956–63) and then at Bennington College (1963–67).

Bibliography

Berman, Phillip L., ed. *The Courage of Conviction*. New York: Dodd, Mead and Company, 1985.

Fried, Michael. *Three American Painters: Kenneth Noland, Jules Olitski, Frank Stella.* Cambridge, MA: Fogg Art Museum, 1965.

Ganis, William V. "Jules Olitski." *Art Criticism* 14, no. 1 (1999): 36–46.

Moffett, Kenworth. *Olitski: New Sculpture.* Boston: Museum of Fine Arts, 1977.

———. *Jules Olitski.* New York: Harry N. Abrams, Inc., Publishers, 1981.

Olitski, Jules. *Jules Olitski.* Boston: Museum of Fine Arts, Distributed by Greenwich, CT: New York Graphic Society, 1973.

———. *Jules Olitski: Communing with the Power.* Vancouver: Buschlen-Mowatt Gallery, 1989.

———. "How My Art Gets Made." *Partisan Review* 68, no. 4 (Fall 2001): 617–623.

Rose, Barbara. *Jules Olitski: Recent Paintings.* New York: Salander-O'Reilly Galleries, Inc., 1993.

Wilkin, Karen. "Life after Formalism." *Art in America* 89, no. 11 (November 2001): 110–115, 159.

Wilkin, Karen and Stephen Long. *The Prints of Jules Olitski: A Catalogue Raisonné, 1954-1989.* New York: Associated American Artists, 1989.

Selected Public Collections

Detroit Institute of the Arts
Israel Museum, Jerusalem
Museum of Modern Art, New York
National Gallery of Canada, Ottawa
Pennsylvania Academy of the Fine Arts, Philadelphia
San Francisco Museum of Modern Art
Smithsonian American Art Museum, Washington, D.C.
Whitney Museum of American Art, New York

P

Philip Pearlstein (1924–), painter, printmaker, watercolorist, and draftsman.

Even if the human figure stands at the center of Philip Pearlstein's art he, like **Alex Katz**, professes disinterest in the psychological aspects of his models, preferring instead to focus on color, light, and composition, often by truncating the limbs of the figures in his canvases. As Pearlstein explained: "I'm concerned with the human figure as a found object" (Herrera, 47) and "I've deliberately tried not to be expressive about the models I've been painting for almost twenty years now, not to make any kind of comment but just to work at the formal problems of representational painting in relation to picture structure" (Strand, 101). Working from life, Pearlstein most commonly paints nude studio models in harsh lighting with a precise, smooth brushstroke. Approaching the human figure realistically in the 1960s and 1970s positioned Pearlstein against the then-current abstract art trends. Subsequently, Pearlstein has been recognized as a leader in the return of figuration in contemporary art, a prime progenitor of New Realism.

Born in Pittsburgh, Pennsylvania, Pearlstein's interest in art manifested when he was a child. Indeed, he was awarded first and third prize in *Scholastic Magazine*'s National High School Art Exhibition, and both winning paintings were featured in *Life* magazine's June 16, 1941, issue. After completing one year of study at the Carnegie Institute of Technology (now called Carnegie Mellon University) on a partial scholarship, he was drafted into the Army (1943–46). While enlisted Pearlstein made documentary sketches and watercolors of infantry training scenes and the life of the soldier, thinking that upon his return to the United States he would become an illustrator. Instead, following the war he renewed his studies at Carnegie Tech, and experimented with various styles; a particularly interesting image from this period is an expressionistic painting of a pious Moses presenting the Tablets of the Law (1948, collection unknown). Pearlstein graduated in 1949 with a B.F.A. and moved to New York, where he shared an apartment with his classmate Andy Warhol for around six months. Pearlstein enjoyed his first work as a professional artist as a catalog illustrator. He earned an M.A. from New York University in art history in 1955, writing his thesis on Francis Picabia. That same year Pearlstein showed his expressionistic, heavily impastoed landscape paintings influenced by Abstract Expressionism at his first one-person show at the Tanager Gallery. In the early 1960s he began to focus on studio models, first

painting figures in an expressionist manner akin to his landscapes. Then, starting in 1963, Pearlstein began painting in a more straightforward fashion on an increasingly larger scale. Typical of Pearlstein's work is the 60 × 72-inch canvas *Two Female Models Sitting and Lying on a Navajo Rug* (1972, Des Moines Art Center, Iowa) (see figure), which shows a pair of unidealized, unemotional females lounging on a brightly patterned rug. The sitting female's head is cropped and the reclining figure's body is contorted allowing the artist to explore the complicated pose, which he paints from a high vantage point. In his large canvases, the artist privileges accessories—such as exotic rugs, mirrors, chairs, and other furniture, often with patterned upholstery—as highly as the posed humans he depicts. *Two Female Models Sitting and Lying on a Navajo Rug* exemplifies the working formula that dominates Pearlstein's oeuvre: studio models are placed in complicated poses amid varied objects painted in a brilliantly colorful palette. This palette then contrasts with the pallid flesh of his human subjects.

In the 1970s Pearlstein reintroduced watercolors to his repertoire, a technique that he had explored while in the Army. *Jerusalem, Kidron Valley* (1986) shows a panorama of ancient architecture and a more recently erected village

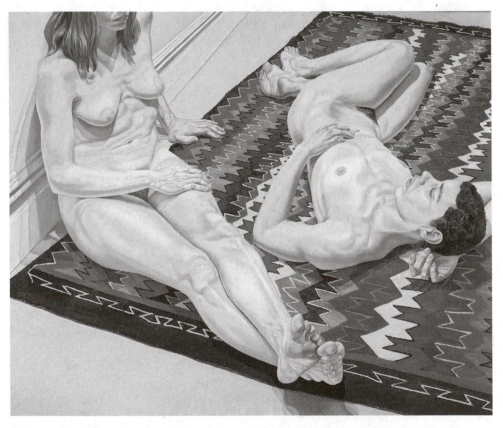

Philip Pearlstein, *Two Female Models Sitting and Lying on a Navajo Rug,* 1972. Oil on canvas, 60 × 72 inches. Des Moines Art Center, Des Moines, Iowa. Purchased with funds from the Coffin Fine Arts Trust; Nathan Emory Coffin Collection of the Des Moines Art Center, 1972.86.

in naturalistic colors. Pearlstein painted the large watercolor, measuring 40 × 119 inches, from nature rather than photographs (the watercolor was used as the basis for a large print with the same name). Pearlstein's watercolors, as his paintings, are factual, dispassionately rendered, representational works that eschew symbolism and narrative. Watercolors of nude studio models also preoccupied the artist from this period forward, as have sepia washes of both landscapes and nudes.

Through the years Pearlstein's teaching has helped him to refine his own art, first at Pratt Institute (1959–63) and then at Brooklyn College (1963–88). While he is best known for his monumental studio nudes, Pearlstein also makes portraits, including a 1979 *Time* magazine cover of Henry Kissinger. Pearlstein has written about his art technique and philosophy in several articles in addition to a publication derived from his M.A. thesis on Picabia. When asked about what, if anything, he considers "Jewish" about his art, Pearlstein responded "almost nothing, but I think that it [my art] is very American – specifically New York and perhaps that includes something Jewish" (Written correspondence).

Bibliography

Baigell, Matthew. "Pearlstein's People." *Art Criticism* 1, no. 1 (Spring 1979): 3–11.

Bowman, Russell. *Philip Pearlstein: The Complete Paintings.* Introduction by Hilton Kramer; Essay by Irving Sandler. New York: Alpine Fine Arts Collection, Ltd., 1983.

Herrera, Hayden. "Pearlstein: Portraits at Face Value." *Art in America* 63 (January 1975): 46–47.

Pearlstein, Philip. "Figure Paintings Today Are Not Made in Heaven." *ARTnews* 61, no. 4 (Summer 1962): 39, 51–52.

———. Written correspondence with the author. May 2, 2005.

Perreault, John. *Philip Pearlstein: Drawings and Watercolors.* Foreword by Philip Pearlstein. New York: Harry N. Abrams, Inc., Publishers, 1988.

Shaman, Sanford Sivitz. "An Interview with Philip Pearlstein." *Art in America* 69, no. 7 (September 1981): 120–126, 213, 215.

Storr, Robert. *Philip Pearlstein: Since 1983.* New York: Harry N. Abrams, Inc., Publishers, 2002.

Strand, Paul, ed. *Art of the Real: Nine American Figurative Painters.* New York: Clarkson N. Potter, Inc., 1983.

Viola, Jerome. *The Painting and Teaching of Philip Pearlstein.* New York: Watson-Guptill Publications, 1982.

Yablonsky, Linda. "Philip Pearlstein's Deadpan Cool." *ARTnews* 101, no. 11 (December 2002): 102–105.

Yezzi, David. "A Conversation with Philip Pearlstein." *New Criterion* 32, no. 4 (December 2004): 19–23.

Selected Public Collections

Carnegie Museum of Art, Pittsburgh
Hirshhorn Museum and Sculpture Garden, Washington, D.C.
Metropolitan Museum of Art, New York

Museum of Fine Arts, Boston
Museum of Modern Art, New York
Philadelphia Museum of Art, Pennsylvania
Spertus Museum of Judaica, Chicago
Whitney Museum of American Art, New York

Irving Penn (1917–), photographer.

Considered one of the most versatile photographers of the twentieth century, Irving Penn produced over one hundred covers for *Vogue* magazine, myriad fashion and advertising spreads for various magazines, and many other photographs in genres such as still life and portraiture.

Born in Plainfield, New Jersey, Penn studied at the Philadelphia Museum School of Industrial Art (1934–38; now The University of the Arts), taking classes with Alexey Brodovitch, art director at *Harper's Bazaar* (**Richard Avedon** and **Garry Winogrand** also studied with Brodovitch). While a student, Penn worked for Brodovitch during the summers of 1937 and 1938, making drawings for the magazine. Following graduation, Penn moved to New York City, supporting himself as a freelance designer for various magazines, including *Harper's* and *Vogue,* and then designing advertisements at Saks Fifth Avenue. Penn took his first photographs in 1938, but at that time continued to more seriously explore painting. Indeed, Penn lived and painted in Mexico for a year (1941–42), and at times took some photographs. Unhappy with his paintings, upon returning to New York, Penn destroyed them. Soon thereafter, Penn was hired as an assistant to the legendary Alexander Liberman, art director at *Vogue.* During his first year at *Vogue,* Penn started shooting photographs for the magazine. The first color photograph he ever published appeared on the cover of *Vogue*'s October 1, 1943, issue, also the first still life to adorn the magazine's cover. These early forays into professional photography were curtailed by a stint in the volunteer American Field Service (1944–45), where he served in Italy and India driving an ambulance and taking photographs.

Following the war, Penn shot fashion photographs for *Vogue* and began a three-year project for the magazine making portraits of figures in the arts, including **Peter Blume** (1947), Alfred Hitchcock (1947), and **Jacob Epstein** (1950). Penn utilized two particular devices in some of his early portraiture: placing, or trapping, his sitters in a small corner constructed of two movable stage flats pushed together on a piece of old carpet, or putting a bulky carpet fragment over a large object and having the sitter either sit or lean on it. At times, these gimmicks inspired interesting reactions from his sitters, even loosening them up, thus allowing Penn to capture a relaxed and fresh picture of his famous subjects. Marc Chagall, for example (1947, National Gallery of Art, Washington, D.C.), stretches languidly across the carpet, which lays atop a horizontal object of sorts. In rich nuances of black and white, Chagall's head rests on his right hand, with his left hand on his chest. The simple lighting and

sparseness of Penn's setting eschews the sitter's environment (an approach antithetical to **Arnold Newman**) and highlights the graceful lines of Chagall's body. Penn's portraits (which extend over his career in addition to the initial three-year commission from *Vogue*) rely on a simplicity and stylishness also inherent in his striking fashion pictures. John Szarkowski describes Penn's portraits as "a wordless conversation between the photographer and the sitter" (26). In 1950, Penn married Lisa Fonssagrives, a model who appeared in several of Penn's fashion shots.

Through the 1940s and beyond, Penn was sent on trips to many international venues, such as France, Italy, Spain, and Peru, on fashion assignments and to take pictures for photo essays. Penn's fashion photographs are known for their economy of means and carefully crafted elegance pursued in the spartan studio, a method unlike Avedon's spontaneous fashion pictures taken in theatrical settings. In 1950 Penn initiated his *Worlds in a Small Room* series, which includes diverse images of different groups, ranging from portraits of workers with the tools of their trades (e.g., a balloon seller, a telegraph messenger, and so on), in Paris, London, and New York, to gypsies and indigenous people from New Guinea, Nepal, and Morocco, among other locales. Rather than shoot ethnographic studies, Penn neutralized the environment for all of his subjects, instead taking his pictures on site either in a makeshift studio composed of blank, neutral walls or in a rented studio.

Dissatisfied with magazine work, in the 1960s Penn more deeply explored the technical side of photographic printing while embarking on several new, innovative series of pictures. Utilizing the platinum–palladium process, a mode more popular at the turn of the century with photographers such as **Alfred Stieglitz** and that yields one-of-a-kind prints known for their lustrous tones and exquisite detail, from 1972 to 1980, Penn conceived three particularly imaginative still life series: first of cigarette butts, then street trash, and finally memento mori (objects symbolizing the transience of life). Penn's editioned, platinum–palladium prints present found objects with the precise clarity he strive for in his fashion subjects, but here he explores imperfection and decay rather than glamour and beauty. The sensuous gradations of tones in *Cigarettes No. 86, New York* (1972, National Gallery of Art, Washington, D.C.) appear luminous in this carefully arranged close-up composition of four dirty cigarette butts. Colin Westerbrook observes that the debris pictures connect to Penn's other photographic interests—portraiture, ethnography, nudes, and fashion pictures—because all have a "melancholy air" (15). Penn also revisited images from years before and reprinted them in platinum, thus revealing details and textures that had been previously obscured. In the late 1980s, Penn used the platinum process for a series of collages comprised of platinum test strips. Uniting diverse images from his oeuvre, ranging from fashion photographs to portraits to pictures of his newer interest in street debris, the series is titled *Platinum Test Materials.* This period of experimentation also instigated Penn to return to a group of close-up nude studies made in the late 1940s. Penn overexposed and bleached the prints of his fleshy, headless women and exhibited them in 1980.

Penn enjoyed his first retrospective, comprising 168 photographs, at New York's Museum of Modern Art in 1984. The show traveled to various venues, including Israel and Japan. More recently, Penn's work hung in 2005 at the National Gallery of Art in Washington, D.C. Several monographs featuring Penn's photographs have been published, including the retrospective *Passage: A Work Record*, which includes commentary by the artist.

Bibliography

Foresta, Merry A. and William F. Stapp. *Irving Penn, Master Images: The Collections of the National Museum of American Art and the National Portrait Gallery*. Washington, D.C.: Smithsonian Institution Press, 1990.

Greenough, Sarah. *Irving Penn: Platinum Prints*. Washington: National Gallery of Art; New Haven: Yale University Press, 2005.

Hambourg, Maria Morris. *Earthly Bodies: Irving Penn's Nudes, 1949-50*. New York: Metropolitan Museum of Art; Boston: Little, Brown and Company, 2002

Penn, Irving. *Worlds in a Small Room*. 1974. Reprint, New York: Penguin Books, 1980.

———. *Passage: A Work Record*. Introduction by Alexander Liberman. New York: Alfred A. Knopf, 1991.

———. *Still Life*. Introduction by John Szarkowski. Boston: Little, Brown and Company, 2001.

———. *A Notebook at Random*. New York: Bulfinch Press, 2004.

Szarkowski, John. *Irving Penn*. New York: Museum of Modern Art; Distributed by New York Graphic Society Books, 1984.

Westerbeck, Colin, ed. *Irving Penn: A Career in Photography*. Chicago: Art Institute of Chicago in association with Boston: Bulfinch Press/Little, Brown and Company, 1997.

Selected Public Collections

Art Institute of Chicago
Fogg Art Museum, Harvard University, Cambridge, Massachusetts
Los Angeles County Museum of Art
Milwaukee Art Museum, Wisconsin
Museum of Modern Art, New York
National Gallery of Art, Washington, D.C.
San Francisco Museum of Modern Art
Victoria and Albert Museum, London

R

Archie Rand (1949–), painter, printmaker, and textile designer.

An abstract and figurative painter who has worked in widely divergent styles and on vastly different scales, Archie Rand has also been one of the major progenitors of Jewish subject matter. Rand's work famously inspired the exhibition *Too Jewish?: Challenging Traditional Identities* at New York's Jewish Museum. Hung in 1996, the show was instigated by curator Norman Kleeblatt's visit to Rand's studio in 1989, where he saw the artist's *The Chapter Paintings* (1989), a series of fifty-four canvases addressing the weekly chapters of the Torah in a variety of styles, sometimes with literal iconography and at other times symbolically or abstractly. Reacting with "embarrassment," to use Kleeblatt's words, at the series "excessive 'Jewishness,'" the curator then resolved to explore the upsurge in Jewish subject matter in several artists' work during the 1990s (Kleeblatt, ix). *The Chapter Paintings* showed at the *Too Jewish?* exhibition, but this series of Jewish imagery was hardly Rand's first work to address his religiocultural heritage. Prior to this period, Rand's richly Jewish art includes 13,000 square feet of murals for Congregation B'nai Yosef in Brooklyn (1974–77); twelve stained-glass windows for Anshe Emet Synagogue (1980) depicting the twelve tribes of Israel, and three windows portraying the patriarchs at Temple Sholom (1981), both in Chicago; and the Michlalah Murals (1984), eight paintings based on the seven days of creation for the Jerusalem College for Women. To this day Rand continues to create Jewish imagery, explaining, "I realized that one of the rights and obligations of any culture is to manifest a visual exponent of that culture. Judaism had been forced externally and internally to ignore that impulse. I wanted to make tangible artifacts that were Jewish, simply so unmistakably and unapologetically Jewish work would exist in the fine arts" (Telephone conversation).

Brooklyn-born Archie Rand grew up in a predominantly middle-class neighborhood, where he went to Hebrew school five days a week at the Yeshiva of Bensonhurst. He later studied at the City College of New York (1965–66), the Art Students League (1966–67), and Pratt Institute, where he received his B.F.A. in 1970. He enjoyed his first public exposure at the age of seventeen in a group show at New York's Tibor de Nagy Gallery (1966), where he exhibited nonobjective paintings influenced by Abstract Expressionism. Soon thereafter, Rand executed a cycle of more than fifty oversized canvases known as the *Letter Paintings* (1967–71). Appropriately, the letter paintings

comprise words, specifically the names of jazz and blues musicians, applied graffiti-like in thick paint to canvases delineated as color fields. Stylistically influenced by his teacher, Larry Poons, at the Art Students League, Rand's *Letter Paintings* function, in part, as memorials to a musical past that was quickly disappearing (Rand himself has worked as a professional pianist).

A turning point in Rand's career was a 1974 commission to paint floor to ceiling wall murals for Congregation B'nai Yosef. Extensively researched by the artist and painted over a three-year period, the thematic images appear on the walls in multiple styles, ranging from Cubism to Abstract Expressionism, and covering subjects traditional for synagogues, like the story of Genesis, and also other themes less commonly depicted in a house of worship, such as the Holocaust. Akin to *The Chapter Paintings*, Rand has made other Jewishly motivated series, including *Sixty Paintings from the Bible* (1992) and *The Nineteen Diaspora Paintings* (2002). The loosely painted canvases in *Sixty Paintings from the Bible* each portray a familiar story from the Bible, rendered in colorful tones and with comic book bubbles that add a fresh and sometimes humorous perspective to the story at hand. *Solomon* (1992, private collection, New York) (see figure) illustrates a scene from the life of King Solomon, a figure recognized for his wisdom. The best-known example of Solomon's cleverness is an incident when two women visit his court with a baby whom both claim as their own (I Kings 3:16–28). Solomon threatened to cut the baby

Archie Rand, *Solomon*, 1992. Acrylic on canvas, 18 × 24 inches. Private collection. Photograph courtesy of the artist.

in half so that each mother could have a child. One mother accepted the decision, while the other mother pleaded with Solomon to give the child to the first woman. Solomon then knew that the second woman was the baby's mother. Rand shows this scene in Solomon's palace, rendered in bright colors with figures gesturing dramatically; a thickly outlined soldier raises his knife while holding the infant, as the mothers watch anxiously while Solomon issues the decree from his throne. The black-and-white blurb in the comic-book balloon reads "Cut the kid in half!! And give one half to each mother!" Rand's colloquial interpretation of the scene, both stylistically and his attribution of common vernacular to the biblical Solomon, combines to convey a moment that is filled with drama as well as humor, in part functioning as a rereading designed to make the viewer think twice about a familiar tale.

The full body of Rand's Jewish projects is too great to enumerate, but more recently he has made a series of paintings titled *The Eighteen* (1998), wherein each canvas includes one of the Eighteen Benedictions (*Amidah*), part of the daily Jewish prayer service. He is currently working on an ambitious project: painting an individual work for each of the 613 *mitzvot*, the commandments proscribed in the Torah. Reflecting on his artistic lineage, Rand states: "I'm in correspondence with the painter **R.B. Kitaj** who I believe has verbally and painterly manifested a Jewishly conscious presence in his art. **Larry Rivers** would play with it and retreat. **Hyman Bloom** and **Jack Levine** manifest Jewish content in an important way" (Telephone conversation).

Also a printmaker, Rand contributed imagery to several books, including fifty-four lithographs in collaboration with Robert Creeley's prose, collected in *Drawn & Quartered* (2001). Rand has had over one hundred solo exhibitions. He has been teaching art at Columbia University since 1991, where he was honored with the Presidential Award for outstanding teaching in 2002. In 1999, Rand received a Guggenheim Foundation Fellowship and also won a Jewish Cultural Achievement Award in the Arts from the National Foundation for Jewish Culture. On receiving the award, Rand stated, "I accept this award on behalf of the Jewish artists who have labored and continue to labor in obscurity. My awareness of their work continues to sustain my efforts" ("Ten Years").

Bibliography

Feld, Ross. "On the Hook: The Work of Archie Rand." *Arts Magazine* 52, no. 4 (December 1977): 136–139.

Goodman, Susan. *Jewish Themes/Contemporary American Artists II*. New York: Jewish Museum, 1986.

Kleeblatt, Norman L., ed. *Too Jewish?: Challenging Traditional Identities*. New York: Jewish Museum; New Brunswick, NJ: Rutgers University Press, 1996.

Rand, Archie. *Archie Rand: Paintings*. Cincinnati: Contemporary Arts Center, 1984.

———. "On God." *New Art Examiner* 26, no. 6 (March 6, 1999): 40–45.

———. Telephone conversation with the author. July 7, 2006.

Rosensaft, Jean Bloch, ed. *Archie Rand: The Nineteen Diaspora Paintings*. New York: Hebrew Union College-Jewish Institute of Religion, 2004.

Seidel, Miriam. *Archie Rand: Paintings on Jewish Themes*. Philadelphia: The Borowsky Gallery, 2005.

Soltes, Ori Z. *Fixing The World: Jewish American Painters in the Twentieth Century.* Hanover, NH: Brandeis University Press, 2003.

"Ten Years of Celebrating the Arts in Jewish Life." *Jewish Culture News* (National Foundation for Jewish Culture) (Fall 1999). Clipping provided by the artist.

Selected Public Collections

Art Institute of Chicago
Carnegie Museum of Art, Pittsburgh
Israel Museum, Jerusalem
Metropolitan Museum of Art, New York
Mint Museum of Art, Charlotte, North Carolina
Museum of Modern Art, New York
San Francisco Museum of Modern Art
Victoria and Albert Museum, London

Abraham Rattner (1893–1978), painter, printmaker, draftsman, watercolorist, and textile designer.

With an estimated one-third of his works depicting religious or biblical themes, critics consistently note the important influence of Judaism on Abraham Rattner's expressionist art (Abraham Rattner Papers, roll 5258, frame 170).[27] As John I. H. Bauer observed in a 1959 exhibition catalog: "Art, for Rattner, is never primarily an esthetic activity. It is a means to an end, an expression of what he repeatedly calls 'livingness,' and a search for the divine in man. It is colored by his own deeply religious, if unorthodox, nature, by his immersion in the old testament and a sense of his rich Jewish heritage" (39).

Born in Poughkeepsie, New York to Russian immigrant parents, Rattner encountered anti-Semitism in his youth. Indeed, anti-Semites burned his father's bakery to the ground and Rattner was beat up by bullies because of his religious background. Escaping provincial Poughkeepsie in 1913, Rattner briefly studied architecture at George Washington University. Soon Rattner focused on his art studies at the Corcoran School of Art in Washington, D.C., and later at the Pennsylvania Academy of the Fine Arts in Philadelphia. His schooling was interrupted by service in the Army during World War I as a camouflage artist, but upon his return from war in 1919, Rattner reenrolled at the Pennsylvania Academy and soon won a fellowship to travel in Europe. After his travels, Rattner lived in Paris (1920–39), only returning to the United States because of Germany's invasion of France. While in Paris, Rattner received additional art instruction at the École des Beaux-Arts, Grand Chaumière, and Académie Ranson. He had his first one-man show at the Galerie Bonjean in Paris (1935), from which the French government bought the painting *Card Party* for the Louvre. Later that year Rattner exhibited his brightly colored figurative paintings influenced by Cubism and Futurism in a one-man exhibition at New York's Julien Levy Gallery. Much of Rattner's early

work was abandoned when he hurriedly left France in 1939 and was destroyed before the artist could return after the war.

Distraught by the war, Rattner responded with a series of Crucifixion paintings conceived in what would become known as his signature style. *Descent from the Cross* (1940, Art Institute of Chicago) shows a Cubist-inspired Jesus helped down from a bright red cross by two geometrically delineated figures. The segmented figures, painted with exaggerated limbs and oversized features, are a colorful contrast to the thick black lines separating the juxtaposition of rich hues. Art historian Piri Halasz observed that Rattner's "Christ was a suffering Jew who personified the entirety of modern humanity being tortured and extirpated by the war" ("Abraham Rattner," 26). Contemporaneous with Rattner's Crucifixion images, Samuel Kootz published *New Frontiers of American Painting.* Rattner's Crucifixion canvas *Darkness Fell over the Land* (1942, collection unknown) was chosen as the cover for the text, and within the book Kootz described Rattner as imbued with "a deeply religious ethical inwardness. He suffers a profound pain–not self-torment–at the injustices of the world, an almost Biblical anguish at war and its causes. He is morally implicated in everything he does" (36). Rattner himself described his turn toward personal subjects, and disavowal of abstraction, as a reaction to World War II in an oral interview from 1968:

> It [World War II] affected me personally very much....anti-semitism [*sic*] was sharply underscored. It was something that troubled me very much personally. And it affected me in this way that I grew further away from the aesthetic thing. I had to keep my balance because my emotional response to these feelings that were stirred up in me went back to my anti-semitic [*sic*] experiences here in America. And I never could get over them because it left an awful mark on me....And now Hitler's voice disturbed me. It disturbed me in what I wanted to do. And I knew I could not keep on with abstraction, I could not keep on with the intellectual searching after an aesthetic direction, that I had to do something about this emotional thing in me (13).

Also influenced by the Holocaust are the canvases and drawings in the Six Million series, such as *Six Million No. 2* (1963, Leepa-Rattner Museum of Art, Tarpon Springs, Florida). Perhaps due to the challenging subject matter, several of these images are almost completely abstract and rendered in black and white. In some of the studies for the series, the words "six million" are written repeatedly over the picture's surface. Like the Six Million series, many of Rattner's later canvases are also painted in multiple versions. Biblically themed paintings on subjects such as Ezekiel, Job, and especially Moses appear on multiple occasions. *Job No. 2* (1948) (Color Plate 13) is a characteristically color-infused, jewel-like canvas for which Rattner is best remembered. As the years progressed, though, Rattner employed more aggressive brushwork and stronger abstraction.

Appropriately—as critics sometimes compared Rattner's luminous canvases to stained glass and mosaics—the artist designed mosaic columns and tapestries for Fairmount Temple in Cleveland, Ohio (1957) and an over

three-story stained-glass window, *And God Said Let There be Light,* for the Chicago Loop Synagogue (1958). The latter project, which contains various Jewish symbols filtered through a modern and personal lens, took Rattner back to Paris, where he supervised the creation of the window for over a year.

Victory–Jerusalem the Golden (1967–68, collection unknown), a large canvas made to honor the celebration of Israel's twentieth anniversary of independence, was reproduced for the cover of a program for an Israel benefit, where the painting was also displayed. Rattner's political engagement with the Jewish plight reached a pinnacle with his *The Gallows of Baghdad* paintings, a 1969 series protesting the hanging of nine Jews in Iraq. In a 1949 statement about his art, Rattner explained his belief that "A painting, if it is achieved at all, is made with the help of God....I would recommend to those who desire to be initiated into the Temple to consider that art belongs to the spirit, and partakes of the nature of religion (Leepa, *Challenge,* 195). Opened in 2002, the Leepa-Rattner Museum of Art at St. Petersburg College in Tarpon Springs, Florida contains the largest holdings of Rattner's work in the world.

Bibliography

Abraham Rattner Papers. Archives of American Art, Smithsonian Institution, Washington, D.C.

Getlein, Frank. *Abraham Rattner.* New York: American Federation of Arts, 1960.

Goodrich, Lloyd and John I.H. Baur. *Four American Expressionists: Doris Caesar, Chaim Gross, Karl Knaths, Abraham Rattner.* New York: Whitney Museum of American Art, 1959.

Halasz, Piri. "Directions, Concerns and Critical Perceptions of Paintings Exhibited in New York, 1940-1949: Abraham Rattner and his Contemporaries." Ph.D. dissertation, Columbia University, 1982.

———. "Abraham Rattner: Rebel With a Cause." *Archives of American Art Journal* 32, no. 3 (1992): 23–32.

Henkes, Robert. *The Spiritual Art of Abraham Rattner: In Search of Oneness.* Lanham, MD: University Press of America, 1998.

Kootz, Samuel M. *New Frontiers in American Painting.* New York: Hastings House Publishers, 1943.

Leepa, Allen. *The Challenge of Modern Art.* 1949. Reprint, New York: A.S. Barnes and Company, Inc., 1961.

———. *Abraham Rattner.* New York: Harry N. Abrams, Inc., Publishers, 1974.

Rattner, Abraham. "An American from Paris." *Magazine of Art* 38 (December 1945): 311–315, 327–328.

———. Oral History Interview with Colette Roberts, May 20, 1968 and June 21, 1968. Transcript in the Archives of American Art, Smithsonian Institution, Washington, D.C.

Taylor, Joshua C., Janet A. Flint, and Abraham Rattner. *"And There Was Light": Studies by Abraham Rattner for the Stained Glass Window, Chicago Loop Synagogue.* Washington, D.C.: Smithsonian Institution Press, 1976.

Weller, Allen S. *Abraham Rattner.* Urbana: University of Illinois Press, 1956.

Selected Public Collections

Albright-Knox Art Gallery, Buffalo, New York
Art Institute of Chicago
Hirshhorn Museum and Sculpture Garden, Washington, D.C.
Leepa-Rattner Museum of Art, St. Petersburg College, Tarpon Springs, Florida
Metropolitan Museum of Art, New York
Philadelphia Museum of Art
San Diego Museum of Art
Smithsonian Museum of American Art, Washington, D.C.

Larry Rivers (1924–2002), painter, printmaker, and sculptor.

Although working in an art world dominated by abstraction, the always controversial and irreverent Larry Rivers retained the figure and often explored historical themes and personal subjects in imagery that highlighted his excellent draftsmanship. Rivers was among the first to use popular matter in his paintings, making him a forerunner of the Pop Art movement. Born Yitzroch Loiza Grossberg in the Bronx to Jewish immigrants from Ukraine, Rivers initially made his reputation as a jazz saxophonist. Taking a cue from a nightclub emcee that randomly introduced his jazz band as "Larry Rivers and His Mudcats," Rivers changed his name in 1940. After a brief stint in the U.S. Army Air Corps during World War II (1942–43) he studied music theory and composition at the Juilliard School of Music (1944–45). During this time he discovered the fine arts through a musical motif based on a painting by the French Cubist Georges Braque. Rivers started painting in 1945, and from 1947 to 1948 he studied at the avant-garde Hans Hofmann School in New York. His initial experimentations show the influence of Abstract Expressionism.

In the early 1950s, Rivers began to paint autobiographical themes in works such as *The Burial* (1951, Fort Wayne Museum of Art, Indiana), a gesturally rendered canvas inspired by the memory of his grandmother's funeral, and *Europe I* (1956, Minneapolis Institute of Arts) and *Europe II* (1956, private collection, New York), the latter based on a formal portrait of Polish relatives. *Bar Mitzvah Photograph Painting* (1961, private collection) more specifically addresses Jewish identity issues. Here two minimally rendered children, Rivers' first cousins, are flanked by their mother and father in this family portrait. Based on a studio photograph, Rivers retains the essence of the photograph as a proof: stenciled diagonally across the canvas are letters spelling "rejected." Avram Kampf argues that in this image Rivers parodies the diluted Bar Mitzvah ceremony—a social rather than a spiritual ritual as practiced in America (64).

Indeed, parody is an important a facet of Rivers work. *Washington Crossing the Delaware* (1953, Museum of Modern Art, New York), for example, mocks the grand heroics of nineteenth-century American history painting. Here Rivers appropriates the imagery of Emanuel Leutze's iconic painting of the

same name (1851, Metropolitan Museum of Art, New York) while also exploring paint application and other formal qualities. The Museum of Modern Art in New York acquired Rivers' version in 1951, his first painting to enter a major public collection.

This mode of parody also pervades *History of Matzah (The Story of the Jews)* (1982–84, Yale University Art Gallery, New Haven), an ambitious project that attempts to tell the nearly four-millennia history of the Jews. Painted on commission from Rivers' frequent patron, the art dealer Jeffrey Loria, *History of Matzah* appears in a collage-like form with images and stories overlapping on three 9 × 14-foot canvases in Part I, titled *Before the Diaspora* (see figure), Part II, *European Jewry,* and Part III, *Immigration to America,* all superimposed on a painted rendering of flat, dry matzah, the unleavened bread which resulted from the Jews' haste when fleeing Egypt (Exod. 12:34; 12:39). Originally intended to be a single mural, *History of Matzah* expanded due to the enthusiasm by which Rivers embraced the project, and the impossibility of representing such a long and storied saga on one canvas.

In *History of Matzah,* Rivers manipulates biblical history through the appropriation of canonical art historical imagery, including Rembrandt's *Moses with the Tablets of the Law* (1659, Gemäldegalerie der Staatlichen Museen, Berlin), Leonardo's *Last Supper* (1495–98, Santa Maria delle Grazie, Milan),

Larry Rivers, *History of Matzah (The Story of the Jews), Part I- Before the Diaspora,* 1982. Acrylic on canvas, 116¾ × 166½ inches. Yale University Art Gallery, New Haven, Connecticut. Gift of Jeffrey H. Loria, B.A. 1962, in memory of Harriet Loria Popowitz. Photo courtesy of Jeffrey Loria. Art © Estate of Larry Rivers/Licensed by VAGA, New York, New York.

and Michelangelo's *David* (1501–04, Galleria dell'Accademia, Florence). With each appropriation, Rivers transforms the iconic figure into a "Jew." For instance, "Michelangelo's" *David* appears with a Semitic nose and a circumcised penis. These commentaries, Samantha Baskind argues, are attempts by Rivers to express his Judaism, an identity that he sometimes suppressed. By projecting aspects of his culture upon the mainstream, she observes, *History of Matzah* stands as a recuperative painting in which Larry Rivers/Yitzroch Grossberg affirms his presence as a Jew (91). Rivers himself states, "I began to wonder if making paintings that have a Jewish theme was some way of proving that I'm not ashamed of [Judaism] at all. I'm not" (Hunter, *Larry Rivers,* 11). Other works influenced by Rivers' Jewish identity include a large mural, *Fall in the Forest at Birkenau* (1990), hanging in the United States Holocaust Memorial Museum, three posthumous portraits of the Holocaust memoirist Primo Levi (1987–88, Collection La Stampa, Turin, Italy), and the illustrations for a Limited Editions Club publication of the Yiddish writer Isaac Bashevis Singer's novel *The Magician of Lublin* (1984).

The multitalented Rivers designed sets for the play *Try! Try!* (1951), written by Frank O'Hara, as well as a play by Le Roi Jones (1964) and Stravinsky's *Oedipus Rex* (1966). Rivers also wrote a play, *Kenneth Koch: A Tragedy* (1954), with O'Hara. In 1957 he began making welded metal sculpture. Rivers wrote poetry, acted on stage, including a stint as Lyndon Johnson in Kenneth Koch's *The Election* (1960), and continued to perform in jazz bands throughout his life.

Rivers wrote an autobiography in 1992 that chronicles his personal and sexual exploits in often lurid detail. In this memoir, titled *What Did I Do?,* as well as in other autobiographical statements, Rivers at times comments on his Jewish identity. For instance, Rivers expressed shame at his name change, albeit in a roundabout manner, when in another text he wrote of his family's reaction to his new name: "My family always used to say, 'Well, why do you have to change–are you ashamed of Grossberg?' And I never would admit that. But in all probability it was whatever Jews go through with those things – names and noses. I had 'em all" (Rivers with Brightman, 30).

Bibliography

Baskind, Samantha. "Effacing Difference: Larry Rivers' *History of Matzah (The Story of the Jews)." Athanor* 17 (Summer 1999): 87–95.
Grossman, Emery. *Art and Tradition.* New York: Thomas Yoseloff, 1967.
Harrison, Helen A. *Larry Rivers.* New York: Harper & Row, Publishers, 1984.
Hunter, Sam. *Larry Rivers.* Waltham, MA: Brandeis University Press, 1965.
———. *Larry Rivers.* New York: Rizzoli International Publications, Inc., 1989.
Kampf, Avram. *Chagall to Kitaj: Jewish Experience in 20th Century Art.* New York: Praeger Publishers, 1990.
Kleeblatt, Norman L. *Larry Rivers' History of Matzah (The Story of the Jews).* New York: Jewish Museum, 1984.
Larry Rivers: Art and the Artist. Foreword by David C. Levy. Essays by Barbara Rose and Jacquelyn Days Serwer. Boston: Little, Brown and Company in association with the Corcoran Gallery of Art, 2002.

Rivers, Larry with Carol Brightman. *Drawings and Digressions*. New York: Clarkson N. Potter, Inc., Publishers, 1979.

Rivers, Larry and Arnold Weinstein. *What Did I Do? The Unauthorized Autobiography*. New York: Harper Collins Publishers, 1992.

Singer, Isaac Bashevis. *The Magician of Lublin*. With lithographs by Larry Rivers. New York: The Limited Editions Club, 1984.

Selected Public Collections

Art Institute of Chicago
Hirshhorn Museum and Sculpture Garden, Washington, D.C.
Musée National d'Art Moderne, Centre Georges Pompidou, Paris
Museum of Modern Art, New York
National Gallery of Art, Washington, D.C.
Smithsonian American Art Museum, Washington, D.C.
Tate Gallery, London
Whitney Museum of American Art, New York

Mark Rothko (1903–70), painter.

Best known for his Abstract Expressionist paintings, Mark Rothko's canonical works are large canvases filled with luminous color fields within which he aimed to convey universal truths through nonillusionistic imagery. Born Marcus Rothkowitz in Dvinsk, Russia, he and his family immigrated to the United States in 1913 to escape virulent anti-Semitism, settling in Portland, Oregon. After two years at Yale University on a scholarship (1921–23), Rothko moved to New York and studied intermittently at the Art Students League beginning in January 1924, notably with **Max Weber** from October through December of 1925 and again from March to May of 1926.

Cobbling together jobs to fund his art, the former Yeshiva student drew maps and illustrations for Rabbi Lewis Browne's book *The Graphic Bible* in 1928. Rothko also supported himself by teaching art to children part-time at the Brooklyn Jewish Center, a position he held from 1929 until 1952. He found early success with expressionistic, painterly, representational canvases of conventional subjects such as landscapes, nudes, still lifes, and genre scenes conceived with a limited palette. These works were shown in a group exhibition at the Opportunity Gallery (1928) and a one-person show at the Contemporary Arts Gallery (1933), both in New York. As a member of The Ten—an artist group that he cofounded in 1935 with **Ilya Bolotowsky**, **Adolph Gottlieb**, and **Ben-Zion**, among others, and affiliated with for five years—Rothko sometimes exhibited images that included Christian iconography, such as the crucifixion. He worked as a Works Progress Administration artist from 1936 to 1939.

In the early 1940s, at which time Rothko ceased signing his canvases with his original Jewish sounding surname, he fell under the influence of Surrealism, mythology, archaic art, and ideas about the unconscious espoused by Carl Jung, often making images of biomorphic forms. *Slow Swirl at the Edge of*

the Sea (1944, Museum of Modern Art, New York) contains such calligraphic, organic shapes, and also employs elements that became synonymous with his classic color-field paintings: an increased size and a more transparent use of paint. Moving past Surrealism, by the end of the decade Rothko painted fully abstractly on a grand scale with an oil technique that approximated his watercolor experimentations in the mid-1940s. Typical of Rothko's signature style is *Orange and Yellow* (1956, Albright-Knox Art Gallery, Buffalo, New York), a large canvas composed of two flat, rectangular shapes of thin color. Filling the canvas, the nearly translucent hues seem to float on the surface of the composition. Rothko exploited this formula with differing color variations, size of color-fields, and application of paint to convey an array of sensations, ranging from meditative to ominous. By 1961, Rothko was a celebrated artist who enjoyed a retrospective at the Museum of Modern Art in New York City.

Rothko received three major public commissions, including the artwork for an octagonal chapel in Houston, Texas designed by Philip Johnson. Decorated with fourteen large canvases in nuanced shades of black and maroon, the Rothko Chapel commission was the perfect venue for Rothko's art as he believed that his work was best viewed when shown in a group. The Rothko Chapel was dedicated in February 1971, a year after the artist committed suicide. While Rothko's palette deepened over the years, most scholars believe that to interpret the darkened, somber paintings as reflective of the artist's emotional state is to do the works an injustice. Indeed, Rothko consistently asserted that his art was not a personal expression but a larger comment on humanity. As Rothko explained in a 1957 interview: "I'm interested only in expressing basic human emotions—tragedy, ecstasy, doom, and so on....And if you...are moved only by their color relationships, then you miss the point!" (Rodman, 93–94).

Matthew Baigell asserts that no other artist explored the Holocaust as consistently as Rothko (14). Baigell argues that Rothko did not directly picture events of the Holocaust but instead, like **Barnett Newman**, "suggested parallel sets of references to horror and brutality" by employing Greeks as his "surrogate Israelites" (99, 111). As Rothko himself explained in a 1943 radio broadcast, myths act as "eternal symbols upon which we must fall back to express basic psychological ideas."[28] Baigell thus interprets paintings such as *Omen of the Eagle* (1942, National Gallery of Art, Washington, D.C.) as a metaphor for the then-current occurrences in Germany. Based on Aeschylus' tragic play *Agamemnon* (458 B.C.E.), *Omen of the Eagle*—a canvas arranged in rows of heads, eagles, colonnades, and feet—analogizes and associates the tragedy of a family that destructs from within, suffering from murder and widespread death, with the Nazi genocide (116–118). At the same time, Rothko painted several canvases with Christian religious imagery, which Baigell also interprets as related to Rothko's Jewishness. *Entombment I* (1946, Whitney Museum of American Art, New York) (see figure), painted after the extent of the Holocaust was revealed, shows five vertical shapes perpendicular to one horizontal shape. Atop the figures a few abstract, round forms float on the canvas. Responding to the Jewish belief that if a person is not properly buried then his or her soul will not find peace, Rothko—Baigell suggests—created

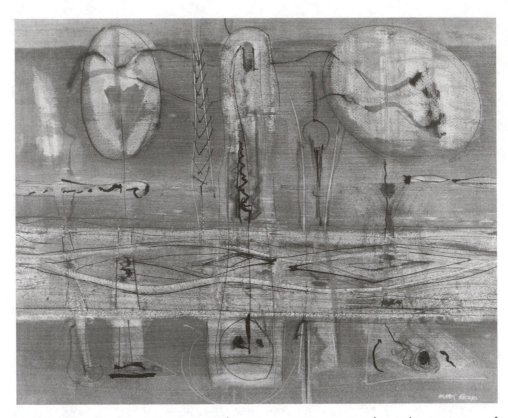

Mark Rothko, *Entombment I,* 1946. Gouache on paper, 20⅜ × 25¾ inches. Whitney Museum of American Art, New York. Purchase 47.10. Photograph © 2001: Whitney Museum of American Art, New York. Art © 2006 Kate Rothko Prizel and Christopher Rothko/Artists Rights Society (ARS), New York.

hovering forms to symbolize the lost souls. Alternately, perhaps Rothko created the painting as a memorial to the six million Holocaust victims (126).

The Mark Rothko Foundation, formed in 1969 to promote Rothko through exhibitions and scholarship and to distribute works in his collection after his death, disbanded in 1986 after donating over 1,000 works to collections around the world. The National Gallery in Washington, D.C. alone received 295 paintings and works on paper and over 650 sketches, an impetus to mount a major retrospective of his work in 1998 that subsequently traveled to the Whitney Museum of American Art and the Musée d'Art Moderne in Paris. Just prior to his death, Rothko was elected to the National Institute of Arts and Letters (1968) and received an honorary Doctorate of Fine Arts degree from Yale University.

Bibliography

Anfam, David. *Mark Rothko, The Works on Canvas: Catalogue Raisonné.* New Haven: Yale University Press; Washington, D.C.: National Gallery of Art, 1998.
Ashton, Dore. *About Rothko.* New York: Da Capo Press, 1996.

Baigell, Matthew. *Jewish Artists in New York: The Holocaust Years.* New Brunswick, NJ: Rutgers University Press, 2002.

Breslin, James E.B. *Mark Rothko.* Chicago: University of Chicago Press, 1993.

Browne, Lewis. *The Graphic Bible.* New York: The Macmillan Company, 1928.

Chave, Anna C. *Mark Rothko: Subjects in Abstraction.* New Haven: Yale University Press, 1989.

Clearwater, Bonnie. *Mark Rothko: Works on Paper.* Introduction by Dore Ashton. New York: Hudson Hills Press, 1984.

Nodelman, Sheldon. *The Rothko Chapel Paintings: Origins, Structure, Meaning.* Austin: University of Texas Press, 1997.

Pappas, Andrea. "Mark Rothko and the Politics of Jewish Identity, 1939-1945." Ph.D. dissertation, University of Southern California, 1997.

Rodman, Selden. *Conversations with Artists.* New York: Capricorn Books, 1961.

Waldman, Diane. *Mark Rothko, 1903–1970: A Retrospective.* New York: Harry N. Abrams, Inc. in collaboration with New York: Solomon R. Guggenheim Foundation, 1978.

———. *Mark Rothko in New York.* New York: Guggenheim Museum, 1994.

Weiss, Jeffrey S. *Mark Rothko.* Washington: National Gallery of Art; New Haven: Yale University Press, 1998.

Selected Public Collections

Hirshhorn Museum and Sculpture Garden, Washington, D.C.
Los Angeles County Museum of Art, California
Museum of Fine Arts, Houston
Museum of Modern Art, New York
Phoenix Art Museum, Arizona
Smithsonian American Art Museum, Washington, D.C.
Tate Gallery, London
Whitney Museum of American Art, New York

S

Miriam Schapiro (1923–), painter, collagist, printmaker, and sculptor.

A pioneer feminist artist and initiator of the Pattern and Decoration movement, Miriam Schapiro's frequently autobiographical work infused with personal symbols (e.g., fan, heart, kimono, etc.) exalts modes of artistic expression typically labeled as feminine. Born in Toronto, Canada to a homemaker mother and artist father, as a child Schapiro relocated with her family to Brooklyn, New York. She studied at the University of Iowa earning three degrees: a B.A. (1945), an M.A. (1946), and an M.F.A. (1949). A few years after finishing school, Schapiro moved to New York with her husband, artist Paul Brach, where she painted along the trends of the day; in the 1950s she made gestural abstractions, and in the 1960s she painted minimal, hard-edged canvases. Throughout these years of experimentation, Schapiro questioned her role as a female artist in an overwhelmingly male profession, sometimes exploring these concerns in her work. Although her canvases conformed to avant-garde styles of the period, Schapiro incorporated some feminist iconography; at this time an egg appears repeatedly in her work, a reference to the fertile and creative woman (Gouma-Peterson, *Miriam Shapiro: Shaping the Fragments,* 52).

After Brach was hired as dean of the California Institute of the Arts in Valencia in 1970 (the couple moved to California in 1967), Schapiro began teaching at the institution. A year later she, the sole female artist on the faculty, and **Judy Chicago** jointly founded the Feminist Art Program. Along with their students, the pair transformed a mansion in downtown Hollywood into a female environment that they called *Womanhouse* (1972). For one month, on view within the house were performances and artworks celebrating and destabilizing ideas about women's lives in the home. In collaboration with Sherry Brody, Schapiro contributed *The Dollhouse* (1972, Smithsonian American Art Museum, Washington, D.C.). Composed of crates that reconstruct the shape of a miniature home, the six furnished rooms within the house are specifically geared for a female artist. The house includes a studio with a nude male model and a small painting on the easel, as well as other highly decorated rooms that anticipate Schapiro's femmages. Indeed, soon after *Womanhouse,* Schapiro started making femmages, a term invented by the artist for her fabric collages combined with paint. Her largest femmage, the fifty-two-foot long, ten-panel *Anatomy of a Kimono* (1976, private collection, Zurich), was begun after Schapiro and Brach moved back to New York in 1975. Integrating typical

female craft objects such as crocheted and embroidered aprons, doilies, table linens, and handkerchiefs into a colorful, heavily patterned whole, Schapiro's femmages endow these domestic handicrafts with the authority of high art. *Provide* (1982, National Academy of Design Museum, New York) is one of several canvas femmages in the typically "female" shape of a heart.

Schapiro has explored issues of high versus low art in prints as well. Made as a collaborative project with nine female artists, the suite of etchings titled *Anonymous Was a Woman* (1977) are impressions of doilies by long forgotten female artists presented as objects worthy of admiration and beautiful in their own right. Schapiro explained the purpose of her femmages and interest in pattern and decoration: "I wanted to validate the traditional activities of women, to connect myself to the unknown women artists who made quilts, who had done the invisible 'women's work' of civilization. I wanted to acknowledge them, to honor them" (Schapiro, 296).

Schapiro's femmage collaborations with largely unknown women were accompanied by concurrent "collaborations" with female painters from the past. Combining reproductions of the work of female artists with ornamented fabrics and paint, Schapiro's "Collaboration Series" creates a gender appropriate artistic lineage in addition to recognizing frequently ignored women artists. An early image from this group, *Collaboration Series: Mary Cassatt and Me* (1976, private collection), presents Cassatt's painting *Mother Reading Le Figaro* (1878, private collection) surrounded by patterned swatches of fabric and a decorative frame. These collaborations continued through the 1980s and 1990s with, among others, Frida Kahlo (a Mexican of Jewish descent) and Russian female painters of the early part of the century such as Natalia Goncharova and Sonia Delaunay (who is also Jewish). Schapiro explained her position: "I want to publish as many women artists as I can, including living women artists. I will collaborate with others to put back into the culture a heritage denied us, and to build our own tradition for the future" (Schapiro, 297). Creating imagery about women was a response to the absence of females and their work in the history of art, and at the same time helped Schapiro transcend personal ambivalence about her mother's gender-induced role in the home.

Recently, Schapiro has directed her autobiographical art toward her Jewish identity. A work on paper in the shape of a house, *My History* (1997, Collection Eleanor and Leonard Flomenhaft, Long Island, New York) (Color Plate 14) is divided into twenty compartments within which Jewish symbols appear. Topped by a menorah, in the compartments Schapiro includes a Star of David, elements that suggest the domestic work of Jewish women like a handcrafted *challah* cover, and other relevant references to Jewish history, such as a photograph of Kahlo and a photograph of the "Tower of Life" at the United States Holocaust Memorial Museum in Washington, D.C. In an important article on Jewish feminist artists, Gail Levin argues that while *My History* is explicitly Jewish, "Schapiro's Jewish identity is already present beneath the surface of several artworks that she produced over her career" (223). Among the works Levin cites are Schapiro's images that include Jewish artists, notably those of Russia ancestry, like Schapiro herself. In another venue, Levin also argues that Schapiro's attraction to feminist activism was instigated by her religiocultural

upbringing; Schapiro inherited the socially conscious values of her politically engaged Jewish father, translating them into her own brand of radicalism (Zalkind, unpaged). Schapiro explains that she is "not religious. It is the cultural aspect of Judaism that interests me. In other words – where I came from and how these people lived before me and now. When I am interested to discuss my identity – being Jewish comes to mind and I make a work that reminds me of what it is to be Jewish" (Written correspondence).

Presented with a lifetime achievement award for an artist from the College Art Association in 2002, Schapiro has also received several honorary doctorates, a grant from the National Endowment for the Arts (1976), and a fellowship from the John Simon Guggenheim Memorial Foundation (1987), among other accolades. In addition to her paintings and works on paper, Schapiro made a sculpture on commission for a building in Rosslyn, Virginia and designed a stained-glass window, titled *Four Matriarchs*, for Temple Sholom [*sic*] in Chicago, Illinois.

Bibliography

Broude, Norma. "Miriam Schapiro and 'Femmage': Reflections on the Conflict Between Decoration and Abstraction in Twentieth-Century Art." In *Feminism and Art History: Questioning the Litany*. Edited by Norma Broude and Mary D. Garrard, 314–329. New York: Harper and Row, Publishers, 1983.

Broude, Norma and Mary D. Garrard. "Conversations with Judy Chicago and Miriam Schapiro." In *The Power of Feminist Art: The American Movement of the 1970s, History and Impact*. Edited by Norma Broude and Mary D. Garrard, 66–85. New York: Harry N. Abrams, Inc., Publishers, 1994.

Demetrakas, Johanna, dir. *Womanhouse*. New York: Women Make Movies, 1999 (43-minute videocassette).

Gouma-Peterson, Thalia, ed. *Miriam Schapiro, A Retrospective: 1953-1980*. Wooster, OH: College of Wooster, 1980.

————. *Miriam Shapiro: Shaping the Fragments of Art and Life*. Foreword by Linda Nochlin. New York: Harry N. Abrams, Publishers, 1999.

Levin, Gail. "Beyond the Pale: Jewish Identity, Radical Politics and Feminist Art in the United States." *Journal of Modern Jewish Studies* 4, no. 2 (July 2005): 205–232.

Meyer, Melissa and Miriam Schapiro. "Waste Not, Want Not: An Inquiry into What Women Saved and Assembled - Femmage." *Heresies: A Feminist Publication on Art and Politics* 1, no. 4 (Winter 1978): 66–69.

Schapiro, Miriam. "Notes from a Conversation on Art, Feminism, and Work." In *Working It Out: 23 Women Writers, Artists, Scientists, and Scholars Talk About Their Lives and Work*. Edited by Sara Ruddick and Pamela Daniels, 283–305. New York: Pantheon Books, 1977.

————. Written correspondence with the author. May 12, 2006.

Zalkind, Simon. *Upstarts and Matriarchs: Jewish Women Artists and the Transformation of American Art*. Essays by Gail Levin and Elissa Authur. Denver, CO: Mizel Center for Arts and Culture, 2005.

Selected Public Collections

Hirshhorn Museum and Sculpture Garden, Washington, D.C.
Jewish Museum, New York

Milwaukee Art Museum, Wisconsin
Museum of Fine Arts, Boston
Museum of Modern Art, New York
Santa Barbara Museum of Art, California
Smithsonian American Art Museum, Washington, D.C.
Whitney Museum of American Art, New York

George Segal (1924–2000), sculptor and painter.

Best known for his stark plaster sculptural figures placed in real environments, George Segal fuses an expressionistic style with the human form to convey psychological and social meaning in his work. Born in the Bronx to Orthodox, immigrant parents from Eastern Europe, Segal studied at multiple venues, including Cooper Union (1941–42), Rutgers University (1942–46; 1961–63), and New York University (1948–49), where **Larry Rivers** was a classmate. Initially Segal painted the human form in a gestural, colorful fashion influenced by Abstract Expressionism. These early canvases were shown at exhibitions in New York, but by 1958 Segal discovered that sculpture was a more effective way for him to suggest his interest in the inner life of the figure. At a February 1959 exhibition at the Hansa Gallery, Segal exhibited three plaster sculptures along with his canvases. For a period of time, Segal continued to paint as he explored the possibilities of his sculpture, but by 1964 sculpture became his primary medium.

Initial experimentations with sculpture were made from burlap, wire, and plaster and executed in a rough, expressive manner akin to his painterly work, but beginning in the summer of 1961 Segal was casting live models from medical bandages saturated with plaster to capture pose and mood. Many of Segal's sculptures, such as *The Diner* (1964–66, Walker Art Center, Minneapolis), display his interest in the psychology of his models and employ a technique wherein he contrasts the white plaster with a single hue in the tableau. Placed in an environment composed of a reconstructed dinette setting, Segal emphasizes the isolation of the two life-size, white figures situated against a red backdrop. As the waitress fills a cup of coffee, the customer quietly sits on his stool at the Formica counter with one hand on his cheek and another toying with his sparse meal. In portraying everyday situations in which humans often fail to interact, Segal composed work that is frequently described as a three-dimensional equivalent to Edward Hopper's mundane scenes of alienated Americans. Akin to *The Diner*, Segal made many sculptures devoted to figures concentrating on mundane tasks communicated by simple yet telling gestures, such as *Woman Shaving Her Leg* (1963, Museum of Contemporary Art, Chicago) and *Alice Listening to Her Poetry and Music* (1970, Staatsgalerie Moderner Kunst, Munich). Segal's demonstrated interest in the emotions of his figures divorces him from the cold impartiality of Pop Art, the predominant style of the period. As critic Henry Geldzahler observed in a 1964 catalog of a Jewish Museum show that included Segal's work "Segal is more humanist than Pop artist. He

is in touch with contemporary culture and presents us with moments from it but with greater involvement and density" (25).

An homage to his father, a kosher butcher in the Bronx during the Great Depression who died six months before the conception of the piece, *The Butcher Shop* (1965, Art Gallery of Ontario, Toronto) (see figure) presents a plaster cast of Segal's mother slaughtering a plaster chicken on a wood-cutting block. Situated in profile behind a recreated glass store window labeled "Baser Kosher" (Meat Kosher) in Hebrew, her impressionist rendering betrays the artist's touch, a technique especially vivid in work completed before 1971 when Segal kept his casts hollow. In contrast, by 1971 Segal began to reproduce negatives of the interior of casts rather than piecing together molds of his models' bodies, thereby creating more lifelike, smoothly rendered, and detailed sculptures. Another development, dating from 1965, was the introduction of bright color to the exterior of some sculptures. In addition to his plaster figures, Segal made several sculptures in homage to modern artists. *Cézanne Still Life No. 1* (1981, collection unknown), for example, reproduces Paul Cézanne's still life, complete with a tilted tabletop and accurate coloring.

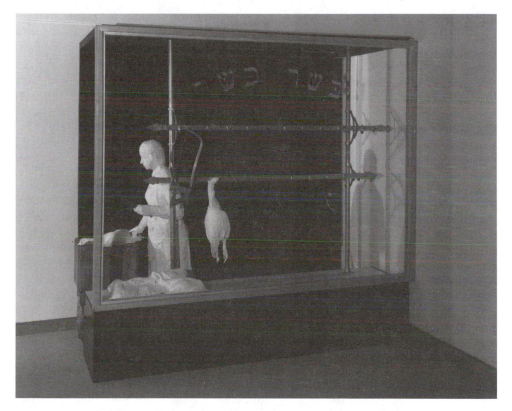

George Segal, *The Butcher Shop,* 1965. Plaster, wood, metal, vinyl, acrylic sheet, 94¾ × 99½ × 50 inches. (Figure height: 62 inch) Art Gallery of Ontario. Toronto. Gift from the Women's Committee Fund, 1966. Art © The George and Helen Segal Foundation/Licensed by VAGA, New York, New York.

Segal executed several public commissions, notably *In Memory of May 4, 1970: Kent State – Abraham and Isaac* (1978), cast in bronze as an allegory in commemoration of the four students killed by National Guardsmen at Kent State University when they were protesting the Vietnam War. After the controversial sculpture picturing Abraham's near execution of his son at God's request was rejected by Kent State, it was subsequently erected at Princeton University in November 1978. Previously, Segal used the story of Abraham and Isaac after a request from the Tel Aviv Foundation for Art and Literature to make a sculpture for Mann Auditorium in Tel Aviv. During his 1973 visit to Israel, Segal cast Abraham as overweight, in contemporary clothes (he wears blue jeans), and generally average in appearance standing over a prone Isaac who lies on a rock that Segal cast from Jerusalem stone. *The Holocaust* (1982), commissioned by the city of San Francisco after an open competition, overlooks the Pacific Ocean from the vantage of Lincoln Park's Palace of the Legion of Honor. Based on photographs of concentration camp victims, including Margaret Bourke-White's famous picture of the liberation of Buchenwald, the memorial shows ten corpses that Segal cast in bronze and then covered in a permanent plaster white patina. The corpses, some clothed and some naked, lie piled on the ground with a lone living figure—modeled from Martin Weyl, Director of the Israel Museum in Jerusalem and a Holocaust survivor himself—standing behind a barbed wire fence. Arranged in a position that can be interpreted as a star or a cross, one of the corpses also references the Bible; a woman, whose head lies on the stomach of a man, holds a partially eaten apple, thus suggesting Eve. The plaster model of the tableau is on display at New York's Jewish Museum. At the installation of the memorial, Segal remarked: "We stack cans in our grocery stores with more order and love than the way the Germans dumped these bodies" (Tuchman, 102).[29]

Several works by Segal address political and social conditions, including *The Bus Riders* (1962, Hirshhorn Museum and Sculpture Garden, Washington, D.C.). A portrait of four bus passengers—three sitting and one standing behind the group—*The Bus Riders* refers to the Freedom Riders and the then-current protests of the civil rights movement. Located in Greenwich Village at Sheridan Park near the scene of the Stonewall Riot, *Gay Liberation* (1980)—a commission from the Mildred Andrews Fund, the same foundation that sponsored the Kent State memorial—shows two women on a park bench, with one figure's hand on her companion's knee, and a male couple standing near the bench. A second version of the sculpture is located on Stanford University's campus. As Sam Hunter observes, "the bench invites the spectator to join the scene, at once adapting the sculpture to its environment and domesticating a potentially threatening subject" (104). For the January 3, 1983, cover of *Time* magazine, Segal designed a sculptural portrait of a family along with two computers (1982, Time Inc., New York) to illustrate the cover story on the "Machine of the Year." In 1997, President Clinton unveiled Segal's three tableaus for the Franklin Delano Roosevelt Memorial, for which **Leonard Baskin** also designed a sculpture. Titled *The Fireside Chat*, *The Rural Couple*, and *The Breadline*, each show scenes of the Great Depression that are imbedded in America's collective memory.

Segal enjoyed a 1978 retrospective exhibition at the Walker Art Center in Minneapolis, which later traveled to San Francisco's Museum of Modern Art and the Whitney Museum of American Art. Among Segal's many accolades, he was bestowed with five honorary Ph.D.s in Fine Arts, from Rutgers University (1970), Kean College (1984), the State University of New York at Purchase (1992), the Massachusetts College of Art (1994), and Ramapo College (1998). He received the National Medal of the Arts in 1999.

Bibliography

Baigell, Matthew. "Segal's Holocaust Memorial." *Art in America* 71, no. 6 (Summer 1983): 134–136.

Blackwood, Michael, dir. *George Segal.* Michael Blackwood Productions. Northvale, NJ: Audio Plus Video, 2000 (58-minute videocassette).

Diamonstein, Barbaralee. "George Segal" [interview]. *Inside New York's Art World.* New York: Rizzoli International Publications, 1979, 354–366.

Dillenberger, Jane. "George Segal's *Abraham and Isaac*: Some Iconographic Reflections." In *Art, Creativity, and the Sacred: An Anthology in Religion and Art.* Edited by Diane Apostolos-Cappadona, 105–124. New York: Crossroad, 1984.

Friedman, Martin and Graham W.J. Beal. *George Segal: Sculptures.* With commentaries by George Segal. Minneapolis: Walker Art Center, 1978.

Grossman, Emery. *Art and Tradition.* New York: Thomas Yoseloff, 1967.

Hunter, Sam and Don Hawthorne. *George Segal.* New York: Rizzoli International Publications, Inc., 1984.

Recent American Sculpture. New York: Jewish Museum, 1964.

Seitz, William C. *Segal.* New York: Harry N. Abrams, Inc., Publishers, 1972.

Tuchman, Phyllis. *George Segal.* New York: Abbeville Press, 1983.

Van der Marck, Jan. *George Segal.* Rev. ed. New York: Harry N. Abrams, 1979.

Young, James E. *The Texture of Memory: Holocaust Memorials and Meaning.* New Haven: Yale University Press, 1993.

Selected Public Collections

Hirshhorn Museum and Sculpture Garden, Washington, D.C.
Miami Art Museum, Florida
Museum of Contemporary Art, Los Angeles
Nasher Sculpture Center, Dallas, Texas
National Gallery of Canada, Ottawa
New Orleans Museum of Art, Louisiana
Smithsonian American Art Museum, Washington, D.C.
Virginia Museum of Fine Arts, Richmond

Richard Serra (1939–), sculptor and draftsman.

An artist who challenges conventions and definitions of sculpture, San Francisco-born Richard Serra retains the original properties of his untraditional materials, which often comprise massive, site-specific structures.

Indeed, truth to materials, both color and texture, as well as large scale and site specificity are the most enduring values in Serra's art. Serra explained the importance of site: "For the most part the site determines how I think about what I am going to build, whether it be an urban or landscape site, a room or other architectural enclosure. Some works are realized from their inception to their completion totally at the site" (Serra, *Richard Serra: Writings, Interviews*, 168).

While working at steel mills to support his education—an important introduction to what would become the artist's favorite material—Serra studied English literature at the University of California at Berkeley and at Santa Barbara (1957–61). At Yale University (1961–64), where he worked with Josef Albers on his well-known book *The Interaction of Color* (1963), Serra earned a B.F.A. and an M.F.A. Following two years in Europe funded by grants, Serra settled in New York in 1966 and began creating work that emphasized temporality and process. *Splashing* (1968), for example, required Serra to throw molten lead into the angle where the floor and wall meet in a room. The hardened, splattered mold recalls paintings by Abstract Expressionist Jackson Pollock, but unlike Pollock's canvases Serra's work is ephemeral. During this time Serra, like **Eva Hesse**, also experimented with various industrial materials, such as rubber and fiberglass, in nonnarrative works designed for interior spaces. Exploring the distinctive qualities of the materials and the consequence of gravity, *Belts* (1966–67, Solomon R. Guggenheim Museum, New York) comprises vulcanized rubber hanging serially from a wall accentuated by neon tubing. Through the late 1960s, Serra also investigated the effects of gravity on heavy, temporally installed, abstract sculpture and on the viewer's confrontation with weighty, unsecured pieces of art arranged vertically. Two hundred tons of identical metal slabs, piled twenty-feet high, loomed perilously over the viewer surveying *Stacked Steel Slabs (Skullcracker Series)* (1969, Fontana, California, destroyed).

A number of sculptures from the early 1980s are huge, minimalist, geometric in form, and at times controversial. His infamous public sculpture *Tilted Arc* (1981) was made on commission from the United States General Services Administration for New York City's Federal Plaza. Many viewed the 12-foot high, 120-foot long curved, tilted slab of Cor-ten steel as threatening in conception, divisive of pedestrian space, and constrictive of the plaza's view. Even after a federal court case during which Serra argued that moving the sculpture would be a violation of his contract and would destroy the site specificity of the piece, the sculpture was removed in 1989.

During the past two decades he has worked on several sculptures related to Holocaust remembrance. Installed next to the Berlin Philharmonic, the abstract, two slab, Cor-ten steel *Berlin Junction* (1987) memorializes those who lost their lives at the hands of the Nazis. *Gravity* (1993), a ten-inch thick, nearly ten-foot square standing, tiered slab of Cor-ten steel, was made on commission for the Hall of Witnesses at the United States Holocaust Memorial Museum (see figure). The title has multiple implications: the gravity of the evils perpetuated by the Nazis, the gravitational forms that keep the large piece erect, and the derivation of the word "grave" from gravity, an

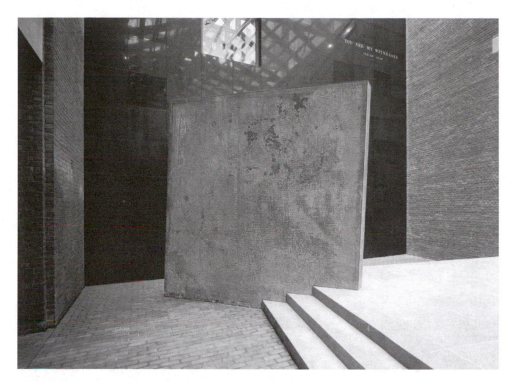

Richard Serra, *Gravity,* 1991. Steel, 12 × 12 × 10 feet. United States Holocaust Memorial Museum, Washington, D.C. Photography by Edward Owen. © 2006 Richard Serra/Artists Rights Society (ARS), New York.

evocation of the mass burials of Holocaust victims. In addition to other works associated with the Holocaust, Serra made two sculptures referring to survivor Primo Levi, one titled after Levi and the other called *The Drowned and the Saved* (1992, Erzbischöfliches Diözesanmuseum, Cologne) after a chapter in *Survival in Auschwitz,* Levi's memoir of his Holocaust experience. The former sculpture was exhibited at the 1995 Whitney Biennial, and the latter originally appeared in the abandoned Synagogue Stommeln in Pulheim, Germany, a locale in which **Sol LeWitt** also designed a Holocaust remembrance. Both of Serra's sculptures are composed of two conjoined steel L-beams that together look like an upside down U or a bridge. Scholar Harriet Senie characterizes the sculpture as "an open barrier held in tense equilibrium. The historical experience of Jewish identity might be similarly described" (210). Critic Hal Foster reads the sculpture as "an icon of spanning and passing, and both kinds of movements are intimated here. There are those who span the bridge, who pass over it, the saved, and those who do not span the bridge, who pass under it, the drowned. These two passages, these two fates, are opposed, but they come together as the two beams come together, in support" (190).

In the early 1970s Serra began making drawings of his sculptures after they had been conceived. He also devised a mode of wall drawing, akin to

LeWitt and **Jonathan Borofsky**, which explored issues of space and employed his favored geometric, minimalist, nearly monochrome approach. First preparing large rolls of Belgian linen with gesso and a coat of black paintstick—which creates a heavy black field of color—Serra then brings the canvas roll into the gallery, cuts the canvas into a shape dictated by the wall, and staples the image to the wall. The objective of the works is to alter the viewer's experience of the room, similar to Serra's sculptural goals. More recently, three of Serra's *Torqued Ellipses*—enormous steel plates twisted into ovals that possess a sense of grace and delicacy despite their heavy material and size—were exhibited at the Dia Center for the Arts in New York (1997–98).

Serra installed an outdoor sculpture at the Israel Museum in Jerusalem in 1987, a year after his first American retrospective at the Museum of Modern Art. Other honors include an Honorary Doctor of Fine Arts degree from the California College of the Arts (1994).

Bibliography

Auping, Michael. *Drawing Rooms: Jonathan Borofsky, Sol LeWitt, Richard Serra.* Fort Worth, TX: Modern Art Museum of Fort Worth, 1994.

Foster, Hal, ed. *Richard Serra.* Cambridge, MA: MIT Press, 2000.

Güse, Ernst-Gerhard, ed. *Richard Serra.* New York: Rizzoli International Publications, Inc., 1988.

Krauss, Rosalind E., Laura Rosenstock, and Douglas Crimp. *Richard Serra: Sculpture.* New York: Museum of Modern Art, 1986.

Pacquement, Alfred. *Richard Serra.* Paris: Centre Georges Pompidou, 1983.

Peyser, Jonathan. "Declaring, Defining, Dividing Space: A Conversation with Richard Serra." *Sculpture* 21, no. 8 (October 2002): 28–35.

Senie, Harriet F. "Perpetual Tension: Considering Richard Serra's Jewish Identity." In *Complex Identities: Jewish Consciousness and Modern Art.* Edited by Matthew Baigell and Milly Heyd, 206–222. New Brunswick, NJ: Rutgers University Press, 2001.

———. *The Tilted Arc Controversy: Dangerous Precedent?* Minneapolis: University of Minnesota Press, 2001.

Serra, Richard. *Richard Serra: Writings, Interviews.* Chicago: University of Chicago Press, 1994.

———. *Richard Serra: Torqued Ellipses.* New York: Dia Center for the Arts, 1997.

Weyergraf, Clara, ed. *Richard Serra: Interviews, Etc., 1970–1980.* Yonkers: Hudson River Museum, 1980.

Selected Public Collections

Fogg Art Museum, Harvard University, Cambridge, Massachusetts
Hirshhorn Museum and Sculpture Garden, Washington, D.C.
Museum of Contemporary Art, Chicago
National Gallery of Art, Washington, D.C.
Nationalgalerie, Berlin
Nelson-Atkins Museum of Art, Kansas City, Missouri
San Francisco Museum of Modern Art
Whitney Museum of American Art, New York

Ben Shahn (1898–1969), printmaker, painter, and photographer.

A diverse artist conversant in several media, Ben Shahn is considered one of the leading Social Realist artists; he remained committed throughout his life to an art commenting on the social and political outrages of his era—from the devastations of the Dust Bowl to World War II to the civil rights movement. At the same time, his Jewish heritage, manifested in a secular form, strongly influenced his work, especially after World War II.

Born in Kovno, Lithuania to Orthodox parents, Shahn remembered his rigorous religious education: "I went to school for nine hours a day, and all nine hours were devoted to learning the true history of things, which was the Bible; to lettering its words, to learning its prayers and its psalms....All the events of the Bible were, relatively, part of the present. Abraham, Isaac, and Jacob were 'our' parents" (Shahn, *Love and Joy*, 5). At eight years old, Shahn immigrated to Brooklyn to join his father, a woodcarver who arrived in America earlier, driven from his European community by anti-Semitism. Interested in art from his years in Lithuania, Shahn apprenticed with a lithographer (1913–17) in his teens. Assisting the senior lithographers, Shahn designed the lettering that accompanied the more experienced artists' drawings, thus began his love of line and of letters. This formative experience instigated several later projects related to lettering and calligraphy, including Shahn's books *The Alphabet of Creation* (1954)—a visual and verbal retelling of an ancient legend delineating the origin of Hebrew letters and their relationship to the divine—and *Love and Joy about Letters* (1963), which includes verbal reminiscences about his fascination with letters of all kinds. Shahn also studied at the Educational Alliance, the Art Students League, and the National Academy of Design (1919–22). The late 1920s were partially spent abroad, funded by income from his lithographs. Returning to the United States in 1929, Shahn had his first one-person show at the Downtown Gallery the following year. Gouaches from this period illustrating the Haggadah (1931) were subsequently sold to the Jewish Theological Seminary and then used to illustrate what would become one of the most popular haggadot (ritual books for the Passover Seder) in America. The haggadah was originally printed in 1965 with the initial twelve illustrations from the 1930s, plus ten new drawings, a title page, and a frontispiece. Shahn also executed the book's Hebrew calligraphy.

Shahn is well known for a series of twenty-three gouaches and two larger tempera panels (1931–32, Museum of Modern Art, New York, and Whitney Museum of American Art, New York), later revisited in 1958 in three serigraphs that portray the events and figures from the infamous trial of Nicola Sacco, a shoemaker, and Bartolomeo Vanzetti, a fish peddler. These two Italian immigrants were put to death in 1927 for an alleged robbery and murder, although the pair are more popularly believed to have been innocent and instead sacrificed for their anarchist activities. Suggesting Shahn's mature style, the pared down, flatly colored images comprising the *Passion of Sacco and Vanzetti* are populated with partly distorted figures that retell the ethnically biased case and comment on the injustices of the American legal system.

An active participant in the federal art programs during the Great Depression, Shahn was a photographer for the Farm Security Administration (1935–38)—he used some pictures of rural America as source material for his paintings—as well as muralist under the auspices of the government (Shahn gained experience as a muralist assisting Diego Rivera on the infamous Rockefeller Center mural). Arranged in a collage-like fashion, Shahn's first mural, *Mural of Jewish Emigres* (1937–38, Roosevelt, New Jersey) for a recently established New Jersey housing project primarily for Jewish garment workers, depicts issues relating to the Jewish American experience, including Eastern European immigration, labor conditions, and the ultimate reform of labor with the establishment of unions. The left section of the crowded mural presents immigrants walking off a ship's gangplank, led by Albert Einstein, and also immigrants working in sweatshops as well as an anti-Semitic slogan, in German: "Germans, beware; don't buy from Jews." Impressed with the community spirit in Roosevelt (then called Jersey Homesteads), in 1939 Shahn moved there, remaining until his death. Additional New Deal murals include a series of thirteen panels for the Bronx Central Post Office (1938–39), titled *Resources of America*, and two others.

During World War II, Shahn designed posters for the Office of War Information (OWI) (1942–44), although only two were ultimately produced. Without accosting the viewer with blood or gore, *This is Nazi Brutality* (1942, New Jersey State Museum, Trenton) (Color Plate 15) combines word and image to comment on Nazi atrocities. Across an oversized, hooded, handcuffed figure's chest runs a recreated ticker tape reiterating the June 11, 1942, Nazi announcement of "success" after the destruction of the village of Lidice: "Radio Berlin. – It is officially announced: – All men of Lidice – Czechoslovakia – have been shot: The Women deported to a concentration camp: The children sent to appropriate centers – The name of the village was immediately abolished." Disturbed by photographs he encountered at the OWI chronicling the suffering perpetrated by the Nazis, Shahn also made paintings influenced by the war. *Boy* (1944, University of Michigan Museum of Art) shows a fully frontal child against a stark, indistinct landscape accompanied by his widowed mother. Although derived from an OWI photograph of the Warsaw Ghetto, scholar Ziva Amishai-Maisels understands the generalized *Boy*, and other images that avoid direct reference to the Holocaust, as Shahn's attempt to explore his Jewish identity while creating an art that remained universal to the general public. In 1944, Shahn joined the Congress of Industrial Organizations' Political Action Committee, where he made more posters and material for Roosevelt's presidential run. His political activism and alleged communist sympathies—which Shahn denied—led to his blacklisting during the McCarthy years.

After the war, Shahn frequently explored Judaism in his art, often incorporating Hebrew lettering in his work and also creating several symbolic, allegorical canvases. Akin to her understanding of Shahn's "Holocaust" imagery as covert, Amishai-Maisels similarly connects some of the artist's more personal later works with Hebrew lettering and text as also expressing hidden, deeper levels of Jewish identity. Shahn identified with Hebrew to such

a degree that he had the final illustration of Hebrew letters in *The Alphabet of Creation* made into a seal (1957) that he sometimes used as a signature.

Shahn participated in a variety of Jewish-related art projects, in addition to those mentioned above. Among them are drawings for a production of the play *The World of Sholom Aleichem* (1953); mosaic murals for synagogues such as Congregation Oheb Shalom in Nashville, Tennessee (1959) and Congregation Mishkan Israel in New Haven, Connecticut (1960); and the design for a stained-glass window representing the 150th psalm for Temple Beth Zion in Buffalo, New York (1965). Well regarded in his lifetime, in 1947 Shahn enjoyed a retrospective at the Museum of Modern Art and a posthumous retrospective at the Jewish Museum (1976). He was one of two artists representing the United States at the Venice Biennale in 1954, and two years later delivered the distinguished Charles Eliot Norton lectures at Harvard University, which were later published as *The Shape of Content*. In celebration of the centennial of his birth, in 1998 the Jewish Museum mounted an exhibition of Shahn's paintings and works on paper.

Bibliography

Amishai-Maisels, Ziva. "Ben Shahn and the Problem of Jewish Identity." *Jewish Art* 12–13 (1986–87): 304–319.

Baigell, Mathew. "Ben Shahn's Postwar Jewish Paintings." In *Artist and Identity in Twentieth-Century America*, 213–231. Cambridge: Cambridge University Press, 2001.

Chevlowe, Susan, et al. *Common Man, Mythic Vision: The Paintings of Ben Shahn.* New York: Jewish Museum under the auspices of The Jewish Theological Seminary of America; Princeton, NJ: Princeton University Press, 1998.

Greenfeld, Howard. *Ben Shahn: An Artist's Life.* New York: Random House, 1998.

Kao, Deborah Martin, Laura Katzman, Jenna Webster. *Ben Shahn's New York: The Photography of Modern Times.* Cambridge: Fogg Art Museum, Harvard University Art Museums; New Haven: Yale University Press, 2000.

Platt, Susan Noyes. "The Jersey Homesteads Mural: Ben Shahn, Bernarda Bryson, and History Painting in the 1930s." In *Redefining American History Painting.* Edited by Patricia M. Burnham and Lucretia Hoover Giese, 294–309. Cambridge: Cambridge University Press, 1995.

Pohl, Frances K. *Ben Shahn: New Deal Artist in a Cold War Climate, 1947-1954.* Austin: University of Texas Press, 1989.

―――. *Ben Shahn.* San Francisco: Pomegranate Artbooks, Inc., 1993.

Prescott, Kenneth W. *The Complete Graphic Works of Ben Shahn.* New York: Quadrangle Press/The New York Times Book Company, 1973.

Shahn, Ben. *The Shape of Content.* Cambridge: Harvard University Press, 1957.

―――. *Love and Joy About Letters.* New York: Grossman Publishers, 1963.

Selected Public Collections

Art Institute of Chicago
Dallas Museum of Art
Jewish Museum, New York
Museum of Modern Art, New York
National Gallery of Art, Washington, D.C.

San Francisco Museum of Modern Art
Smithsonian American Art Museum, Washington, D.C.
Whitney Museum of American Art, New York

Mitchell Siporin (1910–76), painter and draftsman.

Although he worked in several styles and enjoyed a long career, Mitchell Siporin is primarily known for his commitment to social justice issues and his large Works Progress Administration-sponsored murals. His art, however, encompasses a wider variety of subjects and stylistic experimentations, including a foray into abstraction. In 1947, Siporin described his artistic philosophy: "The credo of the artist as man must be identical with the artist's creative purpose. Mine is to grasp, recreate and communicate to my contemporaries the fundamentally (to me) social and emotional meaning of my life" (Lozowick, 166).

Born in New York City to immigrant, Yiddish-speaking parents, Siporin moved to Chicago with his family when he was a year old. His father, a union organizer, greatly influenced Siporin's proclivity for socially involved art. Indeed, after studying at the School of the Art Institute of Chicago and then at Crane College in Chicago in the late 1920s and early 1930s, Siporin made freelance illustrations for *Esquire, Ringmaster,* and *New Masses,* a leftwing periodical. The pen-and-ink *Veteran's Hospital* (1936, Boston Public Library), for *Esquire,* is an expressionistic rendering of several casualties of war; the patients are shown hobbled—in a wheelchair, laying in a hospital bed, and even an amputee on crutches. At the age of twenty-four, Siporin made a series of twenty-five pen-and-ink drawings chronicling the Chicago Haymarket riot of 1886 (1934–35). Akin to **Ben Shahn**'s *Sacco and Vanzetti* series, Siporin's Haymarket series depicts the tragedy in detail, from the innocuous demonstration in Haymarket Square to the unwarranted execution of several of those involved in the incident. Employing exaggeration and purposefully awkward proportions in a crisply delineated style, the compassionate and incisive Haymarket series exhibits some of the hallmarks that would pervade Siporin's later art. Siporin's accomplishments were recognized as early as 1936 when his work was represented in the group exhibition "New Horizons in American Art" at the Museum of Modern Art in New York City.

Having painted a group of four frescoes on "The Teaching of the Arts" for the Albert Lane Technical High School Auditorium in Chicago (1939) and on "The Fusion of Agriculture and Industry" for a post office in Decatur, Illinois (1938), Siporin received a prestigious federal commission to execute fresco murals representing the history of St. Louis for the city's post office building. Painted over a two-year period (1940–42) in collaboration with Edward Millman, this commission—covering 2,913 square feet of wall space—was the largest sponsored by the government's Federal Art Project. Heavily influenced by the Mexican muralists, Mitchell's solid figures, in subdued colors, discover the unbridled land, build railroads, and engage in other activities that

will contribute to the growth of the city. The same year that Siporin began the St. Louis frescoes, he enjoyed his first solo exhibition at the Downtown Gallery in New York City.

During World War II, Siporin served in the Army Art Corps in North Africa and the United States Fifth Army in Italy (1942–45), making drawings and gouaches of military life. While in Europe he saw Mussolini's dead body displayed and the liberation of a concentration camp. Returning from the war, Siporin won a John Solomon Guggenheim Memorial Foundation Fellowship for painting in 1945, which was renewed in 1946, with which he took time to explore his war experiences. As Judith O'Toole observes, Siporin's postwar canvas *Endless Voyage* (1946, University of Iowa Museum of Art, Iowa City) (see figure) addresses a subject that preoccupied Siporin for several years: homelessness and displacement (unpaged). While paintings like *Refugees* (1939, Museum of Modern Art, New York) show a group of figures hopelessly waiting for a train in a nearly barren and desolate landscape and may have been influenced by Siporin's position as a Jew in the Diaspora, *Endless Voyage* deliberately addresses Jewish identity. This expressionist canvas depicts dozens of Jews

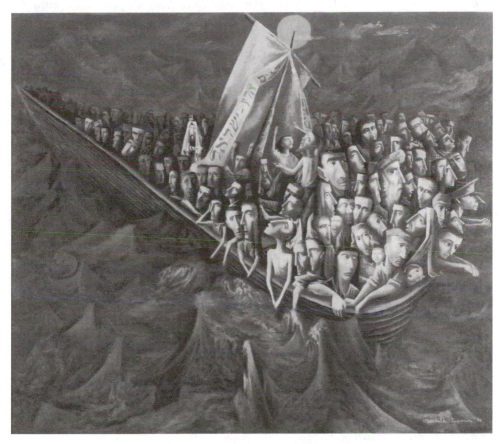

Mitchell Siporin, *Endless Voyage,* 1946. Oil on canvas, 34½ × 39⅜ inches. University of Iowa Museum of Art, Iowa City, Iowa. Museum purchase (1947.44).

sailing in a crowded boat on an agitated sea. Several of the small figures bear numbered tattoos on their forearms, indicating their status as former concentration camp inmates. Many of the emaciated figures in this darkly hued canvas stare into the distance with empty eyes while a few express some hope; a couple dances in the middle of the ship, possibly anticipating the conclusion of the journey. A figure in the left background wears a *tallit* over his head and phylacteries, perhaps praying that the endless voyage will soon end. As indicated by the Hebrew words on the boat's banner, Eretz Israel (Land of Israel), the group's destination will certainly be glorious.

After a year in Italy funded by a Prix de Rome Fellowship (1949), Siporin embarked on a long and distinguished teaching career, first at Colombia University (1950–51) and then at Brandeis University (1951–76), where he founded the Department of Fine Arts. He worked on several series over these years, some in watercolor, including "Imaginary Interviews" (1956–58), "Monet in His Garden" (1959–60), and "Rembrandt and His Models" (1961–62). Images from "Imaginary Interviews" unite diverse figures, for example, the Social Realist **Jack Levine** encounters Al Capone in *Gangster's Funeral* (Levine was famous for his paintings of gangsters, including a canvas of his own titled *Gangster's Funeral*). Also from this series, *The Denial* pictures Franz Kafka, his fiancée Dora Dymant, and the rabbi who refused to marry them. The witty approach evident in these images pervades much of the artist's later production, some of which is more overtly satiric. In 1976, Siporin's work showed at a retrospective exhibition mounted by the Rose Art Museum at Brandeis University. Several years earlier, Siporin served as the first curator of the Brandeis University art collection.

Bibliography

Becker, Heather. *Art for the People: The Rediscovery and Preservation of Progressive- and WPA-Era Murals in the Chicago Public Schools, 1904-1943.* San Francisco: Chronicle Books, 2002.

Belz, Carl. *Mitchell Siporin: A Retrospective.* Waltham, MA: Rose Art Museum, 1976.

Kampf, Avram. *Chagall to Kitaj: Jewish Experience in 20th Century Art.* New York: Praeger Publishers, 1990.

Kennedy, Elizabeth, ed. *Chicago Modern 1893-1945: Pursuit of the New.* Chicago: University of Chicago Press, 2004.

Lozowick, Louis. *One Hundred Contemporary American Jewish Painters and Sculptors.* New York: YKUF Art Section, 1947.

Miller, Dorothy C., ed. *Americans 1942: 18 Artists from 9 States.* With statements by the artists. New York: Museum of Modern Art, 1942.

O'Connor, Francis, V. *Art for the Millions.* Boston: New York Graphic Society Ltd., 1975.

O'Toole, Judith Hansen. *Mitchell Siporin: The Early Years, 1930-1950.* New York: Babcock Galleries, 1990.

Selected Public Collections

Addison Gallery of American Art, Phillips Academy, Andover, Massachusetts
Art Institute of Chicago

Butler Institute of American Art, Youngstown, Ohio
Museum of Modern Art, New York
Portland Art Museum, Oregon
Rose Art Museum, Brandeis University, Waltham, Massachusetts
Smithsonian American Art Museum, Washington, D.C.
Whitney Museum of American Art, New York

Aaron Siskind (1903–91), photographer.

Exploring abstraction through the medium of photography, Aaron Siskind's art came of age during the ascent of Abstract Expressionist painters, with whom he was ideologically aligned. Siskind's sharply focused signature photographs remove recognizable objects from their original context, emphasizing form and shape over documentation and social reality. In a credo from 1950 written for a symposium at the Museum of Modern Art titled "What is Modern Photography?," Siskind explained his working philosophy: "When I make a photograph I want it to be an altogether new object, complete and self-contained, whose basic condition is order (unlike the world of events and actions whose permanent condition is change and disorder)....The object serves only a personal need and the requirements of the picture....It is often unrecognizable; for it has been removed from its usual context, disassociated from its customary neighbors and forced into new relationships" (*Aaron Siskind 100,* unpaged). Siskind's influence as a teacher rivals his reputation as one of the most significant photographers of his era.

 Born on the Lower East Side of New York City to Russian immigrant parents, Siskind received an English degree from the City College of New York (1926) and taught English at the elementary level in New York's public schools for the next twenty-three years. While at City College, Siskind participated in a literary club with **Adolph Gottlieb** and **Barnett Newman**, two figures who years later would become pivotal Abstract Expressionists. Writing poetry and teaching, Siskind did not seriously explore photography until he received a camera as a wedding gift in 1929. On his honeymoon, Siskind shot many pictures and soon became enamored with his newfound hobby. In 1933, he joined the Film and Photo League, a Communist-influenced club of amateur and professional photographers committed to making pictures with a social purpose. Although he learned much from his colleagues at the league about picturemaking, print developing, and other technical aspects of his newfound interest, Siskind soon became disillusioned with the League's strict doctrine, and in 1935 he began to work on his own. The following year, Siskind returned to the club, now the New York Photo League, to head the Features Group. Guided by Siskind, several photo-essays were taken and exhibited at the League, pictures akin to those appearing in *Life* magazine and sponsored by the government's Farm Security Administration. The best-known series produced by the Feature Group, *Harlem Document* (c. 1937–40), records the hardships and joys of life in black Harlem.

His *Tabernacle City* series (c. 1935–40), which looked at a group of summer cottages in a Methodist community located in Martha's Vineyard, begins to exhibit aspects of Siskind's mature approach to photography. Instead of recording people, Siskind focused his attention on the structure of architecture as well as the formal interplay of light and shade, often exploring the details of the homes, such as a corner of a window frame as in *Tabernacle City 1* (c. 1935–38). Unlike his carefully planned social justice photographs, by 1943 Siskind resolved, as he put it in an important essay titled "The Drama of Objects" (1945), "to become as passive as possible" when approaching subjects and "to permit the subject to speak for itself in its own way" (Chiarenza, *Aaron Siskind*, 65).[30] Summering in Gloucester, Massachusetts near Gottlieb, Siskind worked according to this philosophy, creating abstractions of identifiable objects by taking close-up pictures that emphasized texture and form. *Gloucester IH* (1944) (see figure), for example, depicts a dirty, heavily worn glove against a grainy, dark background. From this period on, his photographs investigated other objects that yielded expressive patterns and detail, such as chipped paint and graffiti, and organic elements such as rocks. In these photographs, Siskind aimed to explore the expressive possibilities of shapes on a flat picture plane in rich tonalities from an abstract and symbolic perspective. In 1947, Siskind enjoyed his first one-person show at the Charles Egan Gallery in New York, the same venue that several Abstract Expressionists exhibited their work.

Aaron Siskind, *Gloucester IH*, 1944. Photograph, 12 × 9½ inches. Center for Creative Photography, The University of Arizona, Tucson. © Aaron Siskind Foundation.

From 1972 to 1975, Siskind shot seventy-five pictures in homage to his good friend, Abstract Expressionist Franz Kline. Akin to Kline's white canvases laden with vigorous, gestural strokes of black paint, Siskind's photographic compositions—made in several different venues, including Rome and Mexico—capture dark paint scratched onto walls, shot in close range or cropped by the artist. These powerful pictures, and others by Siskind, are eloquently described by the artist's biographer Carl Chiarenza: "the visual coherence of his pictures is the result of the oneness of form and content, the positioning of all elements into a meaningful whole that can be felt visually to be complete, whether or not it can be translated or articulated" (*Aaron Siskind*, 66).

The opportunity to teach photography compelled Siskind to leave his native New York and move to Chicago. First teaching at Chicago's Institute of Design, where he remained for almost twenty years (1951–71), Siskind was then enticed to the Rhode Island School of Design (1971–76). In 1965, the George Eastman House in Rochester, New York honored Siskind with a retrospective exhibition of 200 photographs. The following year Siskind won a Guggenheim Fellowship, which funded a series of pictures taken in Rome. Endowed by the artist in 1984, the Aaron Siskind Foundation provides fellowships for photographers and promotes contemporary photography. In honor of the 100th anniversary of his birth, from 2001 to 2004 a traveling exhibition of his photographs showed at twelve venues, from the Whitney Museum of American Art to the Hanmi Museum of Photography in Seoul, Korea. For more information on Siskind, visit the webpage of his foundation, www.aaronsiskind.org.

Bibliography

Chiarenza, Carl. "Aaron Siskind's Photographs in Homage to Franz Kline." *Afterimage* 3 (December 1975): 8–13.

———. *Aaron Siskind: Pleasures and Terrors.* Boston: Little, Brown and Company in association with the Center for Creative Photography, 1982.

Entin, Joseph. "Modernist Documentary: Aaron Siskind's Harlem Document." *Yale Journal of Criticism* 12, no. 2 (Fall 1999): 357–382.

Hill, Ronald J. "Aaron Siskind: ideas in Photography." *Record of the Art Museum, Princeton University* 34, no. 1–2 (1980): 4–27.

Howells, Richard. "Order and Fantasy: An Interview with Aaron Siskind." *Word & Image* 15, no. 3 (July–September 1999): 277–285.

Lyons, Nathan, ed. *Aaron Siskind, Photographer.* With a statement by Aaron Siskind. Rochester: George Eastman House, 1965.

Rhem, James Louis. *Aaron Siskind.* London: Phaidon Press Limited, 2003.

Siskind, Aaron. *Places: Aaron Siskind Photographs.* Introduction by Thomas B. Hess. New York: Farrar, Straus and Giroux, 1976.

———. *Aaron Siskind: Photographs, 1932–1978.* Oxford: Museum of Modern Art, 1979.

———. Interview with Barbaralee Diamonstein. In *Visions and Images: American Photographers on Photography.* New York: Rizzoli International Publications, Inc., 1981, 159–166.

———. *Aaron Siskind 100.* New York: PowerHouse Books, 2003.

Selected Public Collections

Dallas Museum of Art
Denver Art Museum
Museum of Contemporary Art, Los Angeles
Nelson-Atkins Museum of Art, Kansas City, Missouri
Neuberger Museum of Art, Purchase, New York
Orlando Museum of Art, Florida
San Francisco Museum of Modern Art
Smithsonian Museum of American Art, Washington, D.C.

Moses Soyer (1899–1974), painter and printmaker.

An artist who kept the human figure at the core of his art, Moses Soyer lived by the motto "my message is people" (Werner, 10). Before Soyer, his twin brother **Raphael Soyer**, and younger brother Isaac Soyer became well-known artists associated with the Social Realist style of painting, the brothers and their family were forced out of tsarist Russia in 1912. After immigrating to the United States and settling in the Bronx, Soyer took free art classes at the Cooper Union and the National Academy of Design (1914–18). Soyer also sketched at the Ferrer Art Club in Spanish Harlem, where he met the Ashcan artist Robert Henri whose uncompromising representations of daily life greatly influenced him. As Soyer recalled: "Henri taught me many things, but most important of all [he] taught me that the theme of man is the noblest theme of art, man in his universe, man in his landscape, man at work" (Willard, 38). Soyer's most seminal art training took place at the Educational Alliance, at which time he formed friendships with **Peter Blume, Chaim Gross**, and **Philip Evergood**. Fellow classmate Blume remembered that Soyer "was the foremost and most advanced of the students around....[his] influence was so strong that my pictures looked like Soyers and anybody that stayed there for any length of time just couldn't help but be influenced by [him]" (Brown, 3). In an introduction to a monograph on Soyer, Evergood described his friend's canvas *Old Man in Skull Cap* (1922, Jewish Museum, New York) (see figure), a sensitive half-length portrait of an observant Jew, as "rightly hailed as one of the outstanding contributions made by a student to the development of the school" (Willard, 13). In 1923, Soyer began teaching at the Educational Alliance, where he worked intermittently throughout his life.

Soyer spent two years in Europe studying at the Académie de la Grande Chaumière and visiting museums with the aid of a travel scholarship from the Educational Alliance (1926–28). Following his initial one-person exhibition at J.B. Neumann's Art Circle Gallery in New York City (1928), Soyer showed his work regularly, including the first exhibition of the World Alliance for Yiddish Culture (1938).

Under the auspices of the Works Progress Administration, Soyer painted ten portable murals addressing the life of the child, which were installed at children's hospitals and libraries throughout New York, and jointly designed a

Moses Soyer, *Old Man in Skull Cap,* 1922. Oil on canvas, 29¾ × 21½ inches. The Jewish Museum, New York. Gift of Henry Margoshes. Photo: The Jewish Museum/Art Resource, NY. Art © Estate of Moses Soyer/Licensed by VAGA, New York, New York.

mural for the Kingsessing Station post office in Philadelphia with Raphael; Moses' depicted a panorama of Philadelphia and his brother painted the bridge that connects Camden and Philadelphia. During the Great Depression, Soyer also painted images of the unemployed and homeless in a representational fashion. Loosely rendered in subdued hues, *Unemployment Agency* (1935, collection unknown) compassionately portrays a dejected man walking through the door of a room wherein two bored figures sit in uncomfortable wooden chairs. More joyous in color and subject is Soyer's canvas *Artists on the WPA* (1935, Smithsonian American Art Museum, Washington, D.C.), an image of several artists painting and sketching in a studio. Grateful for government patronage, Soyer recalled that during the Depression galleries "were at a standstill. The misery of the artist was acute. There was nothing he could turn to. Things began to look much brighter after the progressive victory at the polls. In 1933, the new administration came to the rescue of the artists with the Public Works of Art Project which was administered by the Treasury Department" ("Three Brothers," 207).

Inspired by his dancer-wife and the work of Edgar Degas, one of his favorite artists, beginning in the 1940s Soyer made canvases of lithe dancers stretching, rehearsing, and resting. Throughout his life Soyer remained a figurative painter, frequently imaging studio nudes naturalistically and at quiet moments (among the many women who modeled for him is **Eleanor Antin**). Indeed, Soyer's models are often shown as introspective, sober, and even troubled. Those who sat for portraits with Soyer, notably many of the artist's friends such as David Burliuk, Joseph Stella, and **Abraham Walkowitz**, were never unnecessarily flattered. His self-portrait with Raphael and Isaac, *Three Brothers* (1963–64, Brooklyn Museum, New York), shows the siblings isolated in their own spaces and lost in reverie. Isaac and Raphael quietly sit in chairs with their hands placed in their laps, and Moses stands between the pair in a sparsely decorated room. Painted in muted hues with a predominant palette of blues and grays, Soyer laid down heavy pigment on the canvas, which he scraped and reapplied in an expressionistic manner. Soyer accurately observed: "Most of my paintings reflect an interest in the casual moments in the life of plain people, the gestures and natural attitudes they fall into when they perform habitual tasks, when they are in thought, and when they are not observed by other people" (Soyer, *Moses Soyer,* unpaged).

Illustrated with his own drawings and paintings and written engagingly in the first person, in 1964 Soyer published an instructional text for the general reader on painting the human figure. The Whitney Museum of American Art held a posthumous retrospective for Soyer in 1985.

Bibliography

Brown, Robert F. "Interview with Peter Blume." *Archives of American Art Journal* 32, no. 3 (1992): 2–13.
Grossman, Emery. *Art and Tradition.* New York: Thomas Yoseloff, 1967.
Soyer, Moses. "Three Brothers." *Magazine of Art* 32, no. 4 (April 1939): 201–207, 254.
———. *Painting the Human Figure.* Edited by Robert W. Gill. New York: Watson-Guptill Publications, Inc., 1964.
———. *Moses Soyer: A Human Approach.* New York: ACA Galleries, 1972.
Werner, Alfred. *Moses Soyer.* South Brunswick, NJ: A.S. Barnes and Company, 1970.
Willard, Charlotte. *Moses Soyer.* Foreword by Philip Evergood. Cleveland: The World Publishing Company, 1962.

Selected Public Collections

Hirshhorn Museum and Sculpture Garden, Washington, D.C.
Jewish Museum, New York
Los Angeles County Museum of Art
Metropolitan Museum of Art, New York
Nelson-Atkins Museum of Art, Kansas City, Missouri
Smithsonian American Art Museum, Washington, D.C.
Springfield Museum of Art, Ohio
Whitney Museum of American Art, New York

Raphael Soyer (1899–1987), painter and printmaker.

An artist who depicted American life, especially New York City, Raphael Soyer has at times been considered the quintessential painter of the Jewish American experience. Active throughout a great part of the twentieth century, Soyer remained a representational artist in an abstract art scene. He proudly declared his desire to paint "man and his world" on many occasions, including in *Reality: A Journal of Artists' Opinions,* a short-lived periodical Soyer founded to disseminate the importance of representational art (published annually from 1953 to 1955). Soyer's body of work includes several images that employ overt Jewish iconography, and also art that was influenced by his Jewish identity while not engaging obvious Jewish subjects.

Soyer was born on December 25, 1899, in Borisoglebsk, Russia. The first of six children, Raphael was one of four sons, three of whom—Raphael, his twin brother **Moses Soyer,** and brother Isaac Soyer—became artists. In 1912, when the family was forced to leave Russia because their "Right to Live" permit was revoked, they embarked for the United States, settling in the Bronx.

After taking drawing classes at the Cooper Union Art School (1914–17), Soyer spent four years at the National Academy of Design beginning in fall 1918, and completed his artistic schooling at the Art Students League intermittently from 1920 to 1926. He had his first one-man show at New York City's Daniel Gallery in 1929. It was there that his 1926 painting *Dancing Lesson* (Renee and Chaim Gross Foundation, New York) (see figure), often understood as the exemplar of Jewish American art, was first exhibited publicly. The painting is reproduced in almost all Jewish art books. It adorned the cover of *Painting a Place in America,* a catalog compiled in celebration of the 100th anniversary of the Educational Alliance, even though it was Moses, not Raphael, who studied at the Alliance. The image is also reproduced on the cover of a volume of Jewish American poetry (Barron and Selinger), and used as a visual example of "Jewish acculturation in the New World" in a book on modern Jewish politics (Mendelsohn). *Dancing Lesson* depicts the artist's sister Rebecca teaching Moses to dance. The crowded canvas, which measures only 24 × 20 inches, also shows three figures packed on a couch watching the dance scene. Raphael's youngest brother Israel plays the harmonica on the right side of the sofa, his father and grandmother survey the scene from the couch, and his mother sits on an armchair holding a copy of the Yiddish daily newspaper *Der Tog,* inscribed with Hebrew lettering. A portrait of family ancestors in traditional attire hangs on the wall above the sofa.

Throughout his career, Soyer was interested in Social Realist themes, subjects found in both his paintings and prints. During the Great Depression he often created compassionate renderings of the down-and-out. It may be because of the influence of Judaism's teachings about the importance of social justice (dubbed tikkun olam, or repairing the world, in the twentieth century), Samantha Baskind argues, that Soyer rendered the homeless in such detail in canvases such as *In the City Park* (1934, private collection, New York) (79–109).

Raphael Soyer, *Dancing Lesson,* 1926. Oil on canvas, 24 × 20 inches. Promised gift from the collection, Renee and Chaim Gross Foundation, New York to The Jewish Museum, New York. © Estate of Raphael Soyer, courtesy of Forum Gallery, New York.

Soyer's work was also shaped by his affiliation with Communist organizations in the 1930s, including the John Reed Club.

Overwhelmed by increased traffic after the construction of the East and West Side Highways, Soyer retreated into his studio in the 1940s. Indeed, self-portraits at his easel and studio scenes of female nudes comprise Soyer's artistic interests through the decade. At this time Soyer also began a series of

portraits of his artist-friends as well as artists he admired. In a 1941 one-man show at the Associated American Artists Gallery, twenty-three of Soyer's artist-portraits were exhibited in a section entitled "My Contemporaries and Elders." Among the paintings displayed were portraits of **Philip Evergood** and **Abraham Walkowitz**. In the late 1950s Soyer started to paint outdoor scenes again, most of which were large, brightly colored canvases such as *Farewell to Lincoln Square* (1959, Hirshhorn Museum and Sculpture Garden, Washington, D.C.). Inspired by Soyer's eviction from the Lincoln Arcade Building where he kept a studio for fourteen years (torn down because of the construction of Lincoln Center), the painting measures 60 × 55 inches and depicts eight figures in movement quickly and distractedly departing the scene. Soyer includes himself in the image in a suit and fedora, although nearly hidden; his small head peers from behind two young women at the front of the canvas. This self-portrait is one of many by Soyer that chronicle his physiognomy from youth to old age.

After meeting Isaac Bashevis Singer in the elevator of his New York apartment building, late in life Soyer began several projects with the Yiddish writer. Soyer illustrated a Limited Editions Club publication of two Singer stories, "The Gentleman from Cracow" and "The Mirror" (1979), and the second and third volumes of Singer's memoirs, *A Young Man in Search of Love* (1978) and *Lost in America* (1981). In 1979 Soyer also illustrated a book of his father's Yiddish stories. Soyer was reluctant to speak about Judaism or to identify as a Jewish artist, most notably avoiding the subject in all four of his autobiographies. However, in a late oral interview Soyer spoke more openly about his Jewish identity: "I'm an American Jew, I'm an American citizen, I'm an American artist and I'm a Jew, and this is my life" (Raphael Soyer Papers, reel 4890, frame 47).

Bibliography

Barron, Jonathan N. and Eric Murphy Selinger, eds. *Jewish American Poetry: Poems, Commentary, and Reflections*. Hanover, NH: University Press of New England, 2000.

Baskind, Samantha. *Raphael Soyer and the Search for Modern Jewish Art*. Chapel Hill: University of North Carolina Press, 2004.

Cole, Sylvan, ed. *Raphael Soyer: Fifty Years of Printmaking, 1917-1967*. Rev. ed. New York: Da Capo Press, 1978.

Goodrich, Lloyd. *Raphael Soyer*. New York: Harry N. Abrams, Inc., Publishers, 1972.

Heyd, Milly and Ezra Mendelsohn. "'Jewish' Art?: The Case of the Soyer Brothers." *Jewish Art* 19–20 (1993–1994): 194–211.

Mendelsohn, Ezra. *On Modern Jewish Politics*. New York: Oxford University Press, 1993.

Raphael Soyer Papers. Archives of American Art, Smithsonian Institution, Washington, D.C.

Singer, Isaac Bashevis. *A Young Man in Search of Love*. Paintings and drawings by Raphael Soyer. Garden City, NY: Doubleday and Company, Inc., 1978.

———. *The Gentlemen from Cracow/The Mirror*. Illustrations by Raphael Soyer. New York: Limited Editions Club, 1979.

————. *Lost in America.* Paintings and drawings by Raphael Soyer. Garden City, NY: Doubleday and Company, Inc., 1981.

Soyer, Abraham. *The Adventures of Yemima and Other Stories.* Translated by Rebecca S. Beagle and Rebecca Soyer. Illustrated by Raphael Soyer. New York: The Viking Press, 1979.

Soyer, Raphael. *A Painter's Pilgrimage.* New York: Crown Publishers, Inc., 1962.

————. *Homage to Thomas Eakins, Etc.* Edited by Rebecca L. Soyer. South Brunswick, NJ: Thomas Yoseleff, Ltd., 1966.

————. *Self-Revealment: A Memoir.* New York: Maecenas Press/Random House, 1969.

————. *Diary of an Artist.* Washington, D.C.: New Republic Books, 1977.

Selected Public Collections

Cleveland Museum of Art
Columbia Museum of Art, South Carolina
Hirshhorn Museum and Sculpture Garden, Washington, D.C.
Metropolitan Museum of Art, New York
Montclair Art Museum, New Jersey
Museo Thyssen-Bornemisza, Madrid
National Gallery of Art, Washington, D.C.
Smithsonian American Art Museum, Washington, D.C.

Nancy Spero (1926–), painter, printmaker, and installation artist.

Since the 1970s, Cleveland-born, feminist artist Nancy Spero has appropriated various sources to convey the position of women in a patriarchal society through a combination of figurative imagery and written texts. She studied at the Art Institute of Chicago (1945–49) and in Paris at the Atelier André L'Hote and the Ecole des Beaux-Arts (1949–50). While at the Art Institute, Spero met the artist **Leon Golub**, whom she married in 1951. Highly supportive of each other's work, until Golub's death in 2004 the couple shared a studio at various times, critiqued works in progress, and exchanged source materials.

Conceived while Spero and Golub were living in Paris, her early *Black Paintings* (1959–64) show figures materializing from dark backgrounds. Several of these canvases portray women segregated into stereotypical roles such as mother and lover. In Paris, Spero had her first solo exhibition at the Galerie Breteau (1962). Following the couple's move to New York in 1964, Spero initiated *The War Series* (1966–70), instigated by the escalating Vietnam War. A group of gouache drawings on paper that frequently show the effects of bombing by utilizing iconography that equates the phallus with annihilation, *The War Series* includes a few images that refer to the Holocaust. For example, *Male Bomb/Swastika* (1968) presents a nude male torso with a swastika in lieu of a head, and the inclusion of three Stars of David, one on the figure's

navel, one on his knee, and a third on the tip of his penis (Color Plate 16). *The War Series*, Spero explains, "is about obscenities – sex and phallic extensions of power. Phallic eagles, devouring helicopters, the obscene language of the pilots, phallic Nazi crematoriums" (Kline and Posner, 29). Realizing the possibilities of works on paper and choosing, in the artist's words, "a personal rebellion, recognizing that I would no longer do 'important' work, in terms of collectors' preferences for canvases of the 'proper' dimensions," since *The War Series*, Spero has eschewed the traditional medium of oil and canvas (Kline and Posner, 28).

From 1969 to 1972, Spero worked on images based on the writings of the Frenchman Antonin Artaud. Explored for two years in paintings and then in the *Codex Artaud* (1971–72), her first paper scroll and a format that she would utilize for many years, Spero juxtaposes typed excerpts from Artaud's writings with painted images arranged in a collage-like fashion. Diverse figures appear across strips of paper in the *Codex Artaud* on which Spero also leaves large areas devoid of iconography. Delicate, invented, sometimes fantastical "hieroglyphs," partially inspired by ancient art, pepper the work, as do powerful images of figures in straightjackets and others sticking out phallic tongues. Spero explains that anger prompted the *Codex Artaud* and that she utilized tongues because "in French the 'tongue' is 'langue,' tongue and language – I was sticking my tongue out and trying to find a voice after feeling silenced for so many years" (Spero, *Nancy Spero: Woman Breathing*, 38). For Spero, Artaud's prose, which describes his alienation and anguish, metaphorically articulated the position of women in a patriarchal world: "In choosing Artaud, I chose a pariah, a madman. He was the Other, a brilliant artist, but a victim running in circles" (Spero, *Nancy Spero: 43 Works on Paper*, 1). Following the *Codex Artaud*, Spero focused her images on the experience of women by solely representing her gender. As Spero explained in a written statement from 1985: "I use only images of women, to represent woman as protagonist and hero. This is a reversal of the typical art practice of portraying men as heroes and protagonists. I articulate women's situation and actions from that of repressed, victimized states to buoyant, self-confident stances" (Bird, *Nancy Spero*, 130).

Imagery that delineates the suffering and subjugation of women includes Spero's wall installations, which she began designing in 1988. After reading Bertolt Brecht's poem about Marie Sanders (c. 1934), a woman who slept with a Jew and was subsequently murdered by Nazis for her perceived transgression, Spero made several installations about her, including *Ballad of Marie Sanders, The Jew's Whore* at the Smith College Museum of Art, Northampton, Massachusetts (1990) and at the Jewish Museum's exhibition *From the Inside Out: Eight Contemporary Artists* (1993). *Voices: Jewish Women in Time* was also included in the Jewish Museum show. This latter installation reproduced photographs showing victimized women in the Warsaw Ghetto, concentration camps, and other Nazi-related brutalities, as well as women in a more powerful position, such as female Israeli soldiers and female Israeli and Palestinian peace activists. Interspersed with the colorful imagery were collaged texts of Brecht's poem, a poem by the Jewish Nobel Prize winner Nelly Sachs, and a

stanza of a poem by Jewish poet Irene Klepfisz. Spero also depicted Sanders in lithographs and a scroll. Spero based the figure of Sanders on a photograph found by Golub of a bound, naked woman discovered on the body of a dead Gestapo officer. In 1993, Spero also made a wall installation for the Whitney Museum of American Art addressing a Jewish subject and a victimized woman: *Marsha Bruskina* documents the ordeal of a seventeen-year-old who was the first female killed during the Nazi occupation of the Soviet Union.

Over ninety female figures designed by Spero adorn the platform walls of the Lincoln Center subway station in New York. Glass and ceramic mosaics of stylized female types, ranging from the goddess Athena to a contemporary female athlete, were constructed according to Spero's specifications from 1999 to 2000. Commissioned by the Arts for Transit Program of the Metropolitan Transit Authority, Spero mused about the long-term effects of this permanent installation: "Who can tell what it might mean to have my female images surviving through time? What does this mean in terms of entering the consciousness of society or of women's consciousness of themselves and their place in society? What does it mean to bring a feminine protagonist into the subway environment?" (Enright, 33).

Since 1969, Spero has been a member of Woman Artists in Revolution (WAR), a New York City-based group that has picketed several museums to protest female inequality in the arts; in 1976, for instance, Spero and others demonstrated at the Museum of Modern Art's exhibition "Drawing Now," which showed works by forty-one men but only five women. She cofounded the Artists in Residence Gallery in 1972, an art gallery for women also based in New York City. In 1987 Spero enjoyed her first retrospective exhibition, held at the Institute of Contemporary Arts in London, followed by showings in Edinburgh and in Derry, Northern Ireland.

Bibliography

Bird, Jon, ed. *Otherworlds: The Art of Nancy Spero and Kiki Smith.* London: Reaktion Books, 2003.

Bird, Jon, Jo Anna Isaak, and Sylvère Lotringer. *Nancy Spero.* With writings by Nancy Spero. London: Phaidon Press Limited, 1996.

Buchloch, Benjamin H.D. "Spero's Other Traditions." In *Inside the Visible: An Elliptical Traverse of 20th Century Art, in, of, and from the Feminine.* Edited by M. Catherine de Zegher, 238–245. Cambridge, MA: MIT Press, 1996.

Dobie, Elizabeth Ann. "Interweaving Feminist Frameworks," *Journal of Aesthetics and Art Criticism* 48, no. 4 (Fall 1990): 381–394.

Enright, Robert. "On the Other Side of the Mirror: A Conversation with Nancy Spero." *Border Crossings* 19, no. 4 (November 2000): 18–33.

Goodman, Susan Tumarkin. *From the Inside Out: Eight Contemporary Artists.* New York: Jewish Museum, 1993.

Kline, Katy and Helaine Posner. *Leon Golub and Nancy Spero: War and Memory.* With an interview with Golub and Spero. Cambridge, MA: MIT List Visual Arts Center, 1994.

Nahas, Dominique. *Nancy Spero: Works Since 1950.* Syracuse, NY: Everson Museum of Art, 1987.

Spero, Nancy. *Nancy Spero: 43 Works on Paper, Excerpts from the Writings of Antonin Artaud.* Köln: Galerie Rudolf Zwirner, 1987.

———. *Nancy Spero: Woman Breathing.* Ulm: Das Museum, 1992.

———. *Nancy Spero: The War Series, 1966-1970.* With essays by Robert Storr and Leon Golub. Milano: Charta, 2003.

Selected Public Collections

Art Gallery of Ontario, Canada
Art Institute of Chicago
Corcoran Gallery of Art, Washington, D.C.
Jewish Museum, New York
Museum of Fine Arts, Boston
Museum of Modern Art, New York
Philadelphia Museum of Art
Uffizi Gallery, Florence, Italy

Harry Sternberg (1904–2002), printmaker and painter.

A representational artist whose humanistic work frequently falls under the rubric of Social Realism, Harry Sternberg aimed, as he put it, to make art as "an expression of my time, to be of the people and for the people. The people – their struggles, their aspirations – are both the theme of my art and the audience I want to reach" (Lozowick, 180). When interviewed in his nineties, Sternberg retrospectively commented on why he thought that his work focused on social justice issues: "I think that's part of the Jewish tradition that affected me strongly. Even though I am still not a synagogue-goer" (Oral History). While known especially for his prints, Sternberg was also a painter, muralist, and influential educator.

Sternberg was born in poverty on the Lower East Side of New York City to Orthodox, Eastern European immigrant parents who "hated and distrusted my picture-making," to use the artist's words (Zigrosser, 62–63). He studied at the Art Students League for five years (1922–26) and took private graphic art classes with Harry Wickey (1926–27). When he first took up printmaking, Sternberg made a few scenes of Jewish life. For instance, an early etching, *Synagogue* (1927, Edwin A. Ulrich Museum of Art, Wichita State University, Kansas), portrays a heavily populated genre scene of the venue where Sternberg became a bar mitzvah. At his first solo exhibition at the Weyhe Gallery (1932), Sternberg's predilection for working in series began to manifest. Here he showed, for example, seven prints titled *Principles* (1930–32). Influenced by the satiric work of Francisco Goya, these biting prints explore social ills, relationships, and human folly. *Principle #6: Birth Control* (1931, Edwin A. Ulrich Museum of Art, Wichita State University, Kansas) depicts a nude family walking across a tightrope strung over a deep canyon. Both the man and the woman can barely keep their balance, the woman's plight exacerbated by the fact that she is pregnant and carrying three young children. On the right side of the composition members of the clergy look on apathetically.

The hardships of the Great Depression impelled many artists to create an art of protest, and Sternberg's contributions were particularly unsparing. A commentary on racial intolerance, the ironically titled *Southern Holiday* (1935, Whitney Museum of American Art, New York) appeared in two antilynching exhibitions the year that it was made. *Southern Holiday* shows a muscular, naked, castrated African American man tied to a broken column. Behind this disturbing scene stand factories, contrasting the advances of modern life with the primitive acts of lynching and castration. In one of many annotations to a catalog raisonné of his graphic work, Sternberg recalled, "I was filled with anger and shame as I worked on this stone and evidently transmitted these emotions through the finished print, for I found this image was too disturbing for most people to hang in their homes" (Moore, 115). During these years, Sternberg was actively protesting fascism as a founding member of the American Artists' Congress, an organization dedicated to that very goal, and a contributor to the leftist periodical *New Masses*.

Funded by a 1936 Guggenheim Fellowship, Sternberg made prints, paintings, and drawings illustrating the steel and coal industries in eastern Pennsylvania under a project dedicated to industrial subjects. Intent on first hand experience of the miners' way of life, Sternberg went down into the mines to sketch wearing a headlamp and hardhat. The lithograph *Seventh Level* (1936, San Diego Museum of Art), which refers to the richest part of the mine found deeply underground, shows three miners walking along tracks, their headlamps barely illuminating the dark, claustrophobic space, emphasized by the low ceiling. Sternberg's heavy black tones describe the gloom and grittiness of the underground shaft. His attention to detail extends from the textures of the wood grain of the mine's support system to the drawn tired faces of the workers.

Having won commissions sponsored by the Federal Art Project's Section of Fine Arts, Sternberg made three murals, for post offices in Chicago, Illinois; Sellersville, Pennsylvania; and Ambler, Pennsylvania. For the latter venue, Sternberg designed *The Family–Industry and Agriculture* (1939), which presents a wife and her husband—a worker in overalls—with their infant. The trio sits outside on the grass between factories on the left side of the image and a farm on the right side. Shortly before his death, Sternberg wrote a brief essay recalling that his quiet composition, devoid of the kind of angry rhetoric found in *Southern Holiday*, resulted from the government's efforts to discourage controversial subject matter when artists sent sketches to authorities for approval (Becker, 80).

During the mid-1940s, Sternberg made a series of fourteen serigraph artist-portraits in which he attempted to assimilate elements of the depicted artist's style and an indication of the artist's preferred subject matter with the likeness. After finishing the portrait, Sternberg elicited the artist's signature atop his own. A portrait of Pablo Picasso (1944, Edwin A. Ulrich Museum of Art, Wichita State University, Kansas), for instance, is rendered in a Cubist idiom and shows the Spaniard with a rooster, a favored subject. Among the other artists that Sternberg made serigraph portraits of are **Chaim Gross** (1943),

Abraham Walkowitz (1943), **Philip Evergood** (1944), **William Gropper** (1944), **Moses Soyer** (1944), and **Raphael Soyer** (1944).

In his later years, Sternberg embarked on his highly personal *Tallit Series* (1985–86)—named after the prayer shawl worn by observant Jews when they pray—which includes paintings, drawings, and prints delineating Jewish prayer and study. The woodcuts in the series, made with a power tool, forcefully communicate the piety of observant Jews. *Prayer* (1985–86, San Diego Museum of Art) (see figure) shows a bearded Jew with a *tallit* draped over his head looking up toward heaven. Minimally shaded and boldly rendered, the expressionistic figure can be read as a lamenting Jew akin to the patriarchs delineated by **Ben-Zion** and **William Gropper**.

Sternberg taught at the Art Students League for over thirty years (1933–68), at times working closely with **Will Barnet** (the League's official printer beginning in 1943 and then taught graphic arts) who did printing for him at various times over the years, and at the New School for Social Research (1942–45). Starting in 1957, Sternberg spent considerable amounts of time in California, whereupon he divided his teaching between the League and the Idyllwild School of Music and the Arts at the University of Southern California (1957–68). He wrote several how-to books on art making, including discussions of silkscreen color printing and composition techniques.

Harry Sternberg, *Prayer,* 1985–86. Woodcut, 15⅞ × 19⅞ inches. San Diego Museum of Art. Gift of Dennis and Stephanie Hicks. 2006.35. Photo: Courtesy San Diego Museum of Art.

Bibliography

Becker, Heather. *Art for the People: The Rediscovery and Preservation of Progressive- and WPA-Era Murals in the Chicago Public Schools, 1904-1943*. San Francisco: Chronicle Books, 2002.

Fleuriv, Ellen. *No Sun Without Shadow: The Art of Harry Sternberg*. Escondido, CA: California Center for the Arts, 2000.

Langa, Helen. "Two Antilynching Art Exhibitions: Politicized Viewpoints, Racial Perspectives, Gendered Constraints." *American Art* 13, no. 1 (Spring 1999): 10–39.

———. *Radical Art*. Berkeley: University of California Press, 2004.

Lozowick, Louis. *One Hundred Contemporary American Jewish Painters and Sculptors*. New York: YKUF Art Section, 1947.

Moore, James C. *Harry Sternberg: A Catalog Raisonné of his Graphic Work*. With annotations by Harry Sternberg. Wichita, KS: Edwin A. Ulrich Museum of Art, 1975.

Sternberg, Harry. *Modern Method and Materials of Etching*. New York: McGraw-Hill Book Company, 1949.

———. *Composition*. New York: Pitman Publishing Corporation, 1958.

———. *Realistic Abstract Art*. New York: Pitman Publishing Corporation, 1959.

———. Oral History Interview with Sally Yard. Archives of American Art, Smithsonian Institution, Washington, D.C., 1999 Mar 19–2000 Jan 7. http://www.aaa.si.edu/collections/oralhistories/transcripts/sternb99.htm

Warner, Malcolm. *The Prints of Harry Sternberg*. San Diego: San Diego Museum of Art, 1994.

Zigrosser, Carl. *The Artist in America; Twenty-Four Close-ups of Contemporary Printmakers*. New York: Alfred A. Knopf, 1942.

Selected Public Collections

Cleveland Museum of Art
Fogg Art Museum, Harvard University, Cambridge, Massachusetts
Museum of Modern Art, New York
Oklahoma City Museum of Art
Philadelphia Museum of Art
San Diego Museum of Art
Whitney Museum of American Art, New York
Wichita Art Museum, Kansas

Maurice Sterne (1878–1957), painter, sculptor, and printmaker.

A versatile artist who amalgamated early advanced European developments and the Old Masters, Maurice Sterne is best remembered, when remembered at all, for his Cubist- and Post-Impressionist-inspired paintings composed with mastery of structure, and sculptures utilizing both archaic and modern elements. Not classified with any movement, in his time Sterne was described as "one of the finest draughtsman in contemporary American art. In landscapes and figure paintings, and in sculpture, he shows a thorough understanding of the relation of form and space" (Cahill and Barr, 95).

Born in a shtetl in Latvia, Sterne spent his childhood in Russia, where he discovered his love for art. At an early age he was drawing the events in his home, such as his mother holding the Bible or blessing Sabbath candles (Sterne, *Shadow and Light,* 20). In the initial chapter of his autobiography Sterne lays great stress on his Jewish background, consistently referring to religious holidays as markers for other events in his life. Sterne recalls being chastised for his love of art at an early age: "the graphic arts had absolutely no place in our lives. Religious Jews took very seriously the Biblical injunction against 'graven images' and I was punished badly one day by the rabbi of my school for drawing his picture on the ground with a stick. He said that I had broken the Second Commandment" (7). Anti-Semitism forced Sterne to flee Russia following the death of his father, a rabbi.

A few years after arriving in New York City in 1889 with his Yiddish-speaking mother and siblings, Sterne apprenticed with a map engraver and studied art at Cooper Union (1892) and the National Academy of Design (1894–99). At the National Academy, Sterne took an anatomy class with the renowned Thomas Eakins, who visited weekly from Philadelphia. An Academy scholarship enabled Sterne to travel to France in 1904, and he remained abroad until January 1915. At the French salons he became acquainted with the work of Paul Cézanne, whose work proved influential on Sterne's own. As Sterne wrote in an article about Cézanne: "Only when I realized that his distortion was not due to his inability to draw 'correctly' or to optical imperfection, but to reasons purely compositional – only then did I comprehend that his malformations were in reality transformations" ("Cézanne Today," 54). He began traveling in 1908, visiting many locales, including Egypt and India. For eight months he lived in a Greek monastery (1908) while studying ancient art in Athens. In Greece, Sterne started his first sculpture, *The Bomb Thrower* (1910, Worcester Art Museum, Massachusetts). Standing just under twelve inches high, this bronze head is executed with simplified shapes that reflect the influence of Cézanne.

While in Bali for two years (1912–13), Sterne painted native life and ritual in subdued colors and also made many drawings of his surroundings, estimated as numbering in the thousands (Kallen, 10). *Bali Bazaar* (1913–14, Whitney Museum of American Art, New York) (see figure), for example, presents a mass of half nude, indigenous types crowded into a shallow composition. This painting, like many others that delineate Balinese life, employs flattened forms and patterns. Sterne's work showed at a few venues in Europe, including an exhibition of etchings and drawings at Paul Cassirer's gallery in Berlin (1910).

The same year as his one-person show at the Art Institute of Chicago (1917), Sterne married the wealthy patron and influential intellectual Mabel Dodge Luhan. Their brief marriage took the couple to Taos, New Mexico, where Sterne painted Native Americans. After the dissolution of his marriage, in 1918 Sterne lived in Anticoli Corrado, Italy for a year, a favorite locale from his first trip to Europe and a community to which he would return on many occasions to paint Italian life in the small village. Two years after his death, in 1959, a street in Anticoli was renamed in his honor.

Maurice Sterne, *Bali Bazaar,* 1913–14. Oil on canvas, 36½ × 39 inches. Whitney Museum of American Art, New York; Purchase 54.13. Photograph © Whitney Museum of American Art, New York.

Sterne received a commission to design the Rogers-Kennedy Memorial in Worcester, Massachusetts in 1926. Titled *Monument to Early Settlers,* the nearly thirty-foot tall memorial was unveiled in Elm Park in 1929, the same year that Sterne was elected president of the Society of American Painters, Sculptors and Gravers. A large, horizontal stone structure topped by two bronze figures and a plough, the sculpture features high-relief friezes delineating the life and work of robust pioneers. Other commissions include a mural made under the auspices of the Federal Art Project, *Man's Struggle for Justice* (1935–40), for the Department of Justice Building in Washington, D.C. This five-year project engendered controversy because of the panel "Ordeal," one of twenty panels depicting tools of justice (other panels include "Brute Force" and "Mercy"). "Ordeal" showed two figures being tortured during the Inquisition with a church official as a witness. Refusing to modify the panel at the urging of church dignitaries, the entire mural remained in storage for a period of time before the government acquiesced and installed it in 1941. Sterne's late

canvases, many of which are New England landscapes such as *After Rain* (1947, Philips Collection, Washington, D.C.), are painted in an impressionist manner.

Famous enough to command the first one-person exhibition by an American artist at the Museum of Modern Art (1933), throughout his career Sterne received many additional honors, including retrospective exhibitions at venues such as The Philips Collection in Washington, D.C. (1952), and enjoyed the distinction of being the first contemporary American painter to have a canvas, *Mexican Church Interior* (1934–35), acquired by the Tate Gallery in London (1945). Unfortunately, Sterne has since been relegated to the status of a second-tier artist, largely forgotten by museums and scholars.

In one of the few contemporary accounts of Sterne's work, Martin Ackerman describes him as "not an American painter. In truth, his art has nothing American in it. Sterne's art is the art of a Russian Jew who had trained his mind, his eye and his hand in Paris, Rome, Greece, India and Bali, and who happened to call America his home" (unpaged). Undoubtedly, Sterne was influenced by many different styles and experiences, which Ackerman sees as integrated with the artist's early exposure to Jewish mysticism. Ackerman concludes by asserting that "this Russian Jew [later] found his mysticism in the masters and his light and inspiration from the Orient, creating for himself a personal tradition without ever tinkering with it from the outside" (Ibid.). Editor Charlotte Mayerson's commentary accompanying Sterne's autobiography may have instigated Ackerman's comment: "During...fifty-five years of public notice, it would be difficult to find even one piece for which Sterne supplied the background material which did not lay stress on his Jewish childhood in Latvia. His notebooks, his letters, the conservations his friends remember, are interlaced with recollections of his early life and with speculation about its effect on his work and on his personal motivation. Like so many creative men, Maurice Sterne, painter and sculptor, seems to have carried his childhood with him as a very conscious and tangible part of his adult life" (3).

Bibliography

Ackerman, Martin S. and Diane L. Ackerman, eds. *Maurice Sterne Drawings.* New York: Arco Publishing Company, Inc., 1974.

"An Hour in the Studio of Maurice Sterne." *American Artist* 5, no. 10 (December 1941): 4–9, 39.

Cahill, Holger and Alfred H. Barr Jr., eds. *Art in America: A Complete Survey.* New York: Reynal and Hitchcock, 1935.

Kallen, Horace M. *Maurice Sterne: Retrospective Exhibition, 1902-1932.* New York: Museum of Modern Art, 1933.

Lozowick, Louis. *One Hundred Contemporary American Jewish Painters and Sculptors.* New York: YKUF Art Section, 1947.

Morrin, Peter, Judith Zilczer, and William C. Agee. *The Advent of Modernism: Post-Impressionism and North American Art, 1900–1918.* Atlanta: High Museum of Art, 1986.

Sterne, Maurice. "Cézanne Today." *The American Scholar* 22, no. 1 (Winter 1952–1953): 40–59.

————. *Shadow and Light: The Life, Friends and Opinions of Maurice Sterne.* Edited by Charlotte Leon Mayerson. New York: Harcourt, Brace, and World, Inc., 1965.

Tarbell, Roberta K. *Vanguard American Sculpture.* New Brunswick, NJ: Rutgers University Art Gallery, 1979.

Selected Public Collections

Art Institute of Chicago
High Museum of Art, Atlanta
Museum of Fine Arts, Boston
National Gallery of Art, Washington, D.C.
North Carolina Museum of Art, Raleigh
San Francisco Museum of Modern Art
Smithsonian American Art Museum, Washington, D.C.
Whitney Museum of American Art, New York

Florine Stettheimer (1871–1944), painter.

Largely unknown in her lifetime except to an intimate group of family and friends, Florine Stettheimer created a body of whimsical and playful paintings of the members of her inner circle as well as aspects of upper-class American society. She famously remained unmarried along with two of her sisters, Ettie and Carrie, all three living with their mother in a townhouse on the Upper West Side until 1935. In this sheltered, elegant environment, the trio surrounded themselves with friends from the upper echelons while engaging their intellectual and cultural interests. All three of the cultured, socialite sisters were involved in their own interesting projects: Ettie held a Ph.D. in philosophy and was known for her conversational skills, and Carrie designed a two-storey, sixteen-room doll house (Museum of the City of New York) populated with figurines of her family and friends, intricate furniture, and tiny reproductions of art made by the original artists; among the works in the house is Marcel Duchamp's infamous *Nude Descending a Staircase* made in miniature.

Born in Rochester, New York to wealthy parents, Stettheimer started taking classes at the Art Students League in her early twenties (1892–95). Her art education was augmented by several family trips to Europe; beginning in 1906 Florine, Ettie, Carrie, and their mother traveled intermittently for eight years, at which time Florine studied art in Germany and also kept a studio in Munich (1910–13). In 1912 Stettheimer saw Diaghilev's Ballet Russes in Paris, with costumes by Léon Bakst, a formative experience for the artist that instigated her designs for her own ballet, *Orphée of the Quat'z Arts,* complete with bas-relief scenery and three-dimensional models of the main characters. With the outbreak of World War I, the family returned to the United States.

Back in New York at forty-three years old with a body of canvases, Stettheimer exhibited some of the paintings at a one-person show at M. Knoedler & Company (1916). None of the thickly painted works, often subdued in color, sold. By her own choice, the Knoedler show was the only solo exhibition in Stettheimer's lifetime, although she did occasionally exhibit

individual works in group shows, such as the Carnegie International (1924) and the first Whitney Biennial (1932). Even though art impresarios such as **Alfred Stieglitz** urged her to exhibit at their galleries, Stettheimer displayed her work in her highly decorative studio, including cellophane curtains in the doorways. In a prelude to Stettheimer's first biography, Carl Van Vechten, who saw Stettheimer's studio space first hand, described her bedroom at the studio as "fabulous in her prodigal employment of white lace, cellophane, and crystal blossoms. I am happy to remember how she made stiff paper do her bidding when she arranged the drapes at the window in the dining room of her studio" (Tyler, xii). Showings at Stettheimer's studio were only available to invited guests, many of whom appeared in her portraits, such as art critic Henry McBride (1922, Smith College Museum of Art, Northampton, Massachusetts) and Van Vechten (1922, Yale Collection of American Literature, Beineke Rare Book and Manuscript Library, New Haven, Connecticut).

Following the Knoedler exhibition, Stettheimer style began to evolve into the conception that marks her mature production, partially akin to the colorful, imaginative sets and costumes she sketched for *Orphée of the Quat'z Arts.* Portraits from the late teens of her family and acquaintances, such as the aforementioned *Portrait of Carl Van Vechten,* are stylized conceptions, flatly rendered and simplified with an increasingly bright palette. The sinuous, androgynous Van Vechten sits on a chair at the front of the canvas amid accoutrements that reveal his personality: a typewriter with Stettheimer's signature spelled out in keys along with the date of the painting; books, including a pile at his feet with his own title, *The Tiger in the House;* and a piano (he wrote music criticism), among other pertinent objects. Stettheimer also made pictures of events in her life, such as summer outings in upstate New York where the family rented a summer home. One of many companions who accompanied the Stettheimers to the country was **Elie Nadelman**, who was also purging his art of academic influences, finding inspiration in similar simplified forms for his sculptures. Nadelman appears in *Picnic at Bedford Hills* (1918, Pennsylvania Academy of the Fine Arts, Philadelphia) (see figure), stretching out on the bright yellow grass at the back of the canvas while talking to Ettie. This vividly colorful painting presents a view of the leisure activities of the elite, here visiting the novelist Rupert Hughes' farm. Also appearing in the canvas are Duchamp at front kneeling in a purple suit opening a picnic basket, Carrie with a plate of lobster, and Florine herself sitting on a blanket under a parasol.

In 1929, Stettheimer began designing the acclaimed (and characteristically fanciful) sets and costumes for Virgil Thomson and Gertrude Stein's opera *Four Saints in Three Acts,* which opened in 1934 in Hartford, Connecticut at the Wadsworth Atheneum. She also began another major project in 1929—her *Cathedral* paintings, a series of four canvases each depicting a neighborhood in New York. All now located in the Metropolitan Museum of Art and large in scale, around 60 × 50 inches, *Cathedrals of Broadway* (1929), *Cathedrals of Fifth Avenue* (1931), *Cathedrals of Wall Street* (1939), and *Cathedrals of Art* (1942, left unfinished at Stettheimer's death), are densely peopled images of modern, cosmopolitan life amid famous locales in New York. The symbolic *Cathedral of Art* presents New York City's three major museums: from left to right, the

Florine Stettheimer, *Picnic at Bedford Hills,* 1918. Oil on canvas, 40 5/16 × 50¼ inches. The Pennsylvania Academy of the Fine Arts, Philadelphia. Acc. No. 1950.21. Courtesy of The Pennsylvania Academy of the Fine Arts, Philadelphia. Gift of Ettie Stettheimer.

Museum of Modern Art (MoMA), the Metropolitan Museum of Art, and the Whitney Museum of American Art. Ascending the stairs, hand in hand with the Metropolitan's director Francis Henry Taylor is a nude putto being escorted to the high altar of the cathedral of art. At the far left MoMA director Alfred Barr, Jr. sits in a modernist chair gazing at two Picassos, and at the Whitney stands Juliana Force, the director of the organization. Other art world notables populate the canvas; McBride stands at the base of the column on the right, Stieglitz poses in profile wearing his signature black cloak at the bottom of the red-carpeted stairs, and Stettheimer appears on the far right of the canvas labeled as the commère, the interpreter of the scene. That Stieglitz and other more progressive dealers, as well as the idiosyncratic painter Stettheimer, appear outside the museums indicates, Barbara Bloemink argues, for a reading of Stettheimer's painting as representative of the artist's scorn of the art world (Sussman and Bloemink, 92). In other words, Stettheimer's art, not easily placed within the narratives expounded by these three institutions, confounds the overly proscribed ideologies of the structures she portrays.

Soon after Stettheimer's death, Duchamp arranged a memorial exhibition of her work at MoMA (1946). In recent years, Stettheimer has garnered additional

attention; in 1995 the Whitney Museum of American Art showed a large over-view of her work. Stettheimer's work was featured in a recent exhibition mounted by the Jewish Museum on Jewish women and their salons (2005). Curators Emily Bilski and Emily Braun acknowledge how thoroughly assimi-lated Florine and her sisters were, a position affirmed by Stettheimer's art and writings, both of which nearly always avoid Jewish subjects. However, one of Florine's portraits of Ettie (1923, Columbia University, New York) shows the younger sister reclining on a divan next to a flaming Christmas tree. Stettheimer described the painting in her dairy: "Ettie has a Xmas tree burning bush combination–I have decided the Xmas tree is an outcome of the burning bush of Moses" (Bilski and Braun, 239, n. 65). In addition to Stettheimer's extensive journaling, she was also a poet. A book of Stettheimer's verse, *Crystal Flowers*, was posthumously published with an introduction by Ettie.

Bibliography

Bilski, Emily D. and Emily Braun. *Jewish Women and Their Salons: The Power of Con-versation.* New York: Jewish Museum; New Haven: Yale University Press, 2005.

Bloemink, Barbara J. *The Life and Art of Florine Stettheimer.* New Haven: Yale University Press, 1995.

McBride, Henry. *Florine Stettheimer.* New York: Museum of Modern Art, 1946.

Nochlin, Linda. "Florine Stettheimer: Rococo Subversive." In *Women, Art, and Power and Other Essays.* New York: Harper and Row, Publishers, 1988, 109–135.

Tyler, Parker. *Florine Stettheimer: A Life in Art.* New York: Farrar, Straus and Company, 1963.

Stettheimer, Florine. *Crystal Flowers.* Pawlet, VT: Banyon Press on Rives, 1949.

Sussman, Elizabeth and Barbara J. Bloemink. *Florine Stettheimer: Manhattan Fantas-tica.* New York: Whitney Museum of American Art; Distributed by Harry N. Abrams, Inc., 1995.

Whiting, Cécile. "Decorating with Stettheimer and the Boys." *American Art* 14, no. 1 (Spring 2000): 24–49.

Selected Public Collections

Art Institute of Chicago
Baltimore Museum of Art, Maryland
Los Angeles County Museum of Art
Metropolitan Museum of Art, New York
Museum of Fine Arts, Boston
Museum of Modern Art, New York
Rose Art Museum, Brandeis University, Waltham, Massachusetts
Whitney Museum of American Art, New York

Alfred Stieglitz (1864–1946), photographer.

Alfred Stieglitz is considered the founder of modern photography and a revolutionary who helped to legitimize photography as a fine art as well as to introduce modern art in America through his various galleries, patronage,

and writings. Indeed Stieglitz has been described as "perhaps the most important figure in the history of the visual arts in America" (Stieglitz, ix); characterized by **Abraham Walkowitz**, an artist he promoted, as "the pioneer of modern art" (Lerner and Cowdrey, 14); and named one of the twenty-five most influential artists of the twentieth century (Coleman, 150).

Stieglitz was born on New Year's Day in Hoboken, New Jersey to affluent German immigrants. His cultured family moved to New York City in 1871. They settled on the Upper East Side in an apartment where they sometimes played host to artists, including **Moses Jacob Ezekiel**, who lived with the Stieglitzes from January to August 1878. After a few years studying at the City College of New York (1879–81), Stieglitz and his family went to Germany, where he briefly studied engineering and then began his formal training in photography. When his parents and siblings returned to the United States in 1886, Stieglitz remained in Berlin to continue his training.

By the time he returned to New York in 1890, Stieglitz had already received acclaim for his pictures. During these early years, Stieglitz manipulated his photographs during the printing process to simulate painting techniques. For instance, *Winter, Fifth Avenue* (1893, George Eastman House, Rochester, New York), a lush, soft-focus Pictorialist photograph, impressionistically renders the wintry slush and snow falling on one of New York City's most famous streets. Stieglitz joined the New York Society of Amateur Photographers (1891) and a few years later started to edit the journal *American Amateur Photographer* (1893–96). When the New York Society of Amateur Photographers merged with the Camera Club, Stieglitz became vice-president of the organization and also editor of their official periodical, *Camera Notes* (1897–1902). He founded the Photo-Secession movement (1902) with other artists, including Edward Steichen, and the seminal publication *Camera Work* (1903–17). *Camera Work* provided the first extensive coverage of European artistic developments for an American audience, while also promoting photographers such as **Paul Strand**, who was featured in the periodical's final two issues.

Three years after founding the Photo-Secession group, Stieglitz opened the Little Galleries of the Photo-Secession, more popularly known as "291" after the venue's address at 291 Fifth Avenue. Between 1905 and 1917, eighty-two exhibitions took place at "291," including shows featuring American artists **Abraham Walkowitz**, **Max Weber**, and **Elie Nadelman**, as well as the European avant-garde. To be sure, "291" was the first U.S. venue to stage exhibitions displaying the work of Henri Matisse (1908), Paul Cézanne (1911), and Pablo Picasso (1911), while also promoting photography.

Stieglitz published twelve issues of the magazine *291* (1915–16) before the gallery closed in 1917. This was the same year that the last issue of *Camera Work* appeared and the first summer season that Stieglitz spent at Lake George, a country retreat that is the subject of many of his finest pictures. One of Stieglitz's most enduring projects is his series of over 300 photographs of Georgia O'Keeffe (begun in 1918), whom he married in 1924.

O'Keeffe's influence on Stieglitz was much farther reaching than as his muse and wife. Starting in the twenties, for example, Stieglitz made a series of cloud and sky pictures that he called *Equivalents,* instigated by O'Keeffe's intuitive approach to her own art. Stieglitz's *Equivalents* aimed to convey emotions rather than the obvious subject matter, a goal also propagated by his ambiguous titles derived from music, such as "Symphony" or "Composition." From 1925 to 1929, Stieglitz operated the Intimate Gallery, which focused on the work of American artists—notably Charles Demuth, Arthur Dove, Marsden Hartley, John Marin, and O'Keeffe—and also cutting-edge photography. Stieglitz ran his final gallery, An American Place, from 1929 until his death.

The Steerage (1907, Museum of Modern Art, New York) (see figure) is widely considered Stieglitz's most important photograph, and Stieglitz himself asserted, "If all my photographs were lost and I'd be represented by just one, *The Steerage,* I'd be satisfied" (Stieglitz, 197). Frequently misunderstood as a scene of immigration to the United States, *The Steerage* instead depicts a group of immigrants returning to their native countries. Nonetheless, this image of an immigrant voyage is one of Stieglitz's first "straight" photographs—the mode he would champion for the remainder of his life—wherein he did not manipulate or crop the negative. According to Stieglitz, the scene appealed to him for its formal qualities rather than its subject: "The whole scene fascinated me....A round straw hat, the funnel leaning left, the stairway leaning right, the white draw-bridge with its railing made of chains – white suspenders crossed on the back of a man below, round shapes of iron machinery, a mast cutting into the sky, making a triangular shape. I stood spellbound for a while....I saw shapes related to each other" (Ibid., 194–195). For Stieglitz, the subject mattered less here than the pictorial form. Therefore, that the woman near the center who wears what appears to be a *tallit,* or Jewish prayer shawl, is inconsequential. On the other hand, it may be possible to understand Stieglitz's initial attraction to the scene as related to his Jewishness.

In most scholarship, Stieglitz's Jewish roots are barely mentioned. Benita Eisler asserts that Stieglitz's preferred "identification with all things German helped to deflect questions of ethnic identity" (229) and that he was uncomfortable with his religious background. In a definitive text on modern art published in 1934, Thomas Craven did not describe Stieglitz as a great photographer but as "a Hoboken Jew without knowledge of, or interest in, the historical American background....hardly equipped for the leadership of a genuine American expression" (312). This kind of commentary may support Eisler's claim, for Stieglitz may very well have worried that anti-Semitism could have derailed his larger purpose as a tireless crusader for photography and modernism in his native country. While copious writings by Stieglitz survive, he remained quiet on the subject of Judaism. He did, however, feel that his ambitious, intense, and sometimes alienating personality ensued from his religiocultural heritage. As Stieglitz observed, "I'm beginning to feel it must be the Jew in me that is after all the key to my impossible make up" (Eisler, 229).[31]

Alfred Stieglitz, *The Steerage,* 1907. Photogravure, 12⅝ × 10 3/16 inches. Provenance unknown (436.1986). The Museum of Modern Art, New York. Digital Image © The Museum of Modern Art/Licensed by SCALA/Art Resource, New York. Art © 2006 The Georgia O'Keeffe Museum/Artists Rights Society (ARS), New York.

Over the years, Stieglitz mounted several exhibitions of his photography at his own galleries. In 1934, *America & Alfred Stieglitz: A Collective Portrait*—a collection of twenty-five essays by artists and critics—was published in honor of Stieglitz's seventieth birthday. Almost 1,600 photographs by Stieglitz are housed at the National Gallery of Art in Washington, D.C.

Bibliography

Coleman, A.D. "Breaking the Barriers" (The Century's 25 Most Influential Artists). *ARTnews* 98, no. 5 (May 1999): 150.

Craven, Thomas. *Modern Art: The Men, the Movements, the Meaning.* New York: Simon and Schuster, 1934.

Eisler, Benita. *O'Keeffe and Stieglitz: An American Romance.* New York: Doubleday, 1991.

Frank, Waldo David, Lewis Mumford, Dorothy Norman, Paul Rosenfeld, and Harold Rugg, eds. *America & Alfred Stieglitz: A Collective Portrait,* 1934. Rev. ed. Millerton, NY: Aperture, 1979.

Greenough, Sarah. *Modern Art and America: Alfred Stieglitz and His New York Galleries.* Washington, D.C.: National Gallery of Art, 2001.

———. *Alfred Stieglitz, The Key Set: The Alfred Stieglitz Collection of Photographs.* Washington, D.C.: National Gallery of Art; New York: Harry N. Abrams, 2002.

Greenough, Sarah and Juan Hamilton. *Alfred Stieglitz: Photographs and Writings.* 2nd edition. Washington, D.C.: National Gallery of Art; Boston: Bulfinch Press, 1999.

Homer, William Innes. *Alfred Stieglitz and the American Avant-Garde.* Boston: New York Graphic Society, 1977.

Lerner, Abram and Bartlett Cowdrey. "A Tape Recorded Interview with Abraham Walkowitz." *Archives of American Art Journal* 9, no. 1 (January 1969): 10–17.

Lowe, Sue Davidson. *Stieglitz: A Memoir/Biography.* New York: Farrar Straus and Giroux, 1983.

Norman, Dorothy. *Alfred Stieglitz: An American Seer.* New York: Random House, 1973.

Stieglitz, Alfred. *Stieglitz on Photography: His Selected Essay and Notes.* Compiled and annotated by Richard Whelan. New York: Aperture Foundation, 2000.

Whelan, Richard. *Alfred Stieglitz: A Biography.* Boston: Little, Brown and Company, 1995.

Selected Public Collections

Art Institute of Chicago
Detroit Institute of Arts
High Museum of Art, Atlanta
J. Paul Getty Museum, Los Angeles
Metropolitan Museum of Art, New York
National Gallery of Art, Washington, D.C.
Philadelphia Museum of Art
The Phillips Collection, Washington, D.C.

Paul Strand (1890–1976), photographer and filmmaker.

One of the most influential twentieth-century photographers, Paul Strand's black-and-white pictures of a remarkably diverse body of subjects—ranging from portraits to landscapes of locales around the world to machine parts—precisely portray reality with an immediacy and technical mastery of the medium that enabled him to capture subtleties of light, broad tones, and rich

textures. Articulate about his photographic credo, Strand published several articles about his ideology and technique. In 1917, Strand wrote in the magazine *Seven Arts* that the photographer must possess "a real respect for the thing in front of him expressed in terms of chiaroscuro...through a range of almost infinite tonal values which lie beyond the skill of human hand. The fullest realization of this is accomplished without tricks of process or manipulation through the use of straight photographic methods" (quoted in Tomkins, 142–143).

Born as Paul Stransky in New York City, his father gave him his first camera in 1902. While a student at the Ethical Culture School (1904–08), Strand took classes with Lewis W. Hine, a sociologist whose pictures of children working were instrumental in the enactment of child labor laws. Early on, Strand made soft-focus, pictorialist photographs, influenced by a class field trip with Hine to **Alfred Stieglitz**'s 291 Gallery where he saw other practitioners of the mode. The deliberately out-of-focus, moody *New York* (1913, J. Paul Getty Museum, Los Angeles)—a dreamy, tree-filled landscape—exemplifies this period of Strand's work. His later more straightforward approach was in part instigated by the Armory Show, where he saw the potential of modernist composition for his own medium and preferred subject: the recognizable world around him. This direct technique appealed to Stieglitz, who was working in the same mode, and the gallery owner gave Strand a solo exhibition at the 291 Gallery (1916) and also reproduced the younger artist's photographs in his magazine *Camera Work;* notably, the final issue of the journal (1917) concentrated solely on Strand.

Fascinated with New York City and its inhabitants, in the 1910s Strand took photographs with a false lens that enabled him to capture his subjects unaware. His psychologically acute portrait *Blind Woman, New York* (1916, Aperture Foundation) (see figure) presents an urban type with a sign reading "BLIND" hanging around her neck. Looking at a woman who cannot look back, Strand's picture approximates the ideology of the Ashcan School painters, who aimed to expose the realities of city life. Strand captured many qualities of his subject: her isolation and strength, as well as the physical characteristics of her features. At the same time, Strand was photographing spaces and places, often close-up. *New York* (1916, J. Paul Getty Museum, New York) portrays the city in a very different manner than his earlier photograph of his hometown. An angular image taken of the intersection of architectural elements, Strand aims here to explore shapes and diagonals, and the effects of light and shade on them. A brief stint in the Army Medical Corps (1918–19) as an X-ray technician briefly curtailed his artistic activities.

Strand's artistic concerns expanded to cinema in the early 1920s, when he collaborated with photographer and painter Charles Sheeler on *Manhatta* (1921), a silent, six-minute avant-garde film. His varied interests took him to New Mexico in 1926, where he returned on a few occasions in the early 1930s. New Mexico photographs, such as *Ghost Town, Red River, New Mexico* (1931, J. Paul Getty Museum, Los Angeles), focus on nature and the unique architecture and life of the West in compositions that defined subjects through light, shape, and texture.

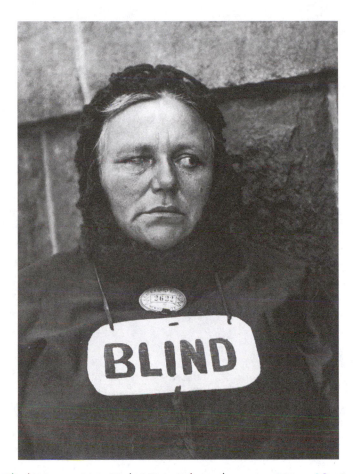

Paul Strand, *Blind Woman, New York,* 1916. Gelatin silver print, 13⅜ × 10⅛ inches. © 1971 Aperture Foundation, Inc., Paul Strand Archive.

At the same time that Strand's marriage fell apart in 1932, he and Stieglitz began to go their separate ways. Escaping this personal strife in New York, Strand traveled to Mexico, where he stayed for two years working as chief of cinema and photography for the Department of Fine Arts for the Secretariat of Education of Mexico. In Mexico, Strand photographed indigenous people, architecture, and the landscape, and also made a part-documentary, part-fictional government film, *Redes* (the English title is *The Wave*), about poor fisherman. After returning to New York City in late 1934, Strand devoted nearly the next ten years to filmmaking. His socially and politically conscious films, some made under the auspices of the nonprofit Frontier Films, for which Strand served as president (1937–42), included *Native Land* (1942), an ambitious film addressing civil rights issues and labor unions.

In 1943 Strand returned to still photography, taking a series of pictures in Vermont. Just two years later he enjoyed a solo exhibition at the Museum of Modern Art (MoMA). Disgusted by McCarthyism, in 1950 Strand moved to Europe, where he resided for the remainder of his life. Traveling extensively,

Strand recorded with his camera many settings and peoples, including the Italian village of Luzzara and its inhabitants (1953) and Egypt's sights and populace (1959), which yielded his publication *Living Egypt* (1969). Strand enjoyed a nearly 500 print retrospective at the Philadelphia Museum of Art (1971), accompanied by a two-volume book of his work, and a retrospective at MoMA and the Los Angeles County Museum of Art, the same year that he was elected a member of the American Academy of Arts and Science (1973). From 1950 until his death, Strand designed many thematic books of his photographs combined with text. He died in 1976 in France.

Strand's photographs and films show no overt evidence of his Jewish background, although it may be possible to argue that his interest in photography and film's capacity to affect change relates to *tikkun olam*.[32] In any case, Alan Trachtenberg notes Strand's religiocultural heritage and observes that he did gravitate to New York Jewish intellectuals, including Stieglitz, and also other such as Waldo Frank and Paul Rosenfeld. Trachtenberg also briefly suggests that Strand and other Jews in his circle, who "displaced [their] Jewishness" may have thus worked and lived as "ardent *Americans* in search of a culture to which they might belong" (Stange, 9).

Bibliography

Greenough, Sarah. *Paul Strand: An American Vision.* Washington, D.C.: National Gallery of Art, in association with Aperture Foundation, 1990.

Hambourg, Maria Morris. *Paul Strand, Circa 1916.* New York: Metropolitan Museum of Art; Distributed by Harry N. Abrams, Inc., 1998.

Lyden, Anne M. *Paul Strand: Photographs from the J. Paul Getty Museum.* Los Angeles: Getty Publications, 2005.

Stange, Maren. *Paul Strand: Essays on His Life and Work.* New York: Aperture, 1990.

Strand, Paul. *Time in New England.* Edited by Nancy Newhall. New York: Oxford University Press, 1950.

———. *Living Egypt.* Text by James Aldridge. Dresden: VEB Verlag der Kunst, 1969.

———. *Paul Strand: A Retrospective Monograph.* Two volumes. Millerton, NY: Aperture Books, 1971.

———. *Ghaha: An African Portrait.* Text by Basil Davidson. Millerton, NY: Aperture, 1976.

Tomkins, Calvin. *Paul Strand: Sixty Years of Photographs; Excerpts from Correspondence, Interviews, and Other Documents.* Millerton, NY: Aperture, 1976.

Selected Public Collections

Cleveland Museum of Art
Dallas Museum of Art
J. Paul Getty Museum, Los Angeles
Museum of Fine Arts, Santa Fe
National Galleries of Scotland, Edinburgh
National Portrait Gallery, Washington, D.C.
Philadelphia Museum of Art
San Francisco Museum of Modern Art

T

Jennings Tofel (1891–1959), painter, draftsman, and book illustrator.

A largely unknown artist who relied on bold, built-up colors to convey his personal and spiritual concerns, Jennings Tofel painted many biblical scenes in an expressionist fashion. Tofel was born as Yehuda Toflevicz in Tomachev, Poland, where he studied at *cheder* (religious school), aiming at one time to pursue Judaism as a career. This resolve was strengthened by an unfortunate childhood accident—Tofel fell from a loft in the family home—that left the artist with a curved spine that stunted his growth and caused his posture to be permanently stooped. His deformity seemed conducive to a life of solitude and scholarship, but such reflection instead impelled Tofel toward a desire for a more private expression. Ultimately, Tofel chose the visual arts as his outlet, and secondarily his writing, which took the form of diary entries, poems, and essays—many on art.

Tofel immigrated to New York at fourteen years old (1905) to escape pogroms. At that time, immigration officers changed Tofel's first name to Isadore. Several years later while Tofel was working as a bookkeeper for a company that did not employ Jews, an official at the firm changed Isadore to Jennings. Although preferring Jennings, Tofel did use Yehuda for essays that he published in Yiddish.

Tofel's interest in art did not begin until 1910, while he was studying at the College of the City of New York. Painting in the visionary vein of William Blake and the American Albert Pinkham Ryder, in 1917 Tofel publicly exhibited his work for the first time in a group exhibition called "Introspective Art" at the Whitney Studio Club (later to become the Whitney Museum of American Art). Two years later the primarily self-taught Tofel enjoyed his first one-person exhibition at the Bourgeois Galleries in New York. The show was a success, yielding sales and an extended run. Soon thereafter Tofel garnered the attention of **Alfred Stieglitz**, an important art dealer as well as a photographer. During the 1920s Stieglitz aided Tofel in the sale of his art, mostly landscapes and works inspired by his imagination. Stieglitz also wrote a laudatory introduction for the catalog of a 1931 exhibition of Tofel's work: "For those who, in its presence, recognize the eternal song, the paintings of Jennings Tofel must have a deep significance" (Jennings Tofel Papers, reel N68–36, frame 31).

In 1926 and 1927 the Jewish Art Center, founded and directed by Tofel and Benjamin Kopman, held exhibitions focusing on Yiddish art and culture,

including Tofel's own show (February 1927). Partially assisted by funds procured by Stieglitz, later in 1927 Tofel traveled abroad to Paris, where he enjoyed a successful one-person exhibition of twenty paintings at Galerie Zak (1928). After briefly returning to New York, Tofel secured additional monies for travel, again with the help of Stieglitz. During his second sojourn in Europe, Tofel decided to visit the country of his youth, and while in Poland he met the woman who he subsequently married. Over his year and a half abroad, Tofel's mature theme of biblical imagery emerged, in part inspired by the observant, Eastern European Jews he observed during his return to his birthplace. Purchased by the Whitney Museum in 1932, *Hagar* (1929) depicts the story of Abraham's handmaid who later became his wife in a manner so unspecific, in both dress and milieu, that without the title the viewer would most likely not recognize the subject. Moreover, some paintings of biblical stories receive ambiguous titles like *Biblical Theme.* Tofel's biblical paintings nearly always focus on the Hebrew Bible, and range in subject from *Jacob and the Angel* (1949, private collection, New York) to *Job* (1958, private collection).

Several years after Tofel and his new bride's return to New York in 1930, the impoverished artist began working for the Works Progress Administration (WPA) (1934). Under the auspices of the WPA, Tofel painted common social themes of the period in canvases such as *Lynching* (1936, private collection), a subject that also interested **Louis Lozowick** and **Harry Sternberg**. Retaining his heavy paint application, Tofel's *Lynching* presents a group of angry, energetic figures manhandling a resigned figure while the lynching rope hangs in the background. Many of Tofel's WPA paintings remained in the public domain after the project ended. Tofel, who was unhappy with the work, was pleased when a collector bought the remaining works and gave them to the artist, who immediately destroyed them.

The events of World War II compelled Tofel to address the Holocaust during the 1940s and 1950s (much of his wife's family perished at Treblinka), although his canvases on the subject still stem from fantasy and sometimes employ allegory. Two large nude figures and an ambiguous, mysterious animal fill the canvas *Beast of Buchenwald* (1947, private collection). Less explicitly, Tofel used the biblical story of Moses in *Moses and the Burning Bush* (1947, Harry N. Abrams Family Collection, New York) (see figure) to comment on the Holocaust. As Jeffrey R. Hayes observes, "the figure of Moses personifies leadership and deliverance from tyranny" (21). Indeed, an oversized Moses consumes the canvas with his bodily presence as disproportionately smaller, anguished figures flee the burning bush. The dark, earthen tones of *Hagar* give way in this later painting to brighter, contrasting colors of red, blue, and green. For Tofel, the merging of the imaginary with the real exemplified the ideal in art. In a 1917 manifesto written for a group show, "Introspective Painters," Tofel noted the importance of "the principles of beauty, order and the faculties of imagination and fancy. A work of art shall be abstracted from nature. Life shall enter it—indeed it must, but through the crucible of the artist's mind" (Powell, xcii). Through the 1950s, these works and others focusing on the

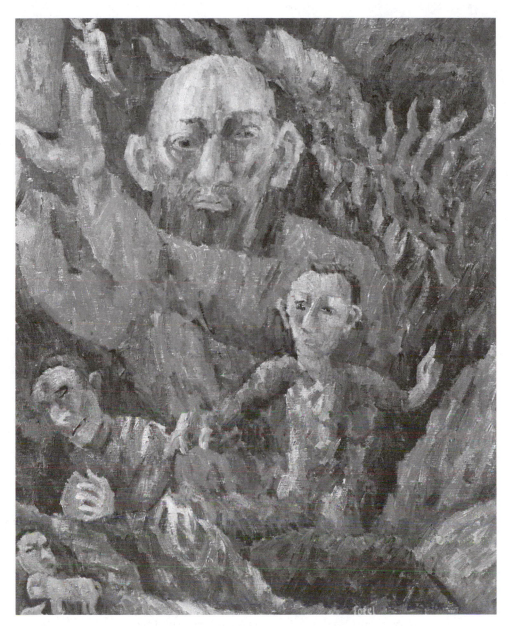

Jennings Tofel, *Moses and the Burning Bush,* 1947. Oil on canvas, 40 × 33 inches. Harry N. Abrams family collection, New York.

human figure and condition showed biennially at one-man shows at the Artists' Gallery in New York.

For a 1948 show at the Jewish Museum called "Jewish artists," Tofel addressed the issue of Jewish art in a catalog essay titled "Know Thyself—Be Thyself." It is worth quoting Tofel at length: "It is no mere figment of the imagination that Jewish artists will create, wherever they may live, a Jewish art. It is not possible, nor would it be salutary for their spiritual

well-being, for them to melt away in the general cultural stream. The Jewish artist, like any other, will become an artist in his own right only as his visions receive integration and direction, through whatever means, new or old, known or unknown; but one element in this integrative process is the deepest immersion in his heritage. It calls for an intensive study of Jewish *genre*, wherever it is found. It calls no less for an alignment with Jewish character, a character that, under the sorest trials, does not break but rises with new fervor and imagination to dedicate itself to its task" (*Jewish Artists*, unpaged).

Tofel wrote poetry and art criticism in Yiddish and English. Notably, the influential collector Katherine S. Dreier, president of the Société Anonyme, published a few of Tofel's essays in 1921 and 1923. Other art essays were published in the Yiddish periodical *Shriftn*. He also made pen illustrations for several books by David Ignatoff, a well-known Yiddish novelist, and delicate line drawings as independent works of art. In 1927, Tofel published two books in Yiddish: *Once There Was a Man* and *Kopman*, a book about his colleague Benjamin Kopman.

Bibliography

Baigell, Matthew. *Jewish Artists in New York.* New Brunswick, NJ: Rutgers University Press, 2002.

Davidson, Abraham A. *The Eccentrics and Other American Visionary Painters.* New York: E.P. Dutton, 1978.

Granick, Arthur. *Jennings Tofel.* Introduction by Alfred Werner. New York: Harry N. Abrams, 1976.

Hayes, Jeffrey R. *Jennings Tofel.* Mahwah, NJ: Ramapo College Art Gallery, 1983.

Jennings Tofel Papers. Archives of American Art, Smithsonian Institution, Washington, D.C.

Jewish Artists. New York: Jewish Museum, 1948.

Kampf, Avram. *Chagall to Kitaj: Jewish Experience in 20th Century Art.* New York: Praeger Publishers, 1990.

Powell, Edith W. "The Introspectives." *The International Studio* 61 (May 1917): xc–xciv.

Selected Public Collections

Butler Institute of American Art, Youngstown, Ohio
Hirshhorn Museum and Sculpture Garden, Washington, D.C.
Lowe Art Museum, University of Miami, Coral Gables, Florida
Neuberger Museum of Art, Purchase, New York
Rose Art Museum, Brandeis University, Waltham, Massachusetts
Smithsonian American Art Museum, Washington, D.C.
Tel Aviv Museum of Art, Israel
Whitney Museum of American Art, New York

W

Abraham Walkowitz (1878–1965), draftsman, painter, and printmaker.[33]

One of the earliest American propagators of European modernist developments, Abraham Walkowitz experimented with avant-garde styles while nearly always retaining the human figure. Several years after his father, a rabbi and cantor, died, Walkowitz, his mother, and siblings escaped pogroms in their native Siberia by immigrating to America. Arriving in 1889, the family settled on the Lower East Side of New York City amid other Jewish immigrants, an environment that would prove formative for Walkowitz's early artistic subjects.

Interested in art from childhood, Walkowitz took some art lessons at age fourteen, later pursuing a more rigorous, and traditional, art education at the National Academy of Design (1898–1900). While teaching at the Educational Alliance (1900–06), Walkowitz befriended **Jacob Epstein**, who was exploring similar interests: the life and people of New York City's Jewish ghetto. The pair published their drawings of pushcart peddlers and other characteristic scenes in local newspapers; some of Walkowitz's images in this vein were later published in a book titled *Faces from the Ghetto* (1946). Art historian Sheldon Reich describes Walkowitz's sensitive portrayals, such as *Head of a Rabbi* (c. 1905) (see figure), as "stemming from his Jewish heritage" (74).

Already attracted to newer techniques, with money saved up from his teaching Walkowitz traveled to Paris in 1906 to view the progressive tendencies of European artists and to study at the Académie Julian. During this time he met **Max Weber**, who became a lifelong friend and with whom Walkowitz shared his studio after Weber returned to America, and also renowned dancer Isadora Duncan. This formative meeting in Auguste Rodin's studio, followed by attendance at five of Duncan's performances from 1906 to 1916, greatly influenced Walkowitz's work. Inspired by her dance, Walkowitz initiated a series of watercolors and drawings of Duncan, numbering in the thousands, that he would continue for his entire life. Moreover, Duncan's flowing movements paralleled Walkowitz's artistic philosophy: to freely and spontaneously execute form by minimal yet fluid means. Walkowitz explained his approach in an artistic credo published in a 1947 book on Jewish artists in America: "I...try to find the concrete elements that are likely to record the sensation in visual forms, in the medium of lines, of color shapes, of space division. When the line and color are sensitized, they seem to me alive with the rhythm

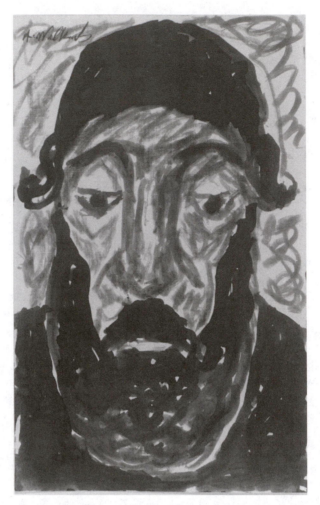

Abraham Walkowitz, *Head of a Rabbi,* c. 1905. Brush and black ink on cream wove paper, 8 7/8" × 5 5/12 inches. Princeton University Art Museum. Gift of Frank Jewett Mather, Jr. x1949-129. © 1970 Photo: Trustees of Princeton University.

which I felt in the thing that stimulated my imagination and my expression" (Lozowick, 190).

Although Walkowitz initiated his first one-man show at a frame shop (1908) after returning to the United States in late 1907, his most auspicious early exhibition occurred in 1912; after meeting **Alfred Stieglitz**, the famous gallery proprietor gave Walkowitz his first solo showing at the 291 Gallery (three additional one-person shows followed in 1913, 1915, and 1916). Until the close of 291 in 1917, Walkowitz and Stieglitz worked together closely; in an oral interview Walkowitz notes that he would spend twelve hours a day at 291 (Lerner and Cowdrey, 14) and that it was he who advised Stieglitz to show Georgia O'Keeffe's work at the gallery, and then hung it for him (Ibid., 15). During these years Walkowitz painted bathers, urban scenes, and landscapes—for example, *Bathers Resting* (1920, Columbus Museum of Art, Ohio)—influenced

by the flat, simplified forms and bright colors of the Post-Impressionists and Fauves. Indeed, Walkowitz was one of the first American artists to incorporate these avant-garde elements into his art. With eleven works selected for the Armory Show (1913), Walkowitz was widely accepted as an important modern; as early as 1925 a book was published with appreciations of him by important art critics, along with one hundred reproduced images.

Walkowitz's art became increasingly abstract as he absorbed additional modern styles. He delineated urban life in a Cubo-Futurist vein in watercolors and drawings; *Metropolis No. 2* (1923, Hirshhorn Museum and Sculpture Garden, Washington, D.C.) conceives of the city as a geometric entity delineated by thin lines. He also made completely abstract, biomorphic drawings, but it is unclear exactly when in his oeuvre these experiments first appeared. Unfortunately, as Reich points out, it is very difficult to understand Walkowitz's stylistic development because late in life he returned to many of his works and erratically postdated them (72). In an effort to promote his art, a number of Walkowitz's works were reproduced in his lifetime in five books, initiated by the artist himself in conjunction with the publisher Emanuel Haldeman-Julius.

After convincing one hundred painters and sculptors to make portraits of him in order to prove his hypothesis that "no matter what or who an artist paints, the artist always reveals himself," an exhibition of these works showed at the Brooklyn Museum in 1944. Among the artists who made portraits of Walkowitz were **Chaim Gross**, **Philip Evergood**, **Raphael Soyer**, **Harry Sternberg**, and his old friend Weber. Five years later the Jewish Museum mounted a retrospective of seventy paintings and drawings by Walkowitz (1949). Largely ignored by galleries and museums and forced to live with a benevolent niece since 1929 because of financial instability, by the late 1940s Walkowitz began to lose his sight to glaucoma and gave up painting. A few years prior to his death, Walkowitz received the distinguished elderly artist award from the American Academy of Arts and Letters (1962).

Bibliography

Homer, William Innes. *Abraham Walkowitz (1878-1965): Watercolors From 1905 through 1920 and Other Works on Paper.* New York: Zabriskie Gallery, 1994.

Lerner, Abram and Bartlett Cowdrey. "A Tape Recorded Interview with Abraham Walkowitz." *Archives of American Art Journal* 9, no. 1 (January 1969): 10–17.

Line Dance: Abraham Walkowitz's Drawings of Isadora Duncan. Newark: University Gallery, University of Delaware, 2000.

Lozowick, Louis. *One Hundred Contemporary American Jewish Painters and Sculptors.* New York: YKUF Art Section, 1947.

Reich, Sheldon. "Abraham Walkowitz, Pioneer of American Modernism." *American Art Journal* 3, no. 1 (Spring 1971): 72–82.

Sawin, Martica. *Abraham Walkowitz, 1878-1965.* Salt Lake City: Utah Museum of Fine Arts, 1975.

Smith, Kent. *Abraham Walkowitz, Figuration 1895-1945.* Long Beach, CA: Long Beach Museum of Art, 1982.

Stahl, Joan. "The Artist Always Reveals Himself." *American Art* 9, no. 3 (Fall 1995): 101–103.

Walkowitz, Abraham. *A Demonstration of Objective, Abstract, and Non-Objective Art.* Girard, KS: Haldeman-Julius Press, 1945.

———. *Isadora Duncan in Her Dances.* Girard, KS: Haldeman-Julius Press, 1945.

———. *Faces from the Ghetto.* New York: Machmadim Art Editions, Inc., 1946.

———. *Art, From Life to Life.* Girard, KS: Haldeman-Julius Press, 1951.

Werner, Alfred. "Abraham Walkowitz Rediscovered." *American Artist* 43, no. 445 (August 1979): 54–59, 82–83.

Selected Public Collections

Brooklyn Museum of Art, New York
Chrysler Museum of Art, Norfolk, Virginia
Delaware Art Museum, Wilmington
Los Angeles County Museum of Art
Museum of Fine Arts, Boston
Phoenix Art Museum
Smithsonian American Art Museum, Washington, D.C.
Whitney Museum of American Art, New York

Max Weber (1881–1961), painter, printmaker, and sculptor.

Max Weber, who was born in Bialystok, Russia to Orthodox, Yiddish-speaking parents, came a long way from his humble, foreign origins to his position, as described in his obituary in the *New York Times*, as "the dean of modern art in this country [who] fought and worked tirelessly to make modern art acceptable here" and "America's most distinguished painter" (37). Indeed, Weber was one of the first Americans to embrace modernist developments, and he was also one of the most consistent Jewish artists to paint scenes based on his religiocultural heritage. Matthew Baigell estimates Weber's output of Jewish subjects as around sixty ("Max Weber's Jewish Paintings," 342). In his autobiography, **William Zorach**, a good friend, described Weber's art as "not decoration but communication with deep religious and racial convictions" (134).

At ten years old, Weber immigrated with his family to the United States, settling in Brooklyn. For two years he studied at the Pratt Institute (1898–1900) with Arthur Wesley Dow. He taught in public schools in Lynchburg, Virginia (1901–03), and drawing and manual training at the State Normal School in Duluth, Minnesota (1903–05). With money earned from these jobs, Weber traveled to Paris in 1905, where he received additional training at the Académie Julian for four months (1905–06) and had the opportunity to view avant-garde developments first-hand. After seeing ten paintings by Paul Cézanne at the 1906 Salon d'Automne, Weber's style began to evolve; he became less concerned with detail and adopted a broader brushstroke. His portrait of artist, friend, and coreligionist **Abraham Walkowitz** (1907, Brooklyn Museum of Art, New York), who he met at the Académie Julian, reflects these changes. Studying also with Henri Matisse (1907), Weber adopted a brighter palette

and flattened, outlined forms. Weber initiated a friendship with Henri Rousseau, whose advice to paint from nature remained a guiding principle for the younger artist. The effect of Pablo Picasso's experimentations with Cubism, which Weber saw in the Spaniard's studio in Paris, manifested soon after his return to New York in 1909, following three years abroad.

With Walkowitz's help, Weber—whose work had shown in Paris—made his American debut at the same frame shop that Walkowitz had his initial exhibition (1909). Percy North believes that at this show Weber most likely exhibited the first Cubist painting in the United States ("Bringing Cubism to America," 69). Weber's one-man show at **Alfred Stieglitz**'s "291" Gallery in January 1911 showed more of his Cubist- and Fauvist-inspired works. After helping Stieglitz mount a show of Picasso's drawings and watercolors at 291 a few months later, the pair had a falling out. Zorach described Weber's relationship with Stieglitz in his autobiography: "Stieglitz had been most enthusiastic about Weber's work at first and exhibited it when Weber had first come back from Paris. But there was considerable jealousy in the little clique at '291.' Stieglitz had considered Weber his protégé. Stieglitz and Weber were both too egocentric and Weber couldn't be a protégé. Stieglitz was an impresario who took artists up as much for his own glory as he did to promote art or an individual artist. Weber sensed this and resented it" (134). Weber enjoyed several more one-person shows between 1910 and 1916. Most critics did not favorably review Weber's modernist work, and thus from 1916 to 1923 he rarely exhibited. Around 1923, Weber's art began to garner some support from critics, and in 1930 he was honored with a retrospective at New York's Museum of Modern Art (MoMA).

Paintings from the years after Weber returned from Paris were executed in a Cubo-Futurist fashion, on occasion accompanied by nonobjective sculpture in the same vein, such as *Spiral Rhythm* (1915, Hirshhorn Museum and Sculpture Garden, Washington, D.C.), one of approximately thirty sculptures in his oeuvre. A typical Cubist painting by Weber, *Rush Hour, New York* (1915, National Gallery of Art, Washington, D.C.) is a dynamic image composed of geometric forms that approximate the energy and motion of city life in a restricted palette. Around 1919, Weber eschewed Cubism.

Weber's Jewish paintings, which he began around 1918, explore a limited subject matter, mostly traditional Jews—often rabbis—studying and praying. Baigell reads these images as a nostalgic witnessing and memorializing of Hasidic piety in an increasingly secularized Jewish American environment as well as a celebration of Judaism even in confrontation with Nazi oppression (*Jewish Artists in New York*, 23, 25). No evidence exists to explain why Weber's interest in Jewish subjects surfaced at this time or why he continued to work on such material. As to his own personal religious practice, Weber remained kosher throughout his life and considered himself Orthodox, although he did not consistently attend synagogue. Instead the artist avowed, "my studio is my synagogue" (Werner, 23). His Jewish images display his interest in various styles. *Invocation* (1918, Vatican Museum, Vatican City) shows three scholars studying at a table painted in a Cubist manner. Weber described the painting in a note for his MoMA show: "Sculpturesque, dynamic form was sought for

in this picture, but the chief aim was to express a deep religious archaic spirit in fitting attitudes and gestures" (Barr, 21). *The Talmudists* (1934, Jewish Museum, New York) portrays several scholars sitting around a table studying, with others in the background conversing enthusiastically about their subject matter. Painted in earthy hues, Weber's figures begin to show aspects of the artist's emerging expressionistic tendencies, which continued to evolve for the remainder of his career and for some exemplify Weber's signature work. Weber described this painting in an article for the Jewish periodical *The Menorah Journal:* "I was prompted to paint 'Talmudists' in the winter of 1934 after a pilgrimage to one of the oldest synagogues of the East Side in New York. I find a living spiritual beauty emanates from, and hovers over and about, a group of Jewish patriarchal types when they congregate in search of wisdom in the teaching of the great Talmudists of the past" (Weber, "A Note on 'Talmudists,'" 100).

To be sure, following his Cubist experimentations, Weber's work became increasingly expressionistic, whether his subjects were still lifes, Jewish imagery, or even a brief foray into Social Realist matter during the Great Depression. Rendered with restless, energetic lines, the highly expressionistic

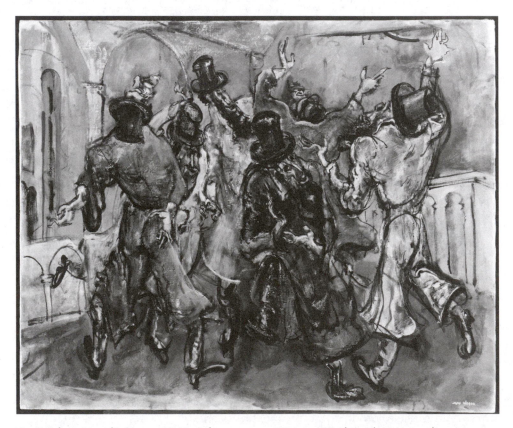

Max Weber, *Hasidic Dance,* 1940. Oil on canvas, 32¼ × 40 inches. The Metropolitan Museum of Art, New York. Edith and Milton Lowenthal Collection, Bequest of Edith Abrahamson Lowenthal, 1991 (1992.24.6). Image © The Metropolitan Museum of Art.

Hasidic Dance (1940, Metropolitan Museum of Art, New York) (see figure) depicts several men dancing joyously and gesturing emphatically as they express the ecstatic emotions of their religious fervor. From 1950 on, Weber abandoned Jewish scenes.

Also inclined to articulating his ideas in print, in the late teens, Weber published articles and poems, sometimes accompanied by the artist's woodcuts, in the Yiddish journal *Shriftn*. Other publications include *Cubist Poems* (1914), *Essays on Art* (1916)—a small volume based on lectures that Weber gave at the White School of Photography in New York—and *Primitives* (1919), a book of poems and eleven woodcuts. The Whitney Museum of American Art held a Weber retrospective in 1949, and in 1957 he was honored with a Doctor of Humane Letters degree from Brandeis University, the same year that he had a large retrospective at the Newark Museum.

Bibliography

Baigell, Matthew. "Max Weber's Jewish Paintings." *American Jewish History* 88, no. 3 (September 2000): 341–360.

———. *Jewish Artists in New York: The Holocaust Years.* New Brunswick, NJ: Rutgers University Press, 2002.

Barr, Alfred H., Jr. *Max Weber: Retrospective Exhibition, 1907-1930.* New York: Plandome Press, Inc., 1930.

"Max Weber Dies; Painter, Was 80" (obituary). *New York Times* (October 5, 1961): 37.

North, Percy. *Max Weber: American Modern.* New York: Jewish Museum, 1982.

———. *Max Weber: The Cubist Decade: 1910-1920.* Introduction by Susan Krane. Atlanta: High Museum of Art, 1991.

———. "Bringing Cubism to America: Max Weber and Pablo Picasso." *American Art* 14, no. 3 (Fall 2000): 58–77.

Rubenstein, Daryl R. *Max Weber: A Catalogue Raisonné of his Graphic Work.* Foreword by Alan Fern. Chicago: University of Chicago Press, 1980.

Tarbell, Roberta K. "Max Weber: The Cubist Decade, 1910-1920." *American Art Review* 5 (Winter 1993): 132–139.

Weber, Max. *Cubist Poems.* London: Elkin Mathews, 1914.

———. *Essays on Art.* New York: William Edwin Rudge, 1916.

———. *Primitives: Poems and Woodcuts.* New York: Spiral Press, 1926.

———. "A Note on 'Talmudists.'" *The Menorah Journal* 23, no. 1 (April–June 1935): 100.

———. *Max Weber.* New York: American Artists Group, 1945.

Werner, Albert. *Max Weber.* New York: Harry N. Abrams, Publishers, Inc., 1975.

Zorach, William. *Art is My Life: The Autobiography of William Zorach.* Cleveland: World Publishing Company, 1967.

Selected Public Collections

Hirshhorn Museum and Sculpture Garden, Washington, D.C.
Jewish Museum, New York
Los Angeles County Museum of Art
Metropolitan Museum of Art, New York

Museum of Fine Arts, Boston
National Gallery of Art, Washington, D.C.
Walker Art Center, Minneapolis, Minnesota
Whitney Museum of American Art, New York

Weegee (Arthur Fellig) (1899–1968), photographer.

A photojournalist chronicling crime and disaster, Weegee specialized in capturing the effects of these tragedies on the people of New York, which he subsequently sold to newspapers and tabloids. Weegee's sensationalized, lurid, nocturnal pictures of bloody corpses, distraught tenement dwellers watching their meager homes engulf in flames, car accidents, and additional agonies—as well as his other photographic subjects—number in the thousands; 5,000 negatives and around 15,000 prints were counted after his death (Talmey, 7). Anticipating Andy Warhol, Weegee cultivated a cult of personality that became synonymous with his name. With mussed up hair sometimes covered by a fedora, rumpled, oversized clothes, unshaven face and a cigar in his mouth, with his signature Speed Graphic camera in hand, Weegee became a popular celebrity first in New York and then nationally. His marketing of self included a special wet stamp for his pictures, "Credit Photo By Weegee the Famous," and the publication of an aggrandizing (therefore not always reliable) autobiography, *Weegee by Weegee*, described on the dust jacket as a book about "The World's Zaniest Photographer" (1961).

Born as Usher H. Fellig in Austria, he arrived in the United States in 1910, whereupon an immigration officer changed his first name to Arthur. Settling on the Lower East Side of Manhattan, by 1913 Weegee dropped out of school to help support his impoverished, religious family, at that time living on the insufficient proceeds from his father's pushcart peddling and intermittent work as a rabbi. Weegee held a series of odd jobs, including his first in the photography field as an assistant to an itinerant photographer who took tintypes of children sitting on a pony. In the early 1920s, Weegee began working part-time in the darkroom of the *New York Times*, and around twenty-four years old he gained full-time employment in a darkroom at Acme Newspictures; on nights when a photographer was unavailable to cover a story Weegee would be dispatched. Unhappy with the attribution of his pictures to Acme rather than specifically crediting the photographer, in 1935 Weegee started freelancing, contributing his signature black-and-white, high contrast pictures to the *New York Times*, *Daily News*, and *PM*, among other papers. Some of the papers owned syndicates and so Weegee's pictures were seen nationwide.

He possessed an uncanny gift for arriving at crime scenes along with the police, an ability that earned him the moniker Weegee (1938), after the Ouija board.[34] This skill was undoubtedly aided by the shortwave police radio installed in his car from 1938 onward, and the proximity of his apartment to

the police station, which was across the street. His seamy pictures captured the underworld in lurid vividness. *Murder in Hell's Kitchen* (1942, J. Paul Getty Museum, Los Angeles), also known as *Off Duty Cop Does Duty, Kills Gunman Who Tries Stickup,* records the grim late-night murder of a man in a suit, laying face down in a pool of blood.[35] The background is dark, with the subject's face accentuated by brighter light. Vertically oriented, the gun is closer in vantage point to the viewer than the corpse. Weegee's initial solo exhibition at the Photo League (1941) was appropriately titled "Weegee: Murder Is My Business."

Naked City, the first of several books combining Weegee's pictures and short bits of text, was published in 1945. Including 18 chapters and 229 images, the book was so popular (it went through six printings in the first six months after it was released) that Universal bought the rights to it. A film of the same name was subsequently produced (1948), with Weegee as an extra in a film noir vision of the gritty city filmed on location. Weegee enjoyed a brief movie career, playing small roles that suited his experience, such as street photographer and derelict. He also provided technical advice for a number of films after his 1947 move to Hollywood. Most famously, Weegee consulted on special effects for Stanley Kubrick's *Dr. Strangelove* (1963).

Weegee's interest in the emotions and circumstances of people experiencing extremes also compelled him to chronicle the life of the poor and the rich, and those on the margins. One of his best-known photographs, *The Critic* (1943, J. Paul Getty Museum, Los Angeles), was taken outside the Metropolitan Opera on opening night of the season. Showing two bejeweled, tiara-clad, high society women after they emerged from their limousine, Weegee captured Mrs. George Washington Kavanaugh and Lady Decies as middle-aged, privileged, smug teetotalers by photographing them with infrared film.[36] Infrared film served two purposes: the pair would not be alerted to his candid shot by a flash and it also provided light that emphasized the garish makeup of the pair. Initially appearing in *Life* magazine, the picture was also included in the show *50 Photographs by 50 Photographers* at New York's Museum of Modern Art (1948).

As a poor immigrant from the Jewishly populated Lower East Side, Weegee was also attracted to others experiencing similar conditions. Among his Jewish-themed photographs are *Cafeteria on East Broadway* (1941, International Center of Photography, New York), a shot of several Orthodox Jewish men in a diner with a neon Star of David in the window; *Rehearsal, Yiddish Theater* (1945, International Center of Photography, New York), a shot of a middle-aged couple dancing on stage; and *Someone Rushed in and Saved the Holy Scrolls from the Synagogue* (1943, International Center of Photography, New York) (see figure). This last work includes many of the elements so important to Weegee's conception. A night scene, Weegee directly captures the immediacy of emotions during a tension-filled, human interest moment as two religious men embracing their sacred Torahs rush down a New York street. His second book, *Weegee's People* (1946), contains human interest shots like these (the first two are in the book), and others of New Yorkers in the bowery sleeping on park benches and in cheap hotels,

Weegee, *Someone Rushed in and Saved the Holy Scrolls from the Synagogue, March 2, 1943*, 1943. Photograph. Photo courtesy of Weegee/International Center of Photography/Getty Images.

trying to stay cool on the beaches of Coney Island amid the oppressive heat of the city, and so forth.[37] Some of Weegee's photographs, such as *The Gay Deceiver* (also called *Transvestite*) (c. 1939, J. Paul Getty Museum, Los Angeles) and *Shorty, the Bowery Cherub* (1942, J. Paul Getty Museum, Los Angeles), picturing a nearly nude dwarf wearing a new year's hat, anticipate the work of **Diane Arbus**.

After settling in Hollywood, Weegee ceased making documentary photographs, instead taking pictures of celebrities and working on his "distortions," the technique he focused on from 1945 until his death. Using kaleidoscopes, mirrors, and curved glass near his camera lens, as well as other techniques, Weegee's distortions exaggerated and altered his subjects to the point of caricature, including Marilyn Monroe and Pablo Picasso. Colin Westerbeck connects Weegee's crime photographs of distressed people and the subsequent distortions, understanding them as "grotesques" (Keller, 128).

Weegee returned to New York in 1952. In addition to his widely acclaimed image-text books and his autobiography, Weegee published how-to manuals for photographers. His prodigious output numbers eleven books, including the posthumously published *The Village* (1989). He also made eight short films. The first, *Manhattan Moods* (1946), which ran sixteen minutes, shows Coney

Island in a distorted fashion and night views of Manhattan. Two years later, Weegee lengthened the film to twenty minutes and renamed it *Weegee's New York*.

Widely recognized as one of the most influential and important freelance journalists, in many ways Weegee the Famous lived up to the hype he provided for himself. Reflecting in his autobiography, Weegee unabashedly observed: "I have inspired many persons to take up photography. As a matter of fact, I inspire myself. . . .I am married to my camera. I belong to the world" (152–153).

Bibliography

Barth, Miles, ed. *Weegee's World*. Boston: Little, Brown and Company in association with the International Center of Photography, 1997.

Coplans, John. "Weegee the Famous." *Art in America* 65, no. 5 (September–October 1977): 37–41.

Keller, Judith. *Weegee: Photographs from the J. Paul Getty Museum*. Los Angeles: J. Paul Getty Museum, 2005.

Talmey, Allene. *Weegee*. Millerton, NY: Aperture, 1978.

Weegee. *Naked City*. New York: Duell, Sloan and Pearce/Essential Books, 1945.

———. *Weegee's People*. New York: Duell, Sloan and Pearce/Essential Books, 1946.

———. *Weegee's Secrets of Shooting with Photo Flash as Told to Mel Harris*. New York: Hartis Publishers, 1953.

———. *Weegee by Weegee: An Autobiography*. 1961. Reprint, New York: Da Capo Press, Inc., 1975.

———. *The Village*. New York: Da Capo Press, 1989.

Weegee and Gerry Speck. *Weegee's Creative Photography*. London: Ward, Lock, and Co., 1964.

Weegee and Mel Harris. *Naked Hollywood*. New York: Pelligrini and Cudahy, 1953.

Weegee and Roy Ald. *Weegee's Creative Camera*. Garden City, NJ: Hanover House, 1959.

Selected Public Collections

Art Institute of Chicago
International Center of Photography, New York
J. Paul Getty Museum, Los Angeles
Los Angeles County Museum of Art
Museum of Fine Arts, Boston
Museum of Modern Art, New York
San Francisco Museum of Modern Art
Smithsonian American Art Museum, Washington, D.C.

Garry Winograd (1928–84), photographer.

Eschewing the socially conscious photographs of his time for a vernacular body of images that are less interested in describing the world they portray than the form of the world as captured in his frame, the inexhaustible

Garry Winogrand made tens of thousands of black-and-white photographs "exploring the uniquely prejudicial (intrinsic) qualities of photographic description" (Szarkowski, *Mirrors and Windows,* 23–24). In an oft-quoted sentence, Winogrand remarked, "I photograph to find out what something will look like photographed" (Longwell, 4). Later, also instructively, he explained that his greater interest was in "the fact of putting four edges around a collection of information or [how] facts transforms [*sic*] it. A photograph is not what was photographed, it's something else....It's about transformation....The photograph should be more interesting or more beautiful than what was photographed" (Diamonstein, 181, 185, 187). Winogrand's photographs of New York City's streets and beyond, most notably of zoos, airports, and the rodeo, are all subjects that appealed to his interest in crowds, movement, and energy, which he frequently captured by tilting his camera when snapping pictures. Taken with a quick-shooting Leica, the subsequent chaotic, crooked images sometimes convey the appearance that his subjects are slipping out of the shot.

Winogrand was influenced particularly by Walker Evans' book *American Photographs* (1938), which showed him how to make intelligent pictures, and **Robert Frank**'s more contemporaneous book *The Americans* (1959). In a short essay, Winogrand described Evans' effect on him: "The photographs in the book taught me to love photographs and photography, like no other photographs I had seen up to that time....Walker Evans' photographs are physical evidence of the highest order of photographic intelligence. His photographs do not kowtow to anybody's idea of how photographs should look. The photographs are about what is photographed, and how what is photographed is changed by being photographed and how things exist in photographs" (Evans, unpaged). In this short excerpt about another photographer, Winogrand summarized his own artistic philosophy.

Winogrand was born in the Bronx. Following a stint in the Army Air Force (1946–47) as a weather forecaster in Georgia, he studied under the G.I. Bill at the City College of New York (1947–48). During the fall of 1948 he took a painting class at Columbia University, where his interest in photography was piqued after entering a darkroom. On a scholarship at the New School for Social Research, Winogrand studied photography with Alexey Brodovitch, art director at *Harper's Bazaar* (Brodovitch also mentored **Irving Penn** and **Richard Avedon**). By 1951, Winogrand was freelancing for commercial magazines, including *Harper's Bazaar*. Two of his photographs were included in the Museum of Modern Art's (MoMA) legendary *Family of Man* exhibition (1955), a show composed of over 500 photographs from sixty-eight countries and in its time the most popular exhibition in the history of photography. In 1960 Winogrand enjoyed his first one-person show, and in 1967 Winogrand's work showed with that of **Diane Arbus** and **Lee Friedlander** (a close friend and an artist with a similar purpose) at MoMA's seminal *New Documents* exhibition.

The 1960s were an extremely busy decade for Winogrand, who codified his approach to picture-making and explored a variety of subjects. From the early 1960s, New York's city streets were firmly entrenched as Winogrand's favorite

theme. While supporting himself by taking pictures for advertising agencies, he focused particularly on attractive women in Manhattan. *New York City* (1968, Center for Creative Photography, Tucson) depicts a woman laughing with her head titled back. Holding a half-eaten ice cream cone in one hand, as well as gloves, a coat, and a purse, the woman stands in front of a store window. In the window the viewer sees reflections of other people on the street, captured in the picture frame on a slight angle. The fascination of the picture is more about the interesting relationship between the main figure in the composition and the headless, suit-wearing manikin in the window, as well as the other various city elements, than the meaning behind why the woman is laughing or who she may be. A selection of Winogrand's women pictures was later published in *Women are Beautiful* (1975), a commercial failure. A John Simon Guggenheim Foundation Fellowship in 1964 (two more followed, in 1969 and 1978) took Winogrand to Texas, Colorado, California, and New York where he shot 20,000 exposures of film. Deemed by Winogrand as generally unsuccessful, this period of experimentation was at the same time an important turning point for the partially self-taught photographer who was defining his aesthetic.

Arguably the most interesting project of the decade was instigated by Winogrand's separation from his first wife in 1963. At this time, Winogrand began taking his young children to the Central Park Zoo. What began as casual family pictures spurred an idea that resulted in his first book, *The Animals* (1969). The forty-six images in *The Animals* acknowledge that indeed the animals photographed were in captivity by including the bars of the cages, an integral part of several images, and the presence of humans. In *New York* (c. 1961, Center for Creative Photography, Tucson) (see figure), for example, Winogrand explores the interaction between the animal and the human onlooker, or rather the disinterest of both parties. His children hang upside down on the railings in front of the rhinoceros cage, to their left a young couple stands by the railing—one watching the children and the other the rhinoceroses—and a third figure snaps a picture of the animals. In the cage, one rhinoceros turns his back to the onlookers and the other glances at the humans halfheartedly. The book was not well received by the general public, accustomed to pictures that show animals as heroic and not encumbered by cages, and was for the most part ignored by critics. In his lifetime, Winogrand never quite mastered the art of photography books, unlike Friedlander's success in this realm.

Having taught at several venues in an adjunct and visiting capacity, in 1973 Winogrand moved to Austin to join the full-time faculty at the University of Texas, where he remained until 1978. While in Texas, Winogrand published *Public Relations* (1977), a compendium of photographs funded by a 1969 Guggenheim grant. The pictures in *Public Relations* do not aim to chronicle the actual events he attended, but "the effect of media on events" to use the artist's words from his Guggenheim application (Szarkowski, *Winogrand*, 32). In other words, Winogrand showed how news is made rather than actively reporting, or succumbing to, a media-constructed message. Once again, the book was poorly received. Winogrand spent the remainder of his short life in California, where he resided beginning in 1978. At his death, over 2,500 rolls

Garry Winogrand, *New York,* c. 1961. Center for Creative Photography, The University of Arizona, Tucson. © Estate of Garry Winogrand.

of undeveloped film were discovered. MoMA mounted a large posthumous retrospective in 1988.

Bibliography

Evans, Walker. *Walker Evans: Photographs from the* Let Us Now Praise Famous Men *Project.* Austin: University of Texas, 1974.

Fraenkel, Jeffrey and Frish Brandt, eds. *The Man in the Crowd: The Uneasy Streets of Garry Winogrand.* Introduction by Fran Lebowitz; Essay by Ben Lifson. San Francisco: Fraenkel Gallery in association with D.A.P./Distributed Art Publishers, 1999.

Harris, Alex and Lee Friedlander, eds. *Arrivals & Departures: The Airport Pictures of Garry Winogrand.* New York: D.A.P./Distributed Art Publishers, 2002.

Longwell, Dennis, ed. "Monkeys Make the Problem More Difficult: A Collective Interview with Garry Winogrand." *Image* 15, no. 2 (July 1972): 1–14.

Stack, Trudy Wilner. *Winogrand 1964.* Santa Fe, NM: Arena Editions, 2002.

Szarkowski, John. *Mirrors and Windows: American Photography Since 1960.* New York: Museum of Modern Art, 1978.

———. *Winogrand: Figments from the Real World.* New York: Museum of Modern Art, 1988.

Winogrand, Garry. *The Animals.* Afterword by John Szarkowski. New York: Museum of Modern Art, 1969.

———. *Women are Beautiful.* Essay by Helen Gary Bishop. New York: Light Gallery Books, 1975.

———. *Public Relations.* Introduction by Tod Papageorge. New York: Museum of Modern Art, 1977.

————. *Stock Photographs: The Fort Worth Fat Stock Show and Rodeo.* Austin: University of Texas Press, 1980.

————. Interview with Barbaralee Diamonstein. In *Visions and Images: American Photographers on Photography.* New York: Rizzoli International Publications, Inc., 1981. 179–191.

Selected Public Collections

Corcoran Gallery of Art, Washington, D.C.
Fotomuseum Winterthur, Switzerland
J. Paul Getty Museum, Los Angeles
Kemper Museum of Contemporary Art, Kansas City, Missouri
Metropolitan Museum of Art, New York
Museum of Fine Arts, Boston
San Francisco Museum of Modern Art
Smithsonian American Art Museum, Washington, D.C.

Z

William Zorach (1887–1966), sculptor and painter.

A sculptor who engaged in the laborious process of carving wood and stone, Zorach Samovich was a pioneer in the twentieth-century American revival of the art of wood sculpture. He immigrated with his parents to the United States in 1891 because, the artist explained in his autobiography, in Lithuania "Jewish families had no rights and they dreaded having their sons drafted into the army....I don't know that we suffered from persecution, but there was always terror of it in our minds" (*Art is My Life*, 4).[38] Upon settling in Ohio, the religious, Yiddish-speaking family adopted the surname Finkelstein. Zorach only completed school through the seventh grade (during which time a teacher dubbed him William), forced into working because of the family's impoverishment. He studied lithography in the evenings at the Cleveland School of Art (1903–06) and soon began earning a wage as a commercial lithographer. After he had saved some money, Zorach moved to New York City in 1908 where he received two years of additional training at the National Academy of Design (1908–10). Again funded by money earned from his work as a lithographer, Zorach went to Paris to study painting at La Palette in 1910. In Paris, Zorach met Marguerite Thompson, an American also studying at La Palette. Thompson's influence, as well as the avant-garde atmosphere in France, impacted Zorach's painting style, which became Fauvist in conception. Four of his colorful paintings were first exhibited publicly at the Salon d'Automne in 1911 before financial circumstances forced Zorach back to Cleveland late that year. By December 1912 he had earned enough money as a lithographer to return to New York, at which time he and Thompson married and assumed the surname Zorach. His paintings, which he exhibited at the revolutionary Armory Show (1913), remained Fauvist-inspired until around 1916, when Zorach began working in a Cubist idiom. During the years 1915–1918, Zorach and his wife showed their work jointly at three exhibitions at New York's Daniel Gallery.

While working on a series of woodblock prints in the summer of 1917, Zorach made his first sculpture out of one of the butternut panels. A fourteen-inch stylized woman carved in relief titled *Waterfall* (private collection), the sculpture was one of twelve wood pieces that Zorach made between the years 1917 and 1922, when he gave up painting entirely to focus on three-dimensions. Early sculptures were angular in conception, akin to

the Cubist style of his canvases, and also influenced by non-Western art. As Zorach explained: "I owe most to the great periods of primitive carving in the past—not to the moderns or to the classical Greeks, but to the Africans, the Persians, the Mesopotamians, the archaic Greeks and of course to the Africans" (Baur, 18). Soon Zorach embraced the more rounded, simplified, classicized forms for which he is best known in directly carved works such as the thirty-one-inch tall mahogany *Mother and Child* (1922, private collection), shown at his first solo exhibition of sculpture held at the Kraushaar Galleries in New York (1924). Several of Zorach's sculptures focus on mothers and children because, as the artist explained, "every artist throughout history has expressed himself through a life motif. I have chosen the mother and child....It is the embodiment and expression of the love of man for his family" (*Art is My Life*, 85). Carved out of a three-ton block of marble, the sixty-five-inch tall *Mother and Child* (1927–30, Metropolitan Museum of Art, New York) is a classicized version of the theme that utilized distortion to emphasize the bond between the figures. Considered by Zorach to be his finest sculpture, it won a $1500 prize from the Art Institute of Chicago in 1931 and entered the collection of the Metropolitan Museum of Art in 1955. From this period on Zorach's work was exhibited regularly at various public venues. Notably, Zorach's paintings, sculptures, watercolors, and drawings were shown at a retrospective exhibition at the Whitney Museum of American Art in 1959.

He executed several public commissions, including *The Spirit of the Dance* (1932) for Radio City Music Hall. Modeled in clay and then cast in aluminum, the sculpture of a female kneeling at the end of a performance appears in the nude. Initially rejected because of a controversy over the figure's nudity, the sculpture was ultimately installed, although in a less auspicious location then originally planned. Late in the decade, Zorach made an over-lifesize pink marble full-length statue of Benjamin Franklin (1936–37) for the Benjamin Franklin Post Office in Washington, D.C. on commission from the Treasury Department Art Projects Committee, and a sixteen-foot tall group sculpture, *Builders of the Future*, for the 1939 World's Fair. Upon request, Zorach submitted a plan for a proposed memorial for the Jews who died in the Holocaust. Although the memorial, planned for Riverside Drive in New York, never materialized, a plaster model survives (1949, Zorach family collection) (see figures). Designed to be viewed in the round, on one side of the tombstone-shaped pedestal topped by a menorah stands a woman protecting her child and on the other side a man looks beseechingly upward to heaven.

From 1913 until his death, Zorach and his wife summered in the country and lived the other months of the year in New York City. The summer of 1916 found Zorach and Marguerite in Provincetown, Massachusetts painting and designing scenery for the Provincetown Players. For the remainder of their life together extended summers—sometimes up to six months—were spent in various venues, particularly Robinhood, Maine beginning in 1923. During the

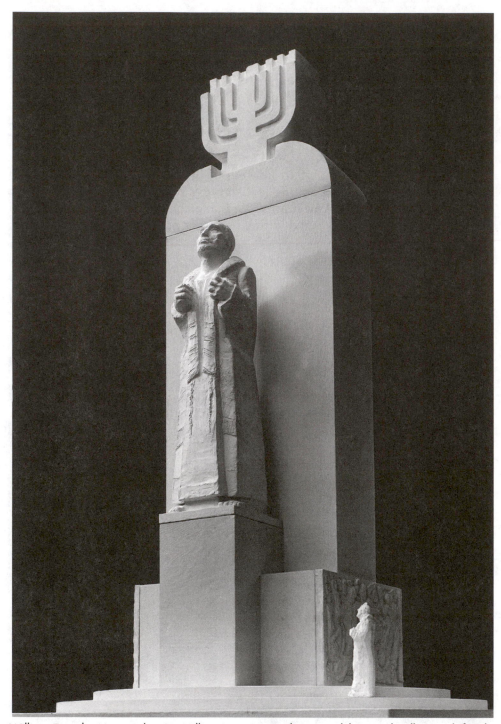

William Zorach, *Memorial to Six Million Jews,* 1949. Plaster model, 36-inch tall. Zorach family collection. Photo courtesy of Jonathan Zorach.

summers Zorach produced many watercolors in addition to his sculpture and also had art students living with him and Marguerite.

Zorach taught at the Art Students League (1929–60) for thirty years and at Columbia University (1932–35), among other institutions. He wrote articles on art and two books: a primer on making sculpture complimented by photographs of Zorach at work and pictures of his 1927–30 *Mother and Child* at various stages of completion, and his autobiography, posthumously published a year after his death. Commenting on nationalism in art during a debate at the Whitney Museum in 1932, Zorach briefly addressed the quandary of Jewish art: "When I speak of national art I do not mean the superficial concern with immediate surroundings. Painting Jewish types does not create a Jewish art, nor concentration on the American scene make an American artist. The artist himself should not be concerned with whether or not he is creating American art, but if his roots are firmly planted in the soil, its flavor will permeate his work no matter what subject or forms he uses" ("The Debate," 21).

Bibliography

Baur, John I.H. *William Zorach.* New York: Frederick A. Praeger, Publishers, 1959.

Brenner, Anita. "Zorach and Modern Art." *Menorah Journal* 16 (1929): 322–332.

"The Debate." *Art Digest* 6, no. 15 (March 15, 1932): 15, 21–22.

Grossman, Emery. *Art and Tradition.* New York: Thomas Yoseloff, 1967.

Nicoll, Jessica. *Marguerite and William Zorach: Harmonies and Contrasts.* Portland, ME: Portland Museum of Art, 2001.

Tarbell, Roberta K. "William Zorach's Reclining Figures." *Archives of American Art Journal* 15 (1975): 3–10.

———. *Catalogue Raisonné of William Zorach's Carved Sculpture.* Ph.D. dissertation, University of Delaware, 1976.

———. *Vanguard American Sculpture.* New Brunswick, NJ: Rutgers University Art Gallery, 1979.

Wingert, Paul S. *The Sculpture of William Zorach.* New York: Pitman Publishing Corporation, 1938.

Zorach, William. *Zorach Explains Sculpture: What It Means and How It Is Made.* New York: Tudor Publishing Company, 1960.

———. *Art is My Life: The Autobiography of William Zorach.* Cleveland: World Publishing Company, 1967.

Selected Public Collections

Israel Museum, Jerusalem
Los Angeles County Museum of Art
Metropolitan Museum of Art, New York
Museum of Fine Arts, Boston
Philadelphia Museum of Art
San Francisco Museum of Modern Art
Smithsonian American Art Museum, Washington, D.C.
Whitney Museum of American Art, New York

Notes

1. As of yet no full-length text exists on the history of Jewish American art and artists. The material that follows is drawn from my own research; Louis Lozowick's introduction to the initial book on Jewish American artists; Joseph Gutmann's pioneering essay "Jewish Participation in the Visual Arts of Eighteenth- and Nineteenth-Century America"; and the important work of Matthew Baigell, especially his essay written for the exhibition catalog *Painting a Place in America*. Unfortunately, Baigell's *American Artists, Jewish Images* (Syracuse: Syracuse University Press, 2006) did not come out in time for consultation for this book.

2. For a critical examination of the effect of the Second Commandment on Jewish art, see Gutmann's classic article, "The 'Second Commandment' and the Image in Judaism." Gutmann accurately refutes the pervasive stance that Judaism is strictly anti-iconic. Bland's intellectual history, *The Artless Jew*, demonstrates that the belief that Jews are iconophobic is steeped, somewhat, in anti-Semitic perceptions and modern constructions of Jewish creativity. See also Olin, *The Nation Without Art*.

3. In the summer of 1949 the *Menorah Journal* published "An Album of Paintings, Drawings and Sculpture by 60 Jewish Artists of America, Europe and Israel," including paintings as diverse as *Landscape* by Adolphe Feder, the biblical scene *The Finding of Moses* by Enrico Glicenstein, El Lissitzky's *Chad Gaya*, Jules Pascin's *Sunday in Central Park*, and Raphael Soyer's *The Artist's Parents*. None of the album's images share a similarity of form or style, and far less than half depict overt Jewish subject matter.

4. For an important discussion of the proliferation of Jewish photographers and how Jewishness may have influenced their images of New York see Max Kozloff, *New York: Capital of Photography*, especially 69–77.

5. On Holocaust imagery across national boundaries see Ziva Amishai-Maisels, *Depiction and Interpretation*. For Holocaust responses by Jewish American artists see Baigell, *Jewish-American Artists and the Holocaust* and parts of *Jewish Artists in New York*.

6. Several other Jewish artists have pictured Jesus as Jewish, notably the Russian Marc Chagall (1887–1985) and the German Maurycy Gottlieb (1856–1879).

7. The Hirshhorn Museum and Sculpture Garden in Washington, D.C., owns a full set representing inhabitants of the city.

8. Original citation, "Theresa Bernstein: A Realist in the Old Sense of the Word," *New York Herald* (November 2, 1919): 5.

9. Symbolizing change, the Sabbath Bride is invited by observant Jews to the synagogue and the home as a metaphor for the transition between the workweek and the period of rest.

10. Bloom and Baskin's work was shown together in 1986 at the Kennedy Galleries. Bloom also did several drawings of rabbis. See *The Drawings of Hyman Bloom* (Baskin designed the catalog).

11. Davidson also sculpted Presidents Herbert Hoover (1921, bronze, Smithsonian Institution, National Portrait Gallery, Washington, D.C.) and Franklin Delano Roosevelt (1934, bronze, Franklin D. Roosevelt Library and Museum, Hyde Park, New York; 1951 stone, Smithsonian Institution, National Portrait Gallery, Washington, D.C.), for whom he also designed a third and fourth inaugural medal, and made a posthumous bronze portrait of Abraham Lincoln (1944, New Jersey State Museum, Trenton). Because Davidson's sculptures have been cast more than once, sometimes posthumously, the same sculpture can be found in several different collections.

12. Tucker and Brookman reprinted Frank's Guggenheim application in their exhibition catalog. A map in the catalog helpfully reconstructs Frank's journey (95).

13. Most of the photographs were made between 1971 and 1975, but some earlier pictures are also included.

14. Original clipping, Emery Grossman, "A Visit with William Gropper." *Temple Israel Light* 8 (March 1962).

15. Naftoli Gross, who had been living in New York since 1914, ultimately became a well-known Yiddish poet and writer.

16. Kitaj often supplies commentary on images. In a book accompanying a 1994–1995 retrospective that showed at the Tate Gallery, Los Angeles County Museum of Art, and the Metropolitan Museum of Art, Kitaj describes several works, including *The Jewish School (Drawing a Golem)* (Morphet, 138) and *The Jew Etc.* (Ibid., 132).

17. In the 1978 exhibition *Abstract Expressionism: The Formative Years*, Robert Hobbs and Gail Levin were the earliest scholars to categorize Krasner as a first-generation Abstract Expressionist.

18. Although scholars term Lassaw's technique a drip technique, the procedure by which he applied these drips was measured, unlike Pollock's spontaneous drips on canvas.

19. Erected in 1987, the memorial sat in a plaza in front of Munster Palace until March 1988 when public dissent over the stark contrast between the work and the charming plaza prompted its demolition.

20. Many Abstract Expressionists saw nature as an influence on their art. In 1958, the Whitney Museum of American Art mounted an exhibition addressing the topic appropriately titled *Nature in Abstraction.*

21. Louis destroyed many of his experimental works done from 1955 to 1957.

22. Bernstein also notes a birth year of 1887 in her biography of her husband, *William Meyerowitz: The Artist Speaks.*

23. Gustave Mosler trained as a lithographer in Germany but found success in America as a businessman. Notably, in the United States, the elder Mosler published a lithographed *Mizrah* (c. 1855). A plaque to hang on the wall of an observant Jewish home to signal the direction one faces to pray, Gustave's *mizrah* is illustrated with stories from the Bible.

24. The original quotation can be found in "New York Jews in Art: No. 11– Henry Mosler," *The Federation Review* 4, no. 4 (March 1910): 77.

25. Originally published in *Camera Work* 32 (October 1910).

26. "Tzim-Tzum," or "Zim Zum," is a Kabbalistic idea that refers to God's process of making space for creation, as described in Genesis. Newman made a Corten steel sculpture titled *Zim Zum I* in 1969 (San Francisco Museum of Modern Art). "The Name" is a reference to God, as observant Jews refer to God as The Name. Newman titled several canvases "The Name."

27. Original clipping, James Berstein, "Abraham Rattner, Artist, at 82." *Newsday* (February 15, 1978).

28. "The Portrait and the Modern Artist," aired on WNYC in New York on October 13, 1943 as part of a series titled "Art in New York." Gottlieb joined Rothko for the broadcast.

29. Quote originally from a talk presented at the Jewish Museum, New York, April 7, 1983.

30. "The Drama of Objects," is reproduced in Carl Chiarenza's *Aaron Siskind: Pleasures and Terrors* (65–66).

31. Original citation is from a letter from Stieglitz to Waldo Frank, dated April 3, 1925.

32. For more on *tikkun olam,* see Preface to the book.

33. Walkowitz's birth date is alternately given as 1878 and 1880. In an oral interview from 1958, Walkowitz explained that his mother changed the date to reflect a later birth so that he would not be drafted into the Tsarist, and anti-Semitic, Russian army before the family could depart for the United States (Lerner and Cowdrey, 12).

34. While Weegee's pseudonym is popularly understood as related to his so-called psychic abilities, it has also been suggested that his darkroom work for the *New York Times* squeegeeing water off prints may account for the name (Barth, 15, 16-17).

35. The dates for Weegee's photographs vary. These discrepancies depend on whether scholars' use the date of the negative or the date when the picture was first printed in the press. Titles also diverge because some scholars use popular titles assigned by art historians while others use those titles inscribed on the print by Weegee (which also sometimes vary) or the caption in the press venue where the print appeared (either a periodical or one of Weegee's books). When appropriate, I provide more than one title, and when available I use the date that the picture was taken rather than its publication date.

36. Lady Decies is sometimes identified by scholars as Lady Peel; however, *Life* magazine noted her name as Lady Decies.

37. *Weegee's People* titles *Rehearsal, Yiddish Theater* as *Invitation to the Dance* in a section called "Back Stage."

38. Zorach's birth year is a matter of debate; scholars alternately cite it as 1887 or 1889. Similarly, scholars disagree on Zorach's arrival in America, providing either 1891 or 1893 as the year of immigration based on the fact that he came to the United States at the age of four, as noted in his autobiography (*Art is My Life,* 3).

Some Initial Reading on Jewish American Art

Baigell, Matthew. *Jewish-American Artists and the Holocaust.* New Brunswick, NJ: Rutgers University Press, 1997.

———. *Jewish Artists in New York: The Holocaust Years.* New Brunswick, NJ: Rutgers University Press, 2002.

Baskind, Samantha. *Raphael Soyer and the Search for Modern Jewish Art.* Chapel Hill: University of North Carolina Press, 2004.

Goodman, Susan. *Jewish Themes/Contemporary American Artists.* New York: Jewish Museum, 1982.

———. *Jewish Themes/Contemporary American Artists II.* New York: Jewish Museum, 1986.

Grossman, Emery. *Art and Tradition.* New York: Thomas Yoseloff, 1967.

Gutmann, Joseph. "Jewish Participation in the Visual Arts of Eighteenth- and Nineteenth-Century America." *American Jewish Archives* 15, no. 1 (April 1963): 21–57.

Heyd, Milly. *Mutual Reflections: Jews and Blacks in American Art.* New Brunswick, NJ: Rutgers University Press, 1999.

Kampf, Avram. *Contemporary Synagogue Art: Developments in the United States, 1945-1965.* New York: Union of American Hebrew Congregations, 1966.

Kleeblatt, Norman L., ed. *Too Jewish?: Challenging Traditional Identities.* New York: Jewish Museum; New Brunswick, NJ: Rutgers University Press, 1996.

Kleeblatt, Norman L., and Susan Chevlowe, eds. *Painting a Place in America: Jewish Artists in New York, 1900–1945.* New York: Jewish Museum, 1991.

Kozloff, Max. *New York: Capital of Photography.* With contributions by Karen Levitov and Johanna Goldfeld. New York: Jewish Museum; New Haven: Yale University Press, 2002.

Levin, Gail. "Beyond the Pale: Jewish Identity, Radical Politics and Feminist Art in the United States." *Journal of Modern Jewish Studies* 4, no. 2 (July 2005): 205–232.

Lozowick, Louis. *One Hundred Contemporary American Jewish Painters and Sculptors.* New York: YKUF Art Section, 1947.

Rashell, Jacob. *Jewish Artists in America.* New York: Vantage Press, 1967.

Soltes, Ori Z. *Fixing The World: Jewish American Painters in the Twentieth Century.* Hanover, NH: Brandeis University Press, 2003.

Werner, Alfred. "Ghetto Graduates." *The American Art Journal* 5, no. 2 (November 1973): 71–82.

Zalkind, Simon. *Upstarts and Matriarchs: Jewish Women Artists and the Transformation of American Art.* Essays by Gail Levin and Elissa Authur. Denver, CO: Mizel Center for Arts and Culture, 2005.

Index

About the Author

SAMANTHA BASKIND is an Assistant Professor of Art History at Cleveland State University. She is the author of *Raphael Soyer and the Search for Modern Jewish Art* (2004).